the Adobe® photoshop® CS5 book

for digital photographers

Scott Kelby

**The Adobe Photoshop
CS5 Book for Digital
Photographers Team**

CREATIVE DIRECTOR
Felix Nelson

TECHNICAL EDITORS
Kim Doty
Cindy Snyder

TRAFFIC DIRECTOR
Kim Gabriel

PRODUCTION MANAGER
Dave Damstra

DESIGNER
Jessica Maldonado

COVER PHOTOS BY
Scott Kelby

Published by
New Riders

Composed in Cronos and Helvetica by Kelby Media Group, Inc.

Trademarks
All terms mentioned in this book that are known to be trademarks or service marks have
been appropriately capitalized. New Riders cannot attest to the accuracy of this information.
Use of a term in this book should not be regarded as affecting the validity of any trademark
or service mark.

Photoshop is a registered trademark of Adobe Systems, Inc.
Macintosh is a registered trademark of Apple, Inc.
Windows is a registered trademark of Microsoft Corp.

Warning and Disclaimer
This book is designed to provide information about Photoshop for digital photographers.
Every effort has been made to make this book as complete and as accurate as possible, but
no warranty of fitness is implied.

The information is provided on an as-is basis. The author and New Riders shall have neither
the liability nor responsibility to any person or entity with respect to any loss or damages
arising from the information contained in this book or from the use of the discs or programs
that may accompany it.

THIS PRODUCT IS NOT ENDORSED OR SPONSORED BY ADOBE SYSTEMS INCORPORATED,
PUBLISHER OF ADOBE PHOTOSHOP CS5.

ISBN 13: 978-0-321-70356-9
ISBN 10: 0-321-70356-1

9 8 7 6 5 4 3

www.newriders.com
www.kelbytraining.com

To my son, Jordan—I am incredibly impressed,
and amazingly proud of the wonderful young man
you have become. Dude—you rock!

ACKNOWLEDGMENTS

After writing books for 12 years now, I still find that the thing that's the hardest for me to write in any book is writing the acknowledgments. It also, hands down, takes me longer than any other pages in the book. For me, I think the reason I take these acknowledgments so seriously is because it's when I get to put down on paper how truly grateful I am to be surrounded with such great friends, an incredible book team, and a family that truly makes my life a joy. That's why it's so hard. I also know why it takes so long—you type a lot slower with tears in your eyes.

To my remarkable wife, Kalebra: We've been married nearly 21 years now, and you still continue to amaze me, and everyone around you. I've never met anyone more compassionate, more loving, more hilarious, and more genuinely beautiful, and I'm so blessed to be going through life with you, to have you as the mother of my children, my business partner, my private pilot, Chinese translator, and best friend. You truly are the type of woman love songs are written for, and as anyone who knows me will tell you, I am, without a doubt, the luckiest man alive to have you for my wife.

To my son, Jordan: It's every dad's dream to have a relationship with his son like I have with you, and I'm so proud of the bright, caring, creative young man you've become. I can't wait to see the amazing things life has in store for you, and I just want you to know that watching you grow into the person you are is one of my life's greatest joys.

To my precious little girl, Kira: You have been blessed in a very special way, because you are a little clone of your mom, which is the most wonderful thing I could have possibly wished for you. I see all her gifts reflected in your eyes, and though you're still too young to have any idea how blessed you are to have Kalebra as your mom, one day—just like Jordan—you will.

To my big brother Jeff, who has always been, and will always be, a hero to me. So much of who I am, and where I am, is because of your influence, guidance, caring, and love as I was growing up. Thank you for teaching me to always take the high road, for always knowing the right thing to say at the right time, and for having so much of our dad in you.

I'm incredibly fortunate to have part of the production of my books handled in-house by my own book team at Kelby Media Group, which is led by my friend and longtime Creative Director, Felix Nelson, who is hands down the most creative person I've ever met. He's surrounded by some of the most talented, amazing, ambitious, gifted, and downright brilliant people I've ever had the honor of working with, and thank God he had the foresight to hire Kim Doty, my Editor, and the only reason why I haven't totally fallen onto the floor in the fetal position after writing both a Lightroom 3 book, and a CS5 book back to back. Kim is just an incredibly organized, upbeat, focused person who keeps me calm and on track, and no matter how tough the task ahead is, she always says the same thing, "Ah, piece of cake," and she convinces you that you can do it, and then you do it. I cannot begin to tell you how grateful I am to her for being my editor, and to Felix for finding her. I guess great people just attract other great people.

Working with Kim is Cindy Snyder, who relentlessly tests all the stuff I write to make sure I didn't leave anything out, so you'll all be able to do the things I'm teaching (which with a Photoshop book is an absolute necessity). She's like a steel trap that nothing can get through if it doesn't work just like I said it would.

The look of the book comes from an amazing designer, a creative powerhouse, and someone whom I feel very, very lucky to have designing my books—Jessica Maldonado. She always adds that little something that just takes it up a notch, and I've built up such a trust for her ideas and intuition, which I why I just let her do her thing. Thanks Jess!

I owe a huge debt of gratitude to my Executive Assistant and Chief Wonder Woman, Kathy Siler. She runs a whole side of my business life, and a big chunk of our conferences, and she does it so I have time to write books, spend time with my family, and have a life outside of work. She's such an important part of what I do that I don't know how I did anything without her. Thank you, thank you, thank you. It means more than you know.

Thanks to my best buddy, our Chief Operating Officer and father of twin little girls, Dave Moser, first for handling the business end of our book projects, but mostly for always looking out for me.

Thanks to everyone at New Riders and Peachpit, and in particular to my way cool Editor, Ted Waitt (who is one heck of a photographer and a vitally important part of everything I do in "Bookland"), my wonderful Publisher Nancy Aldrich-Ruenzel, Marketing Maven Scott Cowlin, Marketing Diva Sara Jane Todd and the entire team at Pearson Education who go out of their way to make sure that we're always working in the best interest of my readers, that we're always trying to take things up a notch, and who work hard to make sure my work gets in as many people's hands as possible.

Thanks to my friends at Adobe: Kevin Connor, John Nack, Mala Sharma, John Loiacono, Terry White, Cari Gushiken, Julieanne Kost, Tom Hogarty, Dave Story, Bryan Hughes, Thomas Nielsen, Russell Preston Brown, and the amazing engineering team at Adobe (I don't know how you all do it). Gone but not forgotten: Barbara Rice, Jill Nakashima, Rye Livingston, Addy Roff, Bryan Lamkin, Jennifer Stern, Deb Whitman, and Karen Gauthier.

Thanks to my "Photoshop Guys": Dave Cross, RC Concepcion, and Corey Barker, for being such excellent sounding boards for the development of this book, and a special shout out to Matt Kloskowski for all his input and ideas for this edition of the book. It's much better because of his input, and I'm very grateful to have his advice, and his friendship. I want to thank all the talented and gifted photographers who've taught me so much over the years, including: Moose Peterson, Joe McNally, Anne Cahill, Vincent Versace, Bill Fortney, David Ziser, Helene Glassman, Kevin Ames, and Jim DiVitale.

Thanks to my mentors, whose wisdom and whip-cracking have helped me immeasurably, including John Graden, Jack Lee, Dave Gales, Judy Farmer, and Douglas Poole.

Most importantly, I want to thank God, and His son Jesus Christ, for leading me to the woman of my dreams, for blessing us with two amazing children, for allowing me to make a living doing something I truly love, for always being there when I need Him, for blessing me with a wonderful, fulfilling, and happy life, and such a warm, loving family to share it with.

OTHER BOOKS BY SCOTT KELBY

The Adobe Photoshop Lightroom 3 Book for Digital Photographers

The Digital Photography Book, vols. 1, 2, and 3

The Photoshop Channels Book

Photo Recipes Live: Behind the Scenes

Scott Kelby's 7-Point System for Adobe Photoshop CS3

Photoshop Down & Dirty Tricks

The iPhone Book

The Mac OS X Leopard Book

Getting Started with Your Mac and Mac OS X Tiger

The Photoshop Elements Book for Digital Photographers

ABOUT THE AUTHOR

Scott Kelby

Scott is Editor, Publisher, and co-founder of *Photoshop User* magazine, Editor-in-Chief of *Layers* magazine (the how-to magazine for everything Adobe), and is host of the top-rated weekly videocast *Photoshop User TV*, and the co-host of *D-Town TV*, the weekly videocast for DSLR shooters.

He is President of the National Association of Photoshop Professionals (NAPP), the trade association for Adobe® Photoshop® users, and he's President of the training, education, and publishing firm, Kelby Media Group, Inc.

Scott is a photographer, designer, and award-winning author of more than 50 books, including *The Adobe Photoshop Lightroom 3 Book for Digital Photographers*, *Photoshop Down & Dirty Tricks*, *The Photoshop Channels Book*, *The iPhone Book*, *The iPod Book*, and *The Digital Photography Book*, vols. 1, 2 & 3.

For six years straight, Scott has been honored with the distinction of being the world's #1 best-selling author of all computer and technology books, across all categories. His book, *The Digital Photography Book*, vol. 1, is now the best-selling book on digital photography in history.

His books have been translated into dozens of different languages, including Chinese, Russian, Spanish, Korean, Polish, Taiwanese, French, German, Italian, Japanese, Dutch, Swedish, Turkish, and Portuguese, among others, and he is a recipient of the prestigious Benjamin Franklin Award.

Scott is Training Director for the Adobe Photoshop Seminar Tour and Conference Technical Chair for the Photoshop World Conference & Expo. He's featured in a series of Adobe Photoshop online courses and DVDs at KelbyTraining.com and has been training Adobe Photoshop users since 1993.

For more information on Scott, visit his daily blog, *Photoshop Insider*, at www.scottkelby.com.

CHAPTER 4 **95**

Attitude Adjustment
Camera Raw's Adjustment Tools

CHAPTER 5 **115**

Scream of the Crop
How to Resize and Crop Photos

CHAPTER 6 145

Jonas Sees in Color
Color Correction Secrets

CHAPTER 7 175

Black & White
How to Create Stunning B&W Images

Seven Things You'll Wish You Had Known Before Reading This Book

It's really important to me that you get a lot out of reading this book, and one way I can help is to get you to read these seven quick things about the book that you'll wish later you knew now. For example, it's here that I tell you about where to download something important, and if you skip over this, eventually you'll send me an email asking where it is, but by then you'll be really aggravated, and well… it's gonna get ugly. We can skip all that (and more), if you take two minutes now and read these seven quick things. I promise to make it worth your while.

(1) You don't have to read this book in order.

I designed this book so you can turn right to the technique you want to learn, and start there. I explain everything as I go, step-by-step, so if you want to learn how to remove dust spots from a RAW image, just turn to page 82, and in a couple of minutes, you'll know. I did write the book in a logical order for learning CS5, but don't let that tie your hands—jump right to whatever technique you want to learn— you can always go back, review, and try other stuff.

(2) Practice along with the same photos I used here in the book.

As you're going through the book, and you come to a technique like "Creating HDR Images in Photoshop CS5," you might not have an HDR-bracketed set of shots hanging around, so in those cases I usually made the images available for you to download, so you can follow along with the book. You can find them at **www.kelbytraining.com/books/cs5** (see, this is one of those things I was talking about that you'd miss if you skipped this and went right to Chapter 1). By the way, the screen captures here are totally just for looks, because these pages would look pretty empty without any images (though you can read the story about them at www.scottkelby.com/blog/2010/archives/10105).

SCOTT KELBY

SCOTT KELBY

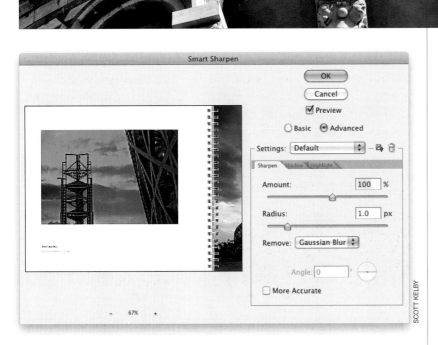

SCOTT KELBY

(3) The intro pages at the beginning of each chapter are not what they seem.
The chapter introductions are designed to give you a quick mental break between chapters, and honestly, they have little to do with what's in the chapter. In fact, they have little to do with anything, but writing these quirky chapter intros has become kind of a tradition of mine (I do this in all my books), so if you're one of those really "serious" types, I'm begging you—skip them and just go right into the chapter because they'll just get on your nerves. However, the short intros at the beginning of each individual project, up at the top of the page, are usually pretty important. If you skip over them, you might wind up missing stuff that isn't mentioned in the project itself. So, if you find yourself working on a project, and you're thinking to yourself, "Why are we doing this?" it's probably because you skipped over that intro. So, just make sure you read it first, and then go to Step One. It'll make a difference—I promise.

SCOTT KELBY

(4) There are things in Photoshop CS5, and in Camera Raw that do the exact same thing.
For example, there's a Lens Corrections panel in Camera Raw, and there's a Lens Correction filter in Photoshop, and they are almost identical. What this means to you is, some things are covered twice in the book (not everybody wants to use Camera Raw, so I have to cover both). As you go through the book, and you start to think, "This sounds familiar...," now you know why. By the way, in my own workflow, if I can do the exact same task in Camera Raw or Photoshop, I always choose to do it Camera Raw, because it's faster (there are no progress bars in Camera Raw) and it's non-destructive (so I can always change my mind later).

(5) I included a chapter on my CS5 workflow, but don't read it yet.
At the end of this book I included a special chapter detailing my own CS5 workflow, but please don't read it until you've read the rest of the book, because it assumes that you've read the book already, and understand the basic concepts, so it doesn't spell everything out (or it would be one really, really long drawn-out chapter).

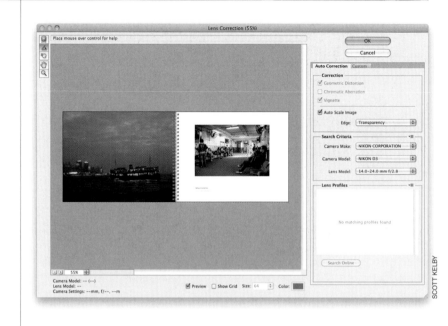

(6) Where's the Bridge stuff?
In CS5, a version of Bridge is built right into Photoshop itself. It's called "Mini Bridge" (I am not making this up), and it does about 85% of what "Big Bridge" does (Adobe doesn't call it Big Bridge, they call it Adobe Bridge). This is great because now you don't have to leave Photoshop and jump to a separate application for finding and working with your images. So, since Mini Bridge is part of CS5, I start the book with a chapter on Mini Bridge. So, what did Adobe do with Big Bridge in CS5? Well, not much. In fact, they only added two new features/tweaks (which gives you some hint as to the future of Bridge, eh?). Anyway, the Mini Bridge chapter replaced the old Bridge ones here in the book, but since some of you may still be using Big Bridge for at least a little while longer (at least until you fall in love with Mini Bridge), I did update the chapters, and put them on the Web for you to download free. You'll find these two at **www.kelbytraining.com/books/cs5**.

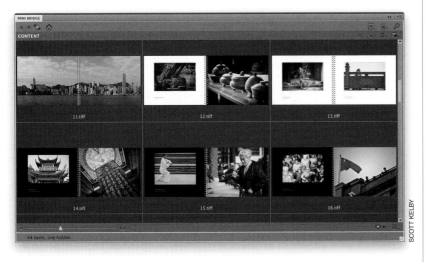

SCOTT KELBY

(7) I made a special bonus video just for you.
I did a special video just for you on a number of different techniques for creative photo layouts. I call this video "How to Show Your Work" and you can find it at **www.kelbytraining .com/books/cs5**.

SCOTT KELBY

(8) This new version includes my "Photoshop Killer Tips!"
Hey, I thought you said it was "Seven Things"? Well, consider this eighth a "bonus thing," because it's about another bonus I added exclusively to this CS5 edition of the book. At the end of every chapter, I added a special section I call "Photoshop Killer Tips" (named after the book of the same name I did a few years ago with Felix Nelson). These are those time-saving, job-saving, "man, I wish I had known that sooner" type tips. The ones that make you smile, nod, and then want to call all your friends and "tune them up" with your new status as Photoshop guru. These are in addition to all the other tips, which already appear throughout the chapters (you can never have enough tips, right? Remember: He who dies with the most tips, wins!). So, there you have it, seven (or so) things that you're now probably glad you took a couple minutes and read. Okay, the easy part is over—turn the page and let's get to work.

Mini Series
using photoshop cs5's mini bridge

If you're reading this chapter opener (and you are, by the way), it's safe to assume that you already read the warning about these openers in the introduction to the book (by the way, nobody reads that, so if you did, you get 500 bonus points, and a chance to play later in our lightning round). Anyway, if you read that and you're here now, you must be okay with reading these, knowing full well in advance that these have little instructional (or literary) value of any kind. Now, once you turn the page, I turn all serious on you, and the fun and games are over, and it's just you and me, and most of the time I'll be screaming at you (stuff like, "No, no—that's too much sharpening you goober!" and "Are you kidding me? You call that a Curves adjustment?" and "Who spilled my mocha Frappuccino?" and stuff like that), so although we're all friendly now, that all ends when you turn the page, because then

we're down to business. That's why, if you're a meany Mr. Frumpypants type who feels that joking has no place in a serious book of learning like this, then you can: (a) turn the page and get to the discipline and order you crave, or (b) if you're not sure, you can take this quick quiz that will help you determine the early warning signs of someone who should skip all the rest of the chapter openers and focus on the "real" learning (and yelling). Question #1: When was the last time you used the word "poopy" in a sentence when not directly addressing or referring to a toddler? Was it: (a) During a morning HR meeting? (b) During a legal deposition? (c) During your wedding vows? Or, (d) you haven't said that word, in a meaningful way since you were three. If you even attempted to answer this question, you're clear to read the rest of the chapter openers. Oh, by the way: pee pee. (Hee hee!)

Getting to Your Photos Using Mini Bridge

Way back in Photoshop 7, we had a feature I loved called the File Browser, which let you access your images from right within Photoshop. Well, when Photoshop CS came a year and a half later, they took the File Browser away and gave us the more powerful Adobe Bridge. The fact that it was more powerful was great, but I hated that it was a totally separate program, and now I had to leave Photoshop to get to my images. Thankfully, in Photoshop CS5, there's Mini Bridge, so we no longer have to leave Photoshop (wild cheers ensue!).

Step One:
By default, Mini Bridge lives just to the left of the Color panel (it's shown circled here in red), and to make it visible, you just click directly on it (#1) and it pops out (as seen here). You can also launch it from the taskbar at the top of the window (#2) by clicking on the Mini Bridge button (also circled in red). When it appears, click on the button called Browse Files, and it launches "Big Bridge" (what I call the full-sized Adobe Bridge) in the background (you won't see it, but Mini Bridge actually needs Big Bridge open to do its thing, but again, this happens in the background, so you won't actually see it at all).

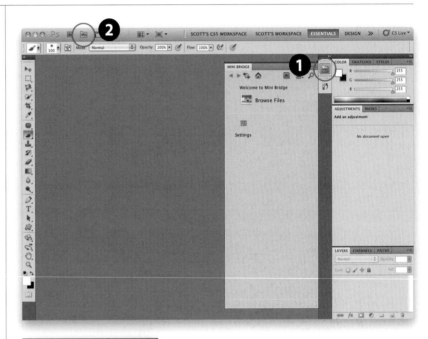

Step Two:
Once Big Bridge launches in the background, Mini Bridge comes alive. At the top there's a Navigation pod, where you can make your way to the photos on your computer. Here, I've clicked on my Pictures folder, and in the Content pod below, it lists the folders I have inside my Pictures folder. To see what's inside one of those folders, you just double-click on it.

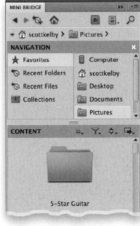

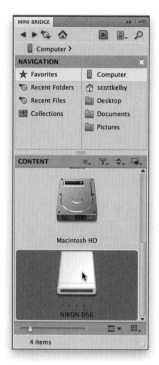

Step Three:

If you've connected a camera or memory card reader to your computer, you can also access the images on it by clicking on Computer at the top right, then in the Content pod, scrolling down until you see your memory card (as shown here). If you double-click on it, you will see the photos on your memory card (though you might have to double-click a few times to dig through the folders on your memory card to get to your photos). Once you get to them, you can open them directly from your card, but honestly, I wouldn't recommend working off the card. That's a recipe for danger—I've heard countless stories of people who have had a memory card become corrupt while working directly off it, so I avoid this unless I'm really desperate (on a deadline to upload a single image, for example).

Step Four:

Instead, I recommend downloading the images to your computer, then using Mini Bridge to access them (which is much safer, because now you have the images on your computer, and a backup on your memory card). To do this, press-and-hold the Option (PC: Alt) key and drag the folder of images from the Mini Bridge panel right onto your desktop or a folder in Finder (PC: Windows Explorer), and it copies the images to your hard drive. Or, you could switch to Big Bridge, then go under Bridge's File menu and choose **Get Photos From Camera**. (*Note:* To learn more about Big Bridge, make sure you download the two free bonus chapters I posted on the download website listed in the introduction.)

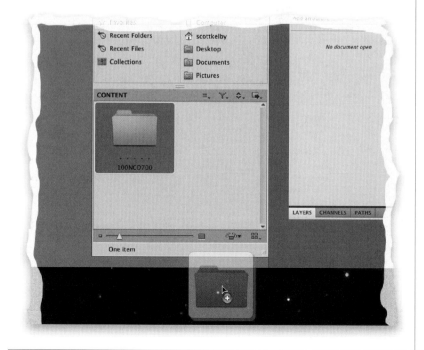

Viewing Your Photos in Mini Bridge

Okay, now that you've found Mini Bridge and you've copied your images onto your computer, let's put it to work and find out which style of Mini Bridge works best for your workflow (luckily, you get to set it up the way you like it), and how to use it quickly to find and view the images you've imported (or the ones already on your computer).

Step One:
By default, Mini Bridge is set up in a tall, thin layout, like the one you see here, but you can make the Mini Bridge panel larger by hovering your cursor over the left edge of the panel until it becomes a double-sided arrow, then clicking-and-dragging out its left side (as shown by the red arrow).

Step Two:
Here I've dragged it to the left so you can see more thumbnails. To make the thumbnails larger, drag the Thumbnails Size slider to the right (it's shown circled here in red). Also, once you've found the images you want to work with, I usually hide the Navigation pod (so I can see more of my thumbnails) by clicking on the little white X in its upper-right corner (you can see it in Step One) .

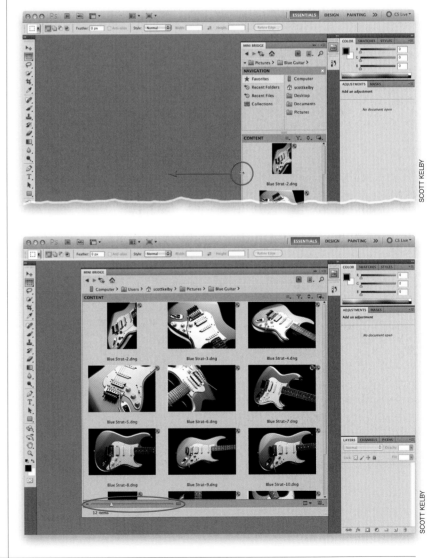

SCOTT KELBY

SCOTT KELBY

Step Three:
The default view is this As Thumbnails view, but you have three other choices: As Filmstrip, which puts your images along the bottom or side (depending on how large you make your Mini Bridge panel); As Details, which displays your thumbnails with some metadata info appearing to the right of them (stuff like the file size, rating, type of file, and so on); and As List, which just lists your images in a vertical row like a Finder (PC: Windows Explorer) window (I've never used the As List view, even once). Here, I've chosen As Filmstrip (by clicking on the View icon in the bottom right of the Content pod—it looks like four squares), which to me is pretty useless, because you're wasting all that space above it, but in the next step, you'll see how to make it pretty useful.

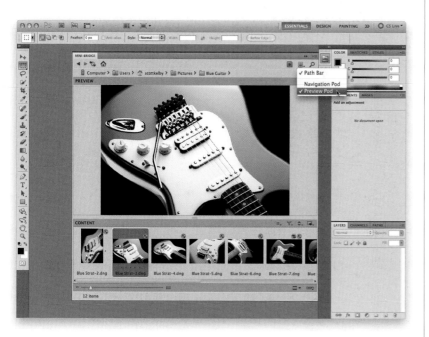

Step Four:
Go up and click on the little icon that looks like a filmstrip at the top of Mini Bridge, and when the menu pops up, choose **Preview Pod** (I have no idea why Adobe started to use the term "pod" for these sections, but I kinda like it). Anyway, once you make this Preview pod visible, now As Filmstrip makes sense, because when you click on a thumbnail down in the filmstrip, a large preview appears above it (I say above it, but it really depends on how wide you've dragged your Mini Bridge panel out, because if you've got it pretty narrow, it'll probably appear on the left side with your filmstrip on the right. This actually works great if the photos you're working on are in portrait orientation, because you'll wind up getting larger previews. Photos in wide [landscape] orientation wind up previewing larger when the filmstrip is at the bottom). To close the Preview pod, just click on the little X in its upper-right corner.

Continued

Step Five:

You can also choose the size of the Preview pod (I dragged Mini Bridge out wider here, so you can see what it looks like when the Preview pod is on the side, rather than on top). You see that bar that separates the thumbnails from the Preview pod? Just click-and-drag that bar to give either the thumbnails more (or less) room, or to resize the Preview pod.

TIP: Zooming in Tighter

If you have the Preview pod visible, to zoom in tighter, just click once on the image in the Preview Pod and it zooms right into where you clicked. Click again to zoom back out.

Step Six:

Now that I've shown you that great Preview pod trick, here's why you might not use it at all: anytime you want to see a really large preview of a thumbnail, just press the **Spacebar**, and you get a huge full-screen preview (as seen here). You can use the Left and Right Arrow keys on your keyboard to see other thumbnails zoomed to full screen like this. When you're done, just press the **Esc** key on your keyboard, or press the Spacebar again. (See? I told you, you might not use that Preview pod thing that much.)

Step Seven:

Okay, now that you know your options, I want to show you how I set up my own Mini Bridge. I dock mine right along the bottom of the window (as seen here). You'll see the advantage of this in the next step, but for now, here's how to dock it down there: Click on the Mini Bridge panel tab (right on the words "Mini Bridge") and drag it all the way to the bottom of the screen until you see a thin blue line appear. That's letting you know it's ready to dock. Now, just let go and it docks right down there. Then I set my view to **As Thumbnails** (from the View icon's pop-up menu in the bottom-right corner of the Content pod).

Step Eight:

There are two reasons why I like docking it down there: (1) To have it tuck itself neatly out of the way, just double-click right on the Mini Bridge tab, and it collapses down to just a tiny gray bar along the bottom. This area at the bottom is probably the least-used part of your screen (side-to-side real estate is more valuable). And (2), since I also use Lightroom, having this filmstrip across the bottom gives me a similar look and feel to the one in Lightroom, so I feel right at home. (Also, if you're coming from Photoshop Elements to Photoshop CS5, this is kinda like Elements' Project Bin to some extent, so you might like Mini Bridge down there, too.) The good news is: you can give it a try, and if you don't like it, just drag that tab right off the bottom and it undocks, so you can put it where you want it (or even have it as its own floating window).

Use Full-Screen Review Mode to Find Your Best Shots Fast

One of my favorite features of Mini Bridge is Review mode, because this is where Mini Bridge really feels big! By making your images much larger onscreen, it makes it much easier to find your best shots, and Review mode really makes whittling things down to just the best shots from your shoot so much easier.

Step One:
To see the images in Mini Bridge in Review mode, make sure either no images are selected or all the images you want to see are selected (by Command-clicking [PC: Ctrl-clicking] on them), then choose **Review Mode** from the Preview icon's pop-up menu at the bottom-right of the Content pod (as shown here). By the way, if you have less than four images, it doesn't go into the full carousel slide show version of Review mode like you see in the next step—it just puts the four in full-screen Preview mode (yawn).

Step Two:
When you choose Review Mode, it enters a full-screen view with your images in a cool carousel-like rotation (as seen here). This mode is great for two big reasons: The first being it makes a really nice onscreen slide show presentation. You can use the **Left and Right Arrow keys** on your keyboard to move through the photos or the arrow buttons in the lower-left corner of the screen (as a photo comes to the front, it becomes larger and brighter). If you want to open the image in front in Photoshop, press the letter **O**. To open the front photo in Adobe Camera Raw, press **R**. To open all your images in Camera Raw, press **Option-R (PC: Alt-R)**. To leave Review mode, press the **Esc key**. If you forget any of these shortcuts, just press **H**.

Step Three:

The second reason to use Review mode is to help you narrow things down to just your best photos from a shoot. Here's how: Let's say you have five or six similar photos, or photos of a similar subject (in this case, a guitar), and you want to find the single best one out of those. Start by Command-clicking (PC: Ctrl-clicking) on just those photos (in the Content pod) to select them, and enter Review mode. As you move through the photos (using the Left and Right Arrow keys on your keyboard), and you see one come to front that's not going to make the cut, just press the **Down Arrow key** on your keyboard (or click the Down Arrow button on-screen) and that photo is removed from the screen. Keep doing this until you've narrowed things down to just the final image.

Step Four:

Like I mentioned, once you fall below five images, you no longer get the carousel view. Instead, it looks more like regular Preview mode—it's just full screen (as seen here). In Review mode, you can zoom in tight on a particular area using the built-in Loupe. Just move your cursor over the part of the photo you want a closer look at, and click to bring up the Loupe for that photo (as shown here, in the image in the top right). To move it, click-and-hold inside the Loupe and drag it where you want it. To make it go away, just click once inside it. Once you've whittled things down to just your keepers, you can give each a star rating (like a 5-star rating by pressing **Command-5 [PC: Ctrl-5]**)—more on this on the next page.

Sorting and Arranging Your Photos

Ah, finally we get to the fun part—sorting your photos. We generally have the same goal here: quickly finding out which are the best shots from your shoot (the keepers), marking them as your best shots, and then separating those from the rest, so they're just one click away when you need them. That way you can view them as slide shows, post them on the Web, send them to a client for proofing, or prepare them for printing.

Step One:
When you view your images in Mini Bridge, by default, they're sorted manually by filename, so it's pretty likely that the first photo you shot will appear in the upper-left corner of the Content pod, or the left end of the filmstrip. I say it's "pretty likely" because there are exceptions (if you did multiple shoots on different cameras, or shot on different memory cards, etc.), but most likely they'll appear first one shot first. If you want to change how they are sorted, click on the Sort icon (it looks like up and down arrows) at the top-right of the Content pod, and a pop-up menu of options will appear (as seen here).

Step Two:
Let's start by quickly rating our photos to separate the keepers from the rest of the bunch. First, I switch to a view mode that's better for decision making, like Full Screen Preview mode (select any photo and then press the **Spacebar**) or Review mode (we just went through this). Now, use the **Left and Right Arrow keys** on your keyboard to move through the full-screen images.

Step Three:

Probably the most popular method for sorting your images is to rate them using Mini Bridge's 1- to 5-star rating system (with 5 being your best images). That being said, I'm going to try to convince you to try a rating system that is faster and more efficient. Let's start by finding the bad ones. When you see a photo that is really bad (way out of focus, the flash didn't fire, the subject's eyes are closed, etc.), press **Option-Delete (PC: Alt-Delete)** to mark that photo as a Reject. The word Reject appears in red in the bottom-left after you do this in Full Screen Preview mode, below the photo in Review mode, and below the thumbnail, as well (shown circled here in red). It doesn't delete them; it just marks 'em as Rejects. *Note:* Mini Bridge displays your Rejects right alongside your other photos, but if you don't want to see your Rejects, you can hide them by going under the Select icon's pop-up menu and choosing **Show Reject Files** (as shown here).

Step Four:

When you see a "keeper" (a shot you may want to print, or show to the client, etc.), then you'll press **Command-5 (PC: Ctrl-5)** to mark that photo as a 5-star image, and this star rating will appear below the selected photo (shown circled here in red). So that's the drill—move through your photos and when you see a real keeper, press Command-5, and when you see a totally messed up photo, press Option-Delete to mark it as a Reject. For all the rest of the photos, you do absolutely nothing. So, why not use the entire star rating system? Because it takes way, way too long (I'll explain why on the next page).

Continued

Step Five:

Here's why I don't recommend using the entire star rating system: What are you going to do with your 2-star images? They're not bad enough to delete, so we keep 'em, right? What about your 3-star ones? The client won't see these either, but we keep 'em. What about your 4-star photos (the ones that weren't quite good enough to be five stars)? We keep them, too. See where I'm going? Why waste your valuable time deciding if a photo is a 2- or a 3- or a 4-star, if all you're going to do is keep 'em anyway? The only shots we really care about are the ones we want off our computer (they're messed up and just wasting disk space) and our best shots from that shoot. So, once you've gone through and ranked them, let's get rid of the dogs. Click-and-hold on the Filter Items by Rating icon at the top right of the Content pod (it looks like a funnel) and choose **Show Rejected Items Only** (as shown here) to see just the Rejects.

Step Six:

Now Command-click (PC: Ctrl-click) on all the Rejects, then press the Spacebar to open them in Full Screen Preview, and press **Command-Delete (PC: Ctrl-Delete)** on each one to move them to your Trash (PC: Recycle Bin). Next, go under the Filter Items by Rating icon's pop-up menu again, but this time choose **Show 5 Stars** (as shown here) to filter things down so just your keepers—your 5-star images—are visible in Mini Bridge.

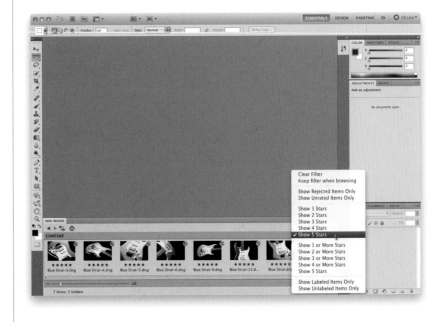

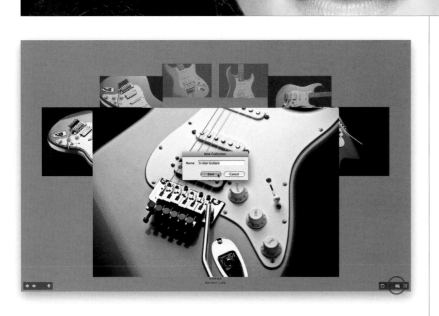

Step Seven:

At this point, we want to set things up so that, in the future, these 5-star photos are just one click away at any time, and we do that using collections (which are stored in Big Bridge). Here's how it works: Select all your 5-star photos, then enter Review mode. You'll see a button in the bottom-right corner (to the left of the X [Close] button, and shown circled here in red). Click it, and it brings up a dialog where you can name and save your images to a collection. Type in "5-Star Guitars" and click the Save button.

TIP: Removing Ratings and Reject Labels

To remove a photo's star rating, just click on the photo, then press **Command-0 (zero; PC: Ctrl-0)**. You can use the same shortcut to remove the Reject label.

Step Eight:

When you click that Save button, a collection of just these photos is saved. Now these best-of-that-shoot photos will always be just one click away—just click on the Panel View icon (the center icon at the top right of Mini Bridge— shown circled here in red) and choose **Navigation Pod** from the pop-up menu to make the Navigation pod visible again. Then, on the far left of the Navigation pod, click on Collections, then click on the 5-Star Guitars collection (as shown here), and just that shoot's 5-star photos appear.

Finding Your Photos by Searching

Mini Bridge has a search function that lets you either use your computer's built-in search (like the Mac's Spotlight search or Windows Search), or you can use Bridge's Advanced Search, which has searching power more like the one in Big Bridge. Here's how it works:

Step One:

If you click on the magnifying glass icon at the top-right corner of the Mini Bridge panel, a search dialog appears where you have three different choices in the pop-up menu for how to search: (1) You can use your computer's built-in search to search your entire computer (which is surprisingly handy), or (2) just the current folder. Or (3), you can use a standard Bridge search (which searches just the filename and any embedded keywords) to narrow things down in just your current folder.

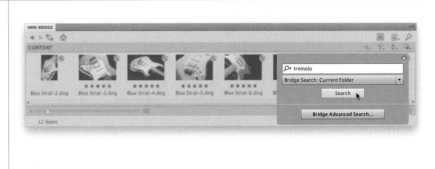

Step Two:

In the image shown in Step One, I typed in the keyword "tremolo" and chose the basic Bridge search of the current folder, and Mini Bridge displayed the results of this keyword search, which in this case was just two images with a clear view of the entire tremolo (as seen here). To leave the search results and return to your previous folder of images, just click the Back Button (the left arrow) at the top-left corner of the Mini Bridge panel.

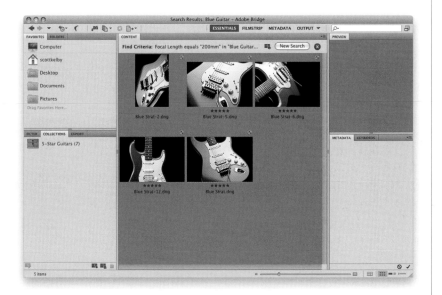

Step Three:

If you want more search control, then click the Bridge Advanced Search button at the bottom of the search dialog, and it brings up the Find dialog you see here. You choose where it's going to search from the Source Look In pop-up menu up top (by default, it includes your Pictures folder, any favorite locations you've saved in Big Bridge, and your desktop). You choose what to search for using the Criteria pop-up menus, and the best way to see what you can search for is simply to click-and-hold on the first pop-up menu (it's a pretty darn amazing list, including searching through all the EXIF data embedded into your photo at the moment you took the shot).

Step Four:

When you click Find, the results of your search are displayed in the Content panel of Big Bridge itself (as seen here) and you can open any of the images directly into Photoshop (just double-click on them) or Camera Raw (if they're RAW images, they'll automatically open in Camera Raw first. If not, you can open JPEG or TIFF images in Camera Raw by clicking on them, then pressing **Command-R [PC: Ctrl-R]**. Easy to remember—just think "R" for "RAW").

TIP: Deleting Photos in Mini Bridge

You can delete photos in Mini Bridge by going into Full Screen Preview mode and pressing Delete (Mac or PC). You'll get a dialog asking if you want to re-ject the file or delete it. If you press **Command-Delete (PC: Ctrl-Delete)**, it automatically puts it in the Trash (PC: Recycle Bin) and moves on to the next image.

Customizing the Look of Mini Bridge

To me, the default colors of Mini Bridge are just plain boring (I mean, how exciting is light gray?). To me, the default colors make it feel more like a boring business tool, and less like a photographer's tool, which is why the first thing I did when I launched Mini Bridge was to search around to find out how to customize the background colors. Here's how you can customize yours:

Step One:
Here's the default look for Mini Bridge, which pretty much makes my case (above) for why I needed to change the background colors, and make it feel more like a photographer's application than a business one. To customize the look of your Mini Bridge, go to the fly-out menu at the very top-right corner of the Mini Bridge panel, and choose **Settings** (as shown here). When the Settings info appears, click on Appearance to make those controls visible.

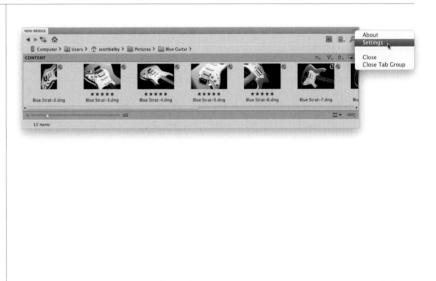

Step Two:
When the Appearance controls appear, drag the User Interface Brightness slider quite a bit to the right, which gives the main panel interface and Navigation pod a nice dark gray look, as shown here at the bottom. At this point, the Content and Preview pods still have that light gray background behind them, and to change that you drag the Image Backdrop slider quite a bit to the right, as well (I usually want some contrast between the user interface and the background, so I usually make the background darker—or even black—by dragging way to the right). That's it—now just hit the Back button (the left arrow up top) twice and your new colors are in place.

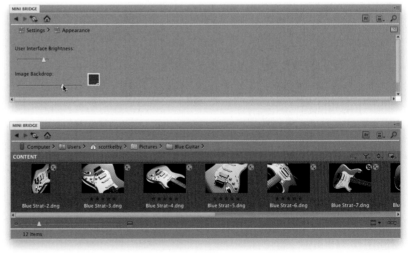

Photoshop Killer Tips

Syncing Mini Bridge with Big Bridge

If you want to sync Adobe Bridge (I call it "Big Bridge") and Mini Bridge (so they both display the same images at the same time), start in Mini Bridge and click the Go to Adobe Bridge icon at the top right of the panel. This launches Big Bridge (or sends you over there if it's already up and running), where you'll need to click the Return to Adobe Photoshop icon (it's a little boomerang) near the top left of the window, and it boomerangs you back to Photoshop. Now, Mini Bridge and Big Bridge will both display the same folder of images. To turn off the syncing, press **Command-Option-O (PC: Ctrl-Alt-O)** to switch applications and choose a new folder, or just change applications using the Dock (on a Mac) or the taskbar (on a PC).

Seeing a Larger Preview in Mini Bridge

When you're looking at thumbnails in Mini Bridge, and you want to see a larger preview of your currently selected image (but not a full-screen preview), press **Shift-Spacebar**, and Mini Bridge displays that selected image as large as possible within the Preview pod (this one's handier than it sounds, so give it a quick try). Just click the Close button in the bottom right to close it.

Stop the Scrolling Madness

If you don't like scrolling through tons of images in Mini Bridge, try this instead: go down to Mini Bridge's View icon's pop-up menu (in the bottom right of the panel), and choose **Show Items in Pages**. Now, it will display as many thumbnails as it can fit in the Content pod at the size it's at, but to see the rest of the photos in this folder, you don't scroll, you use the left/right arrow buttons at the bottom right of the

pod. Each time you click, a new page of thumbnails appears. Give this one a try and see how you like it (it works better than it sounds).

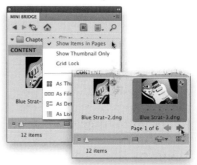

Seeing Just the Thumbnails Alone

When I'm searching for just the right image, I want my distractions at a minimum, and if that sounds like you, try choosing **Show Thumbnail Only** from the View icon's pop-up menu in the bottom-right corner of the Mini Bridge panel. That hides the file's name, any star ratings, color labels, or any other distracting stuff, so you can focus on the images.

Continued

Photoshop Killer Tips

See DSLR Videos in Mini Bridge

If you imported HD video you shot with your DSLR, believe it or not, you can actually preview the video using Mini Bridge. Just click on the thumbnail for your video clip, then press the **Spacebar** and your video plays full screen.

Dragging-and-Dropping Right from Mini Bridge

If you already have a document open in Photoshop, you can drag-and-drop images directly from Mini Bridge right into that document and it appears as a Smart Object (not too shabby!). If the photo is in RAW format, it opens in Camera Raw first (for any last minute tweaking), but then opens when you click OK. But my favorite drag-and-drop tip is this: You don't have to have a document already open. Just drag-and-drop your image from Mini Bridge right into the center area where your document would normally be, and it opens your photo in a new image window. You gotta try this! (If you're using a Mac, though, you need to have Application Frame turned on [under the Window menu] for this to work. If you don't, your image will just copy to your desktop.)

Review Mode Time Saver

I mentioned earlier in the chapter that if you're in Mini Bridge's Review mode (see page 8) and you find an image you want to work on, you can press **R**

to open the image in Camera Raw (it doesn't matter whether it's a RAW image, a JPEG, or a TIFF), and if you want to open a JPEG, TIFF, or even a PSD from Review mode directly into Photoshop, you can press **O**, but you can also Right-click on the image and choose **Open** from the pop-up menu, and it opens right up. You can also do other things from this pop-up menu, like add a color label to your image, or add a star rating, or rotate the file.

Getting to Mini Bridge's Preferences

There are a few options for how Mini Bridge works (and looks), and you get to these by clicking on the Home Page icon at the top left of the Mini Bridge panel, then clicking on the Settings icon. Here, you can choose your colors for Mini Bridge (under the Appearance settings), and you can choose how Mini Bridge interacts with Big Bridge there, as well (under the Bridge Launching settings), or reset your settings.

Hidden Slide Show Shortcuts

If you select a bunch of images in Mini Bridge, and choose **Slideshow** from the Preview icon's pop-up menu (at the bottom right of the panel), you get a full-screen, auto-advancing slide show complete with transitions. But there are some hidden shortcuts you can use while it's running that are pretty handy. For example: Press the **R key** to pause the slide show and open the current photo in Camera Raw (just press the **Spacebar** to resume the slide show once you're done in Camera Raw); press the **Period key** to add a 1-star rating, press it twice to add a 2-star rating, and so on; press the **Left Bracket key** to rotate counterclockwise, and the **Right Bracket key** to rotate clockwise; press the **L key** to bring up the Slideshow Options dialog (shown here); and press the

Photoshop Killer Tips

+ (plus sign) key to zoom in, and the **– (minus sign) key** to zoom out. The numbers **1–5** also add star ratings, and **6–9** add color labels. Lastly, just press the **H key** to get a list of the slide show shortcuts.

The Path Bar Is Live

The Path Bar that shows the path to the current folder you're viewing isn't just for looks—it's live—meaning you can click on any of the folders in the path and jump to that folder.

Hide the Preview Panel

Okay, technically, Adobe calls them pods (not panels), but either way, there's not much reason to have the Preview pod visible in Mini Bridge, because it just takes up space. If you want to see an image preview, use the tip I showed you earlier—press **Shift-Spacebar** and it temporarily shows your image in the Preview pod, or you can just hit the **Spacebar** itself and see your image previewed full screen. So, in short, uncheck Preview Pod from the Panel View icon's pop-up menu (the center icon at the top right of the panel) and use the room you save for something else.

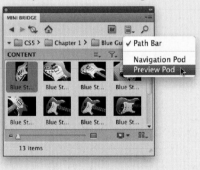

Adding Favorites to Mini Bridge

So, how do you get your favorite, most-used folders added to Mini Bridge's Navigation pod, so they're just one click away? Click the Go to Adobe Bridge icon at the top of the panel to jump to Big Bridge, then in the Folders panel (at the top left of the window), find the folder you want

to make a favorite. Once you find it, Right-click on it and choose **Add to Favorites** from the pop-up menu, then click the Return to Adobe Photoshop icon (the boomerang icon in the top left of the window) to jump back to Photoshop. Now, you'll see that folder added to your Favorites list in Mini Bridge.

Photo by Scott Kelby | Exposure: 1/640 sec | Focal Length: 10.5mm | Aperture Value: ƒ/2.8

WWF Raw

the essentials of camera raw

Now, if you're reading the English-language version of this book, you probably instantly recognized the chapter title "WWF Raw" from the wildly popular American TV series *Wasabi with Fries Raw* (though in Germany, it's called *Weinerschnitzel Mit Fischrogen Raw*, and in Spain, it's called simply *Lucha Falsa*, which translated literally means "Lunch Feet"). Anyway, it's been a tradition of mine, going back about 50 books or so, to name the chapters after a movie title, song title, or TV show, and while "WWF Raw" may not be the ideal name for a chapter on Camera Raw essentials, it's certainly better than my second choice, "Raw Meat" (named after the 1972 movie starring Donald Pleasence. The sequel, *Steak Tartare*, was released straight to DVD in 1976, nearly 20 years before DVDs were even invented, which is quite remarkable for a movie whose French version wound up being called *Boeuf Gâté Dans la Toilette*, with French actor Jean-Pierre Pommes Frites playing the lead role of Marcel, the dog-faced boy). Anyway, finding movies, TV shows, and song titles with the word "raw" in them isn't as easy as it looks, and since this book has not one, not two, not three, but…well, yes, actually it has three chapters on Camera Raw, I'm going to have to do some serious research to come up with something that tops "WWF Raw," but isn't "Raw Meat," and doesn't use the same name I used back in the CS4 edition of this book, which was "Raw Deal" (from the 1986 movie starring California Governor Arnold from *Happy Days*. See, that was a vague reference to the guy who played the diner owner in the '70s sitcom *Happy Days*, starring Harrison Ford and Marlon Brando). But what I really can't wait for is to see how the people who do the foreign translations of my books translate this intro. C'est magnifique, amigos!

Working with Camera Raw

Although Photoshop Camera Raw was originally created to process photos taken in your camera's RAW format, you can also use it to process your JPEG and TIFF photos. A big advantage of using Camera Raw that many people don't realize is that it's just plain easier and faster to make your images look good using Camera Raw than with any other method. Camera Raw's controls are simple, they're instantaneous, and they're totally undoable, which makes it hard to beat. But first, you've got to get your images into Camera Raw for processing.

Opening RAW Images:

Since Camera Raw was designed to open RAW images, if you double-click on a RAW image (whether in Mini Bridge or just in a folder on your computer), it will launch Photoshop and open that RAW image in Camera Raw (its full official name is Photoshop Camera Raw, but here in the book, I'll just be calling it "Camera Raw" for short, because…well… that's what I call it). *Note:* If you double-click on what you know is a RAW image and it doesn't open in Camera Raw, make sure you have the latest version of Camera Raw—images from newly released cameras need the latest versions of Camera Raw to recognize their RAW files.

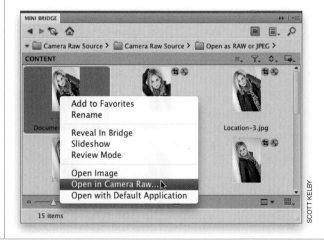

Opening JPEG & TIFF Images from Mini Bridge:

If you want to open a JPEG or TIFF image from Mini Bridge, it's easy: Right-click on it and, from the pop-up menu, choose **Open in Camera Raw.**

Opening JPEG & TIFF Images from Your Computer:

If you want to open a JPEG or TIFF image from your computer, then here's what you do: On a Mac, go under Photoshop's File menu and choose **Open**. When the Open dialog appears, click on your JPEG (or TIFF, but we'll use a JPEG as our example) image, and in the Format pop-up menu, it will say JPEG. You need to click-and-hold on that Format pop-up menu, and from that menu choose **Camera Raw**, as shown here. Then click the Open button, and your JPEG image will open in Camera Raw. In Windows, just go under Photoshop's File menu and choose **Open As**, then navigate your way to that JPEG or TIFF image, change the Open As pop-up menu to **Camera Raw**, and click Open.

Opening Multiple Images:

You can open multiple RAW photos in Camera Raw by selecting them first (either in Mini Bridge or in a folder on your computer), then just double-clicking on any one of them, and they'll all open in Camera Raw and appear in a filmstrip along the left side of the Camera Raw window (as seen here). If the photos are JPEGs or TIFFs, in Mini Bridge, select 'em first, then switch to Review mode, and press **Option-R (PC: Alt-R)**. If they're in a folder on your computer, then you'll need to use Mini Bridge to open them, as well (just use the Path bar in Mini Bridge to navigate to where those images are located, then select them, switch to Review mode, and press Option-R).

Continued

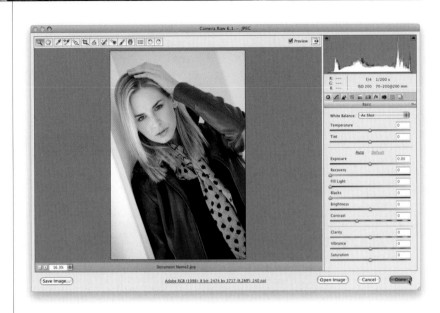

Editing JPEG & TIFF Images in Camera Raw:

One thing about editing JPEGs and TIFFs in Camera Raw: When you make adjustments to a JPEG or TIFF and you click the Open Image button, it opens your image in Photoshop (as you'd expect). However, if you just want to save the changes you made in Camera Raw without opening the photo in Photoshop, then click the Done button instead (as shown here), and your changes will be saved. There is a big distinction between editing JPEG or TIFF images and editing a RAW image. If you click the Open Image button, you're actually affecting the real pixels of the original JPEG or TIFF, whereas, if this were a RAW image, you wouldn't be (which is another big advantage of shooting in RAW). Once you open your JPEG or TIFF in Photoshop, you're opening and editing the real image, and you'll have to save it with a different name to keep the original. Just so you know.

The Two Camera Raws:

Here's another thing you'll need to know: there are actually two Camera Raws—one in Photoshop, and a separate one in Bridge. The advantage of having two Camera Raws comes into play when you're processing (or saving) a lot of RAW photos—you can have them processing in Bridge's version of Camera Raw, while you're working on something else in Photoshop. If you find yourself using Bridge's Camera Raw most often, then you'll probably want to press **Command-K (PC: Ctrl-K)** to bring up Bridge's Preferences, click on General on the left, and then turn on the checkbox for Double-Click Edits Camera Raw Settings in Bridge (as shown here). Now, double-clicking on a photo opens RAW photos in Bridge's Camera Raw, rather than Photoshop's.

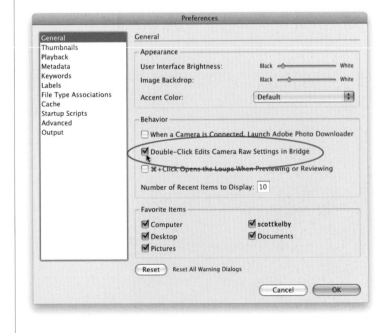

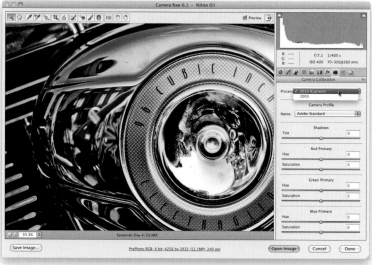

Okay, this part is only for those who have been using Camera Raw in previous versions of Photoshop (CS4, CS3, and so on), because if this is the first time you'll be using it, this won't affect you at all, so you can skip this. Here's why: in Photoshop CS5, Adobe dramatically improved the math behind how it processes noise reduction, sharpening, and post-crop vignetting for RAW images. If you have RAW images you edited in earlier versions of Camera Raw, and you open them in CS5, you'll have a choice to make (though, I think it's an easy one).

Choosing the Right Process Version (Not for New Users)

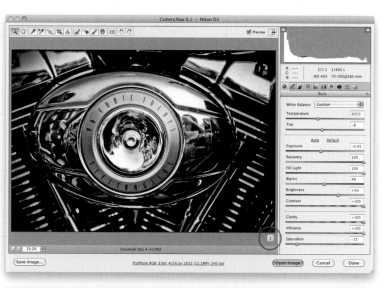

Step One:
When you open a RAW image in CS5's Camera Raw 6 that you previously edited in Camera Raw from an earlier version of Photoshop (like CS4 or CS3), you'll see a warning appear in the bottom-right corner of the Preview area (actually, it's an exclamation point, shown circled here in red). That's letting you know that your image is still being processed using the old Camera Raw processing algorithm from back in 2003, but you have the option of updating the image to use the new, improved processing, called "Process Version 2010."

Step Two:
To update your previously edited RAW photo to Process Version 2010, you can either click directly on the exclamation point warning (which is the fastest, easiest way), or click on the Camera Calibration icon (it's the third icon from the right at the top of the Panel area) and choose **2010 (Current)** from the Process pop-up menu at the top of the panel (I'd only do it this way if I was charging by the hour). Now, if your image didn't have any sharpening applied, or noise reduction, or post-crop vignetting, you're not going to notice a change, but if it did, you'll be amazed at how much better it looks now.

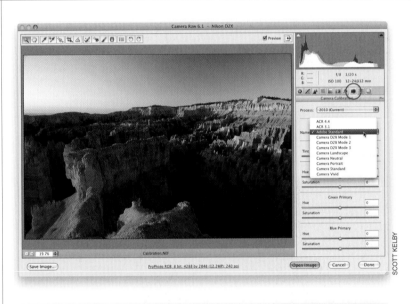

Miss the JPEG Look? Try Applying a Camera Profile

If you've ever wondered why RAW images look good on your camera's LCD, but look flat when you open them in Camera Raw, it's because what you see on your LCD is a JPEG preview (even though you're shooting in RAW), and your camera automatically adds color correction, sharpening, etc., to them. When you shoot in RAW, you're telling the camera, "Turn all that color enhancement and sharpening off—just leave it untouched, and I'll process it myself." But, if you'd like that JPEG-processed look as a starting place for your RAW photo editing, camera profiles can get you close.

Step One:
Click on the Camera Calibration icon (the third icon from the right) near the top of the Panel area, and in the Camera Profile section, click-and-hold on the Name pop-up menu, and you'll see a list of camera profiles available for your particular camera (it reads the embedded EXIF data, so it knows which brand of camera you use). For example, if you shoot Nikon, you'll see a list of the in-camera picture styles you could have applied to your image if you had taken the shot in JPEG mode, as seen here (if you shoot in RAW, Camera Raw ignores those in-camera profiles, as explained above). If you shoot Canon, you'll see a slightly different list, but it does the same type of thing.

Step Two:
The default profile will be Adobe Standard. Now, ask yourself this: "Does the word 'Standard' ever mean 'Kick Butt?'" Not usually, which is why I suggest you try out the different profiles in this list and see which ones you like. At the very least, I would change it to **Camera Standard**, which I think usually gives you a better starting place (as seen here).

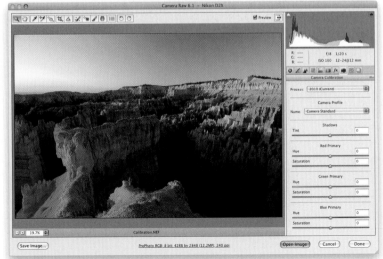

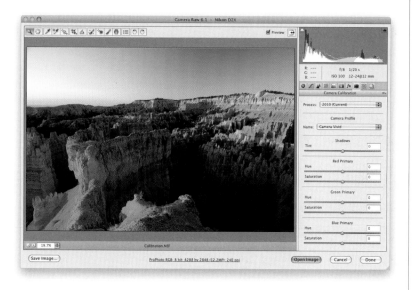

Step Three:

Depending on the individual photo you're editing, Camera Standard might not be the right choice, but as the photographer, this is a call you have to make (in other words, it's up to you to choose which one looks best to you). I usually wind up using either Camera Standard, Camera Landscape, or Camera Vivid for images taken with a Nikon camera, because I think Landscape and Vivid look the most like the JPEGs I see on the back of my camera. But again, if you're not shooting Nikon, Landscape or Vivid won't be one of the available choices (Nikons have eight picture styles and Canons have six). If you don't shoot Canon or Nikon, then you'll only have Adobe Standard, and possibly Camera Standard, to choose from, but you can create your own custom profiles using Adobe's free DNG Profile Editor utility, available from Adobe at http://labs.adobe.com.

Step Four:

Here's a before/after with only one thing done to this photo: I chose Camera Vivid (as shown in the pop-up menu in Step Three). Again, this is designed to replicate the color looks you could have chosen in the camera, so if you want to have Camera Raw give you a similar look as a starting point, give this a try. Also, since Camera Raw allows you to open more than one image at a time (in fact, you can open hundreds at a time), you could open a few hundred images, then click the Select All button that will appear at the top-left corner of the window, change the camera profile for the first-selected image, and then all the other images will have that same profile automatically applied. Now, you can just click the Done button.

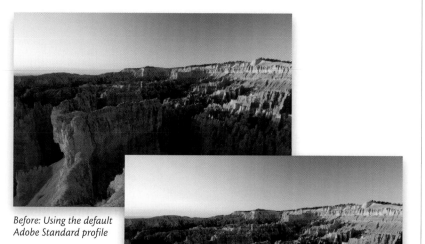

Before: Using the default Adobe Standard profile

After: Using the Camera Vivid profile

The Essential Adjustments: White Balance

If you've ever taken a photo indoors, chances are the photo came out with kind of a yellowish tint. Unless you took the shot in an office, and then it probably had a green tint. If you just took a shot of somebody in the shade, the photo probably had a blue tint. Those are white balance problems, and if we properly set our white balance in the camera, we won't see these color problems (the photos will just look normal), but since most of us shoot with our cameras set to Auto White Balance, we're going to run into them. Luckily, we can fix them pretty easily.

Step One:

Adjusting the white balance is usually the very first thing I adjust in my own Camera Raw workflow, because getting the white balance right will eliminate 99% of your color problems right off the bat. At the top of the Basic panel (on the right side of the Camera Raw window), are the White Balance controls. If you look to the right of the words "White Balance," you'll see a pop-up menu (shown circled here in red), and by default it shows you the "As Shot" white balance (you're seeing the white balance you had set in your camera when you took the shot). For this shot, I had my white balance set to Auto for shooting outdoors, and then I walked into a hotel lobby where I took this shot, and that's why the white balance is way, way off.

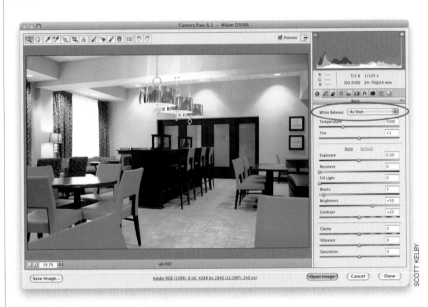

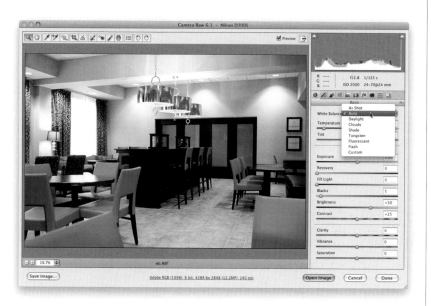

Step Two:

There are three ways to change the white balance in your photo, and the first is to simply choose one of the built-in White Balance presets. Fairly often, that's all you need to do to color correct your image. Just click on the White Balance pop-up menu, and you'll see a list of white balance settings you could have chosen in the camera. Just choose the preset that most closely matches what the lighting situation was when you originally took the photo (for example, if you took the shot in the shade of a tree, you'd choose the Shade preset). Here I tried each preset and Auto seemed to look best—it removed the yellowish tint. I also tried Tungsten, which looked pretty good, as well. That's why it doesn't hurt to try each preset and simply choose the one that looks best to you. (*Note:* This is the one main area where the processing of RAW and JPEG or TIFF images differs. You'll only get this full list of white balance presets with RAW images. With JPEGs or TIFFs, your only choice is As Shot or Auto white balance.)

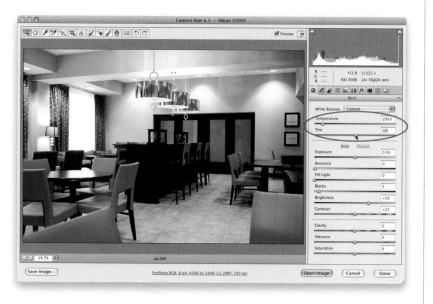

Step Three:

The second method is to use the Temperature and Tint sliders (found right below the White Balance preset menu). The bars behind the sliders are color coded so you can see which way to drag to get which kind of color tint. What I like to do is use the built-in presets to get close (as a starting point), and then if my color is just a little too blue or too yellow, I drag in the opposite direction. So, in this example, the Auto preset was close, but made it a little too blue, so I dragged the Temperature slider a little bit toward yellow and the Tint slider toward magenta to brighten the reds (as shown here).

Continued

Step Four:

Just a couple of other quick things about manually setting your white balance using the Temperature and Tint sliders: If you move a slider and decide you didn't want to move it after all, just double-click directly on the little slider "nub" itself, and it will reset to its previous location. By the way, I generally just adjust the Temperature slider, and rarely have to touch the Tint slider. Also, to reset the white balance to where it was when you opened the image, just choose As Shot from the White Balance pop-up menu (as seen here).

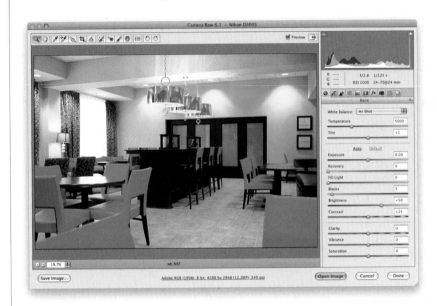

Step Five:

The third method is my personal favorite, and the method I use the most often, and that is setting the white balance using the White Balance tool (I). This is perhaps the most accurate because it takes a white balance reading from the photo itself. You just click on the White Balance tool in the toolbar at the top left (it's circled in red here), and then click it on something in your photo that's supposed to be a light gray (that's right—you properly set the white balance by clicking on something that's light gray). So, take the tool and click it once on a light shadow area on the glass in the back door (as shown here) and it sets the white balance for you. If you don't like how it looks, then just click on a different light gray area.

TIP: Quick White Balance Reset

To quickly reset your white balance to the As Shot setting, just double-click on the White Balance tool up in the toolbar.

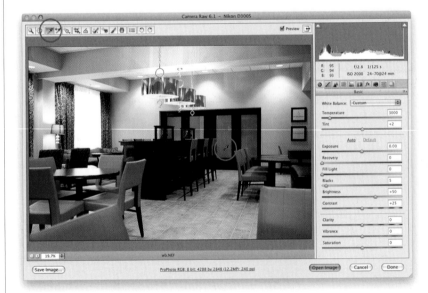

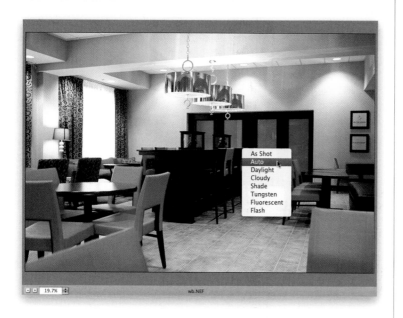

Step Six:
Now, here's the thing: although this can give you a perfectly accurate white balance, it doesn't mean that it will look good. White balance is a creative decision, and the most important thing is that your photo looks good to you. So don't get caught up in that "I don't like the way the white balance looks, but I know it's accurate" thing that sucks some people in— set your white balance so it looks right to you. You are the bottom line. You're the photographer. It's your photo, so make it look its best. Accurate is not another word for good. By the way, you can just Right-click on your image to access the White Balance pop-up menu (as shown here).

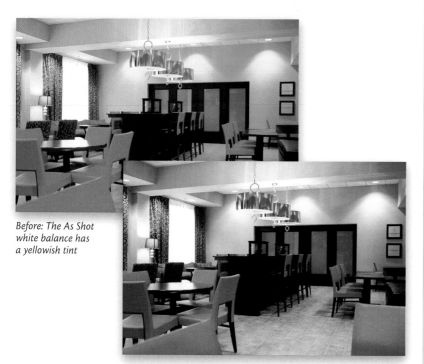

Before: The As Shot white balance has a yellowish tint

After: With one click of the White Balance tool, everything comes together

Step Seven:
Here's a before/after so you can see what a difference setting a proper white balance makes (by the way, you can see a quick before/after of your white balance edit by pressing the letter **P** on your keyboard to toggle the Preview on/off).

TIP: Using the Swatch Card
To help you find that neutral light gray color in your images, I've included a swatch card in the back of this book (it's perforated, so you can tear it out), and it has a special Camera Raw white balance light gray swatch area. Once your lighting is set, just have your subject hold it while you take one shot. Then, open that image in Camera Raw, and click the White Balance tool on the swatch card to instantly set your white balance. Now, apply that same white balance to all the other shots taken under that same light (more on how to do that coming up in the next chapter).

The Essential Adjustments #2: Exposure

The next thing I fix (after adjusting the white balance) is the photo's exposure. Now, some might argue that this is the most essential adjustment of them all, but if your photo looks way too blue, nobody will notice if the photo's under-exposed by a third of a stop, so I fix the white balance first, then I worry about exposure. In general, I think of exposure as three things: highlights, shadows, and midtones. So in this tutorial, I'll address those three, which in Camera Raw are the exposure (highlights), blacks (shadows), and brightness (midtones).

Step One:
The Exposure slider affects the overall exposure of the photo (dragging to the right makes your overall exposure lighter; dragging to the left makes it darker). But don't just start dragging the Exposure slider yet, because there's something we need to really watch out for, and that's clipping the highlights (where areas of the photo get so bright that they lose all detail). Luckily, Camera Raw has built-in clipping warnings, so you don't lose highlight detail. First, look at this photo's histogram at the top right of the window. See the solid white triangle in the top-right corner? That's warning you that some parts of this photo are already clipping.

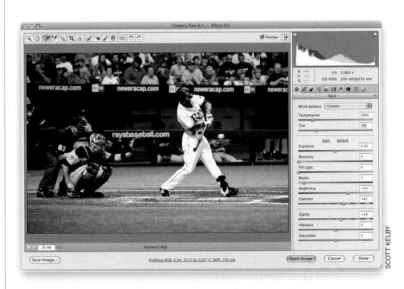

Step Two:
If you want to see exactly which areas are clipping (so you can see if they are even areas we need to worry about), just move your cursor over that highlight warning triangle, click on it, and any areas that are clipping will show up in red (as shown here). That see-your-clipping-areas-in-red warning will now stay on while you're making your adjustments. Click on the little highlight triangle again (or press the letter **O** on your keyboard) to toggle this feature off/on.

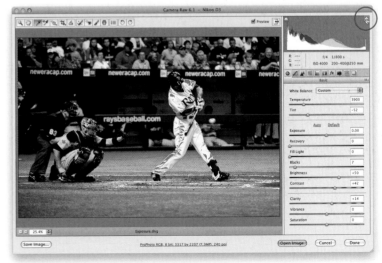

Step Three:

If you don't like the red clipping warning, or if you have a photo with a lot of red in it, and the red warnings aren't easily seen, there is another warning you can use. Just press-and-hold the Option (PC: Alt) key and then click-and-hold the Exposure slider. This turns your preview area black, and any clipped areas will appear in their color, as seen here (so if the Blue channel is clipping, you'll see blue; if parts of the Green channel are clipping, you'll see areas of green; but of course, the worst is to see areas in solid white, which means all the colors are clipping). By the way, this warning will stay on as you drag the Exposure slider, as long as you have the Option key held down. Also, some things will always clip, like a photo with the sun visible in it, or a specular highlight on the chrome bumper of a car, but that's okay—they don't have any detail. We're only concerned about recovering areas that actually have important detail.

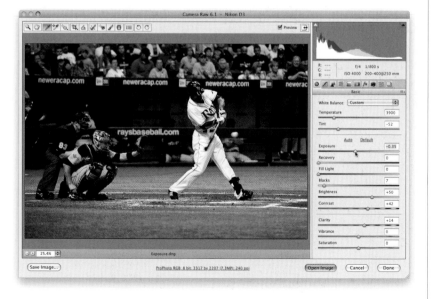

Step Four:

So, now that we know how to find out when we have a clipping problem, how do we make the problem go away? Well, since this problem happens when things get too bright, you could always drag the Exposure slider to the left until the clipping warnings go away. For example, here I lowered the exposure (by dragging the Exposure slider to the left) until the clipping warning finally went away, but that's a really bad tradeoff. We fixed one problem (clipped highlights), but now we have another problem that may be worse (a really underexposed photo). Luckily, there's something simple we can do that lets us keep the overall exposure where we need it, and avoid clipping the highlights at the same time.

Continued

Step Five:

Start by dragging the Exposure slider until the exposure looks right to you (here the exposure looked good to me, but some of the important highlight areas were clipping, as shown in Step Three). Now, drag the Recovery slider (located right below the Exposure slider) to the right, and as you do, just the very brightest highlights are pulled back (recovered) from clipping. Keep dragging until the white highlight clipping warning turns solid black (like the one shown here), and you're done! By the way, you can use that same press-and-hold-the-Option (PC: Alt)-key trick while you're dragging the Recovery slider, and the screen will turn black, revealing just the clipped areas. As you drag to the right, you'll actually see the clipped areas go away. Now you've got your overall exposure where you want it, and you have detail in all your highlights at the same time. How sweet is that?

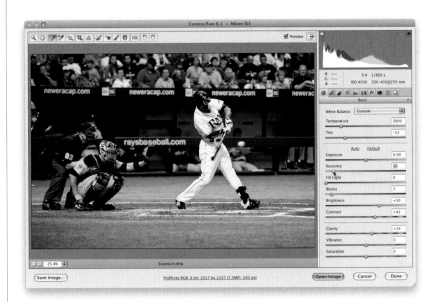

Step Six:

Next, I adjust the shadow areas using the Blacks slider. Dragging to the right increases the amount of black in the darkest shadow areas of your photo. Dragging to the left opens up (lightens) the shadow areas. I switched photos here to show you a better example of how the Blacks slider works.

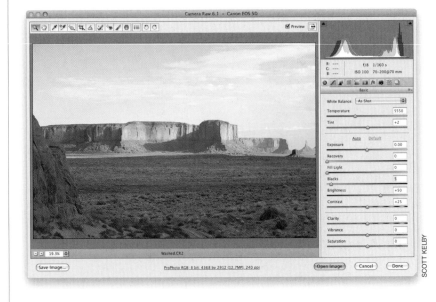

SCOTT KELBY

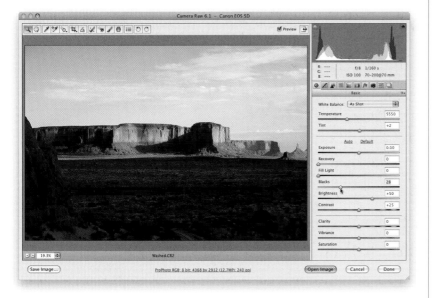

Step Seven:

Increasing the blacks will usually saturate the colors in your photo, as well, so if you have a really washed out photo (as shown in the previous step), just drag the Blacks slider to the right until the color and depth come back (as they have here). Compare this with the original shown in the previous step, and you can see what a dramatic difference increasing the blacks can make for a washed out photo. Okay, let's switch back to the baseball photo, and pick up there.

Step Eight:

While my biggest concern is clipping the highlights, there's also a shadow clipping warning to let you know when areas have gotten so dark that they lose all shadow detail. That warning is the triangle on the top left of the histogram. If you move your cursor over it and click, any areas that are solid black will appear in bright blue (as seen here). If there's shadow clipping, the only fix is to drag the Blacks slider to the left to reduce the amount of blacks in the shadows, but I generally don't do that, because to me that usually makes a photo look flat and too low-contrast. So, I avoid lowering the Blacks amount below the default setting of 5 unless absolutely necessary (here the clipped areas are just shadows, not important detail, so I ignore them). But hey, that's just me. You can also use the press-and-hold-the-Option (PC: Alt)-key trick with the Blacks slider. As you might expect, this works in the opposite way the highlight warning works; instead, the preview area turns solid white, and any areas that are solid black have lost detail and actually have turned to solid black.

Continued

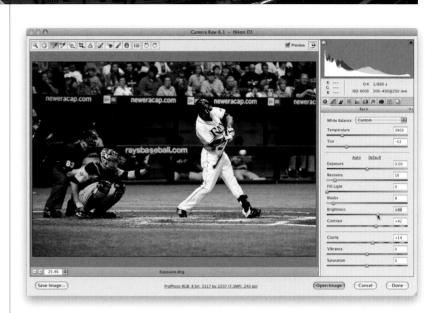

Step Nine:

The next slider down is Brightness. Since you've already adjusted the highlights (Exposure slider) and the shadows (Blacks slider), the Brightness slider adjusts everything else (I relate this slider to the midtones slider in Photoshop's Levels adjustment, so that might help in understanding how this slider differs from the Exposure or Blacks sliders). Of the three main adjustments (Exposure, Blacks, and Brightness), this one I personally use the least—if I do use it, I usually just drag it a very short amount to the right to open up some of the midtone detail. But in this case, I dragged it a little to the left to keep the photo from looking too bright. There are no warnings for midtones, but if you push it far enough to the right, you could see some highlight clipping.

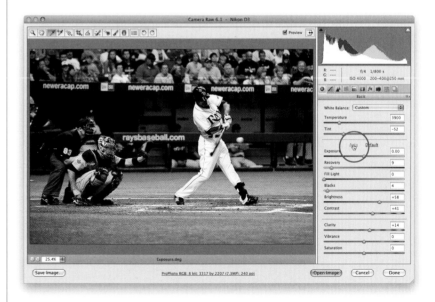

Step 10:

If you don't feel comfortable making these adjustments yourself, you can always give Camera Raw a crack at it by clicking the Auto button (it's the underlined word Auto, shown circled here in red). When you click on Auto, your photo will either look better, or not. If it's not, just press **Command-Z (PC: Ctrl-Z)** to Undo the Auto adjustment, and then try the correction yourself using the Exposure, Blacks, and Brightness sliders. Here, I clicked the Default button (to the right of the Auto button) to reset Camera Raw to its defaults, and then I clicked the Auto button. In this case, it looks kinda bright to me, and that's why it's important to learn to be able to make these corrections yourself.

If you're not quite comfortable with manually adjusting each image, like I mentioned at the end of the last tutorial, Camera Raw does come with a one-click Auto function, which takes a stab at correcting the overall exposure of your image (including shadows, fill light, contrast, and recovery), and at this point in Camera Raw's evolution, it's really not that bad. If you like the results, you can set up Camera Raw's preferences so every photo, upon opening in Camera Raw, will be auto-adjusted using that same feature.

Letting Camera Raw Auto-Correct Your Photos

Step One:
Once you have an image open in Camera Raw, you can have Camera Raw take a stab at setting the overall exposure (using the controls in the Basic panel) for you by clicking on the Auto button (shown circled in red here). In older versions of Camera Raw, this Auto correction feature was…well…let's just say it was less than stellar, but it's gotten much better since then, and now it does a somewhat decent job (especially if you're stuck and not sure what to do), so click on it and see how it looks. If it doesn't look good, no sweat—just press **Command-Z (PC: Ctrl-Z)** to Undo.

Step Two:
You can set up Camera Raw so it automatically performs an Auto Tone adjustment each time you open a photo—just click on the Preferences icon up in Camera Raw's toolbar (it's the third icon from the right), and when the dialog appears, turn on the checkbox for Apply Auto Tone Adjustments (shown circled here), then click OK. Now, Camera Raw will evaluate each image and try to correct it. If you don't like its tonal corrections, then you can just click on the Default button, which appears to the right of the Auto button (the Auto button will be grayed out because it's already been applied).

Adding "Snap" (or Softening) to Your Images Using the Clarity Slider

This is one of my favorite features in Camera Raw, and whenever I show it in a class, it never fails to get "Oooohs" and "Ahhhhs." I think it's because it's just one simple slider, yet it does so much to add "snap" to your image. The Clarity slider (which is well-named) basically increases the midtone contrast in a way that gives your photo more punch and impact, without actually sharpening the image (much like certain Curves adjustments in Photoshop can add snap and punch to your photos).

Step One:
The Clarity slider is found in the bottom section of the Basic panel in Camera Raw, right above the Vibrance and Saturation sliders. (Although its official name is Clarity, I heard that at one point Adobe engineers considered naming it "Punch" instead, as they felt using it added punch to the image.) To clearly see the effects of Clarity, first zoom in to a 100% view by double-clicking on the Zoom tool up in the toolbar (it looks like a magnifying glass). In the example shown here, I only zoomed to 50% so you could see more of the image.

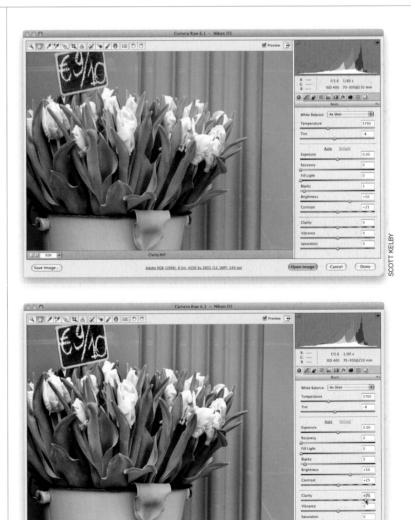

Step Two:
Using the Clarity control couldn't be easier—drag the slider to the right to increase the amount of snap (midtone contrast) in your image (compare the top and bottom images shown here). Almost every image I process gets between +25 and +50 Clarity. If the image has lots of detail, like a cityscape, or a sweeping land-scape shot, or something with lots of little details like a motorcycle (or leaves and flowers), then I'll go as high as +75 to +80, as seen here. If the subject is of a softer nature, like a portrait of a child, then in that case, I don't generally apply any Clarity at all.

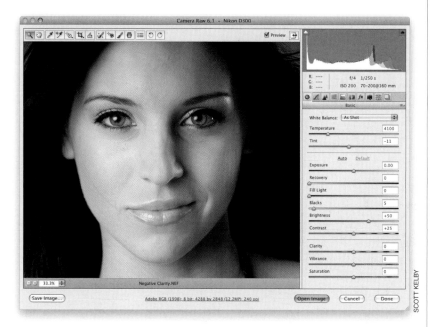

SCOTT KELBY

Step Three:
You can also use the Clarity control in reverse—to soften skin. This is called adding negative Clarity, meaning you can apply less than 0 (zero) to reduce the midtone contrast, which gives you a softening effect. For example, here's an original image without any negative Clarity applied.

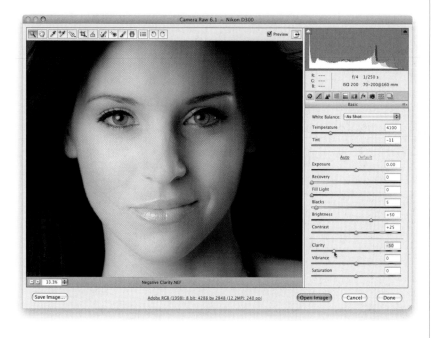

Step Four:
Now drag the Clarity slider to the left (which gives you a negative amount of Clarity), and take a look at how much softer our subject's skin looks. Everything else in the image looks softer too, so it's an overall softening, but in the chapter on the Adjustment Brush (Chapter 4), you'll learn how to apply softening just to your subject's skin (or anything else you need softened), while leaving the rest of the image sharp.

Fixing Backlit Photos by Adding Fill Light

If you have to deal with a backlit subject (and we all do at one time or another, either intentionally or by accident), then you're going to love the Fill Light slider. Unlike the Shadow/Highlight adjustment in Photoshop (which requires you to jump through a few hoops and tweak a number of sliders, so it doesn't look fake and "milky"), the Fill Light slider not only looks more natural, but because of that, it lets you apply more Fill Light and still have your image look good. However, there is one little tweak you'll need to know, but it couldn't be easier.

Step One:
Here's a pretty typical image where the subject, shot near sunset, is backlit with the setting sun, and while you can see some detail, the detail areas of the subject are mostly in the shadows.

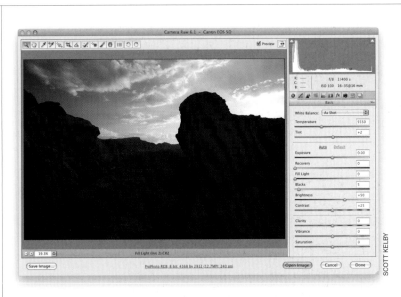

Step Two:
Dragging the Fill Light slider to the right opens up those lower mid-shadow areas, and lets detail that was once hidden in the shadows be revealed (as seen here).

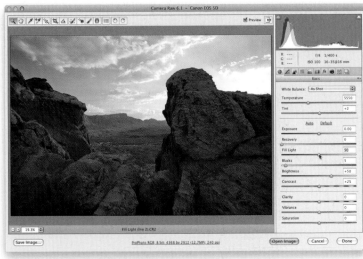

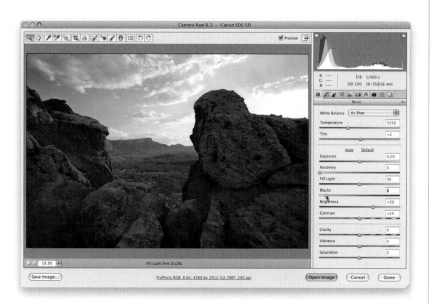

Step Three:

If you have to drag the Fill Light slider quite a bit to the right (as I did here), you're going to run into a little problem in that your deeper shadows might start to look a bit washed out. So when I have to push things as far as I did here, I generally drag the Blacks slider over to the right just a little to bring back some of the richness and color saturation in the deep shadow areas. Now, there is a difference if you're working with RAW or JPEG/TIFF images. With RAW images, the default setting for the Blacks will be 5, and generally all you'll need to do is move them over to 7 or 8 (as shown here). However, on JPEG or TIFF images, your default is 0, and I tend to drag them a little farther. Of course, every image is different, but either way, you shouldn't have to move the Blacks slider too far (just remember—the farther you move your Fill Light slider to the right, the more you'll have to compensate by adding more Blacks).

Step Four:

Here's a before/after with only two edits applied to this photo: (1) I dragged the Fill Light slider over to 50, and (2) I dragged the Blacks slider to 8.

TIP: Multiple Undos

This is one of those little hidden features that not many users know about, but Camera Raw has its own built-in multiple undo feature. To use it, just press **Command-Option-Z (PC: Ctrl-Alt-Z)** and it undoes your edits (including moving sliders) one by one. Also, unlike Photoshop's History undos it's not just limited to 20 undos.

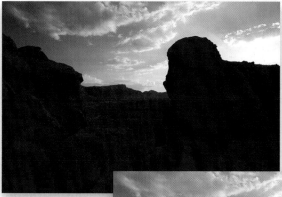

Before: The subject is in the shadows

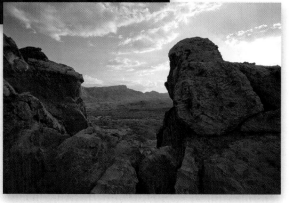

After: Using Fill Light and adding Blacks

Adjusting Contrast Using Curves

When it comes to adding contrast to a photo, I pretty much avoid the Contrast slider in Camera Raw's Basic panel as much as possible, because it's too broad and too lame. So, when it comes to creating contrast, try the Tone Curve instead, and you'll never go back to that one broad and lame slider that is too broad and too lame.

Step One:
After you've done all your exposure and tone adjustments in the Basic panel, skip the Contrast slider and click on the Tone Curve icon (it's the second icon from the left). There are two different types of curves available here: the Point curve, and the Parametric curve. We'll start with the Point curve, so click on the Point tab at the top of the panel. Here's what the photo shown here looks like with no added contrast in the Point curve (notice that the pop-up menu above the curve is set to Linear, which is a flat, unadjusted curve). *Note:* If you shoot in RAW, by default the curve will be set to Medium Contrast (since your camera didn't add any contrast). If you shoot in JPEG, it'll be set to Linear, which means no contrast has been added (since it's a JPEG, your camera already added it. See the top of page 26 for more on this).

Step Two:
If you want more contrast, choose **Strong Contrast** from the Curve pop-up menu (as shown here), and you can see how much more contrast this photo now has, compared with Step One. The difference is the Strong Contrast settings create a much steeper curve, and the steeper the curve, the more contrast it creates.

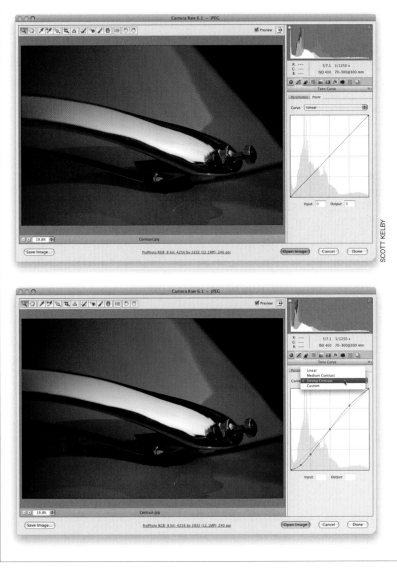

SCOTT KELBY

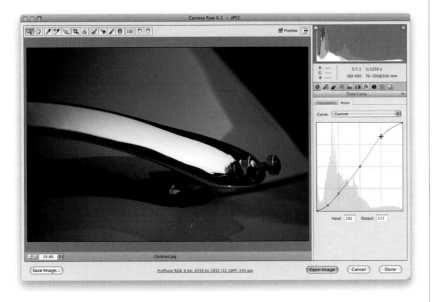

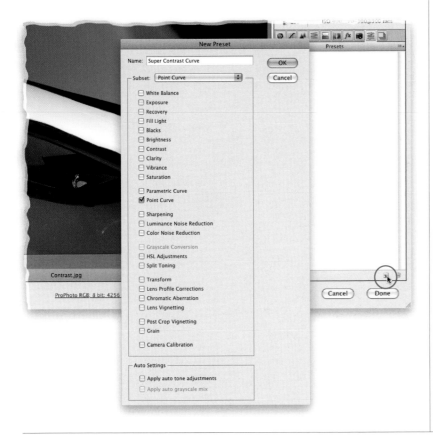

Step Three:

If you're familiar with Photoshop's Curves and want to create your own custom curve, start by choosing any one of the preset curves, then either click-and-drag the adjustment points on the curve or use the **Arrow keys** to move them (I think it's easier to click on a point, then use the Up and Down Arrow keys on your keyboard to move that part of the curve up or down). If you'd prefer to start from scratch, choose **Linear** from the Curve pop-up menu, which gives you a flat curve. To add adjustment points, just click along the curve. To remove a point, just click-and-drag it right off the curve (drag it off quickly, like you're pulling off a Band-Aid).

Step Four:

If you create a curve that you'd like to be able to apply again to other photos, you can save this curve as a preset. To do that, click on the Presets icon (the second icon from the right) at the top of the Panel area to bring up the Presets panel. Next, click on the New Preset icon (which looks just like Photoshop's Create a New Layer icon) at the bottom of the panel. This brings up the New Preset dialog (shown here). If you just want to save this curve setting, from the Subset pop-up menu near the top, choose **Point Curve**, and it turns off the checkboxes for all the other settings available as presets, and leaves only the Point Curve checkbox turned on (as shown here). Give your preset a name (I named mine "Super Contrast Curve") and click OK.

Continued

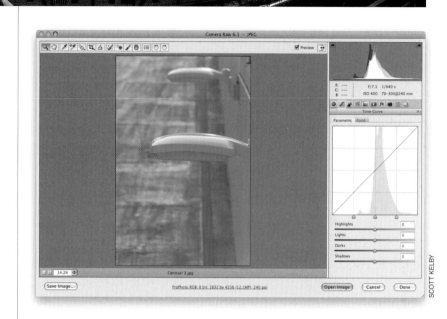

Step Five:

If you're not comfortable with adjusting the Point curve, try the Parametric curve, which lets you craft your curve using sliders that adjust the curve for you. Click on the Parametric tab, and you'll see four sliders, which control the four different areas of the curve, but before you start "sliding," know that the adjustments you make here are added to anything you did in the Point Curve tab (if you did anything there first).

Step Six:

The Highlights slider controls the highlights area of the curve (the top of the curve), and dragging it to the right arcs the curve upward, making the highlights brighter. Right below that is the Lights slider, which covers the next lower range of tones (the area between the midtones and the highlights). Dragging this slider to the right makes this part of the curve steeper, and increases the upper midtones. The Darks and Shadows sliders do pretty much the same thing for the lower midtones and deep shadow areas. But remember, dragging to the right opens up those areas, so to create contrast, you'd drag both of those to the left instead. Here, to create some real punchy contrast, I dragged both the Highlights and Lights sliders to the right, and the Darks and Shadows sliders to the left.

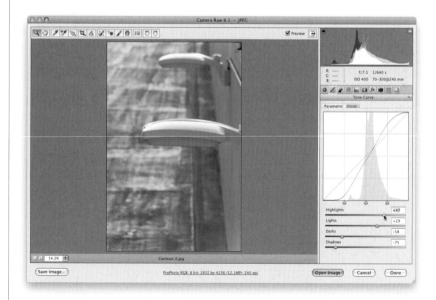

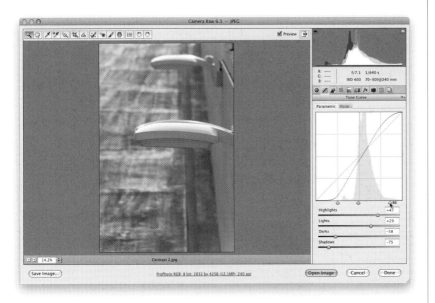

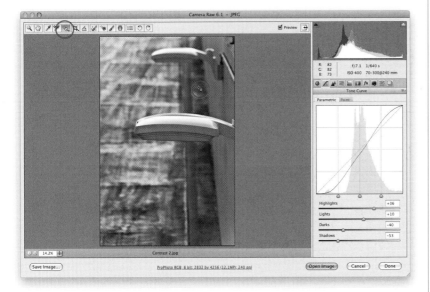

Step Seven:

Another advantage of the Parametric curve is that you can use the region divider controls (under the curve) to choose how wide a range each of the four sliders covers. So, if you move the far-right region divider to the right (shown here), it expands the area controlled by the Lights slider. Now the Highlights slider has less impact, flattening the upper part of the curve, so the contrast is decreased. If I drag that same region divider control back to the left instead, it expands the Highlights slider's area, which steepens the curve and increases contrast.

Step Eight:

If all of this makes you a bit squeamish, have I got a tool for you: it's called the Targeted Adjustment tool (or TAT for short) and you'll find it up in the toolbar at the top of the window (it's the fifth tool from the left, shown circled here). Just move the tool over the part of the image you want to adjust, then drag upward to lighten that area, or downward to darken it (this just moves the part of the curve that represents that part of the image). A lot of photographers love the TAT, so make sure you give it a try, because it makes getting that one area you want brighter (or darker) easier. Now, there is one caveat (I've been waiting to use that word for a while), and that is: it doesn't just adjust that one area of your photo—it adjusts the curve itself. So, depending on the image, other areas may get lighter/darker, too, so just keep an eye on that while you're adjusting. In the example shown here, I clicked and dragged upward to brighten up that shadowy area, and the curve adjusted to make that happen automatically.

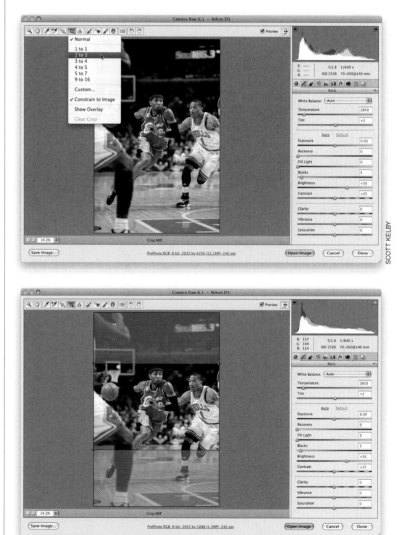

Cropping and Straightening

There's a distinct advantage to cropping your photo here in Camera Raw, rather than in Photoshop CS5 itself, and that is you can return to Camera Raw later and bring back the uncropped version of the image. This even holds true for JPEG and TIFF photos, as long as you haven't overwritten the original JPEG or TIFF file. To avoid overwriting, when you save the JPEG or TIFF in Photoshop, just change the filename (that way the original stays intact). With RAW images, you don't have to worry about that, because it doesn't let you overwrite the original.

Step One:
The Crop tool **(C)** is the sixth tool from the left in the toolbar. By default, it pretty much works like Photoshop's Crop tool (you click-and-drag it out around the area you want to keep), but it does offer some features that Photoshop doesn't—like access to a list of preset cropping ratios. To get them, click-and-hold on the Crop tool and a pop-up menu will appear (as shown here). The Normal setting gives you the standard drag-it-where-you-want-it cropping. However, if you choose one of the cropping presets, then your cropping is constrained to a specific ratio. For example, choose the 2 to 3 ratio, click-and-drag it out, and you'll see that it keeps the same aspect ratio as your original uncropped photo

Step Two:
Here's the 2-to-3-ratio cropping border dragged out over my image. The area to be cropped away appears dimmed, and the clear area inside the border is how your final cropped photo will appear. If you want to see the cropped version before you leave Camera Raw, just switch to another tool in the toolbar. (*Note:* If you draw a set size cropping border and want to switch orientation, click on the bottom-right corner and drag down and to the left to switch from wide to tall, or up and to the right to switch from tall to wide.)

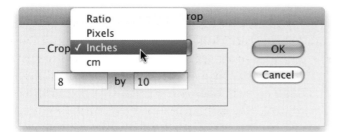

Step Three:

If you reopen your cropped photo again in Camera Raw, you'll see the cropped version. To bring back the cropping border, just click on the Crop tool. To remove the cropping altogether, press the **Esc** or **Delete (PC: Backspace) key** on your keyboard (or choose **Clear Crop** from the Crop tool's pop-up menu). If you want your photo cropped to an exact size (like 8x10", 13x19", etc.), choose **Custom** from the Crop tool's pop-up menu to bring up the dialog you see here. You can choose to crop by inches, pixels, or centimeters.

Step Four:

Here, we're going to create a custom crop so our photo winds up being exactly 8x10", so choose Inches from the Crop pop-up menu, then type in your custom size. Click OK, click-and-drag out the cropping border, and the area inside it will be exactly 8x10". Click on any other tool in the toolbar or press **Return (PC: Enter)**, and you'll see the final cropped 8x10" image (as seen here). If you click the Open Image button, the image is cropped to your specs and opened in Photoshop. If, instead, you click the Done button, Camera Raw closes and your photo is untouched, but it keeps your cropping border in place for the future.

TIP: Seeing Image Size

The size of your photo (and other information) is displayed under the preview area of Camera Raw (in blue underlined text that looks like a Web link). When you drag out a cropping border, the size info for the photo automatically updates to display the dimensions of the currently selected crop area.

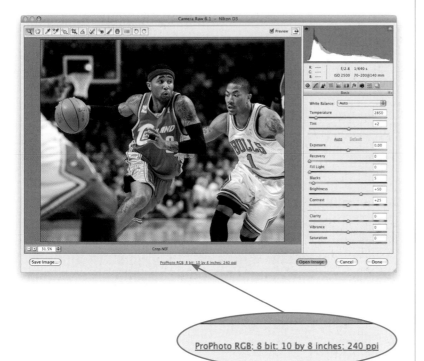

ProPhoto RGB: 8 bit; 10 by 8 inches; 240 ppi

Continued

Step Five:

If you save a cropped JPEG or TIFF photo out of Camera Raw (by clicking the Done button), the only way to bring back those cropped areas is to reopen the photo in Camera Raw. However, if you click the Save Image button and you choose **Photoshop** from the Format pop-up menu (as shown), a new option will appear called Preserve Cropped Pixels. If you turn on that checkbox before you click Save, when you open this cropped photo in Photoshop, it will appear to be cropped, but the photo will be on a separate layer (not flattened on the Background layer). So the cropped area is still there—it just extends off the visible image area. You can bring that cropped area back by clicking-and-dragging your photo within the image area (try it—use the Move tool [V] to click-and-drag your photo to the right or left and you'll see what I mean).

Step Six:

If you have a number of similar photos you need to crop the same way, you're going to love this: First, select all the photos you want to crop in Camera Raw (either in Mini Bridge or on your computer), then open them all in Camera Raw. When you open multiple photos, they appear in a vertical filmstrip along the left side of Camera Raw (as shown here). Click on the Select All button (it's above the filmstrip) and then crop the currently selected photo as you'd like. As you apply your cropping, look at the filmstrip and you'll see all the thumbnails update with their new cropping instructions. A tiny Crop icon will also appear in the bottom-left corner of each thumbnail, letting you know that these photos have been cropped in Camera Raw.

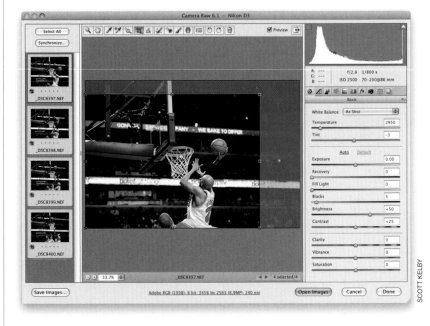

SCOTT KELBY

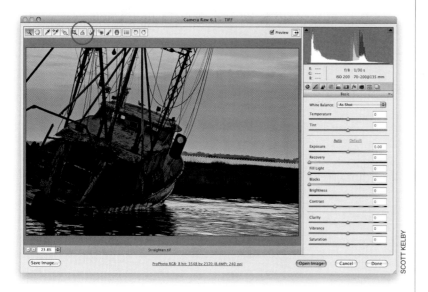

SCOTT KELBY

Step Seven:

Another form of cropping is actually straightening your photos using the Straighten tool. It's a close cousin of the Crop tool because what it does is essentially rotates your cropping border, so when you open the photo, it's straight. In the Camera Raw toolbar, choose the Straighten tool (it's immediately to the right of the Crop tool, and shown circled here in red). Now, click-and-drag it along the horizon line in your photo (as shown here). When you release the mouse button, a cropping border appears and that border is automatically rotated to the exact amount needed to straighten the photo (as shown in Step Eight).

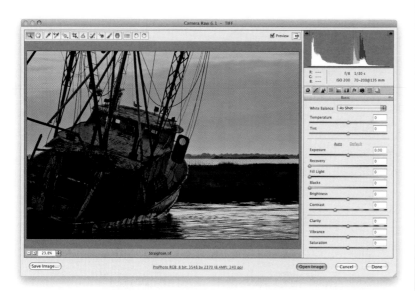

Step Eight:

You won't actually see the straightened photo until you switch tools, press **Return (PC: Enter)**, or open the photo in Photoshop (which means, if you click Save Image or Done, Camera Raw closes, and the straightening information is saved along with the file. So if you open this file again in Camera Raw, you'll see the straightened version, and you won't really know it was ever crooked). If you click Open Image instead, the straightened photo opens in Photoshop. Again, if this is a RAW photo (or if it's a JPEG or TIFF and you clicked the Done button), you can always return to Camera Raw and remove this cropping border to get the original uncropped photo back.

TIP: Canceling Your Straightening

If you want to cancel your straightening, just press the **Esc key** on your keyboard, and the straightening border will go away.

Photoshop Killer Tips

Skipping the Camera Raw Window Altogether

If you've already applied a set of tweaks to a RAW photo, you probably don't need the Camera Raw editing window opening every time you open the file. So, just press-and-hold the Shift key when you double-click on the RAW file in Mini Bridge, and the image will open in Photoshop, with the last set of edits already applied, skipping the Camera Raw window altogether. If you didn't apply any tweaks in Camera Raw, it just opens with the Camera Raw defaults applied. Either way, it's a big time saver.

Rate Your Images in Camera Raw

You don't have to be in Mini Bridge to add or change star ratings. If you've got multiple images open, you can do it right in Camera Raw. Just press **Command-1, -2, -3 (PC: Ctrl-1, -2, -3)**, and so on, to add star ratings (up to five stars). You can also just click directly on the five little dots that appear below the thumbnails in the filmstrip on the left.

Seeing a True Before/After

The weird thing about the way Camera Raw handles previews is it does them on a panel-by-panel basis, so if you make a bunch of changes in the Basic panel, then switch to the Detail panel, and makes changes there, when you turn off the Preview checkbox (on the top right of the Preview area), it doesn't give you a real before/after. It just gives you a before/after of the panel you're in right now, which doesn't give you a true before/after of your image editing. To get a real before/after of all your edits in Camera Raw, click on the Presets icon (the second icon from the right at the top of the Panel area) or the Snapshots icon (the far right icon), and now when you toggle on/off the Preview checkbox, it shows you the real before/after.

Don't Get Fooled by the Default Button

If you've edited your image in Camera Raw, and then you decide you want to start over, clicking the Default button in the Basic panel (it's to the left of the Auto button) won't return your image to how it looked when you opened it. Instead, to get back to the original way your image looked when you first opened it in Camera Raw, go to the Camera Raw flyout menu and choose

Camera Raw Defaults. You can also press-and-hold the Option (PC: Alt) key, and the Cancel button will change to a Reset button.

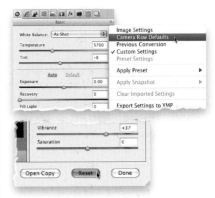

Cool Raw Retouching Trick

There's a pretty common retouching technique in Photoshop for reducing hot spots (shiny areas on a subject's face), which uses the Healing Brush to completely remove the hot spot, then under the Edit menu, choosing Fade Healing Brush, and lowering the Opacity there. A little hint of the hot spot comes back, so it looks more like a highlight than a shine (it actually works really well). You can do something similar in Camera Raw when using the Spot Removal tool (set to Heal) by removing the hot spot (or freckle, or wrinkle) and then using the Opacity slider in the Spot Removal options panel.

Photoshop Killer Tips

Deleting Multiple Images While Editing in Camera Raw

If you have more than one image open in Camera Raw, you can mark any of them you want to be deleted by selecting them (in the filmstrip on the left side of Camera Raw), then pressing the Delete key on your keyboard. A red "X" will appear on those images. When you're done in Camera Raw, click on the Done button, and those images marked to be deleted will be moved to the Trash (PC: Recycle Bin) automatically. To remove the mark for deletion, just select them and press the Delete key again.

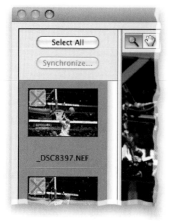

Get a Larger Preview Area

If you have multiple images open in Camera Raw, and need more room to see the preview of the image you're currently working on, just double-click right on that little divider that separates the filmstrip from the Preview area, and the filmstrip tucks in over to the left, out of the way, giving you a larger preview. To bring it back, just double-click on that

divider again (it's now over on the far left side of the Camera Raw window) and it pops back out.

Constrained Cropping Is Here

In CS5, they added the ability to crop while keeping the same aspect ratio as the original image. Click-and-hold on the Crop tool in Camera Raw's toolbar, and from the pop-up menu that appears, choose **Constrain to Image**.

Rule-of-Thirds Cropping Is Here

This one Adobe borrowed from Camera Raw's sister program Photoshop Lightroom, because now (like in Lightroom), you can have the "Rule-of-Thirds" grid appear over your cropping border anytime by just clicking-and-holding on the Crop tool in the toolbar, then choosing **Show Overlay**.

Jump to Full Screen Mode in Camera Raw

If you want to see your image in Camera Raw as large as possible, just press the **F key**, and Camera Raw expands to Full Screen mode, with the window filling your monitor, giving you a larger look at your image.

Shortcut for Viewing Sharpening

The best zoom magnification to view your sharpening in Camera Raw is a 100% view, and the quickest way to get there is to just double-click the Zoom tool.

Help with Fixing Chromatic Aberrations

If you have an image where you have more than one chromatic aberration (which is quite common), this might make things easier: when you're fixing the first color, press-and-hold the Option (PC: Alt) key before you start dragging the slider. This isolates that color slider, and lets you focus on fixing just that one color for now.

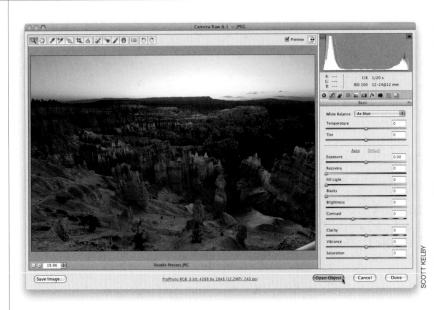

Double-Processing to Create the Uncapturable

As good as digital cameras have become these days, when it comes to exposure, the human eye totally kicks their butt. That's why we shoot so many photos where our subject is backlit, because with our naked eye we can see the subject just fine (our eye adjusts). But when we open the photo, the subject is basically in silhouette. Or how about sunsets, where we have to choose which part of the scene to expose for—the ground or the sky—because our camera can't expose for both? Well, here's how to use Camera Raw to overcome this exposure limitation:

Step One:

Open the photo you want to double-process. In this example, the camera properly exposed for the foreground, so the sky is totally blown out. Of course, or goal is to create something our camera can't—a photo where both the inside and outside are exposed properly. To make things easy, we're going to open this image as a Smart Object in Photoshop, so press-and-hold the Shift key, and the Open Image button at the bottom changes into the Open Object button. Click that button to open this version of the photo in Photoshop as a Smart Object (you'll see the advantage of this in just a minute).

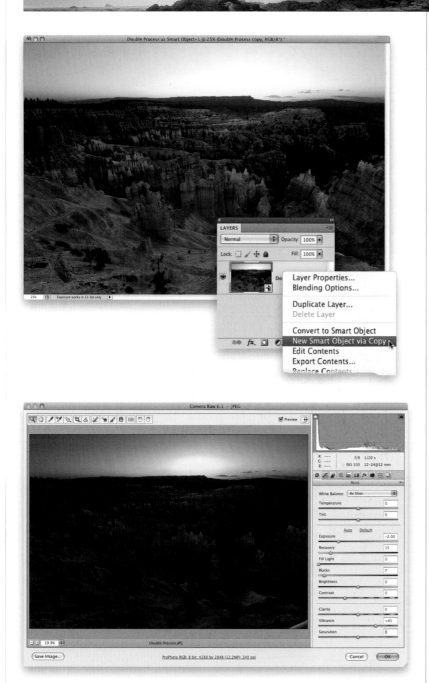

Step Two:
Your image will open in Photoshop as a Smart Object (you'll see the layer thumbnail has a little page icon in the bottom-right corner). So, now we need a second version of this image—one we can expose for the sky. If you just duplicate the layer, it won't work, because this duplicate layer will be tied to the original layer, and any changes you make to this duplicate will also be applied to the original layer. So, to get around that, go to the Layers panel, Right-click on the layer, and from the pop-up menu that appears, choose **New Smart Object via Copy**. This gives you a duplicate layer, but breaks the link.

Step Three:
Now double-click directly on this duplicate layer's thumbnail and it opens this duplicate in Camera Raw. Here, you're going to expose for the sky, without any regard for how the foreground looks (it will turn really dark, but who cares—you've already got a version with it properly exposed on its own separate layer). So, drag the Exposure slider way over to the left, until the sky looks properly exposed (I also increased the Recovery, Blacks, and Vibrance settings). Now, click OK.

Continued

Editing Multiple Photos at Once

One of the biggest advantages of using Camera Raw is that it enables you to apply changes to one photo, and then easily apply those exact same changes to a bunch of other similar photos taken in the same approximate setting. It's a form of built-in automation, and it can save you an incredible amount of time when editing your shoots.

Step One:
The key to making this work is that the photos you edit all are shot in similar lighting conditions, or all have some similar problem. In this case, our photos are from an indoor basketball game, and there's a green color cast to them from the lighting on the court. In Mini Bridge, start by selecting the images you want to edit (click on one, press-and-hold the Command [PC: Ctrl] key, then click on all the others). If they're RAW images, just double-click on any one of them and they open in Camera Raw, but if they're JPEG or TIFF images, you'll need to select them, then switch to Review mode, and then press **Option-R (PC: Alt-R)**.

Step Two:
When the images open in Camera Raw, you'll see a filmstrip along the left side of the window with all the images you selected. Now, there are two ways to do this and, while neither one is wrong, I think the second method is faster (which you'll see in a moment). We'll start with the first: Click on an image in the filmstrip, then make any adjustments you want to make this one image look good (I tweaked the white balance so it wasn't so green).

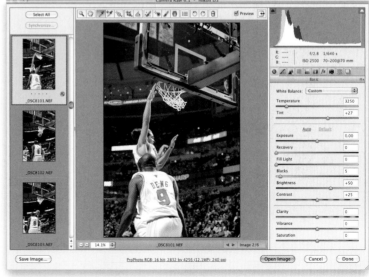

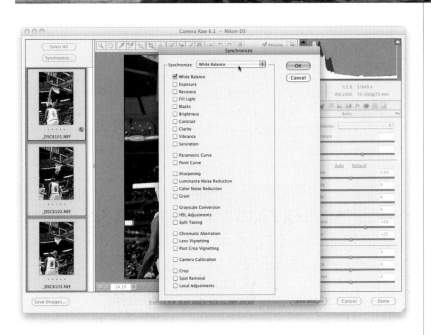

Step Three:

Once you've got one of the photos looking good, click the Select All button up at the top of the filmstrip to select all the photos (even though it selects the rest of the photos, you'll notice that the image you edited is actually the "most selected" image, with a highlight border around it). Now click the Synchronize button (it's right below the Select All button) to bring up the Synchronize dialog (seen here). It shows you a list of all the things you could copy from this "most selected" photo and apply to the rest of the selected photos. Choose White Balance from the pop-up menu at the top, and it unchecks all the other stuff, and leaves just the White Balance checkbox turned on.

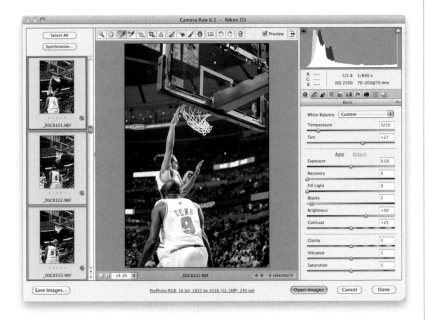

Step Four:

When you click the OK button, it applies the White Balance settings from the "most selected" photo to all the rest of the selected photos (if you look in the filmstrip, you'll see that all the photos have had their white balance adjusted). Okay, so why don't I like this method? Although it does work, it takes too many clicks, and decisions, and checkboxes, which is why I prefer the second method.

TIP: Editing Only Select Photos

If you only want certain photos to be affected, and not all the ones open in Camera Raw, then in the filmstrip, Command-click (PC: Ctrl-click) on only the photos you want affected and click the Synchronize button.

Continued

Step Five:

In the second method, as soon as Camera Raw opens, click the Select All button to select all your images, then go ahead and make your changes. As you make the changes to your "most selected" photo, all the others are updated with your new settings almost instantly, so you don't have to remember which settings you applied—when you move one slider, all the images get the same treatment, so you don't need the Synchronize dialog at all. Try out both methods and see which one you like, but if you feel the need for speed, you'll probably like the second one much better.

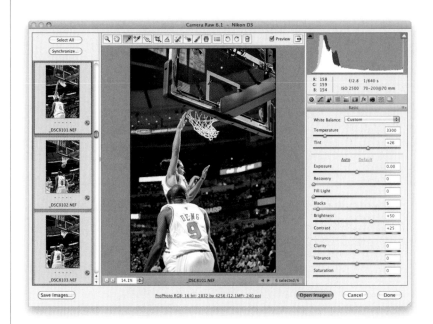

If you shoot in JPEG, your digital camera applies sharpening to your photo right in the camera itself, so no sharpening is automatically applied by Camera Raw. But if you shoot in RAW, you're telling your camera to ignore that sharpening, and that's why, when you bring a RAW image into Camera Raw, by default, it applies some sharpening, called "capture sharpening." In my workflow, I sharpen twice: once here in Camera Raw, and once more right before I output my final image from Photoshop (called "output sharpening"). Here's how to apply capture sharpening in Camera Raw:

Sharpening in Camera Raw

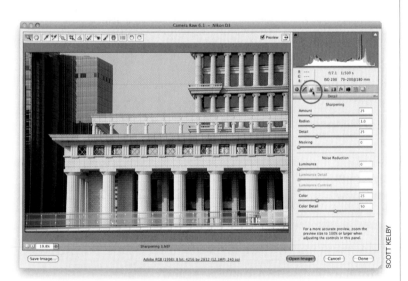

SCOTT KELBY

Step One:

When you open a RAW image in Camera Raw, by default, it applies a small amount of sharpening to your photo (not the JPEGs or TIFFs, only RAW images). You can adjust this amount (or turn it off altogether, if you like) by clicking on the Detail icon, as shown here, or using the keyboard shortcut **Command-Option-3 (PC: Ctrl-Alt-3)**. At the top of this panel is the Sharpening section, where by a quick glance you can see that sharpening has already been applied to your photo. If you don't want any sharpening applied at this stage (it's a personal preference), then simply click-and-drag the Amount slider all the way to the left to lower the amount of sharpening to 0 (zero), and the sharpening is removed.

Step Two:

If you want to turn off this automatic, by default sharpening (so capture sharpening is only applied if you go and manually add it yourself), first set the Sharpening Amount slider to 0 (zero), then go to the Camera Raw flyout menu and choose **Save New Camera Raw Defaults** (as shown here). Now, RAW images taken with that camera will not be automatically sharpened.

Continued

Fixing Chromatic Aberrations (That Colored-Edge Fringe)

Chromatic aberration is a fancy name for that thin line of colored fringe that sometimes appears around the edges of objects in photos. Sometimes the fringe is red, sometimes green, sometimes purple, blue, etc., but all the time it's bad, so we might as well get rid of it. Luckily, Camera Raw has a built-in fix that does a pretty good job.

Step One:
Open a photo that has signs of chromatic aberrations. If they're going to appear, they're usually right along an edge in the image that has lots of contrast (like along the edges of these rock formations). Press **Z** to get the Zoom tool and zoom in on an area where you think (or see) the fringe might be fairly obvious. Here, there's red fringe running along the edges of the rocks. To remove this, start by clicking on the Lens Corrections icon (the sixth icon from the left) at the top of the Panel area.

Step Two:
In the Profile tab, turn on the Enable Profile Corrections checkbox and Photoshop tries to remove the color fringe based on your lens' make and model (it learns this from your image's EXIF data. See page 66 for more on this). If the image still needs correction, try the C. Aberration slider under Amount. If the automatic way doesn't work for you, try getting rid of the fringe manually.

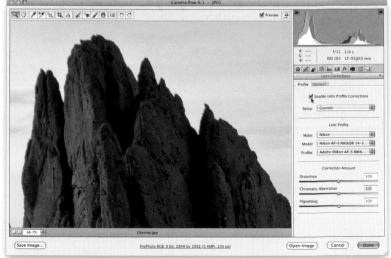

Step
Befor
one
if yo
appli
the s
can s
actua
Ctrl-
in th
choc
Appl
show
this
only
Cam
oper
ing i

Step
In p
had
see
addr
not
view
the
The
view
Zoo
here
zoo
Det
zoo

Step Three:

At the top of the Lens Corrections panel, click on the Manual tab. Down in the Chromatic Aberration section, there are only two sliders and you just drag toward the color you want to fix (they're labeled—the top one fixes red or cyan fringe; the bottom fixes blue or yellow fringe). But before you begin dragging sliders, you may want to click on the Detail icon (the third icon from the left at the top of the Panel area) and lower the Sharpening Amount to 0% (if you added any or are fixing a RAW image), because sharpening can also cause color fringes to appear (and you want to make sure you're curing the right problem).

Step Four:

Start by moving the top Chromatic Aberration slider all the way to the right (toward cyan), which reduces the red fringe. Here, there's still just a little color fringe, so try choosing **All Edges** from the Defringe pop-up menu, which seems to do the trick.

TIP: Editing TIFFs and JPEGs

Although you can edit TIFFs and JPEGs in Camera Raw, there is one "gotcha!" Once you edit one of those in Camera Raw, if you click the Done button (rather than opening the image in Photoshop), you'll need to always open that photo from within Camera Raw to see the edits you made. That's because those edits live only inside of Camera Raw; if you bypass Camera Raw and open an edited TIFF or JPEG directly into Photoshop, the Camera Raw edits you made earlier won't be visible.

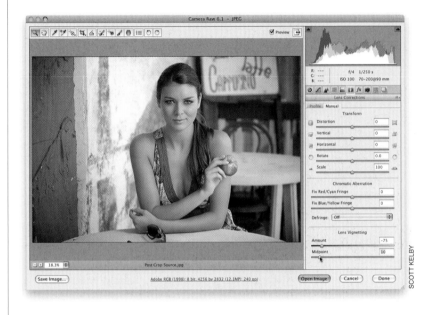

Step Five:

So far, adding the vignette has been pretty easy—you just drag a couple of sliders, right? But where you'll run into a problem is when you crop a photo, because you're also cropping the vignetting effect away, as well (after all, it's an edge effect, and now the edges are in a different place, and Camera Raw doesn't automatically redraw your vignette at the newly cropped size). So, start by applying a regular edge vignette (as shown here).

Step Six:

Now, let's get the Crop tool **(C)** from the toolbar, crop that photo in pretty tight, and you can see what the problem is—the vignette effect we just added is pretty much gone (the dark edges were cropped away).

Note: Adobe originally added the ability to add a vignette after you've cropped an image (called Post Crop Vignetting) back in Photoshop CS4, but the problem was when you added it, it didn't look nearly as good as the regular non-cropped vignetting (even though it offered more control, as seen at the bottom of the Effects panel shown in Step Seven). It kind of looked just like adding muddy dark gray to the edges. Yeech!

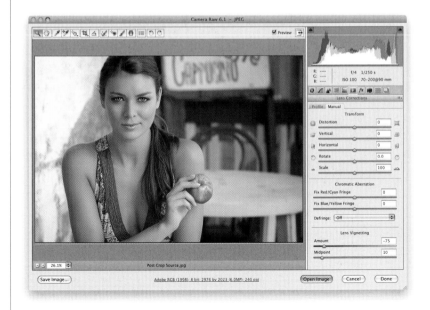

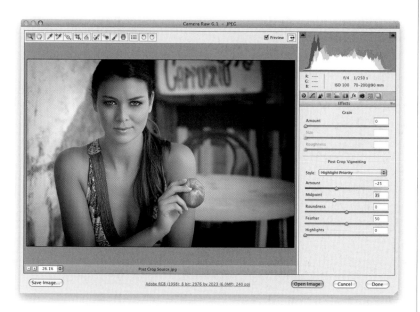

Step Seven:

Let's go add a post-crop vignette by clicking on the Effects icon (the fourth icon from the right) and, under Post Crop Vignetting, dragging the Amount slider to the left to darken the edges, then using the Midpoint slider to choose how far into your image this vignetting will extend (as seen here). Now, here's what they've added in CS5 (it makes all the difference in the world): At the top of the Post Crop Vignetting section is a pop-up menu with three different types of vignetting: Highlight Priority (which I think far and away looks the best, and the most like the original vignetting we applied back in Step Five), which tries to maintain the highlight details as the edges are darkened; Color Priority tries to maintain the color while the edges are darkened (it's okay, but not great); and Paint Overlay is the old method from CS4 that almost everybody hated (apparently somebody liked it, because it's still there). I would stay away from this one altogether.

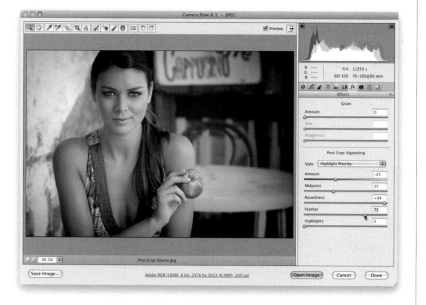

Step Eight:

Below the Midpoint slider is the Round-ness slider that gives you control over the roundness of the vignetting (lower the Feather amount to 0, so you can get a better idea of what the Roundness slider does). The farther to the right you drag, the rounder the shape gets, and when you drag to the left, it actually becomes more like a large, rounded-corner rect-angle. The Feather slider determines how soft that oval you created with the Roundness slider becomes. I like it really soft, so it looks more like a spotlight, so I usually drag this slider quite a bit over to the right (here I dragged it over to 73, but I wouldn't hesitate to go higher, depending on how it looks on the photo).

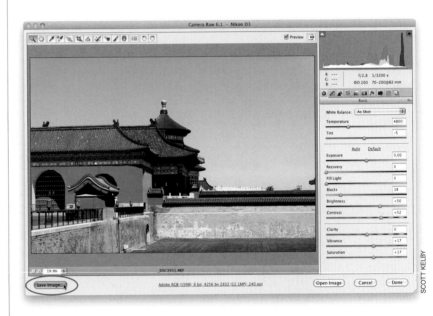

The Advantages of Adobe's DNG Format for RAW Photos

Adobe created DNG (an open archival format for RAW photos) because, at this point in time, each camera manufacturer has its own proprietary RAW file format. If, one day, one or more manufacturers abandon their proprietary format for something new (like Kodak did with their Photo CD format), will we still be able to open our RAW photos? With DNG, it's not proprietary—Adobe made it an open archival format, ensuring that your negatives can be opened in the future, but besides that, DNG brings another couple of advantages, as well.

Step One:

There are three advantages to converting your RAW files to Adobe DNG: (1) DNG files are generally about 20% smaller. (2) DNG files don't need an XMP sidecar file to store Camera Raw edits, metadata, and keywords—the info's embedded into the DNG file, so you only have one file to keep track of. And, (3) DNG is an open format, so you'll be able to open them in the future (as I mentioned in the intro above). If you have a RAW image open in Camera Raw, you can save it as an Adobe DNG by clicking the Save Image button (as shown here) to bring up the Save Options dialog (seen in the next step). *Note:* There's really no advantage to saving TIFF or JPEG files as DNGs, so I only convert RAW photos.

Save Options

Destination: Save in New Location

Select Folder... /Users/scottkelby/Pictures/

Save
Cancel

File Naming
Example: vignette 3a.dng

Document Name + +

+ +

Begin Numbering:

File Extension: .dng

Format ✓ Digital Negative
JPEG
Comp TIFF er
Photoshop
JPEG Preview: Medium Size

☐ Embed Original Raw File

DNG File Handling
☐ Ignore sidecar ".xmp" files
☐ Update embedded JPEG previews: Medium Size

Step Two:
When the Save Options dialog appears, at the bottom of the dialog, from the Format pop-up menu, choose **Digital Negative** (shown here), click Save, and you've got a DNG.

TIP: Setting Your DNG Preferences
Once you've converted to DNG, Camera Raw does give you a few preferences for working with these DNG files. Press **Command-K (PC: Ctrl-K)** to bring up Photoshop's Preferences dialog, then click on File Handling in the column on the left side, and click on the Camera Raw Preferences button (or press **Command-K** when you have Camera Raw open). When the dialog appears, go to the DNG File Handling section (shown here). You'd choose Ignore Sidecar ".xmp" Files only if you use a different RAW processing application (other than Camera Raw or Lightroom), and you want Camera Raw to ignore any XMP files created by that application. If you turn on the Update Embedded JPEG Previews checkbox (and choose your preferred preview size from the pop-up menu), then any changes you make to the DNG will be applied to the preview, as well.

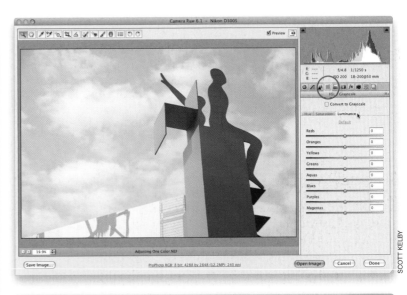

Adjusting or Changing Ranges of Color

In the next chapter, you're going to learn how to paint an adjustment over any part of your image, but sometimes you need to affect an entire area (like you need the entire sky bluer, or the sand warmer, or a piece of clothing to be an entirely different color). In those cases, where you're adjusting large areas, it's usually quicker to use the HSL adjustments, which not only let you change color, but also let you change the saturation and the lightness of the color. It's more powerful, and handy, than you might think.

Step One:
Here's the original image of a red sculpture on a washed-out, cloudy blue sky, and what I'd like to do is tweak the color of that sky so it's a richer blue, which would add a nice contrast to the red sculpture. You tweak individual colors, or ranges of color, in the HSL/Grayscale panel, so click on its icon at the top of the Panel area (it's the fourth one from the left—circled here in red). Now, click on the Luminance tab (as shown here) to bring up the Luminance controls (which control how bright the colors appear).

Step Two:
The blue in the sky is washed out, so we need to bring some richness and depth back into the color, so drag the Blues slider way over to the left toward the darker blues (those color bars behind each slider give you an idea of what will happen when you drag a slider in a particular direction). Now drag the Aquas sliders to the left quite a bit, too (as shown here). Moving the Aquas slider added a little more saturation to the blue in the sky. How did I know this was going to do that? I had no idea. I just dragged each slider back and forth real quick to see what it would do. I know—it sounds awfully simple, but it works.

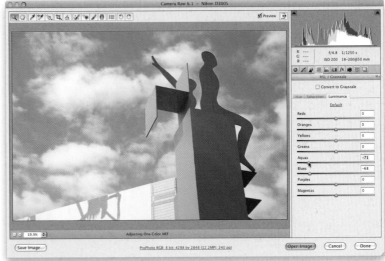

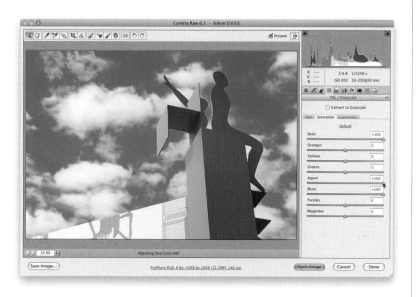

Step Three:
So now the Blues are bright, but they're not rich and bold yet, so click on the Saturation tab near the top of the panel, and then drag the Blues slider all the way over to the right, and the sky just comes alive with color. I also dragged the Aquas slider to the right, too (as shown here), because it had such a great effect on the sky earlier, and I dragged the Reds slider to the right to bring out the red in the sculpture. Now that the photo is really vivid, you may see some unintentional edge vignetting in the corners, so just go to the Lens Corrections panel, click on the Manual tab and, under Lens Vignetting, drag the Amount slider to the right until it goes away (for me, it was about +26, and I didn't need to touch the Midpoint slider at all. See page 74 for more on fixing vignetting).

Step Four:
To actually change colors (not just adjust an existing color's saturation or vibrance), you click on the Hue tab near the top of the panel. The controls are the same, but take a look at the color inside the sliders themselves now—you can see exactly which way to drag to get which color. In this case, to make the red sculpture yellow, you'd drag the Reds and Oranges sliders to the right. Easy enough. To make the sculpture orange, drag the Reds slider to +79, drag the Oranges slider to −32, and the Yellows slider over to −100. How did I figure this one out? You guessed it— I started dragging sliders around (don't tell anybody I actually do this).

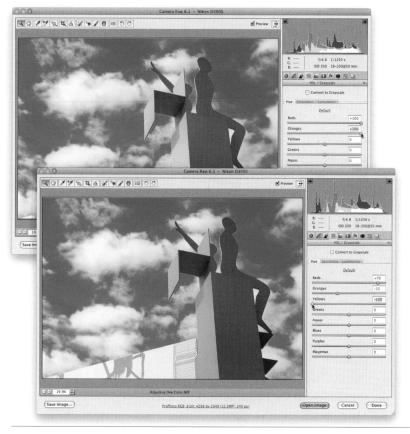

Removing Spots, Specks, Blemishes, Etc.

If you need to remove something pretty minor from your photo, like a spot from some dust on your camera's sensor, or a blemish on your subject's face, or something relatively simple like that, you can use the Spot Removal tool right within Camera Raw. If it's more complicated than just a simple spot or two, you'll have to head over to Photoshop and use its much more powerful and precise retouching tools (like the Healing Brush tool, Patch tool, and Clone Stamp tool).

Step One:

This photo has some simple problems that can be fixed using Camera Raw's Spot Removal tool. You start by clicking on the Spot Removal tool (the seventh tool from the right in the toolbar) or by pressing **B** to get it, and a set of options appears in the Spot Removal panel on the right (seen here). Using the tool is pretty simple—just move your cursor over the center of a spot that needs to be removed (in this case, it's those spots in the sky where my camera's sensor got dirty), then click, hold, and drag outward, and a red-and-white circle will appear, growing larger as you drag outward. Keep dragging until that circle is a little larger than the spot you're trying to remove (as shown here below). Don't forget, you can use the Zoom tool (**Z**) to zoom in and get a better look at your spots before you drag out your circle.

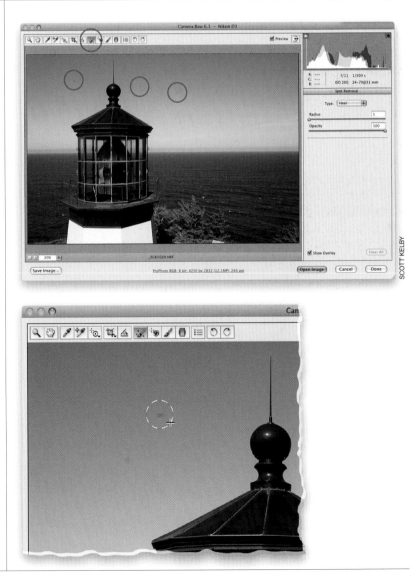

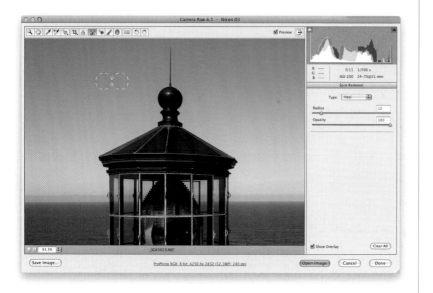

Step Two:
When you release the mouse button, a second circle (this one is green and white) appears to show you the area where Camera Raw chose to sample your repair texture from (it's usually very close by), and your spot or blemish is gone (as seen here).

TIP: When to Fix Blemishes in Camera Raw
So, what determines if you can fix a blemish here in Camera Raw? Basically, it's how close the blemish, spot, or other object you need to remove is to the edge of anything. This tool doesn't like edges (the edge of a door, a wall, a person's face, etc.), so as long as the blemish (spot, etc.) is all by itself, you're usually okay.

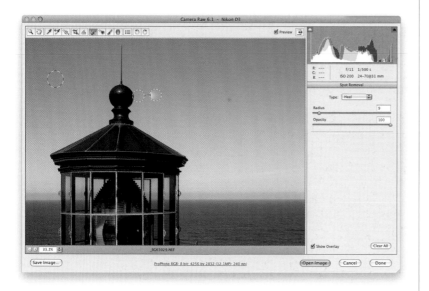

Step Three:
To remove a different spot (like the one to the right of the lighthouse here), you use the same method: move over that spot, click, hold, and drag out a circle that's slightly larger than the spot, then release the mouse button. In this case, Camera Raw did sample a nearby area, but unfortunately it also sampled a bit of the top of the lighthouse, and it copied it to the sky area where we were retouching, making the retouch look very obvious with that piece of lighthouse hanging out there.

Continued

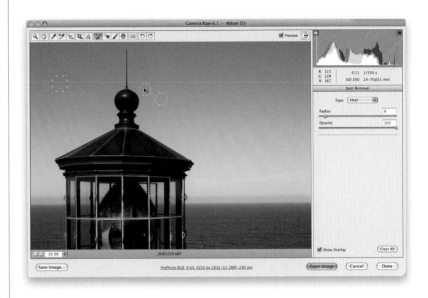

Step Four:

If this happens, here's what to do: move your cursor inside the green-and-white circle, and drag that circle to a different nearby area (here, I dragged upward to a clean nearby area), and when you release the mouse button, it resamples texture from that area. Another thing you can try, if the area is at all near an edge, is to go to the top of the Spot Removal panel and choose **Clone** rather than Heal from the Type pop-up menu (although I use Heal about 99% of the time, because it generally works much better).

Step Five:

When you're done retouching, just change tools and your retouches are applied (and the circles go away). Here's the final retouch after removing all the spots in the sky from my dirty sensor. Use this tool the next time you have a spot on your lens or on your sensor (where the same spot is in the same place in all the photos from your shoot). Then fix the spot on one photo, open multiple photos, and paste the repair onto the other selected RAW photos using Synchronize (see "Editing Multiple Photos at Once," earlier in this chapter, and just turn on the Spot Removal checkbox in the Synchronize dialog).

Some cameras seem to have their own "color signature," and by that I mean that every photo seems to be a little too red, or every photo is a little too green, etc. You just know, when you open a photo from that camera, that you're going to have to deal with the slight color cast it adds. Well, if that's the case, you can compensate for that in Camera Raw, and then set that color adjustment as the default for that particular camera. That way, any time you open a photo from that camera, it will automatically compensate for that color.

Calibrating for Your Particular Camera

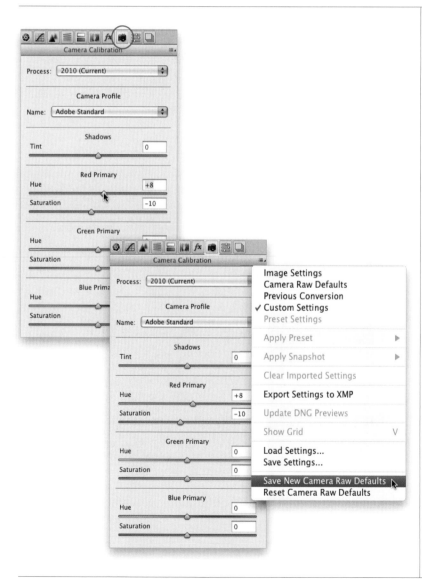

Step One:
To calibrate Camera Raw so it fixes a persistent color cast added by your camera, open a typical photo taken with that camera in Camera Raw, and then click on the Camera Calibration icon (it looks like a camera and is the third icon from the right at the top of the Panel area). So, let's say that the shadow areas in every photo from your camera appear slightly too red. In the Camera Calibration panel, drag the Red Primary Saturation slider to the left, lowering the amount of red in the entire photo. If the red simply isn't the right shade of red (maybe it's too hot and you just want to tone it down a bit), drag the Red Primary Hue slider until the red color looks better to you (dragging to the right makes the reds more orange).

Step Two:
To have Camera Raw automatically apply this calibration each time a photo from that particular camera is opened in Camera Raw, go to Camera Raw's flyout menu (in the top right of the panel), and choose **Save New Camera Raw Defaults** (as shown here). Now, when you open a photo from that camera (Camera Raw reads the EXIF data so it knows which camera each shot comes from), it will apply that calibration. *Note:* You can adjust your blues and greens in the same way.

Reducing Noise in Noisy Photos

This is, hands down, not only one of the most-requested features by photographers, but one of the best in all of CS5. Now, if you're thinking, "But Scott, haven't Photoshop and Camera Raw both had built-in noise reduction before CS5?" Yes, yes they did. And did it stink? Yes, yes it did. But, does the new noise reduction rock? Oh yeah! What makes it so amazing is that it removes the noise without greatly reducing the sharpness, detail, and color saturation. Plus, it applies the noise reduction to the RAW image itself (unlike most noise plug-ins).

Step One:
Open your noisy image in Camera Raw (the Noise Reduction feature works best on RAW images, but you can also use it on JPEGs and TIFFs, as well). The image shown here was shot at a high ISO using a Nikon D300S, which, like most cameras in its price range, doesn't do a very good job in low-light situations, so you can expect a lot of color noise (those red, green, and blue spots) and luminance noise (the grainy looking gray spots).

Step Two:
Sometimes it's hard to see the noise until you really zoom in tight, so zoom into at least 100% (here, I zoomed into 200%), and there it is, lurking in the shadows (that's where noise hangs out the most). Click on the Detail icon (it's the third icon from the left at the top of the Panel area) to access the Noise Reduction controls. I usually get rid of the color noise first, because that makes it easier to see the luminance noise (which comes next). Here's a good rule of thumb to go by when removing color noise: start with the Color slider over at 0 (as shown here) and then slowly drag it to the right until the moment the color noise is gone. *Note:* A bit of color noise reduction is automatically applied to RAW images—the Color slider is set to 25. But, for JPEGs or TIFFs, the Color slider is set to 0.

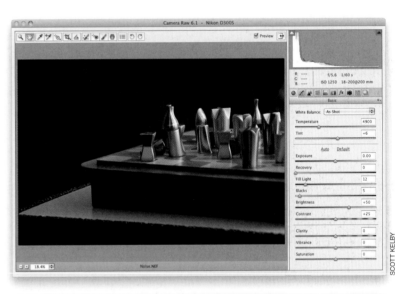

Step Three:
So, click-and-drag the Color slider to the right, but remember, you'll still see some noise (that's the luminance noise, which we'll deal with next), so what you're looking for here is just for the red, green, and blue color spots to go away. Chances are that you won'zt have to drag very far at all—just until that color noise all turns gray. If you have to push the Color slider pretty far to the right, you might start to lose some detail, and in that case, you can drag the Color Detail slider to right a bit, though honestly, I rarely have to do this for color noise.

Step Four:
Now that the color noise is gone, all that's left is the luminance noise, and you'll want to use a similar process: just drag the Luminance slider to the right, and keep dragging until the visible noise disappears (as seen here). You'll generally have to drag this one farther to the right than you did with the Color slider, but that's normal. There are two things that tend to happen when you have to push this slider really far to the right: you lose sharpness (detail) and contrast. Just increase the Luminance Detail slider if things start to get too soft (but I tend not to drag this one too far), and if things start looking flat, add the missing contrast back in using the Luminance Contrast slider (I don't mind cranking this one up a bit, except when I'm working on a portrait, because the flesh tones start to look icky). You probably won't have to touch either one all that often, but it's nice to know they're there if you need them.

Continued

Step Five:

Rather than increasing the Luminance Detail a bunch, I generally bump up the Sharpening Amount at the top of the Detail panel (as shown here), which really helps to bring some of the original sharpness and detail back. Here's the final image, zoomed back out, and you can see the noise has been pretty much eliminated, but even with the default settings (if you're fixing a RAW image), you're usually able to keep a lot of the original sharpness and detail. A zoomed-in before/after of the noise reduction we applied here is shown below.

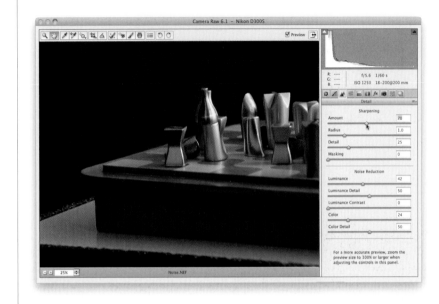

Before *After*

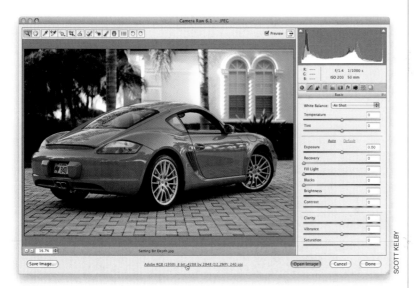

Since you're processing your own images, it only makes sense that you get to choose what resolution, what size, which color space, and how many bits per channel your photo will be, right? These are workflow decisions, which is why you make them in the Workflow Options dialog. Here are my recommendations on what to choose, and why:

Setting Your Resolution, Image Size, Color Space, and Bit Depth

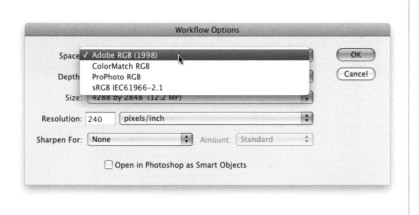

Step One:
Once you've made all your edits, and the photo is generally looking the way you want it to, it's time to choose your resolution, size, etc. Directly below the Camera Raw Preview area (where you see your photo), you'll see your current workflow settings—they are underlined in blue like a website link. Click on that link to bring up the Workflow Options dialog (which is seen in the next step).

Step Two:
We'll start at the top by choosing your photo's color space. By default, it shows the color space specified in your digital camera, but you can ignore that and choose the color space you want the photo processed with. I recommend choosing the same color space that you have chosen as Photoshop's color space. For photographers shooting in RAW or using Lightroom, I recommend that you choose ProPhoto RGB, but if you're shooting in JPEG or TIFF format, then I still recommend that you choose Adobe RGB (1998) for Photoshop's color space, and then you would choose the same color space here, from the Space pop-up menu. See my color management and printing chapter (Chapter 12) for more on why you should use ProPhoto RGB or Adobe RGB (1998).

Continued

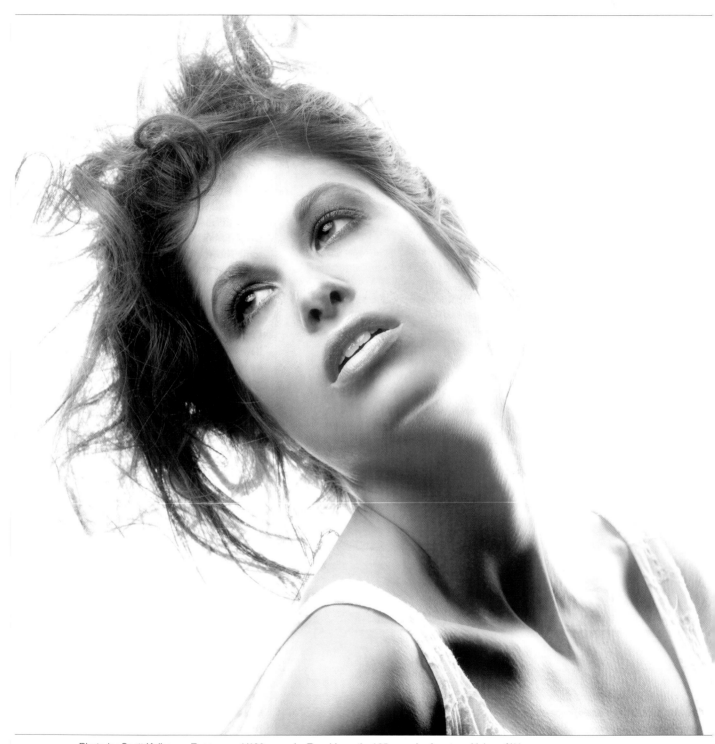

Attitude Adjustment
camera raw's adjustment tools

When I went searching for songs with the word "adjustment" in them, I quickly found Aerosmith's "Attitude Adjustment," which would make this an easy choice for me as an Aerosmith fan, but there's no real way for you to know if the title I'm referencing up there is actually the one by Aerosmith, or if I secretly went with another song with the exact same title by hip hop artists Trick Trick and Jazze Pha. In iTunes, this song was marked with the Explicit label, so I thought I'd better listen to the free 30-second preview first, because I wanted to make sure I didn't pick a song whose free preview was too explicit, but while listening to that preview, something very unexpected happened to me that I haven't gotten over to this very day. The sad truth is that I couldn't understand a word they were saying. I even played it back a couple of times, and I was waiting for naughty words to jump out at me, but I could barely make out anything they said. It just sounded like a bunch of noise. This can only mean one thing—I'm old. I remember playing songs for my parents when I was younger, and I remember my mom saying, "I can't understand a word they're saying" and she had that irritated look that only old people who can't understand a word they're hearing can get. But this time it was me. Me—that young, cool guy (stop giggling) experiencing my first "old people" moment. I was sad. I just sat there for a moment in stunned silence, and then I said "F&*$ S#!& A@# M*%$#%" and in no time flat, my wife stuck her head in the room and said, "Are you writing rap lyrics again?" At that moment, I felt young again. I jumped up out of my chair, but then I grabbed my back, and yelled "F*%$#% R%^$!" My wife then said, "I can't understand a word you're saying." Peace out!

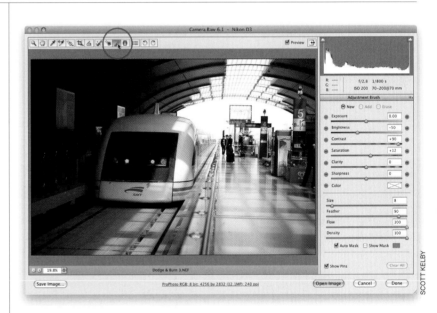

Dodging, Burning, and Adjusting Individual Areas of Your Photo

One of my favorite features in Camera Raw is the ability to make non-destructive adjustments to individual areas of your photos (Adobe calls this "localized corrections"). The way they've added this feature is pretty darn clever, and while it's different than using a brush in Photoshop, there are some aspects of it that I'll bet you'll like better. We'll start with dodging and burning, but we'll add more options in as we go.

Step One:

First, do all your regular edits to your photo (exposure, recovery, blacks, etc.). Next, click on the Adjustment Brush tool in the toolbar at the top of the Camera Raw window (as shown here) or just press the letter **K** on your keyboard. When you do this, an Adjustment Brush panel appears on the right side of the window with all the controls for using the Adjustment Brush (seen here). In the example shown here, we want to balance the overall light by darkening (burning) parts of the station (which are getting direct sun), and then brightening (dodging) the entire left side of the station that's in the shadows. With the Adjustment Brush, you can choose what kind of adjustment you want first, and then you start painting. But the way it works is that you kind of just guess how much of an adjustment you think you'll want. Then, if after you painted over the area, you think it needs more (or less) of the adjustment, you can just drag the slider (kind of like editing after the fact).

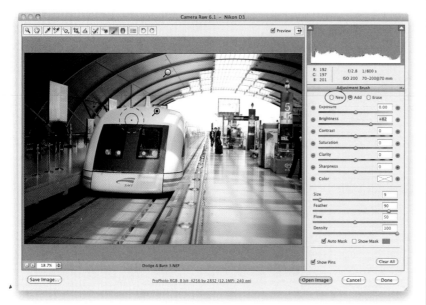

Step Two:

We'll start by lightening the left side of the station. Click on the + (plus sign) button to the right of the Brightness slider, which sets all the other sliders to 0 and increases the amount of Brightness to +25 (clicking the – [minus sign] button to its left zeros everything out, but sets the Brightness to –25). Go ahead and click that + button three more times to increase it to +100, then start painting over the left side of the station (as shown here). As you paint, it brightens the midtone areas where you're painting. Again, you don't have to know exactly how much lighter you want your exposure, because you can change it after the fact by just moving the Brightness slider (more on this in a moment).

Step Three:

Now we want to brighten the front of the train, but we want to control the brightness separately from the left side of the station. The way to do that is to click the New radio button (circled here in red), drag the Brightness slider to 82, then start painting over the left front of the train (shown here). Now, take a look back at the roof where you painted in the previous step. See that white pin on the ceiling? That represents your first adjustment—painting on the ceiling. The green pin on top of the train represents what you're editing right now—the train. So, if you move the Brightness slider now, it only affects the brightness of the area you painted on the train. If you want to adjust the roof, then you'd click on that white pin, and it will turn green, letting you know that it's now the area you're adjusting, and when you move the Brightness slider, it will just affect the roof.

Continued

Step Four:

Now let's darken the platform on the right. Click the New button again, then click the – (minus sign) button to the left of Brightness twice, so it zeros all the sliders out, and sets the Brightness to –50. Then, start painting over the right side of the station and, as you do, it starts darkening (burning in) those areas. I just painted over the floor, the tracks on the right side, and the right front and side of the train itself.

TIP: Brushes Build Up

By default, the brush is designed to build up as you paint, so if you paint over an area and it's not dark enough, paint another stroke over it. This build-up amount is controlled by the Flow and Density sliders at the bottom of the panel. The Density slider kind of simulates the way Photoshop's airbrush capabilities work with its Brush tools, but the effect is so subtle here that I don't ever change it from its default setting of 100.

Step Five:

The –50 amount for the right side of the train station looks a little too dark, so drag the Brightness slider back until it reads –40. This is what I mean about adjusting the amount after the fact. You can do this for any section you painted over—just click on the pin that represents that area, it will turn green to let you know it's active, then the sliders are automatically set to where you originally set them for that area, so you can make changes.

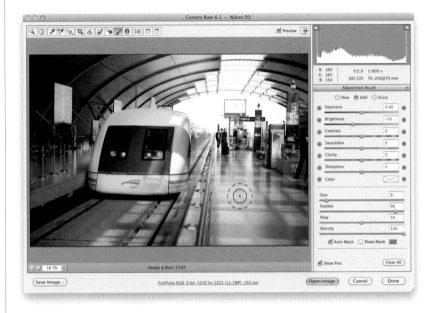

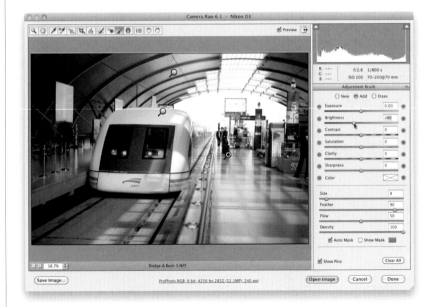

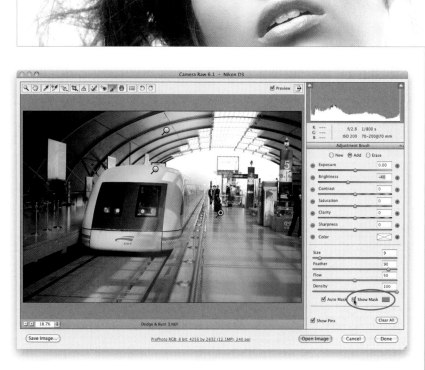

Step Six:

So, how do you know if you've really painted over the entire area you wanted to adjust? How do you know whether you've missed a spot? Well, if you turn on the Show Mask checkbox near the bottom of the panel, it puts a red tint over the area you painted (as seen here), so you can see if you missed anything (you can change the color of the mask overlay by clicking on the color swatch to the right of the checkbox). If you don't want this on all the time, you can just hover your cursor over any pin and it will temporarily show the masked area for that pin. Now that you know where you painted, you can go back and paint over any areas you missed.

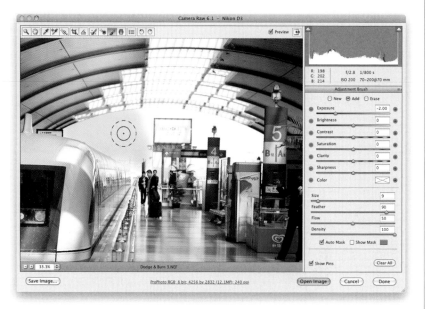

Step Seven:

Now, let's unlock a little more of the power of the Adjustment Brush. The sky behind the train looks pretty much white (rather than blue), so click the New button, then click the – (minus sign) button to the left of Exposure four times to darken the highlights a lot. Also, make sure the Auto Mask check-box is turned on (at the bottom of the panel). Now you won't have to worry too much about accidentally painting over the train, because it senses where the edges of what you're painting over are (based on color), and it helps to keep you from spilling paint outside the area you're trying to affect. The key is to make sure the little crosshair in the center of the brush doesn't touch any areas you don't want it to paint, so paint over just the sky with the Exposure set to –2, and as long as you don't let that crosshair touch anything but sky, it'll paint over just the sky.

Continued

Step Eight:

Let's go ahead and paint over the rest of the sky (but I would probably shrink the brush size a little bit to get into those tighter areas). Remember, it's okay if the edges of the brush extend onto the roof and the train, and so on—just don't let that center crosshair touch any of those areas. Besides just brightening and darkening areas (dodging and burning), I think one of the slickest things about the Adjustment Brush is that you can add other adjustments, like Clarity or Sharpness, over just the areas you want them. For example, drag the Brightness slider to –13 to darken up the sky a bit more, then drag the Saturation slider to the right to around +27 to add more blue to the sky (as seen here. For multiple adjustments, you have to drag the sliders, not click the + or - buttons). These are added to your original Exposure adjustment.

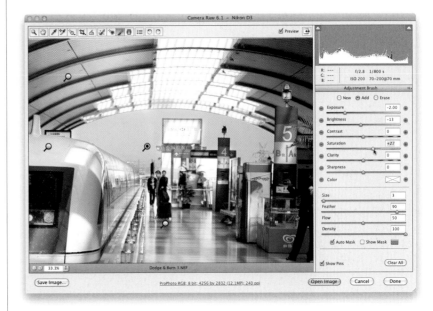

Step Nine:

If you want to change the color of the sky (your currently active area), then click directly on the Color swatch (just below the Sharpness slider) and a Color Picker appears (seen here). Just click your cursor on the color you want (I clicked on a sky-blue color), and it adds this tint to your selected area, which in this case adds more blue into the sky. You can adjust the color's intensity with the Saturation slider at the bottom of the Color Picker.

TIP: Choosing What to Edit

If you have multiple pins, and you drag a slider, Camera Raw will adjust whichever pin is currently active (the pin filled with green and black). So to choose which adjustment you want to edit, click directly on the pin first to select it, then make your changes.

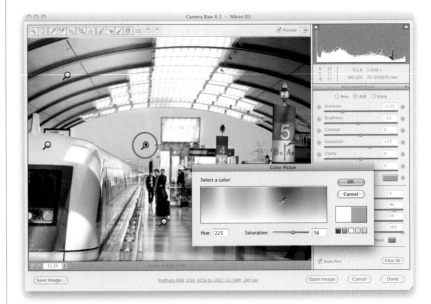

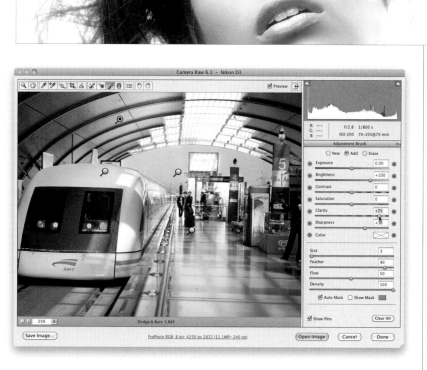

Step 10:
Now that we have a few pins in place, let's switch to a different pin and tweak that area. Click on the pin on the roof on the left side of the station. Now raise the Clarity amount to +75, and increase the Sharpness amount to +36.

TIP: Deleting Adjustments
If you want to delete any adjustment you've made, click on the adjustment's pin to select that adjustment (the center of the pin turns black), then press the Delete (PC: Backspace) key on your keyboard.

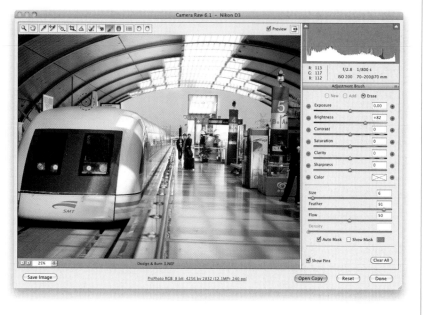

Step 11:
If you make a mistake (like a spillover), and accidentally paint over an area you didn't mean to paint over, you can erase the spillover by either clicking on the Erase radio button at the top of the panel and then painting over those areas, or just pressing-and-holding the **Option (PC: Alt)** key, which temporarily switches the brush to Erase mode. For example, I moved my cursor over the pin on the train to check how my painting went, and when the red mask appeared, I could see that I accidentally painted over the top of the train a bit, so I clicked on that pin, then held the Option key and painted over that area (as shown here) until the spillover was gone.

Continued

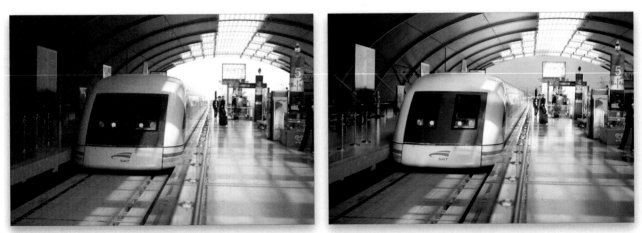

Step 12:

Here are a couple of other things about the Adjustment Brush you'll want to know: The Feather slider controls how soft the brush edges are—the higher the number, the softer the brush (I paint with a soft brush about 90% of the time). For a hard-edged brush, set the Feather slider to 0. The Flow slider controls the amount of paint that comes out of the brush (I leave the Flow set at 50 most of the time).

Below is a before/after, which shows how useful dodging and burning with the Adjustment Brush can be.

Size	9
Feather	90
Flow	50
Density	100

☑ Auto Mask ☐ Show Mask

☑ Show Pins Clear All

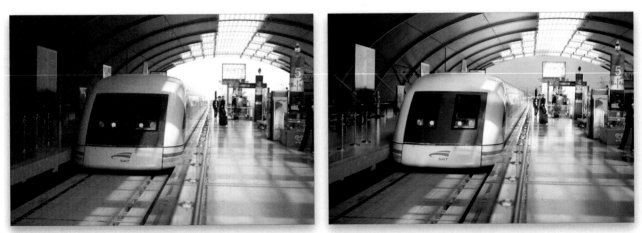

Before *After*

Retouching Portraits in Camera Raw

One of the main things we've always had to go to Photoshop for was retouching portraits, but now, by using the Spot Removal tool, along with the Adjustment Brush, we can do a lot of simple retouching jobs right here in Camera Raw, where they're completely non-destructive and surprisingly flexible.

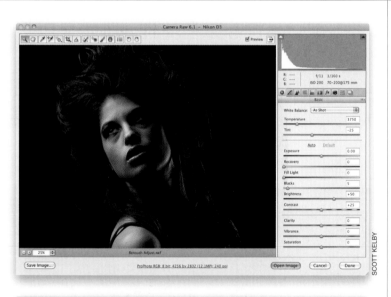

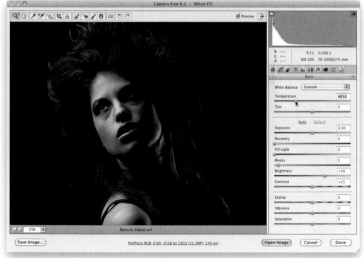

SCOTT KELBY

Step One:

In the portrait shown here, we need to do some basic fixes first (the white balance, for one, is way off), then we want to make three retouches: (1) we want to lighten and brighten her eyes, (2) we want to remove any blemishes and soften her skin, and (3) we want to sharpen her eyes and eyelashes. These were all things we'd have to go into Photoshop for, but now we can do all three right here in Camera Raw. Let's start by fixing the white balance first, then we'll do the retouch. The image at the top here shows the As Shot white balance, which is way too blue. From the White Balance pop-up menu, choose Flash (since the photo was taken with a studio flash), which gets rid of the blue, but for this particular image, to me it makes it look too warm (yellow), so drag the Temperature slider to the left a bit (as shown in the bottom image) until the skin tones look about right (not too yellowish). Next, we'll do some retouching, and we'll start with brightening the whites of her eyes.

Continued

Special Effects Using Camera Raw

There are some really nice special effects you can apply from right within Camera Raw itself, and some of these are easier to achieve here than they are by going into the rest of Photoshop and doing it all with layers and masks. Here are two special effects that are popular in portrait and wedding photography: (1) drawing attention by turning everything black and white, but leaving one key object in full color (very popular for wedding photography and photos of kids), and (2) creating a soft, dramatic spotlight effect by "painting with light."

Step One:

For the first effect (where we make one part of the image stand out by leaving it in color, while the rest of the image is black and white), we want to set up the Adjustment Brush so it paints in black and white, so start by getting the Adjustment Brush **(K)**, then in the Adjustment Brush options panel, click on the – (minus sign) button to the left of Saturation four times to set the brush so it paints with –100 saturation. Why didn't we just drag the Saturation slider all the way to the left? It's because by clicking on that – button first, all the other sliders are zeroed out, so we don't accidentally adjust something else at the same time.

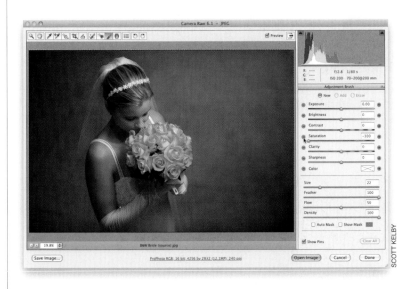

Step Two:

In just a moment, we're going to paint over most of the image, and this will go a lot faster if you turn off the Auto Mask checkbox near the bottom of the panel (so it's not trying to detect edges as you paint). Once that's off, make your brush nice and big (drag the Size slider to the right or press the **Right Bracket key**), and paint over most of the image, but make sure you don't get too close to the area right around the bouquet, as shown here, where I left about a ½" area untouched all around the bouquet.

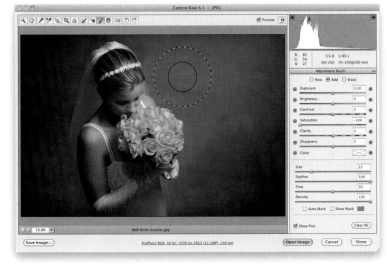

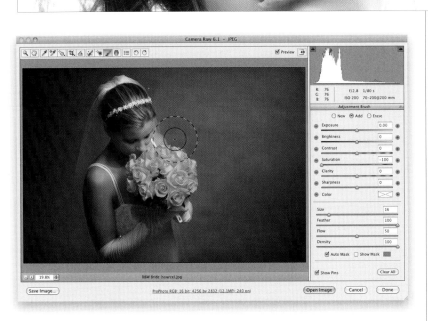

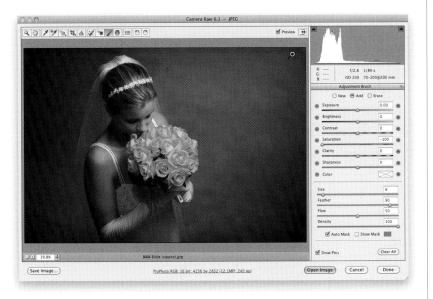

Step Three:

Now you'll need to do two things: (1) make your brush size smaller, and (2) turn on the Auto Mask checkbox. The Auto Mask feature is really what makes this all work, because it will automatically make sure you don't accidentally make the object in your image that you want to remain color, black and white, as long as you follow one simple rule: don't let that little plus-sign crosshair in the center of the brush touch the thing you want to stay in color (in our case, it's the bouquet of flowers). Everything that little crosshair touches turns black and white (because we lowered the Saturation to −100), so your job is to paint close to the flowers, but don't let that crosshair actually touch the flowers. It doesn't matter if the edges of the brush (the round rings) extend over onto the flowers (in fact, they'll have to, to get in really close), but just don't let that little crosshair touch, and you'll be fine. This works amazingly well (you just have to try it for yourself and you'll see).

Step Four:

Here, we've painted right up close to the bouquet and yet the flowers and even the green leaves are still in color because we were careful not to let that crosshair stray over onto the flowers. Okay, now let's use a similar technique in a different way to create a different effect using the same image. Start by pressing the Delete (PC: Backspace) key to get rid of this adjustment pin and start over from scratch with the original color image.

Continued

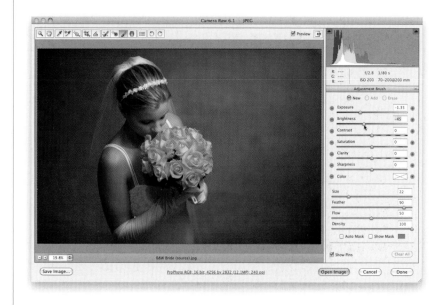

Step Five:

Here's the original full-color image again. Get the Adjustment Brush and click the – (minus sign) button beside Exposure to zero everything out. Then drag the Exposure slider down to around –1.35 and drag the Brightness slider down to around –45, as shown here.

Step Six:

Turn off the Auto Mask checkbox, and using a large brush, paint over the entire image (as shown here) to greatly darken it.

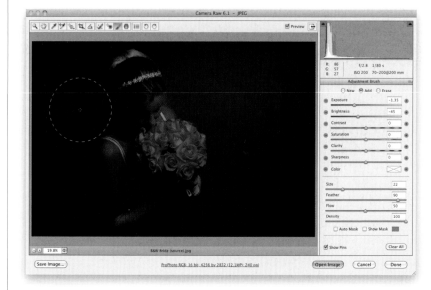

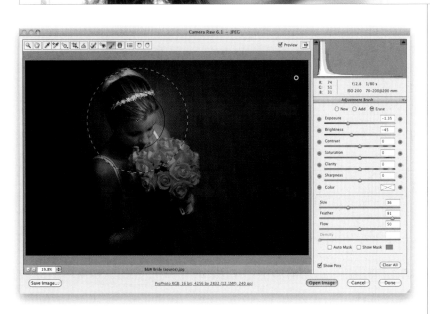

Step Seven:

Now, click the Erase radio button at the top of the Adjustment Brush's options panel (or just press-and-hold the **Option [PC: Alt] key** to temporarily switch to the Erase tool), set your brush to a very large brush size (like the one shown here), set your Feather (softness) amount to around 90, then click once right over the area you want lit with a soft spotlight (like I did here, where I clicked on the bride's forehead). What you're doing is essentially revealing the original image in just that one spot, by erasing the darkening you added in the previous step.

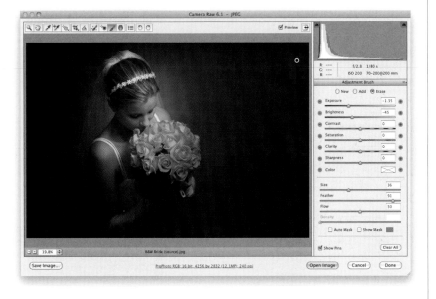

Step Eight:

Click just a few more times on the image, maybe moving down ½" or so, to reveal just the areas where you want light to appear, and you'll wind up with the image you see here as the final effect.

Photoshop Killer Tips

Painting a Gaussian Blur

Okay, technically it's not a Gaussian blur, but in Camera Raw CS5, you can now paint with a blur effect by lowering the Sharpness amount (in the Adjustment Brush panel) below 0 (actually, I'd go all the way to –100 to get more of a Gaussian-type blur look). This is handy if you want to add a blur to a background for the look of a more shallow depth of field, or one of the 100 other reasons you'd want to blur something in your photo.

Why There Are Two Cursors

When you use the Adjustment Brush, you'll see there are two brush cursors displayed at the same time, one inside the other. The smaller one shows the size of the brush you've selected; the larger (dotted-line circle) shows the size of the

feathering (softening) you've applied to the brush.

Double-Stacking Adjustments

If you apply an adjustment with the Adjustment Brush, and you drag the slider all the way to the right, but it's not enough, just click the New radio button (at the top of the panel), and paint over that same area with the same setting again. It will double-up the amount of the adjustment (this is great for those high-contrast effects on clothes, where it exaggerates every little wrinkle, highlight, and shadow).

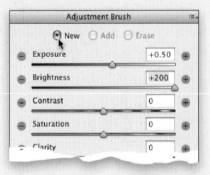

How to Set the Color to None

Once you pick a color using the Adjustment Brush's Color Picker, it's not real obvious how to reset the color to None (no color). The trick is to click on the Color swatch (in the middle of the Adjustment Brush options panel) to reopen the Color Picker, then drag the Saturation slider down to 0. Now, you'll see the X over the Color swatch, letting you know it's set to None.

Hiding the Edit Pins

To temporarily hide the edit pins that appear when you use the Adjustment Brush, just press the **V key** on your keyboard (it toggles the pins' visibility on/off).

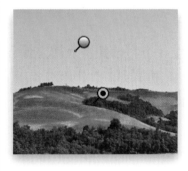

Painting Straight Lines

If you want to paint a straight line using the Adjustment Brush, you can use the same trick we use with Photoshop's Brush tool: just click once where you want the line to start, press-and-hold the Shift key, then click once where you want the straight line to end, and the Adjustment Brush will draw a perfectly straight line between the two. Really handy when working on hard edges, like the edge of a building where it meets the sky.

Save a "Jump Back" Spot

If you're familiar with Photoshop's History panel, and how you can make a snapshot at any stage of your editing, so you can jump back to that look with just one click, well…good news: you can

Photoshop Killer Tips

do that in Camera Raw, too! You can save a snapshot while you're in any panel by pressing **Command-Shift-S (PC: Ctrl-Shift-S)**. Then you can jump back to how the image looked when you took that snapshot by clicking on it in the Snapshots panel.

Starting Over from Scratch

If you've added a bunch of adjustments using the Adjustment Brush, and you realize you just want to start over from scratch, you don't have to click on each one of the edit pins and hit the Delete (PC: Backspace) key. Instead, click on the Clear All button in the bottom-right corner of the Adjustment Brush options panel.

Changing Brush Size with Your Mouse

If you Right-click-and-hold with the Adjustment Brush in Camera Raw, you'll

see a little two-headed arrow appear in the middle of your brush. This lets you know you can drag side-to-side to change the size of your Adjustment Brush (drag left to make it smaller and right to make it bigger).

Seeing Paint as You Paint

Normally, when you paint with the Adjustment Brush, you see the adjustment (so if you're darkening an area, as you paint, that area gets darker), but if you're doing a subtle adjustment, it might be kind of hard to see what you're actually painting (and if you're spilling over into an area you don't want darkened). If that's the case, try this: turn on the Show Mask checkbox (near the bottom of the Adjustment Brush panel). Now, when you paint, it paints in white (the default mask color, which you can change by clicking on the color swatch to the right of the checkbox), so you

can see exactly the area you're affecting. When you're done, just press the **Y key** to turn the Show Mask checkbox off. This one's worth a try.

Add Your Own Color Swatches

When you click on the Color swatch in the Adjustment Brush panel, you see that there are five color swatches in the bottom-right corner of the Color Picker. They're there for you to save your most-used colors, so they're one click away. To add a color to the swatches, first choose the color you want from the color gradient, then press-and-hold the Option (PC: Alt) key and when you move your cursor over any of those five color swatches, it will change into a paint bucket. Click that little bucket on any one of the swatches, and it changes the swatch to your currently selected color.

Two Quick Things About Working in Photoshop CS5

Before we begin, you'll want to know about tabbed browsing (especially if you're coming to CS5 from CS3), and how Adobe tweaked workspaces in CS5 (workspaces are just various layouts of panels that you use depending on what you're working on—you might use one set of panels when you're retouching photos, but a different set when you're painting. You set things up so you have just what you need visible when you need it). They're really handy, but Adobe changed something in CS5 that is either really good or kinda weird (decide for yourself).

Tabbed Documents:
Back in CS4, Adobe introduced tabbed documents to help you manage all your open images (so opened documents appear as tabs at the top of the current window, as seen here, kind of like tabs in a Web browser). To see any tabbed image, just click on the tab (as shown here), or you can toggle through the tabs by pressing **Control-Tab**.

Turning Off the Tabs:
One of the most popular questions I hear to this day is: "How do you turn those tabbed documents off?" You can turn this tabbing off by going under the Photoshop (PC: Edit) menu, under Preferences, and choosing **Interface**, then turning off the checkbox for Open Documents as Tabs. Also, you'll probably want to turn off the Enable Floating Document Window Docking checkbox (right below it), too, or it will dock your single open image.

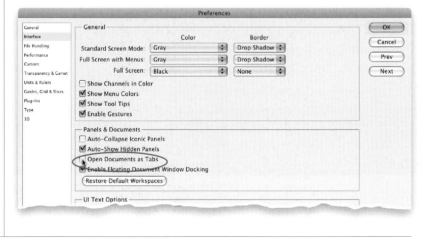

SCOTT KELBY

Setting Up Your Workspace:

CS5 comes with a number of built-in workspace layouts for different tasks (like painting, or photography, or design, etc.) with just the panels visible Adobe thought you'd need. You can find them by clicking on the double-arrow button to the right of the workspaces in the Application Bar (shown circled here). I use one layout all the time for my own work (it's shown here). To create your own custom workspace layout, just click-and-drag the panels where you want them. To nest a panel (so they appear one in front of another), drag one panel over the other. When you see a blue outline appear, release the mouse button and it nests. If you need more panels, they're under the Window menu.

TIP: Rotating the View on a Wacom Tablet

If you work with your tablet in your lap, click the Rotate View icon up in the Application Bar. Then, click-and-hold in your image and a compass overlay appears in the center of it. Now you can just drag to rotate your view.

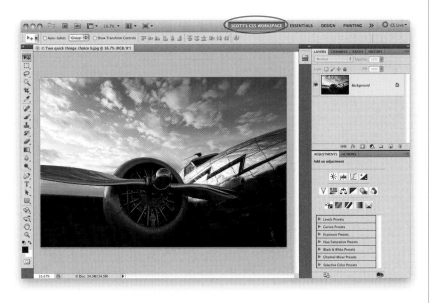

One-Click Access:

Once your panels are set up where you want them, go under the Window menu, under Workspace, and choose **New Workspace**, so you can save your layout so it's always one click away (it will appear as a button in the Application Bar, as seen here). In CS5, Adobe changed things, so if you use a workspace and change a panel's location, it remembers. That's okay, but you'd think that clicking on your workspace would return things to normal. It doesn't. Instead, you have to go under the Window menu, under Workspace, and choose **Reset [your workspace name]**. It's weird, I know.

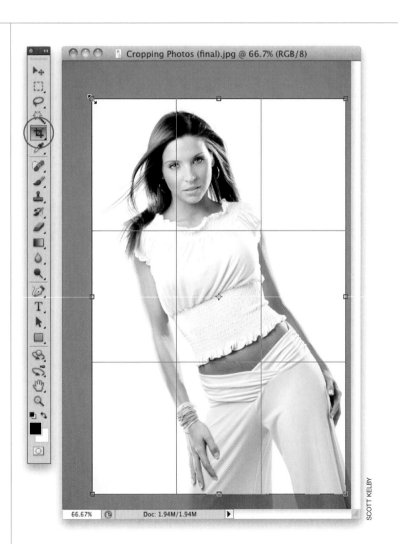

Cropping Photos

There are a number of different ways to crop a photo in Photoshop. We'll start with the basic garden-variety options, and then we'll look at some ways to make the task faster and easier. At the end of this project, I've added a way to see your cropping that won fame when it was added to Adobe Photoshop Lightroom, but I figured out an easy way to get the exact same cropping trick here in Photoshop CS5.

Step One:
Press the letter **C** to get the Crop tool (or choose it from the Toolbox) and click-and-drag out a cropping border over your photo (as shown here). The area to be cropped away appears dimmed (shaded). You don't have to get your cropping border right when you first drag it out, because you can edit it by clicking-and-dragging the points that appear in each corner and at the center of each side. Also, now in CS5, when you drag out the cropping border and release the mouse button, a "Rule of Thirds" grid appears inside the border to help you make better cropping decisions. (*Note:* The "rule of thirds" is where you visually divide the image into thirds, position your horizon so it goes along either the top horizontal line or the bottom one, then position the focal point at the center intersections of those lines.)

TIP: Getting Rid of the Shading
The area to cropped away appears dimmed or shaded, and to toggle that shading off/on, just press the **Forward Slash (/) key** on your keyboard.

Cropping Photos (final).jpg @ 66.7% (RGB/8)

66.67% Doc: 1.94M/1.94M

SCOTT KELBY

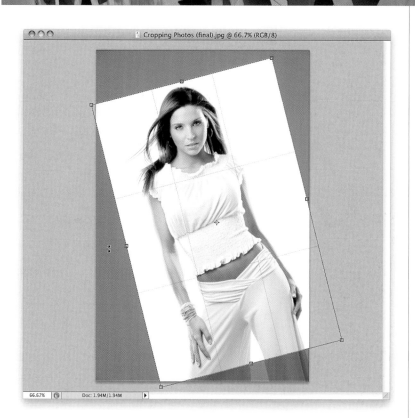

Step Two:
While you have the cropping border in place, if you need to rotate your photo, just move your cursor anywhere outside the border. When you do this, the cursor will change into a double-headed arrow. Just click, hold, and drag up (or down) and the cropping border will rotate in the direction you choose.

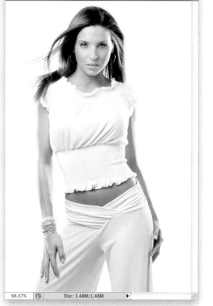

Step Three:
Once you have the cropping border right where you want it, press the **Return (PC: Enter) key** to crop your image. The final cropped image is shown here, where we cropped off some of the excess background. You can see the uncropped image on the previous page.

Continued

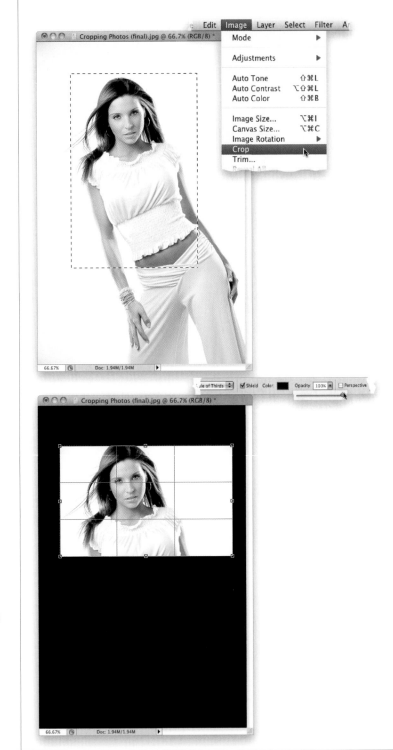

Step Four:

Another popular way to crop is to skip the Crop tool altogether and just use the Rectangular Marquee tool **(M)** to put a selection around the area of your photo you want to keep. You can reposition the selection by clicking inside the selected area and dragging. When your selection is positioned where you want it, go under the Image menu and choose **Crop**. The area outside your selection will be cropped away instantly. Press **Command-D (PC: Ctrl-D)** to Deselect.

Step Five:

Okay, are you ready for the ultimate cropping experience? It's inspired by Lightroom's popular Lights Out full-screen cropping method, where as you crop, it surrounds your photo with solid black, so you see a live preview of what the final cropped photo will look like as you crop. It's pretty sweet, and once you try it, you won't want to crop any other way. Luckily, you can do the same thing here in Photoshop. Start by taking the Crop tool and dragging it over part of your photo (it doesn't matter where or what size). In the Options Bar, there's an Opacity field, which lets you choose how light the area you're cropping away is going to display onscreen. Click on the downward-facing triangle and increase the Opacity to 100%, so it's solid black (as shown here).

Step Six:

Now press the **Esc key** to remove your cropping border. Press **Tab**, then the **F key** twice to hide all of Photoshop's panels and menus, plus this centers your photo onscreen surrounded by solid black (as seen here). That's it—you're in "Lights Out cropping mode" because you made any cropped-away area solid black, which matches the black full-screen area surrounding your photo. So, try it yourself—get the Crop tool again, drag out a cropping border, then drag any one of the cropping handles inward and you'll see what I mean. Pretty sweet, eh? When you're done cropping, press **Return (PC: Enter)**, then press the letter **F** once more to leave full-screen mode, then press the **Tab key** to bring your panels, menus, and Toolbox back.

TIP: Deciding Not to Crop

If you drag out a cropping border and then decide you don't want to crop the image, you can either press the **Esc key** on your keyboard, click on the "No!" symbol in the Options Bar, or just click on a different tool in the Toolbox, which will bring up a dialog asking if you want to crop the image. Click on the Don't Crop button to cancel your crop.

Cropping to a Specific Size

If you're outputting photos for clients, chances are they're going to want them in standard sizes so they can easily find frames to fit their photos. If that's the case, you'll find this technique handy, because it lets you crop any image to a predetermined size (like 5x7", 8x10", and so on).

Step One:
Let's say our image measures roughly 17x11", and we want to crop it to be a perfect horizontal 10x8". First, press the **C key** to get the Crop tool, and up in the Options Bar on the left, you'll see Width and Height fields. Enter the size you want for the width, followed by the unit of measurement you want to use (e.g., "in" for inches, "px" for pixels, "cm" for centimeters, "mm" for millimeters, etc.). Next, press the **Tab key** to jump over to the Height field and enter your desired height, again followed by the unit of measurement.

Step Two:
Click within your photo with the Crop tool and drag out a cropping border. You'll notice that as you drag, the border is constrained to a horizontal shape, and once you release the mouse button, no side points are visible—only corner points. Whatever size you make your border, the area within that border will become a 10x8" photo.

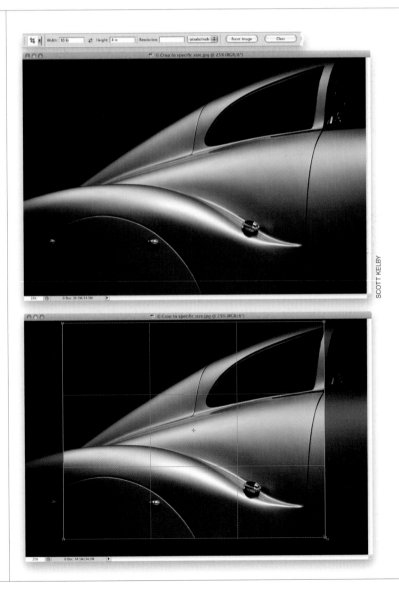

SCOTT KELBY

Step Three:

After your cropping border is onscreen, you can reposition it by moving your cursor inside the border (your cursor will change to an arrow). You can now drag the border into place, or use the **Arrow keys** on your keyboard for more precise control. When it looks right to you, press **Return (PC: Enter)** to finalize your crop, and the area inside your cropping border will be 10x8". (I made the rulers visible by pressing **Command-R [PC: Ctrl-R]**, so you could see that the image measures exactly 10x8".)

TIP: Clearing the Width and Height

Once you've entered a Width and Height in the Options Bar, those dimensions will remain in place until you clear them. To clear the fields (so you can use the Crop tool for freeform cropping to any size), just go up in the Options Bar and click on the Clear button (while you have the Crop tool active, of course).

COOLER TIP: Cropping to Another Photo's Size

If you already have a photo that is the exact size and resolution that you'd like to apply to other images, you can use its settings as the crop dimensions. First, open the photo you'd like to resize, and then open your ideal-size-and-resolution photo. Get the Crop tool, and then in the Options Bar, click on the Front Image button. Photoshop will automatically input that photo's dimensions into the Crop tool's Width, Height, and Resolution fields. All you have to do is crop the other image, and it will share the exact same specs as your ideal-size photo.

Creating Your Own Custom Crop Tools

Although it's more of an advanced technique, creating your own custom tools isn't complicated. In fact, once you set them up, they will save you time and money. We're going to create what are called "tool presets." These tool presets are a series of tools (in this case, Crop tools) with all our option settings already in place. So we'll create a 5x7", 6x4", or whatever size Crop tool we want. Then, when we want to crop to 5x7", all we have to do is grab the 5x7" Crop tool preset. Here's how:

Step One:
Press the letter **C** to switch to the Crop tool, and then go under the Window menu and choose **Tool Presets** to bring up the Tool Presets panel. You'll find that five Crop tool presets are already there. (Make sure that the Current Tool Only checkbox is turned on at the bottom of the panel, so you'll see only the Crop tool's presets, and not the presets for every tool.)

Step Two:
Go up to the Options Bar and enter the dimensions for the first tool you want to create (in this example, we'll create a Crop tool that crops to a wallet-size image). In the Width field, enter 2. Then press the **Tab key** to jump to the Height field and enter 2.5. *Note:* If you have the Rulers set to Inches under the Units section in Photoshop's Units & Rulers Preferences **(Command-K [PC: Ctrl-K])**, when you press the Tab key, Photoshop will automatically insert "in" after your numbers, indicating inches.

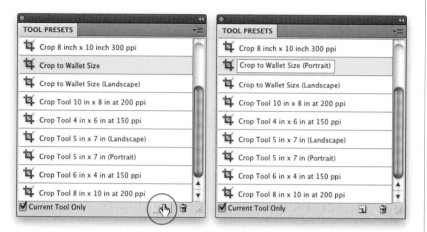

Step Three:

In the Tool Presets panel, click on the Create New Tool Preset icon at the bottom of the panel (to the left of the Trash icon). This brings up the New Tool Preset dialog, in which you can name your new preset. Name it, click OK, and the new tool is added to the Tool Presets panel. Continue this process of typing in new dimensions in the Crop tool's Options Bar and clicking on the Create New Tool Preset icon until you've created custom Crop tools for the sizes you use most. Make sure the name is descriptive (for example, add "Portrait" or "Landscape"). If you need to change the name of a preset, just double-click directly on its name in the panel, and then type in a new name.

Step Four:

Chances are your custom Crop tool presets won't be in the order you want them, so go under the Edit menu and choose **Preset Manager**. In the resulting dialog, choose **Tools** from the Preset Type pop-up menu, and scroll down until you see the Crop tools you created. Now just click-and-drag them to wherever you want them to appear in the list, and then click Done.

Step Five:

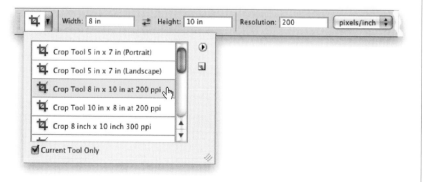

Now you can close the Tool Presets panel because there's an easier way to access your presets: With the Crop tool selected, just click on the Crop icon on the left in the Options Bar. A pop-up menu of tools will appear. Click on a preset, drag out a cropping border, and it will be fixed to the exact dimensions you chose for that tool.

Custom Sizes for Photographers

Photoshop's dialog for creating new documents has a pop-up menu with a list of preset sizes. You're probably thinking, "Hey, there's a 4x6", 5x7", and 8x10"— I'm set." The problem is there's no way to switch the resolution of these presets (so the Portrait, 4x6 will always be a 300 ppi document). That's why creating your own custom new document sizes is so important. Here's how:

Step One:
Go under the File menu and choose **New**. When the New dialog appears, click on the Preset pop-up menu to reveal the list of preset types, and choose **Photo**. Then click on the Size pop-up menu to see the preset sizes, which include 2x3", 4x6", 5x7", and 8x10" in both portrait and landscape orientation. The only problem with these is that their resolution is set to 300 ppi by default. So, if you want a different size preset at less than 300 ppi, you'll need to create and save your own.

Step Two:
For example, let's say that you want a 5x7" set to landscape (that's 7" wide by 5" tall). First choose Photo from the Preset pop-up menu, then choose Landscape, 5x7 from the Size pop-up menu. Choose your desired Color Mode (below Resolution) and Color Profile (under Advanced), and then enter a Resolution (I entered 212 ppi, which is enough for me to have my image printed on a high-end printing press). Once your settings are in place, click on the Save Preset button.

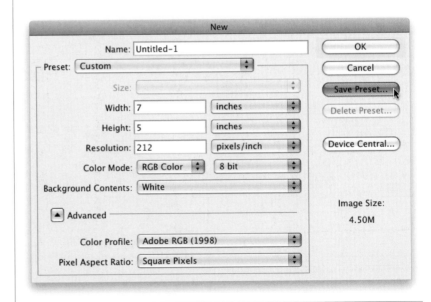

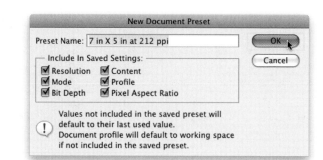

Step Three:
This brings up the New Document Preset dialog. In the Preset Name field, enter your new resolution at the end of the size. You can turn on/off the checkboxes for which parameters you want saved, but I use the default setting to include everything (better safe than sorry, I guess).

Step Four:
Click OK and your new custom preset will appear in the New dialog's Preset pop-up menu. You only have to go through this once. Photoshop will remember your custom settings, and they will appear in this Preset pop-up menu from now on.

Step Five:
If you decide you want to delete a preset, it's simple—just open the New dialog, choose the preset you want to delete from the Preset pop-up menu, and then click the Delete Preset button. A warning dialog will appear asking you to confirm the delete. Click Yes, and it's gone!

Resizing Digital Camera Photos

If you're used to resizing scans, you'll find that resizing images from digital cameras is a bit different, primarily because scanners create high-res scans (usually 300 ppi or more), but the default settings for many digital cameras produce an image that is large in physical dimensions, but lower in pixels-per-inch (usually 72 ppi). The trick is to decrease the physical size of your digital camera image (and increase its resolution) without losing any of its quality. Here's the trick:

Step One:
Open the digital camera image that you want to resize. Press **Command-R (PC: Ctrl-R)** to make Photoshop's rulers visible. As you can see from the rulers, the photo is about 59" wide by 39" high.

Step Two:
Go under the Image menu and choose **Image Size** (or press **Command-Option-I [PC: Ctrl-Alt-I]**) to bring up the Image Size dialog. Under the Document Size section, the Resolution setting is 72 ppi. A resolution of 72 ppi is considered "low resolution" and is ideal for photos that will only be viewed onscreen (such as Web graphics, slide shows, and so on), but it's too low to get high-quality results from a color inkjet printer, color laser printer, or for use on a printing press.

Step Three:
If we plan to output this photo to any printing device, it's pretty clear that we'll need to increase the resolution to get good results. I wish we could just type in the resolution we'd like it to be in the Resolution field (such as 200 or 240 ppi), but unfortunately this "resampling" makes our low-res photo appear soft (blurry) and pixelated. That's why we need to turn off the Resample Image checkbox (it's on by default). That way, when we type in a Resolution setting that we need, Photoshop automatically adjusts the Width and Height of the image down in the exact same proportion. As your Width and Height come down (with Resample Image turned off), your Resolution goes up. Best of all, there's absolutely no loss of quality. Pretty cool!

Step Four:
Here I've turned off Resample Image and I entered 240 in the Resolution field for output to a color inkjet printer. (I know, you probably think you need a lot more resolution, but you don't. In fact, I never print with a resolution higher than 240 ppi.) This resized my image to nearly 12x18" so it's just about perfect for printing to my Epson Stylus Photo R2880 printer, which makes up to 13x19"-sized prints—perfect!

Continued

Step Five:

Here's the Image Size dialog for our source photo, and this time I've lowered the Resolution setting to 180 ppi. (Again, you don't need nearly as much resolution as you'd think, but 180 ppi is pretty much about as low as you should go when printing to a color inkjet printer.) As you can see, the Width of my image is no longer 59"—it's now almost 24". The Height is no longer 39"—now it's almost 16". Best of all, we did it without damaging a single pixel, because we were able to turn off Resample Image, which normally, with things like scans, we couldn't do.

Step Six:

When you click OK, you won't see the image window change at all—it will appear at the exact same size onscreen—but look at the rulers. You can see that it's now about 15" high by about 23" wide. Resizing using this technique does three big things: (1) it gets your physical dimensions down to size (the photo now fits easily on an 16x24" sheet); (2) it increases the resolution enough so you can output this image on a color inkjet printer; and (3) you haven't softened, blurred, or pixelated the image in any way—the quality remains the same—all because you turned off Resample Image. *Note:* Do not turn off Resample Image for images that you scan on a scanner—they start as high-res images in the first place. Turning Resample Image off like this is only for low-res photos taken with a digital camera.

If you have a bunch of images that you need resized, or converted from TIFFs to JPEGs (or from PSDs to JPEGs, for that matter), then you will love the built-in Image Processor. It's kind of hidden in a place you might not expect it (under the Scripts menu), but don't let that throw you—this is a really handy, and really easy-to-use, totally automated tool that can save you tons of time.

Automated Saving and Resizing

Step One:
Go under the File menu, under Scripts, and choose **Image Processor**. By the way, if you're working in Adobe Bridge (rather than Photoshop), you can Command-click (PC: Ctrl-click) on all the photos you want to apply the Image Processor to, then go under the Tools menu, under Photoshop, and choose Image Processor. That way, when the Image Processor opens, it already has those photos pegged for processing. Sweet!

Step Two:
When the Image Processor dialog opens, the first thing you have to do is choose the folder of photos you want it to "do its thing" to by clicking on the Select Folder button, then navigating to the folder you want and clicking Choose (PC: OK). If you already have some photos open in Photoshop, you can click on the Use Open Images radio button (or if you choose Image Processor from Bridge, the Select Folder button won't be there at all—instead it will list how many photos you have selected in Bridge). Then, in the second section, decide whether you want the new copies to be saved in the same folder or copied into a different folder. No big whoop (that's a technical term).

Continued

Step Three:

The third section is where the fun begins. This is where you decide how many copies of your original you're going to wind up with, and in what format. If you turn on the checkboxes for Save as JPEG, Save as PSD, and Save as TIFF, you're going to create three new copies of each photo. If you turn on the Resize to Fit checkboxes (and enter a size in the Width and Height fields), your copies will be resized, too (in the example shown here, I chose a small JPEG of each file, then a larger TIFF, so in my folder I'd find one small JPEG and one larger TIFF for every file in my original folder).

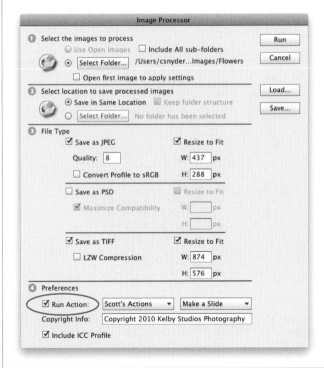

Step Four:

In the fourth section, if you've created an action that you want applied to your copies, you can also have that happen automatically. Just turn on the Run Action checkbox, then from the pop-up menus, choose which action you want to run. If you want to automatically embed your copyright info into these copies, type your info in the Copyright Info field. Lastly, there's a checkbox that lets you decide whether to include an ICC profile in each image or not (of course, I'm going to try to convince you to include the profile, because I included how to set up color management in Photoshop in Chapter 12). Click the Run button, sit back, and let it "do its thing," and before you know it, you'll have nice, clean copies aplenty.

So, since you saw earlier how much resolution you need to have to create a decent-sized print, how do photographers get those huge poster-sized prints without having super-high-megapixel cameras? It's easy—they upsize the images in Photoshop, and the good news is that unless you need to resize your image by more than 300%, you can do this all right in Photoshop without having to buy a separate resizing plug-in (but if you need more than a 300% size increase, that's where those plug-ins, like OnOne Software's Genuine Fractals, really pay off).

Resizing for Poster-Sized Prints

Step One:
Open the photo you want to resize, then go under the Image menu and choose **Image Size**. When the Image Size dialog appears, in the Pixel Dimensions section at the top, to the right of the Width field, you'll see a pop-up menu where Pixels is chosen (if this section isn't active, turn on the Resample Image checkbox at the bottom). Click on that menu and choose **Percent** (as shown here). Both the Width and Height will change to Percent, because they're linked together by default.

Continued

Step Two:
Now type in either 200% or 300% (although there is some debate about this, it seems to work best if you move up/down in 100% increments) in the Width field (again, since they're linked, the Height field will automatically change to the same number).

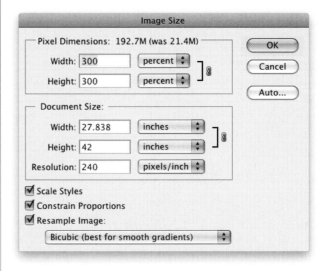

Step Three:
At the bottom of the dialog is a pop-up menu that decides which algorithm is used to upsize your photo. The default is Bicubic (Best for Smooth Gradients), and I use that for most everyday resizing stuff, but when it comes to jumping in big increments, like 200% or 300%, I switch to **Bicubic Smoother** (which Adobe says is "Best for Enlargements"), as shown here.

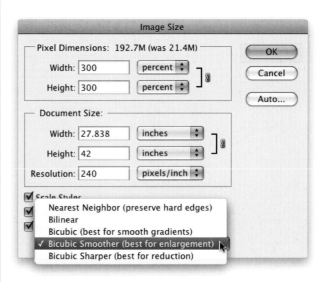

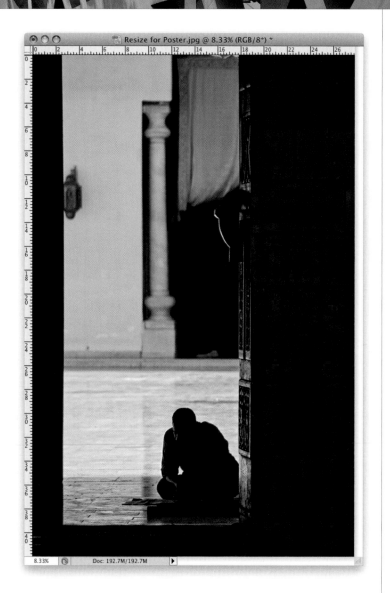

Step Four:
My buddy (and Epson printing expert) Vincent Versace breaks this rule. According to Vincent's research, the key to his resizing technique is to not use the sampling method Adobe recommends (Bicubic Smoother), but instead to choose Bicubic Sharper, which he feels provides better results. So, which one is the right one for you? Try both on the same image (that's right—just do a test print), and see if you can see a visible difference. Here's the final image resized to nearly 28x42" (you can see the size in the rulers by pressing **Command-R [PC: Ctrl-R]**).

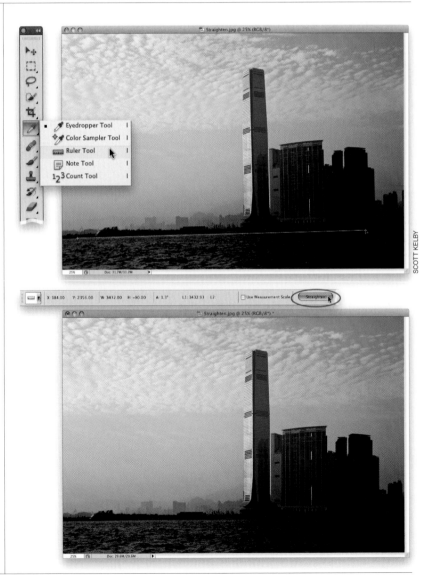

Straightening Crooked Photos

There have always been workarounds for straightening images in Photoshop, but they were always just that—workarounds. Now, in Photoshop CS5, there finally is a dedicated feature that makes the process really fast and simple.

Step One:
Open the photo that needs straightening. Choose the Ruler tool from Photoshop's Toolbox (it looks like a little ruler, and it's hidden behind the Eyedropper tool, so just click-and-hold for a moment on the Eyedropper tool until the Ruler tool appears in the flyout menu). Try to find something in your photo that you think is supposed to be straight or relatively straight (the horizon, in this example). Click-and-drag the Ruler tool horizontally along this straight edge in your photo, starting from the left and extending to the right.

Step Two:
Now, just click the Straighten button up in the Options Bar (it's shown circled here in red), and you're done. Not only has it straightened your photo, but it has cropped off any white space left by the straightening, too.

There's a different set of rules we use for maintaining as much quality as possible when making an image smaller, and there are a couple of different ways to do just that (we'll cover the two main ones here). Luckily, maintaining image quality is much easier when sizing down than when scaling up (in fact, photos often look dramatically better—and sharper—when scaled down, especially if you follow these guidelines).

Making Your Photos Smaller (Downsizing)

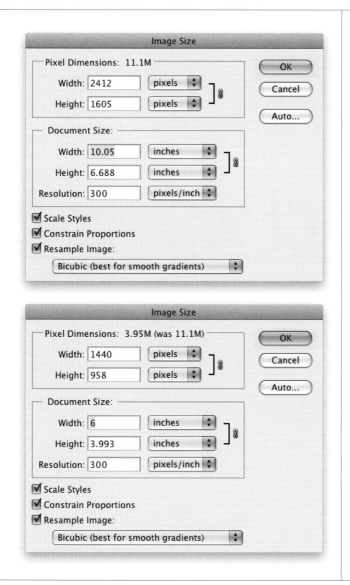

Downsizing photos where the resolution is already 300 ppi:

Although earlier we discussed how to change image size if your digital camera gives you 72-ppi images with large physical dimensions (like 24x42" deep), what do you do if your camera gives you 300-ppi images at smaller physical dimensions (like a 10x6" at 300 ppi)? Basically, you turn on Resample Image (in the Image Size dialog under the Image menu), then simply type in the desired size (in this example, we want a 6x4" final image size), and click OK (don't change the Resolution setting, just click OK). The image will be scaled down to size, and the resolution will remain at 300 ppi. IMPORTANT: When you scale down using this method, it's likely that the image will soften a little bit, so after scaling, you'll want to apply the Unsharp Mask filter to bring back any sharpness lost in the resizing (go to Chapter 11 to see what settings to use).

Continued

Making one photo smaller without shrinking the whole document:

If you're working with more than one image in the same document, you'll resize a bit differently. To scale down a photo on a layer, first click on that photo's layer in the Layers panel, then press **Command-T (PC: Ctrl-T)** to bring up Free Transform. Press-and-hold the Shift key (to keep the photo proportional), grab a corner point, and drag inward. When it looks good, press **Return (PC: Enter)**. If the image looks softer after resizing it, apply the Unsharp Mask filter.

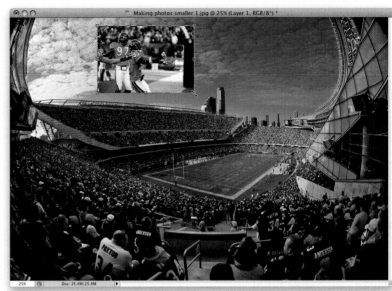

TIP: Reaching the Free Transform Handles

If you're resizing a photo on a layer using Free Transform and you can't reach the handles (because the edges of your photo extend outside the image area), just press **Command-0 (PC: Ctrl-0)**, and your window will automatically resize so you can reach all the handles—no matter how far outside your image area they once were. Two things: (1) This only works once you have Free Transform active, and (2) it's Command-0—that's the number zero, not the letter O.

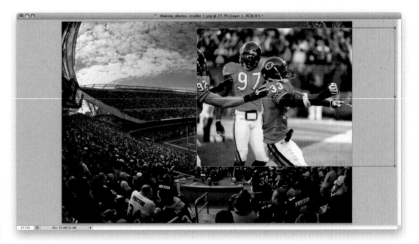

SCOTT KELBY

Resizing problems when dragging between documents:

This one gets a lot of people, because at first glance it just doesn't make sense. You have two documents, approximately the same size, side-by-side onscreen. But when you drag a 72-ppi photo (a USAF Thunderbirds jet) onto a 300-ppi document (Untitled-1), the photo appears really small. Why? Simply put—resolution. Although the documents appear to be the same size, they're not. The tip-off that you're not really seeing them at the same size is found in each photo's title bar. Here, the jet image is displayed at 100%, but the Untitled-1 document below is displayed at only 25%. So, to get more predictable results, make sure both documents are at the same viewing size and resolution (check in the Image Size dialog under the Image menu).

TIP: Automated Cropping & Straightening

Want to save time the next time you're scanning prints? Try gang scanning (fitting as many photos on your flatbed scanner as will fit and then scan them as one big single image), and then you can have Photoshop automatically straighten each individual image and place it into its own separate document. You do this by going under the File menu, under Automate, and choosing **Crop and Straighten Photos**. No dialog will appear. Instead, Photoshop will look for straight edges in your photos, straighten the photos, and copy each into its own separate window (by the way, it seems to work best when the photos you scan as a group have similar tonal qualities. The more varied the colors of the photos are, the harder time it seems to have straightening the images). This automation also works on single, crooked images.

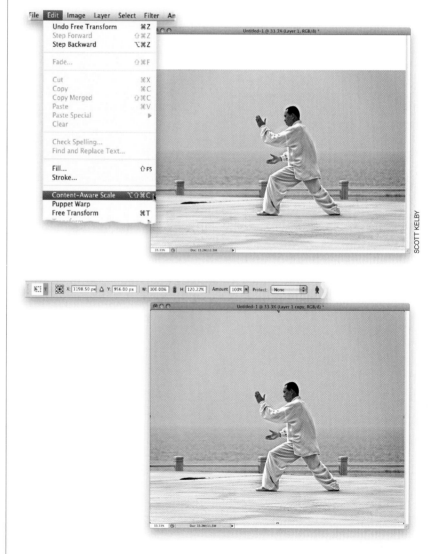

Resizing Just Parts of Your Image Using "Content-Aware" Scaling

We've all run into situations where our image is a little smaller than the area where we need it to fit. For example, if you resize a digital camera image so it fits within a traditional 8x10" image area, you'll have extra space either above or below your image (or both). That's where Content-Aware Scaling comes in— it lets you resize one part of your image, while keeping the important parts intact (basically, it analyzes the image and stretches, or shrinks, parts of the image it thinks aren't as important). Here's how to use it:

Step One:
Create a new document at 8x10" and 240 ppi. Open a digital camera image, get the Move tool **(V)**, and drag-and-drop it onto the new document, then press **Command-T (PC: Ctrl-T)** to bring up Free Transform. Press-and-hold the Shift key, then grab a corner point and drag inward to scale the image down, so it fits within the 8x10" area (as shown here), and press **Return (PC: Enter)**. Go under the Edit menu and choose **Content-Aware Scale** (or press **Command-Option-Shift-C [PC: Ctrl-Alt-Shift-C]**).

Step Two:
Grab the top handle, drag straight upward, and notice that it stretches the sky upward, but pretty much leaves the man intact, without stretching or bloating him. If you keep dragging upward, it will start dragging him, so you can't drag forever, but luckily you see a live onscreen preview, so you'll know how far you can drag. When you've dragged far enough, press **Return** to lock in your change. (*Note:* The button that looks like a person in the Options Bar tells Content-Aware Scale that there are people in the photo, so it avoids anything with a skin tone. It doesn't always work, but it's worth a try.)

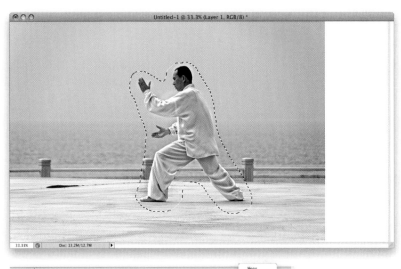

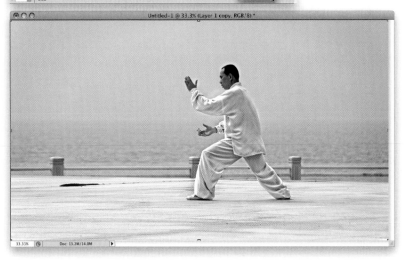

Step Three:

There are two more controls you need to know about: First, if you try Content-Aware Scale and it stretches your subject more than you want, go get the Lasso tool **(L)** and drag a selection around your subject (as shown here, top left), then go under the Select menu and choose **Save Selection**. When the Save Selection dialog appears, just click OK. Then bring up Content-Aware Scale again, but this time, go up in the Options Bar and choose your selection from the Protect pop-up menu (as shown here) to tell Photoshop where your subject is. Now you can drag to the right to fill the empty space with the least stretching.

Step Four:

There's also an Amount control up in the Options Bar, which determines how much stretching protection is provided. At its default of 100%, it's protecting as much as possible. At 50%, it's a mix of protected resizing and regular Free Transform, and for some photos that works best. The nice thing is the Amount control is live, so as long as your handles are still in place, you can lower the Amount and see live onscreen how it affects your resizing.

Photoshop Killer Tips

Seeing Your Final Crop in Camera Raw

When you crop a photo in Camera Raw, you can see the final cropped image without having to open the image in Photoshop. Once your cropping border is in place, just change tools and you'll see the cropped version (in some previous versions, the cropped away area was still visible; it was just dimmed).

Instant Background Layer Unlocking

This is one of those little tips that just makes you smile. To instantly turn your Background layer into a regular layer without having a dialog pop up first, just click-and-drag the little lock icon to the right of the word "Background" straight into the trash (thanks to Adobe's Julieanne Kost for sharing this one).

Get Your Channel Shortcuts Back

Back in CS3, and all earlier versions of Photoshop, you could look at the individual color channels for a photo by pressing **Command-1**, **Command-2**, **Command-3**, and so on (on a PC, you'd use **Ctrl-1**, **Ctrl-2**, etc., instead). In CS4, they changed the shortcuts, which

totally bummed out a lot of longtime users, but thankfully in CS5, you have the option to bring those glory days of channel shortcuts back to the pre-CS4 era. Go under the Edit menu, choose **Keyboard Shortcuts**, then near the top of the dialog, turn on the Use Legacy Channel Shortcuts checkbox.

Set Defaults in Layer Styles

Finally, you can set your own custom defaults for layer styles like Drop Shadow or Glow. All you have to do is create a new layer in the Layers panel by clicking on the Create a New Layer icon, then choose the layer style you want from the Add a Layer Style icon's pop-up menu (like Outer Glow, for example). In the Layer Style dialog, enter your own settings (like changing the glow from yeech yellow to white, or black, or anything but yeech yellow), then click on the Make Default button near the bottom of the dialog. To return to the factory default (yeech) settings, click the Reset to Default button.

Layer Mask from Layer Transparency

Here's a nice time saver: you can make the transparent areas of any layer into a mask in just one step: go under the Layer menu, under Layer Mask, and choose **From Transparency**.

Save 16-Bit to JPEG

If you work with 16-bit photos (and a lot of RAW shooters do, since that's the default bit-depth for RAW photos), when you went to the Save dialog to save your photo, there was no option to save your image as a JPEG, because JPEGs have to be in 8-bit mode, so you'd have to close the dialog, convert to 8-bit, then go and Save again. In CS5, they've changed it so JPEG is now a choice, but what it does is make a copy of the file, which it converts to 8-bit, and saves that instead. This leaves your 16-bit image still open onscreen and unsaved, so keep that in mind. If you want to save the 16-bit version separately, you'll need to save it as a PSD or TIFF like before. For me, once I know it has saved an 8-bit JPEG, I don't

Photoshop Killer Tips

need the 16-bit version any longer, so I close the image and click the Don't Save button, but again, that's just me.

Cool New Zoom Tool Feature

Want a handy, smooth way to use the Zoom tool? Just click-and-hold any-where within your photo, and drag to the right to smoothly zoom in. Drag back to the left to zoom out.

One Click to Close All Your Tabs

If you're using the Tabs feature (all your documents open as tabs), then you'll definitely want to know this tip: to close all your open tabs at once, just Right-click on any tab and choose **Close All**.

Lens Corrections Grid

If you're using Camara Raw's Lens Corrections panel to do things like straighten buildings or flatten rounded horizon lines, press the letter **V** on your keyboard, and an alignment grid appears over your image to help you line things up. To hide it again, press V again.

Assign a Keyboard Shortcut to the Color Picker

In CS5, Adobe now lets you assign a keyboard shortcut to bring up the Fore-ground (or Background) Color Picker (this is handier than it sounds). Go under the Edit menu, under Keyboard Shortcuts, and from the Shortcuts For pop-up menu, choose **Tools**. Then scroll down near the bottom, and you'll see Foreground Color Picker and Background Color Picker. Click on whichever one you want, and type in the shortcut you want. I have to tell you up front: most of the

good shortcuts are already taken (in fact, almost all combinations of shortcuts are already taken), but my buddy Dave Cross came up with a good idea. He doesn't use the Pen tool all that much, so he used the letter P (for Picker). When you enter "P," it's going to warn you that it's already being used for something else, and if you click the Accept and Go to Conflict button at the bottom left, it assigns P to the Color Picker you chose, and then sends you to the Pen tool to choose a new shortcut. If you don't need to assign one to the Pen tool (you don't use it much either), then just leave it blank and click OK.

Visual Way to Change Your Brush Size and Softness

This is incredibly handy, because you can actually see and control the exact size and amount of softness for your current brush tip. Hold Option-Ctrl (PC: Alt-Ctrl) then click-and-drag (PC: Right-click-and-drag) up/down to control the softness/hardness of the brush, and left/right to control the size.

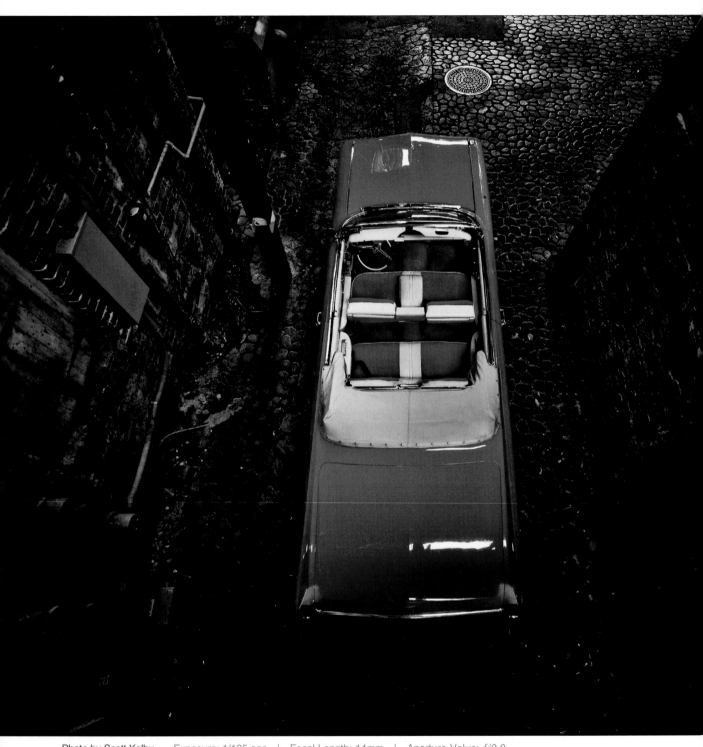

Photo by Scott Kelby Exposure: 1/125 sec | Focal Length: 14mm | Aperture Value: *f*/2.8

Jonas Sees in Color
color correction secrets

As soon as I saw this album title, I knew I had to use it, because my four-year-old daughter is a big fan of the Jonas Brothers (which on some level should make the Jonas Brothers sad, not only because I doubt that their goal was a fan base that still rides a trike, but because by the time she's seven, they will already be "old news" to her, and when I bring up their name, she'll look at me like I'm "forty-a-hundred," which is how old she thinks I am anyway). Anyway, I knew this was a lock for the title, but then I clicked on the album cover, fully expecting to see Kevin, Joe, and Nick Jonas (familiar faces in our home), but instead it was a totally different band. In fact, the name of the band was also Jonas Sees in Color. You see, I "assumed" that because the word Jonas was in there, that it would be the title of a Jonas Brothers album, but that's what happens when you assume (what's that old

saying, "When you assume, that makes a sum of a and e"?). Anyway, I wondered on some level if, with that name, the band was trying to do the same thing with their name that some companies do with their product names, so someone not paying close attention might, for example, buy a Buckstar bag of coffee off the grocer's shelf, when they thought they were buying Starbucks, because of the sound-alike name and the package's similar look and feel. If that were the case, then someone looking to buy a Jonas Brothers song might actually buy one from Jonas Sees in Color, but in this case, it's entirely possible they might like the Jonas Sees in Color songs better (hey, don't bank your career on the attention span of a four-year-old). This got me to thinking, and long story short—that's precisely why I changed my pen name to J. Kelby Rowling, and my next book is titled *Harry Porter and the Odor of the Pen Tool*.

Step Three:

First, we need to set some preferences in the Curves dialog, so we'll get the results we want when color correcting. We'll start by setting a target color for our shadow areas. To set this preference, in the Curves dialog, double-click on the black Eyedropper tool (the Eyedroppers are found below the center of the curve grid, and the shadow Eyedropper is the first Eyedropper from the left [the one half-filled with black], as shown here).

Step Four:

When you double-click on that shadow Eyedropper, it brings up the Color Picker asking you to select your target shadow color. This is where you'll enter some new RGB numbers that will help remove any color casts your camera introduced in the shadow areas of your photo. We're going to enter values in the R, G, and B (Red, Green, and Blue) fields of this dialog (the Blue field is highlighted here).

For R, enter 7
For G, enter 7
For B, enter 7

Now click OK to save these numbers as your target shadow settings. Because these figures are evenly balanced (they're all the same number), it helps ensure that your shadow areas won't have too much of one color (which is exactly what causes a color cast—too much of one color), and by using 7 we get dark shadows while still maintaining shadow detail in our inkjet prints.

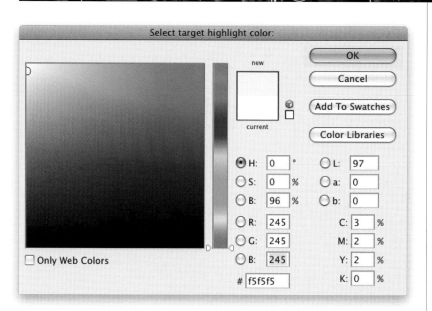

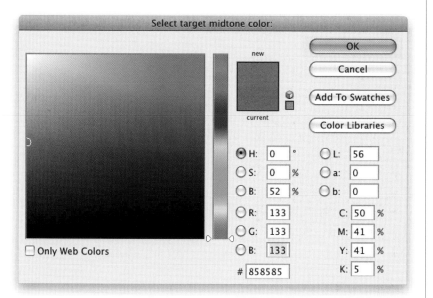

Step Five:

Now we'll set a preference to make our highlight areas neutral. Double-click on the white Eyedropper (the third of the three Eyedroppers at the bottom of the Curves dialog). The Color Picker will appear asking you to Select Target Highlight Color. Click in the R field, and then enter these values (*Note:* To move from field to field, just press the **Tab key**):

For R, enter 245
For G, enter 245
For B, enter 245

Click OK to set those values as your highlight target.

Step Six:

Now, set your midtone preference. You know the drill: Double-click on the mid-tone Eyedropper (the middle of the three Eyedroppers), so you can Select Target Midtone Color. Enter these values in the RGB fields:

For R, enter 133
For G, enter 133
For B, enter 133

Then click OK to set those values as your midtone target. That's it—you've done all the hard work. The rest from here on out is pretty easy.

Continued

Step Seven:

If you still have the Curves dialog open, click OK to exit it for now, and you'll get a warning dialog asking you if you want to Save the New Target Colors as Defaults. Click Yes (as shown here), and from this point on, you won't have to enter these values each time you correct a photo, because they'll already be entered for you—they're now the default settings. So, the next time you color correct a photo, you can skip these seven steps and go straight to the correcting.

Step Eight:

Okay, now that you've entered your preferences (target colors) in the Curves dialog, you're going to use these same Curves Eyedropper tools (shown here) to do most of your color correction work. In a nutshell, here's what you'll do with those three Eyedroppers:

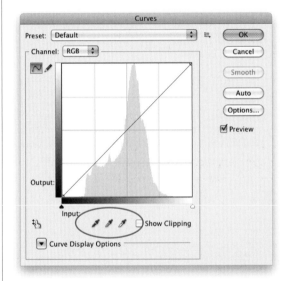

(1) Find something in your photo that you know is supposed to be the color black. If you can't find something black, find the darkest area in your photo and convert that area to your target shadow color by clicking on that area once with the shadow Eyedropper.

(2) Find something in your photo that you know is supposed to be the color white. If you can't find something white, find the brightest area in your photo and convert that area to your target highlight color by clicking on that area once with the highlight Eyedropper.

(3) Find a neutral gray area in your photo and convert that to your target midtone color by clicking on that area once with the midtone Eyedropper.

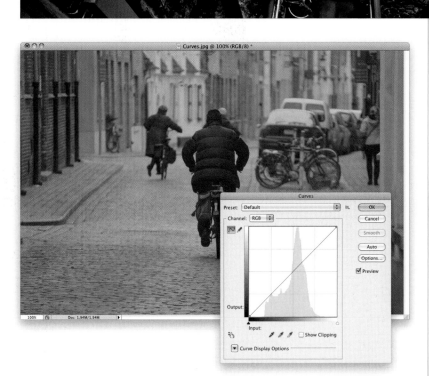

Step Nine:

Let's start by setting the shadows first, so press **Command-M (PC: Ctrl-M)** to bring back up the Curves dialog (shown here). Now, your job is to look at the photo and find something that's supposed to be the color black. In most photos, this won't be a problem—you'll see a dark area of shadows (like the parts of the bicyclist's jacket in this photo, or a black car tire, or a black shirt, etc.), and in those cases, it's no sweat. But, if you can't find something that's supposed to be the color black, then you can have Photoshop show you exactly where the darkest part of the photo is.

TIP: Using Curves from the Adjustments Panel

If you're familiar with adjustment layers, you can apply your Curves as an adjustment layer, instead, using the Adjustments panel. Just click on the icon that looks like the Curves grid, and instead of getting a floating dialog, you can adjust your curve from right within the panel. More on adjustment layers later on.

Step 10:

There are two sliders directly under the curve grid that can help you find where the darkest and brightest parts of your image are. Start by turning on the Show Clipping checkbox (shown here), and your image area turns solid white, then click-and-hold on the left (shadow) slider. As you drag the slider to the right, the first areas that appear onscreen are the darkest parts of your photo. That's Photoshop telling you exactly where to click, so remember where those areas are (in this case, I'd probably choose the bottom of the bicyclist's jacket, because it's showing up as solid black, which means all three color channels are solid black).
Continued

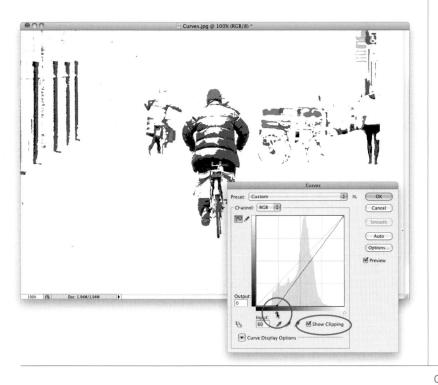

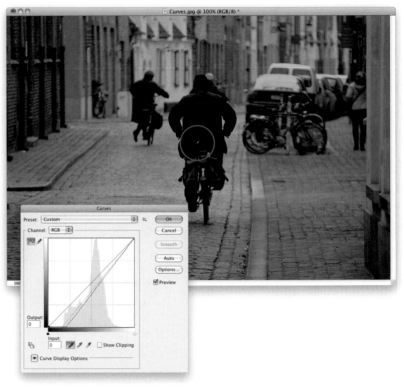

Step 11:

Now that you know where your shadow area is, drag that shadow slider back to the left, and turn off the Show Clipping checkbox. Click on the shadow Eyedropper, move out over your photo (while the Curves dialog is still open), and click once on that shadow area. In this case, click in the shadow area at the bottom of the bicyclist's jacket (shown circled here in red), and it converts your shadow areas to a neutral shadow color, and the color cast is removed from them (compare this photo with the one in Step Nine and you'll see the difference this one click makes, in both color and contrast).

TIP: Turning Off the Channel Overlays

When you click in that shadow area, three new lines appear in your curve, showing how the Red, Green, and Blue channels were affected by your move. Although some users love seeing these lines, some folks (like me) find it really distracting. If you'd like those channel lines turned off, just click on the triangle next to Curve Display Options at the bottom left of the Curves dialog, then turn off the checkbox for Channel Overlays (as shown here).

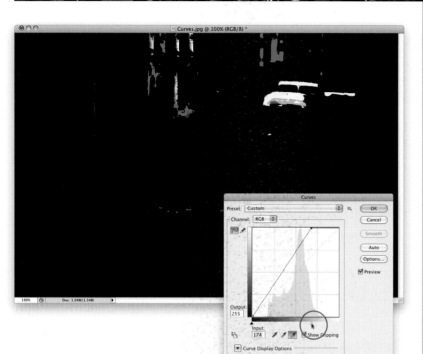

Step 12:
Now, on to setting the highlight point. Your job: find something that's supposed to be the color white. Again, this is usually pretty easy, but if you can't find something white, you can use the same trick you just learned to have Photoshop show you where the lightest part of your photo is. Turn on the Show Clipping checkbox again, but this time drag the far-right slider to the left. The screen turns black (as shown here), and as you drag to the left, the first white areas that appear are the lightest parts of your image.

TIP: Skipping the Show Clipping Checkbox
Pressing-and-holding the **Option (PC: Alt) key** and dragging those Input sliders does the same thing as temporarily turning on the Show Clipping checkbox.

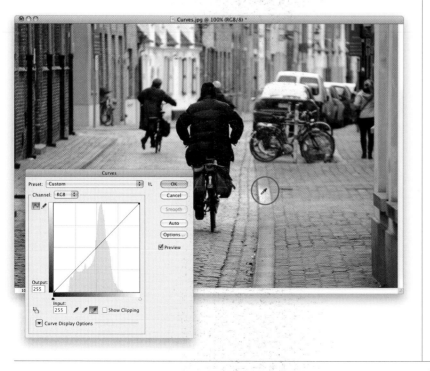

Step 13:
Now that you know where your highlight area is, drag that highlight slider back all the way to the right, and turn off the Show Clipping checkbox. Click on the highlight Eyedropper, move out over your photo, and click once on that highlight area. I try to look for a white area that has some detail (rather than clicking on what's called a specular highlight, which is a blown out highlight area with no detail, like the sun, or a bright sun reflection on a chrome car bumper, etc.). In this case, I clicked on the curb to the right of the bicyclist (as shown here), and that made the highlight areas neutral and removed any color cast in the highlights (we're only two clicks into this correction, and look how much better the photo already looks).

Continued

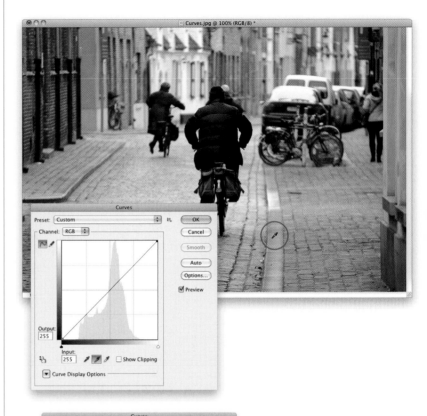

Step 14:

Now for your third click—finding something that's supposed to be a neutral gray. This one's a little trickier, because not every photo has a neutral gray area, and the Curves dialog doesn't have a "find the gray" trick like it does for shadows and highlights, but never fear—there's a project coming up in this chapter that shows you a way to find that neutral area every time. In the example we're working on, finding an area that's supposed to be a neutral gray isn't a problem—you can click on another part of the curb (as I did here). It neutralizes the color cast in the midtones, and as you can see here, it removed that blue color cast that was still there after neutralizing the highlights and shadows. Now we have a much warmer and more natural looking tone.

Step 15:

Before you click OK, you're going to use Curves to increase the overall contrast in the photo (in fact, it's the best way to increase contrast in Photoshop). Plus, it's easy: (1) first, click once right in the very center of the grid to add a point; (2) click above and to the right of the center, right along the line, where the gray grid lines intersect with the diagonal line; and (3) add one more point on the line, where the lines intersect at the bottom quarter (they're shown circled here).

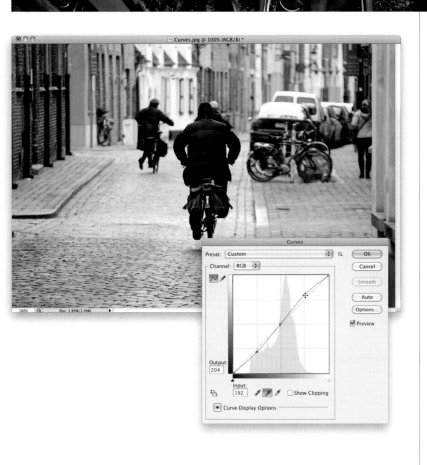

Step 16:

Now, while the bottom-left point is selected, press the **Down Arrow key** on your keyboard eight or nine times to move that point of the curve downward, which increases the contrast in the shadow areas. Then, click on the top-right point, but now press the **Up Arrow key** on your keyboard 10 or 12 times to increase the contrast in the highlights. Moving the top point up and the bottom point down like this steepens the curve and adds more contrast. Now you can click OK, and you're done.

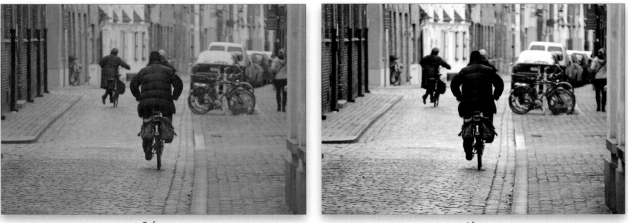

Before *After*

The Advantages of Adjustment Layers

Before we really dive into color, we need to spend two minutes with the Adjustments panel. Of all the enhancements added in Photoshop CS4, the Adjustments panel was my favorite, because it streamlined our workflow so dramatically that even if you'd never used adjustment layers before, you had to start working with them. So, from this point in the book on, we'll use adjustment layers every chance we get, because of all the advantages they bring. Here's a quick look at them and how to use them to your advantage:

Advantage One:
Undos That Li ve Forever

By default, Photoshop keeps track of the last 20 things you've done in the History panel (shown here), so if you need to undo a step, or two, or three, etc., you can press **Command-Option-Z (PC: Ctrl-Alt-Z)** up to 20 times. But, when you close your document, all those undos go away. However, when you make an edit using an adjustment layer (like a Levels or Curves adjustment), you can save your image as a layered file (just save it in Photoshop format), and your adjustment layers are saved right along with it. You can reopen that document days, weeks, or even years later, click on that adjustment layer, and either undo or change that Curves, Levels, or other tonal adjustment. It's like an undo that lives forever.

Advantage Two:
Built-In Masks

Each adjustment layer comes with a built-in layer mask, so you can easily decide which parts of your photo get the adjustment just by painting. If you want to keep an area of your photo from having the adjustment, just get the Brush tool **(B)** and paint over it in black. There's more on layer masks to come, but they offer tremendous flexibility, and since they don't actually affect the pixels in your image, they're always undoable.

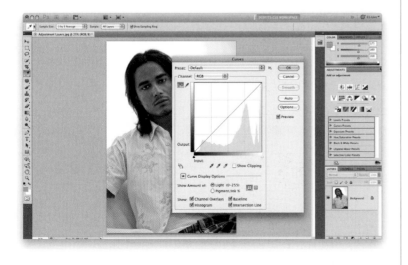

Advantage Three:
One-Click Presets

Adobe has added a bunch of built-in presets that you can apply with one click right from within the Adjustments panel. Plus, if you come up with a setting you like, you can save your own custom presets. So, for example, if you come up with a favorite Levels setting (using a Levels adjustment layer), you can save it as a preset (by choosing **Save Levels Preset** from the panel's flyout menu), and then apply it anytime from the Adjustment panel's Preset list with just one click.

Advantage Four:
Blend Modes

When you apply an adjustment layer, you get to use the layer blend modes. So if you want a darker version of your adjustment, you can just change the layer blend mode of your adjustment layer to Multiply. Want a brighter version? Change it to Screen. Want to make a Curves adjustment that doesn't affect the skin tone as much? Change it to Luminosity. Sweet!

Advantage Five:
Everything Stays Live

Back in previous versions of Photoshop, when you created an adjustment layer (let's say a Curves adjustment layer, for example), it would bring up the floating Curves dialog (as seen here). While it was onscreen, the rest of Photoshop was frozen—you couldn't make changes or do anything else until you closed the Curves dialog by either applying your adjustment or hitting Cancel. But thanks to the Adjustments panel, everything stays live—you just go to the Adjustments panel and make your changes there. There is no OK or Apply button, so you can change anything anytime. This will make more sense in the next step.

Continued

Step One:

The best way to understand this whole "live" thing is to try it, so go open any photo (it really doesn't matter which one), then go to the Adjustments panel and click on the Curves icon (it's the third one in the top row). Rather than bringing up the Curves dialog in front of your image (and freezing everything else), the Adjustments panel now displays the curve, so you can make your adjustments, but everything stays live—you can adjust your curve, go right down and change the blend mode of a layer, or paint a few brush strokes, then grab another part of the curve and adjust it. There's no OK button, and everything stays live. This is bigger than it sounds (ask anyone who's used CS3).

Step Two:

If you're thinking the curve itself looks a little small stuck in that narrow panel, Adobe must have been thinking the same thing, because there's a little icon in the bottom-left corner of the panel (shown circled here in red), and if you click on it, it expands the size of the entire panel so everything's easier to work with (as seen here).

Step Three:

Now let's delete our Curves adjustment layer by dragging it onto the Trash icon at the bottom of the panel. Add a Hue/Saturation adjustment by clicking on its icon (it's the second one in the middle row). Drag the Saturation slider way over to the left to remove most of the color, for the look you see here. Now, the way adjustment layers work is this: they affect every layer below them. So if you have five layers below it, all five layers will have their color desaturated like this. However, if you want this adjustment layer to just affect the one single layer directly below it (and not the others), then click on the clipping icon (it's the third from the left at the bottom of the panel, shown circled here in red). This clips the adjustment layer to the layer directly beneath it.

Step Four:

There are a couple other options: To edit any adjustment layer you've already created, just click on it once in the Layers panel and its controls will appear in the Adjustments panel. To return to the list of adjustment layers and their presets, click on the Return to Adjustment List icon at the bottom of the panel (shown circled here in red). To hide any adjustment layer you've created, click on the Eye icon (either at the bottom of the Adjustments panel, or to the left of the adjustment layer in the Layers panel). To reset any panel to its default settings, click the round arrow icon to the immediate left of the Trash icon. To see a before/after of just your last change, click the icon to the left of the Reset icon. The hardest thing about the Adjustments panel is figuring out which icon represents which adjustment, so just move your cursor over an icon, and its name appears in the upper-left corner of the panel.

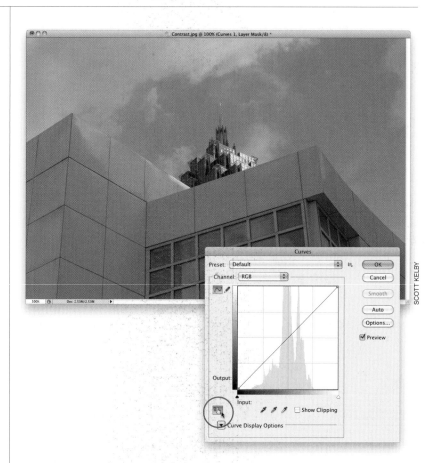

Adjusting Contrast Using the Targeted Adjustment Tool

Besides using Curves for color correction, this is also a powerful tool for creating contrast, because it gives you a range of control you really can't get any other way. Of course, in the past, you really had to know Curves inside and out to tweak individual areas of your image, but thanks to the Targeted Adjustment Tool (or TAT for short), you can now click-and-drag right on the image, and the tool will tweak the right part of the curve for you automatically. It's way cooler than it sounds.

Step One:

Here's a pretty flat-looking photo that could use a Curves adjustment to bring more contrast to the photo and, as I mentioned above, we're going to use the TAT (shown circled in red here), so we really don't have to mess with the curve at all, we just have to tell Photoshop two simple things: (1) which area of the photo we want to adjust, and (2) if we want that area to be darker or brighter. That's it—and we do the whole thing using just our mouse. So, start by pressing **Command-M (PC: Ctrl-M)** to open the Curves dialog and clicking on the TAT.

TIP: Using a Curves Adjustment Layer

Don't worry—if you use a Curves adjustment layer (rather than just using the standard Curves dialog seen here), it has the TAT, too! (Get it, TAT too? Tattoo? Aw, come on, that one wasn't that bad.)

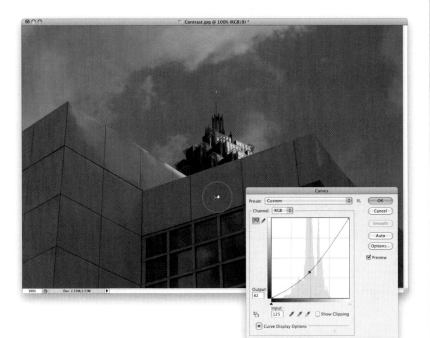

Step Two:
Now, move your cursor outside the Curves dialog, and out over the part of your image you want to adjust. In our case, we want to make the buildings and sky darker. Start by clicking-and-holding on the building in the foreground, and you'll notice that your cursor turns into a hand with a two-headed arrow, pointing up/down. That tells you that dragging up/down will make the adjustment. In our case, we want this area darker, so drag downward. As you do, it knows exactly which part of the curve to adjust to darken that area.

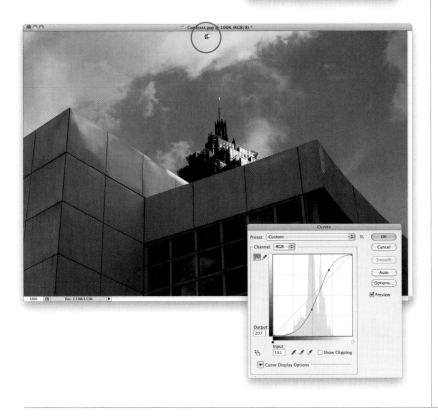

Step Three:
So, now that we've darkened the buildings and sky, let's go make the white clouds brighter. Move your cursor over them, but this time you're increasing the brightness, so you'd click-and-drag upward (rather than downward). As you do this, it knows exactly which part of the curve to adjust to affect that area (if you look at the curve, you can see a new point has been added on the top right of the curve—that was added when you clicked-and-dragged on the clouds).

Continued

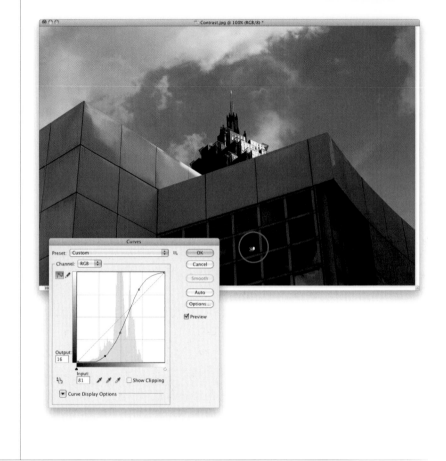

Step Four:

Lastly, now that we've darkened the building, let's darken the windows a bit by moving our cursor over a window, and clicking-and-dragging downward to darken that area (also note where it added a new curve point, and how it adjusted that new point downward). This is so darn easy to do, but as you can see, it's also pretty darn powerful.

Before　　　　　　　　　　　　　　　　　　*After*

If you're shooting in a studio or on location, whether you're shooting portraits or products, there's a technique many pros use that can make the color-correction process so easy that you'll be able to train laboratory test rats to correct photos for you. The secret is this: in the back of this book I included my version of a gray card, and it's perforated, so you can easily tear it out. By sticking this card into the first shot of your shoot (and shooting it again only if your lighting setup changes), it will make your color correction almost automatic.

The Trick Pros Use to Make Color Correction Simple

Step One:
When you're ready to start shooting and the lighting is set the way you want it, tear out the swatch card from the back of this book and place it within your shot (if you're shooting a portrait, have the subject hold the card for you), then take the shot. After you've got one shot with the swatch card, you can remove it and continue with the rest of your shoot.

Step Two:
When you open the first photo taken in your studio session, you'll see the swatch card in the photo. By having a card that's pure white, neutral gray, and pure black in your photo, you no longer have to try to determine which area of your photo is supposed to be black (to set the shadows), which area is supposed to be gray (to set the midtones), or which area is supposed to be white (to set the highlights). They're right there in the card.

Continued

Step Three:

Go to the Adjustments panel and click on the Curves icon (it's the third one from the left in the top row). Click the black Eyedropper on the black panel of the card to set the shadows, then click the middle gray Eyedropper on the darker gray panel to set the midtones. Finally, click the white Eyedropper on the white panel to set the highlights (as shown here), and the photo will nearly correct itself. No guessing, no Threshold adjustment layers, no using the Info panel to determine the darkest areas of the image—now you know exactly which part of that image should be black and which should be white.

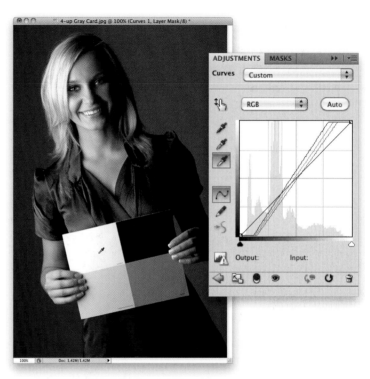

Step Four:

Once you have the Curves setting for the first image, you can correct the rest of the photos using the exact same curve: Just open the next photo and position it so you can see part of both photos. Now click back on the first photo (the one you corrected), click on the Curves adjustment layer in the Layers panel, and drag-and-drop that adjustment layer onto the second photo. Do this until all the photos are corrected. (*Note:* You won't be able to drag-and-drop the adjustment layer if you're working in the Application Frame, so be sure that you're viewing your photos in floating windows.)

Before

After

Finding a neutral midtone while color correcting has always been kind of tricky. Well, it was until Dave Cross, who works with me as Senior Developer, Education and Curriculum for the National Association of Photoshop Professionals (NAPP), came into my office one day to show me his amazing trick for finding right where the midtones live in just about any image. When he showed me, I immediately blacked out. After I came to, I begged Dave to let me share his very slick trick in my book, and being the friendly Canadian he is, he obliged.

Dave's Amazing Trick for Finding a Neutral Gray

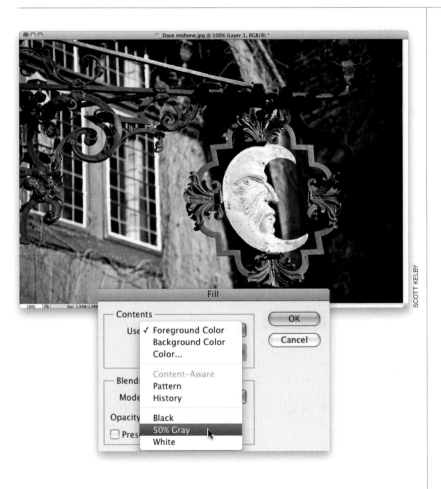

Step One:
Open any color photo, and click on the Create a New Layer icon at the bottom of the Layers panel to create a new blank layer. Then, go under the Edit menu and choose **Fill**. When the Fill dialog appears, in the Contents section, from the Use pop-up menu, choose **50% Gray** (as shown here).

Continued

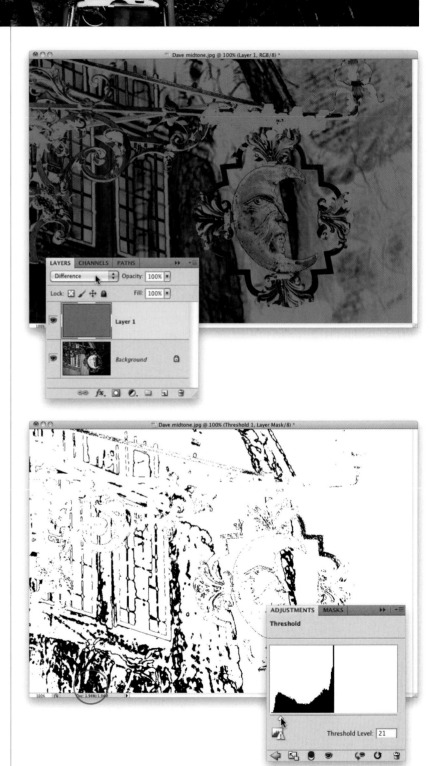

Step Two:

When you click OK, it fills your layer with (you guessed it) 50% gray (you can see the gray thumbnail for Layer 1 in the Layers panel shown here). Now, go to the Layers panel and change the blend mode of this layer to **Difference**. Changing the layer blend mode to Difference doesn't do much for the look of your photo (as you can see here), but don't worry—it's only temporary.

Step Three:

Choose **Threshold** from the Create New Adjustment Layer pop-up menu at the bottom of the Layers panel. Then, in the Adjustments panel, drag the slider under the histogram all the way to the left (your photo will turn completely white). Now, slowly drag the slider back to the right, and the first areas that appear in black are the neutral midtones. In the bottom left of this photo is a decent-sized area of black, so that will be our midtone correction point. To help you remember exactly where that area is, get the Color Sampler tool (nested under the Eyedropper tool), and click on that spot to add a Color Sampler point as a reminder. Then click the Trash icon at the bottom of the Adjustments panel to discard the adjustment layer.

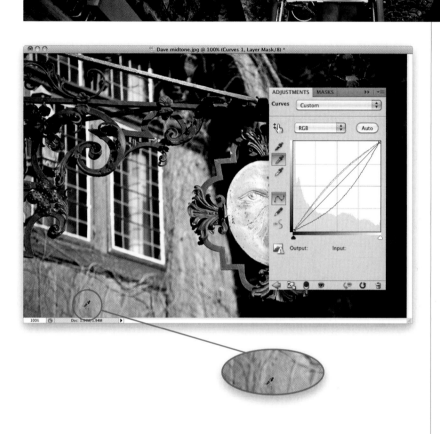

Step Four:

Now that your midtone point is marked, go back to the Layers panel and drag the 50% gray layer onto the Trash icon to delete it (it already did its job, so you can get rid of it). You'll see your full-color photo again. Now, click on the Curves icon in the Adjustments panel (the second icon from the right in the top row) to open the Curves Adjustments panel, get the midtones Eyedropper (it's the middle Eyedropper), and click directly on that Color Sampler point (shown circled in red here).

Step Five:

That's it; you've found the neutral midtones and corrected any color cast within them. So, will this trick work every time? It works most of the time, but you will run across photos that just don't have a neutral midtone, so you'll have to either not correct the midtones or go back to what we used to do—guess.

Before

After

Adjusting RGB Flesh Tones Using the TAT

So what do you do if you've used Curves to properly set the highlights, mid-tones, and shadows, but the flesh tones in your photo still look too red? Try this quick trick that works great for getting your flesh tones in line by removing the excess red.

Step One:

Open a photo that you've corrected using the Curves technique shown earlier in this chapter. If the whole image appears too red, skip this step and go on to Step Three. However, if it's just the flesh-tone areas that appear too red, press **L** to get the Lasso tool and make a selection around all the flesh-tone areas in your photo. Press-and-hold the Shift key to add other flesh-tone areas to the selection, such as arms, hands, legs, etc., or press-and-hold the Option (PC: Alt) key to subtract from your selection. This can be a really loose selection like the one shown in Step Two.

Step Two:

Go under the Select menu, under Modify and choose **Feather**. Enter a Feather Radius of 3 pixels (as shown here), and then click OK. By adding this feather, you're softening the edges of your selection, which will keep you from having a hard, visible edge show up where you made your adjustment.

TIP: Hiding the Selection Border

Once you've made a selection of the flesh-tone areas, you might find it easier if you hide the selection border from view (that makes it easier to see what you're correcting) by pressing **Command-H (PC: Ctrl-H)**.

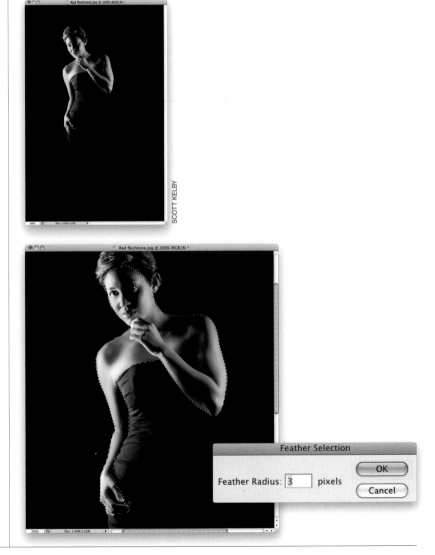

SCOTT KELBY

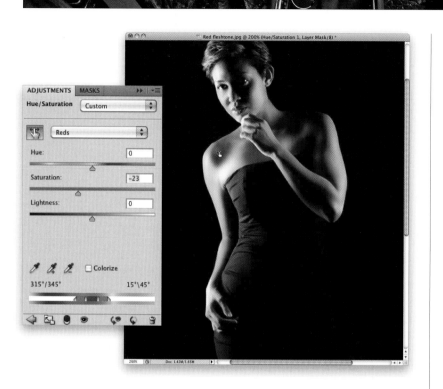

Step Three:

In the Adjustments panel, click on the Hue/Saturation icon, and when the Hue/Saturation options appear, click on the TAT (the Targeted Adjustment Tool—more on how it works on page 160). To reduce some of the red in her skin tone, move the cursor over an area of her shoulder that looks overly red, click-and-hold the tool, and drag to the left. The tool knows which Hue/Saturation slider to move (it jumps to the Reds, and reduces the Saturation amount), so just keep dragging until her skin tone looks more natural (a before/after is shown below). When it looks good to you, press **Command-D (PC: Ctrl-D)** to Deselect, completing the technique.

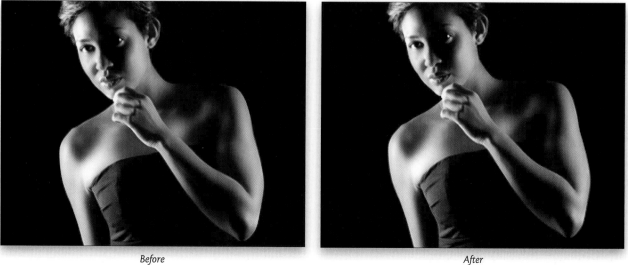

Before　　　　　　　　　　　　　*After*

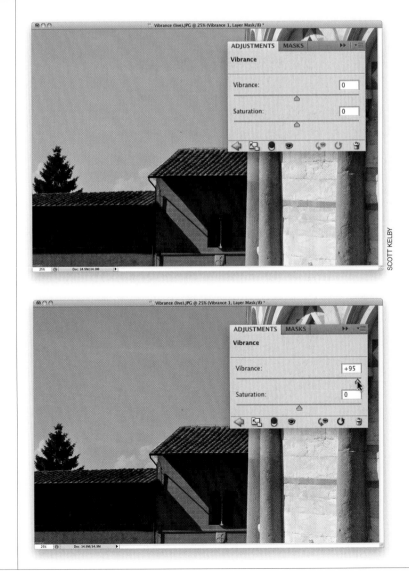

Creating Vibrance Outside of Camera Raw

Vibrance—one of my favorite features in Camera Raw—is also available outside of Camera Raw. It pretty much does the same thing that Vibrance inside of Camera Raw does—it boosts the least vivid colors in your photo the most, it affects the already vivid colors the least, and it tries to avoid boosting skin tones. And, it's an adjustment layer, so you get the built-in mask, as well. Sweet! Here's how it works:

Step One:
Just click the Vibrance icon in the Adjustments panel (the first icon in the center row), and the Vibrance controls appear (as seen here). Adobe also put a Saturation slider there, and I avoid it like the plague (except for using it occasionally to remove color), so if I come to this panel, it's for Vibrance—not Saturation. However, you can use this Saturation slider in conjunction with Vibrance (like lowering Saturation, which evenly takes color from the entire photo, then really boosting Vibrance, so the dullest colors start to stand out more).

Step Two:
Using Vibrance is a no-brainer—just drag the slider to the right (as shown here), and the farther you drag it, the more vibrant your less vibrant colors become.

TIP: The Sponge Has Vibrance
Unless you take your images to a printing press, you probably haven't used the Sponge tool (O), which either saturates or desaturates the color in any areas you paint with it, and is often used to desaturate colors that are out-of-gamut (colors too vibrant for a CMYK printing press). Well, Vibrance is an option (in the Options Bar) for that tool that will focus more on less saturated colors while not affecting already saturated colors as much.

Email applications (and nearly all Web browsers) don't support color management. So, if you're working in Adobe RGB (1998) or ProPhoto RGB as your Photoshop color space, when you email your photos or post them on the Web, they probably look like %$*# (with the colors all desaturated and flat-looking). Ah, if only there was a trick that would let anyone you email (or anybody who sees your photos on the Web) see your photos pretty much the same way you do in Photoshop (of course, there is—I just wish I knew it. Kidding!) Here ya go:

Keeping Great Color When Emailing or Posting Photos to the Web

SCOTT KELBY

Step One:
To convert this photo to the proper color space for emailing or posting to the Web, go under the Edit menu and choose **Convert to Profile**. This brings up the Convert to Profile dialog (shown here). The Source Space at the top shows you the current color space your photo is in (if you're working in Adobe RGB [1998], like in this example, that's what you'll see here). For your Destination Space (what you're converting to), choose sRGB IEC61966-2.1 from the Profile pop-up menu (as shown here) and click OK. That's it—it's ready to go.

Step Two:
One quick way to ensure that your photo has been converted to sRGB is to look at the window's title bar. If you've got Photoshop's color space set to Adobe RGB (1998), which is pretty typical for photographers, and you just converted this photo to a different color space (sRGB), then you have a "profile mismatch." So, you should see an asterisk right after (RGB/8) in the title bar (as shown circled here in red), which is Photoshop's way of letting you know that your photo is one space, and Photoshop is in another. In this case, that's a good thing.

Photoshop Killer Tips

Dragging Multiple Images from Mini Bridge

If you have more than one image in Mini Bridge you want to place into an open document, just select them all first, then drag-and-drop them as a group into the open document, and they'll come in all on their own separate layers (this is really handy if you're putting together a collage). However, there's something you'll need to know: Once you drag them, the first selected image appears in your open document as a Smart Object—ready for you to resize (if you want)—but the next image won't appear until you first press **Return (PC: Enter)** to lock in the size for your placed Smart Object. For RAW images, the first selected image will open in Camera Raw first, and then when you click OK, it'll appear as a Smart Object, as well. So basically, it's: (1) drag-and-drop, (2) Click OK in Camera Raw if it's a RAW image, and then (3) press Return (PC: Enter) for the next photo to appear.

Dragging Images from Your Desktop

In CS5, you don't actually have to have an image visible in Mini Bridge to get it into an open document in Photoshop. You can literally drag-and-drop an image

on your desktop directly into an open Photoshop document. These appear with a "resize border" around them, but they're not Smart Objects. Just choose your size, then press **Return (PC: Enter)** to lock in your size. From then on, it's just like any other regular layer.

Resize Image During Place Preferences

By default, when you drag-and-drop an image into an open document in Photoshop CS5, it assumes you want to resize it to fit entirely within that document, but if you'd rather not have this option turned on, press **Command-K (PC: Ctrl-K)** to bring up Photoshop's Preferences, click on General on the left, then in the Options section, turn off the Resize Image During Place checkbox.

Shortcut for Highlighting the First Field in Adjustment Layers

Adobe added a nice feature that's handy when you're working with adjustment layers: when you're in the Adjustments panel, you can automatically highlight the first adjustment field by pressing **Shift-Return (PC: Shift-**

Enter) on your keyboard. Then you can jump from field to field using the **Tab key**. When you're done in the fields, just press **Return (PC: Enter)**.

TAT Always On in the Adjustments Panel

The Hue/Saturation, Curves, and Black & White Adjustment layers all give you the option of using the Targeted Adjustment Tool (or TAT, for short), and now in CS5, you can have the TAT active automatically each time you choose one of those adjustments. The next time you have one of those adjustments open in the Adjustments panel, from the panel's flyout menu, choose **Auto-Select Targeted Adjustment Tool**. Now, the TAT will always be active when you choose a Hue/Saturation, Curves, or Black & White adjustment layer.

Photoshop Killer Tips

The 32-Bit Mode Lighting Effects
If you're running Photoshop in 64-bit mode, you've probably noticed that the Lighting Effects filter doesn't work or even appear in the Filter menu (under Render). If you need to use it, you'll have to quit Photoshop, and re-launch it in 32-bit mode, and then it will be available. On a Mac, once you've quit Photoshop, go to your Applications folder, click on the Adobe Photoshop CS5 icon, and press **Command-I** to bring up the Get Info window. Turn on the Open in 32-bit Mode checkbox, re-launch Photoshop, and you'll find Lighting Effects under the Filter menu. This is currently unavailable on a PC.

Change the Opacity of Multiple Layers
This is one we've all wanted for a while: the ability to change the opacity of multiple layers at the same time. All you do

is select the layers you want to affect, then lower the Opacity at the top of the Layers panel, and the opacity for all the selected layers is lowered to the same amount, as well. Ahhhhhh, it's the little things, isn't it?

Jump to Any Layer
You don't have to keep the Layers panel open to change layers—it's faster to just press-and-hold the **Command (PC: Ctrl) key** and then click right within the image itself with the Move tool (**V**), and it makes that area of your image's layer active. If you fall in love with this way of selecting layers, you can have it on all the time (no having to hold the Command key) by first getting the Move tool, then up in the Options Bar, turning on the Auto-Select checkbox. One thing to keep in mind: if the opacity of a particular layer gets really low (like 20%), you won't be able to select it using Auto-Select (hey, I thought you'd want to know).

Make Your Own Custom Panels
Adobe has a separate utility called the "Configurator," which lets you create your own custom panels by dragging-and-dropping (for example, you could create a Retouching panel, with just the tools and menu items, plus any scripts or actions you use when you're doing retouching). You download the Configurator directly from Adobe's website at http://labs.adobe.com/technologies/configurator/ (it's free).

Change Thumbnail Sizes
If you want to see larger-sized thumbnails in your Layers panel, just Right-click in an open space beneath the layer stack (click in that gray area right below the Background layer), and from the pop-up menu that appears, choose **Large Thumbnails**. Now, you get nice big thumbnails.

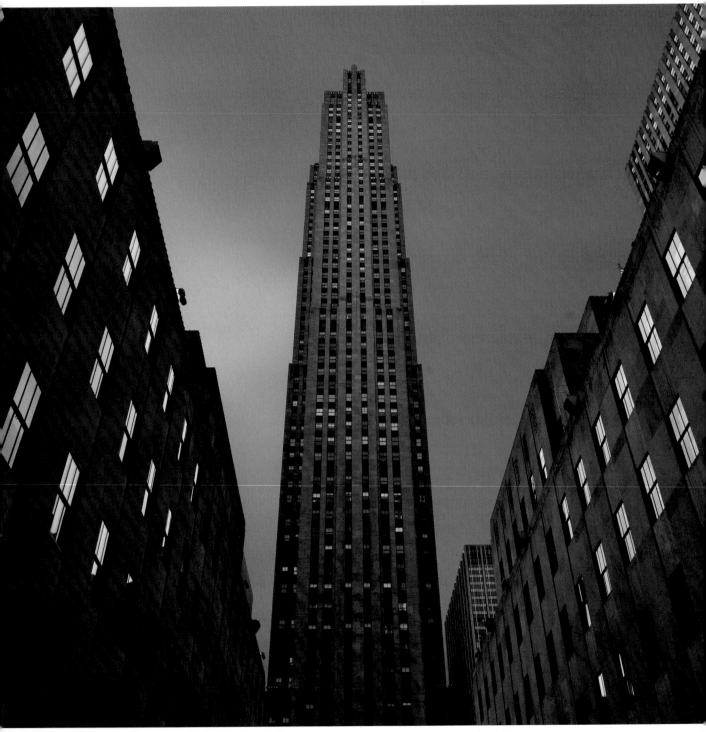

Photo by Scott Kelby | Exposure: 1/1600 sec | Focal Length: 24mm | Aperture Value: ƒ/8

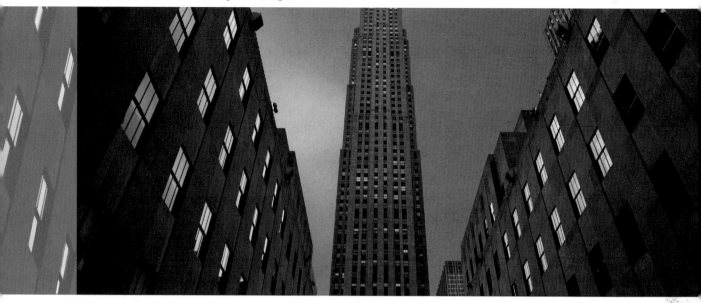

Black & White
how to create stunning b&w images

I know what you're thinking, "He's given up on the whole movie name/song title/TV show thing," but actually the "Black & White" you see above is from the song by the 1970s hit machine Three Dog Night. (Remember the song: "The ink is black. The page is white. Together we learn to read and write"? I can't believe with captivating lyrics like that, these guys aren't still crankin' out the hits.) Anyway, back in the CS4 intro for this chapter, I wrote that I had toyed with the idea of using the song "Black Widow" by Mötley Crüe, but I chose not to for a very legitimate (yet, secret until now) reason: I couldn't figure out how to add those two little dots above the letter "u" in Crüe, so I went with Elvis Costello's "Black and White World" instead (it was an easy choice, as it contains no crazy dots above any letters). I have to admit, I am a bit embarrassed that I didn't know what those little dots are called, so I did a Google search for this phrase: "two little dots above the

letter U." It returned six search results, including a Facebook group called (and I'm not making this up): "It is a crime to write über without the Umlaut." At that moment I realized two things: (1) it's called an umlaut, and (2) people get totally psychotic about things like a missing umlaut. This is probably why, in the printed version of my CS4 book, not only did my editor Kim add the umlaut above the "u" for me, but she also added an umlaut over the "o" in Mötley. You're thinking, "Wow, she's good!" and she totally is, but I know her dirty little secret. She only knew there was a problem there to fix because she's a huge "big hair bands from the '80s" fan. If, instead, she had been a fan of Sheena Easton or Garth Brooks back then, you know and I know she would have changed it to read "Motley Crew," just like she referred to the song "Walk This Way" as being performed by Arrow Smith. (Kidding, Kim. Just a joke. Really!)

Converting to Black and White Using Camera Raw

Although Photoshop has its own Black & White conversion adjustment layer, I never, ever use it, but that's only because it totally stinks (I don't know any pros who use it). I think you can create a much better black-and-white conversion using Camera Raw, and it's much faster and looks infinitely better. Well, that is as long as you don't get suckered into using the HSL/Grayscale panel in Camera Raw, which is nothing more than the Black & White adjustment layer hiding in Camera Raw, trying to sucker in some poor unsuspecting soul.

Step One:
We'll start by opening a color image in Camera Raw (as seen here). Converting from color to black and white is simple—just click on the HSL/Grayscale icon (it's the fourth icon from the left) and then turn on the Convert to Grayscale checkbox at the top of the panel (as seen here). That's all you want to do here (trust me).

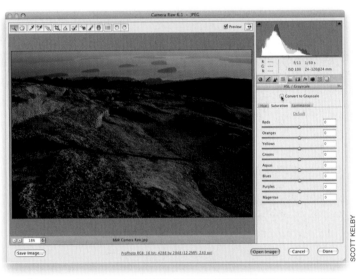

Step Two:
Once you click on that Convert to Grayscale checkbox, it gives you an incredibly flat conversion (like the one you see here), and you might be tempted to drag those color sliders around, until you realize that since the photo is already converted to black and white, you're kind of just dragging around in the dark. So, the best advice I can give you is to get out of this panel just as fast as you can. It's the only hope for making this flat-looking grayscale image blossom into a beautiful butterfly of a B&W image (come on, I at least get five points for the butterfly metaphor thingy).

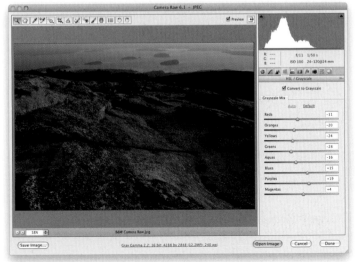

SCOTT KELBY

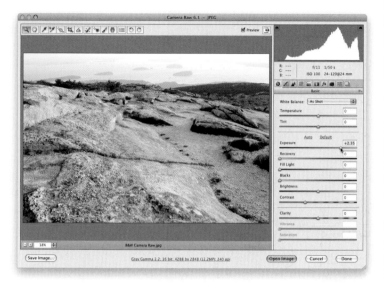

Step Three:

When you talk to photographers about great B&Ws, you'll always hear them talk about high-contrast B&Ws, so you already know what you need to do— you need to create a high-contrast B&W. That basically means making the whites whiter and the blacks blacker. Start by going to the Basic panel and dragging the Exposure slider as far over to the right as you can without clipping the highlights (I dragged to +2.35 here; see page 32 for more on clipping high- lights). If you clip them just a little, drag the Recovery slider over until the white clipping triangle (up in the histogram) turns black again. If you have to drag it pretty far, you're better off just lowering the Exposure amount instead, or your conversion may look a little flat in the highlights.

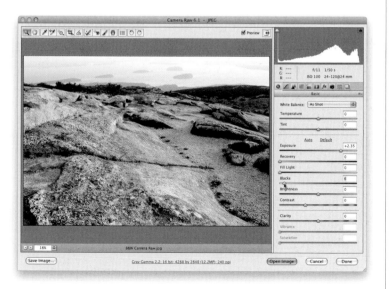

Step Four:

Now, drag the Blacks slider to the right until it really starts to look contrasty (as shown here, where I dragged to 6). If part of it gets too dark, drag the Fill Light slider a little to the right to open up those areas. So far, I've increased the Exposure and the Blacks.

Continued

Step Five:

The last two things I do are to increase the contrast (you can go to the Tone Curve panel and choose **Strong Contrast** from the pop-up menu at the top of the Point tab, or in this one instance, it's okay to just drag the Contrast slider to the right until the image looks real contrasty). Then, I increase the Clarity amount (which adds midtone contrast), and I usually push this one to around 75 for black-and-white images (unless it's a portrait, then I'll usually set it to around 25, unless it's a baby, then I leave it set at 0). A before/after of the conversion is shown below (the Auto conversion from the HSL/Grayscale panel is shown at left, with the simple Camera Raw tweaks you just learned at right). Pretty striking difference, eh?

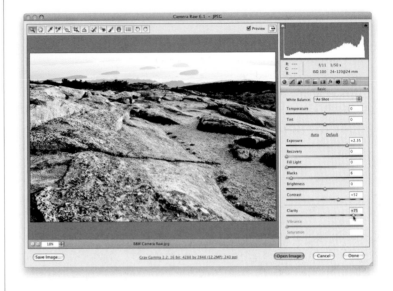

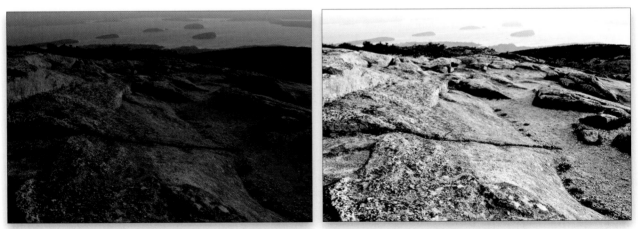

Before (the Auto grayscale conversion) *After (tweakin' it a bit)*

Some of the best techniques unfold when you least expect it, and this technique is a perfect example. I was working on a completely different technique when I stumbled upon this and I fell in love. It's about the easiest, fastest, most predictable way to create stunning high-contrast B&W images. Plus, at the end I show you how you can get two different variations to choose from with just a few clicks each. Not bad, eh matey?

Scott's Favorite High-Contrast B&W Technique

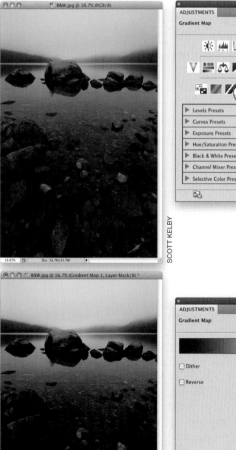

SCOTT KELBY

Step One:
Open the color photo you want to convert into a high-contrast B&W image. You start by pressing the letter **D** to set your Foreground color to black, and then in the Adjustments panel, click on the Gradient Map icon (it looks like a horizontal gradient—it's shown circled in red here).

Step Two:
Once you click that button, you're done! The Gradient Map options appear, but you don't have to do anything. Not a bad B&W conversion, eh? Believe it or not, just the simple act of applying this black-to-white gradient map will almost always give you a much better conversion than choosing Grayscale from the Image menu's Mode submenu, and I feel it's generally even better than both the default and Auto settings in the Black & White adjustment layer. Now, if I was going to nitpick this conversion, I'd like to see the edges a little darker. Easy enough.

Continued

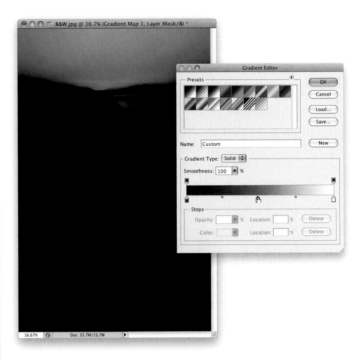

Step Three:
If you find a photo (like this one) where you want to tweak the conversion a little (like darkening the edges), then go to the Adjustments panel, and click directly on the gradient to bring up the Gradient Editor dialog. Once it appears, click once directly below the center of the gradient to add a color stop to your gradient (as shown here). The stop appears in the color black, so it's going to greatly darken your photo, but you'll fix that in the next step.

Step Four:
Double-click on that color stop you created and Photoshop's Color Picker appears (seen here). All you have to do is click-and-drag your cursor all the way over to the left side of the Color Picker, right up against the edge (as shown here), and pick a gray color. As you slide up and down that left side, let go of the mouse button and look at your photo, and you'll see the midtones changing as you drag. Once you find a spot that looks good (in our case, one where the center looks lighter), click OK to close the Color Picker (don't close the Gradient Editor, though—just the Color Picker at this point—because there's another tweak you can do. Of course, what we've done so far is probably all you'll have to do, but since there is something else you can do, I at least want to show you, but know that this next step usually isn't necessary).

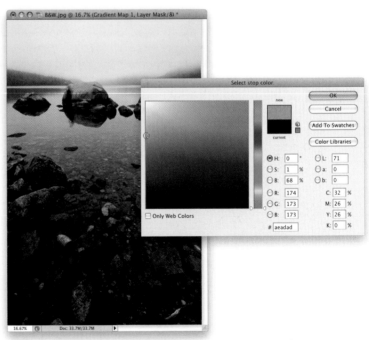

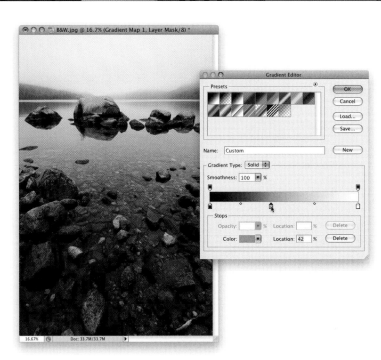

Step Five:
Once you're back at the Gradient Editor, and your color stop is now gray, you can drag that middle gray stop around to adjust the tone of your image (as shown here). What's weird is you drag the opposite way that the gradient shows. For example, to darken the photo, you drag to the right, toward the white end of the gradient, and to lighten the photo, you drag left toward the dark end. Freaky, I know. One other thing: unlike almost every other slider in all of Photoshop, as you drag that color stop, you do not get a live preview of what's happening—you have to release the mouse button and then it shows you the results of your dragging. Click OK, and you're done.

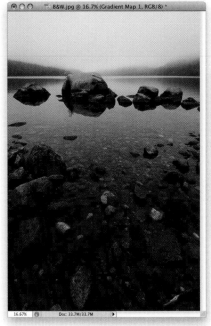

Step Six:
Here's one of the two variations I talked about in the introduction for this technique: just go to the Layers panel and lower the Opacity of your Gradient Map adjustment layer to 70% (as shown here). This bleeds back in a little of the color, and gives a really nice subtle "wash" effect (compare this slightly-colored photo with the full-color photo in Step One, and you'll see what I mean. It's kinda nice, isn't it?). Okay, now raise it back up to 100% for the second variation, which is also a second version of your B&W conversion.

Continued

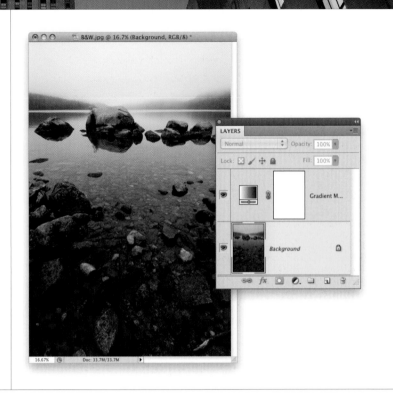

Step Seven:

For this version, go to the Layers panel and click on the Background layer, which is still in color. If you remove the color from that Background layer, you'd get a somewhat different conversion, right? Right! So, once you've clicked on the Background layer, press **Command-Shift-U (PC: Ctrl-Shift-U)**, which is the shortcut for the Desaturate command (it's found under the Image menu, under Adjustments). This removes the color and gives you a different look (although the change is fairly subtle with this photo, with some photos it's pretty dramatic—it just depends on the photo). But, either way, wouldn't you rather choose between two B&W conversions and then pick your favorite? If you don't like this other look, just press **Command-Z (PC: Ctrl-Z)** to Undo it.

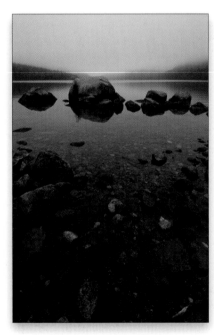

Regular grayscale conversion

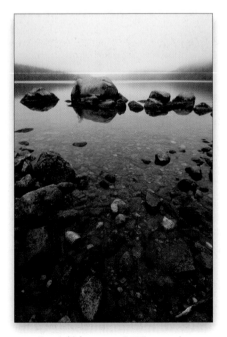

Scott's high-contrast B&W conversion

Split toning is a traditional darkroom special effect where you apply one tint to your photo's highlights, and one tint to your photo's shadow areas, and you even can control the saturation of each tint and the balance between the two for some interesting effects. Although split-toning effects can be applied to both color and B&W photos, you probably see it most often applied to a B&W image, so here we'll start by converting the photo to black and white, then apply the split-tone effect.

Split Toning

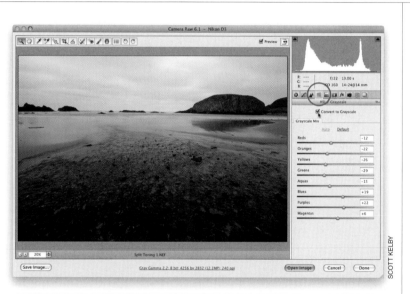

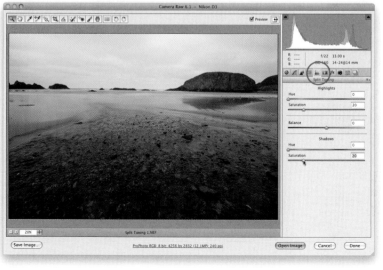

SCOTT KELBY

Step One:
Start by converting your full-color image to black and white by clicking on the HSL/Grayscale icon (the fourth icon from the left) at the top of the Panel area and then just turning on the Convert to Grayscale checkbox at the top of the panel (see page 228 for one of my favorite methods for converting to black and white).

Step Two:
Now, click on the Split Toning icon (the fifth icon from the left) at the top of the Panel area (it's circled in red here). At this point, dragging either the Highlights or Shadows Hue slider does absolutely nothing because, by default, the Saturation sliders are set to 0. So, do yourself a favor and drag the Saturation sliders for both the Highlights and Shadows to around 20 right now, so at least you can see what you're doing while you're dragging the Hue sliders.

TIP: Seeing Your Colors
To temporarily see your hues at their full 100% saturation, just press-and-hold the Option (PC: Alt) key, then click-and-drag a Hue slider. It helps when picking your colors, if you don't feel like taking my advice and increasing the saturation (like I mentioned at the end of Step Two).

Continued

Step Three:

Now, click-and-drag the Highlights Hue slider until you find a highlight hue you like. Once that's in place, do the same thing with the Shadows Hue slider. Since you increased the Saturation amount to 20 back in Step Two, you'll immediately see your tint appear on your image. In the example shown here, we have a yellow tint in the highlights and a blue tint in the shadows. I know what you're thinking, "Scott, I'm not sure I like split toning." I hear ya—it's not for everybody, and it's definitely an acquired taste (and I'm not quite sure I've acquired it yet), but some people love 'em. There's a name for these people. Freaks! (Kidding.)

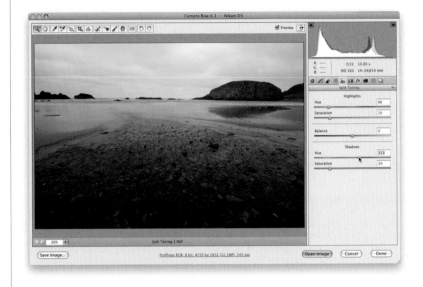

Step Four:

There is one more control—a Balance slider, which lets you control whether your split tone favors your highlight or shadow color. Just drag left, then back right, and you'll instantly see what this slider does (here, I dragged the Balance slider over to the left and you can see that the split tone now has more blue in the shadow areas). If you do find a split-toning combination you like (hey, it could happen), I'd definitely jump to page 240 to find out how to turn that into a one-click preset, so you don't have to go through all this every time you want a quick split-tone effect.

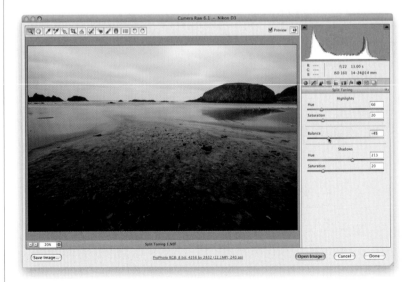

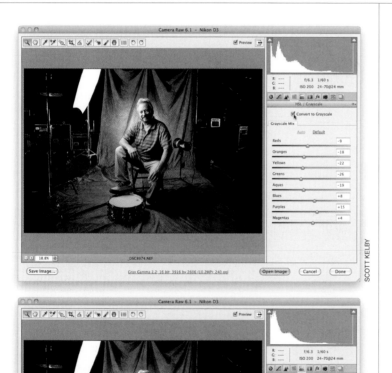

Don't let the fact that this technique fits neatly on one page make you think it's not a rocking technique, because this is the best and fastest duotone technique I've ever used (and it's the only one I use in my own workflow). I used to do a more complicated version, but then my buddy Terry White showed me a technique he learned from one of his buddies whose duotone he adored, and well…now I'm passing it on to you. It's very easy, but man does it work like a charm.

Duotones Made Crazy Easy

Step One:
Start by converting your color image to black and white by clicking on the HSL/Grayscale icon (the fourth icon from the left) at the top of the Panel area and then turning on the Convert to Grayscale checkbox at the top of the panel (see page 231 for one of my favorite methods for converting to black and white).

Step Two:
Now, click on the Split Toning icon at the top of the Panel area (it's the fifth icon from the left), and then, in the Shadows section, increase the Saturation amount to 25 as a starting point. Next, just drag the Shadows Hue slider until you have a nice sepia-tone hue (I generally use something around 28). If you think it's too intense, lower the Saturation and you're done. That's right—completely ignore the Highlights controls altogether, and you'll love the results you get (ignore the powerful pull of the Highlights sliders. I know you feel on some level that they will make things better, but you are already holding the magical key to great duotones. Don't blow it!). That's it—that's the whole ball of wax (I told you it was easy, but don't let that fool you. Try printing one of these and you'll see what I mean). Mmmm. Duotone.

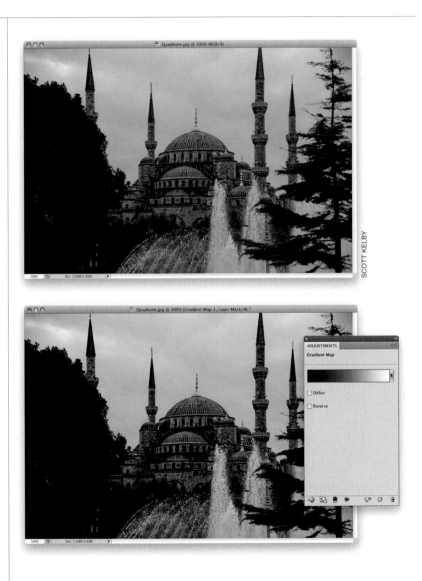

Quadtoning for Richer B&Ws

If you've ever wondered how the pros get those deep, rich-looking B&W photos, you might be surprised to learn that what you were looking at weren't just regular B&W photos, instead they were quadtones or tritones—B&W photos made up of three or four different grays and/or brown colors to make what appears to be a B&W photo, but with much greater depth. For years, Photoshop had a bunch of very slick presets buried somewhere on your computer, but luckily in CS5, they're just one click away.

Step One:
Open the photo you want to apply your quadtoning effect to (the term quadtoning just means the final photo will use four different inks mixed together to achieve the effect. Tritones use three inks, and do I really have to mention how many duotones use?). Quadtoning effects seem to look best with (but are not limited to) two kinds of photos: (1) landscapes, and (2) people.

Step Two:
To create a quadtone, you'll have to convert to Grayscale mode first, but by now you know what a flat-looking B&W photo that creates, so instead try this (from a few pages ago): Press the letter **D** to set your Foreground and Background colors to their defaults of black and white, then click on the Gradient Map icon in the Adjustments panel. When the Gradient Map options appear in the panel, you don't need to make any changes. Now, before you can make a quadtone, you need to convert this image to Grayscale mode by going under the Image menu, under Mode, and choosing **Grayscale**. It will ask you if you want to flatten your layers, so click the Flatten button. (It will also ask you if you want to discard the color info. Click Discard.)

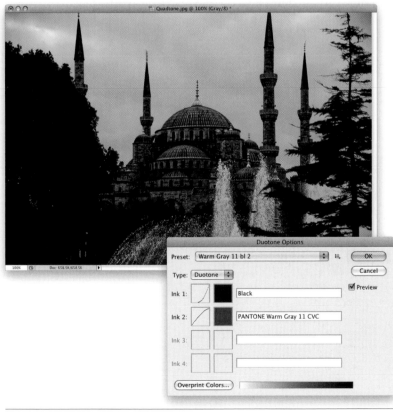

Step Three:

Once your photo is in Grayscale mode, the Duotone menu item (which has been grayed out and unchoosable until now) is now open for business (if you're in 8-bit mode). So, go under the Image menu, under Mode, and choose **Duotone**. When the Duotone Options dialog appears (shown here), the default setting is for a one-color Monotone (a cruel joke perpetrated by Adobe engineers), but that's no big deal, because we're going to use the built-in presets from the pop-up menu at the top. Here, you'll literally find 137 presets (I counted). Now, you'd think they'd be organized by duotones first, tritones, then quadtones, right? Nope—that makes too much sense (in fact, I'm not sure they're in any order at all).

Step Four:

I thought I'd give you a few of my favorites to get you started. One I use often is named "Bl 541 513 5773" (the Bl stands for black, and the three sets of numbers are the PMS numbers of the three other Pantone colors used to make the quadtone). How about a nice duotone? It uses black and it adds a reddish brown to the mix. It's called "478 brown (100%) bl 4," and depending on the photo, it can work really well (you'll be surprised at how different these same quadtones, tritones, and duotones will look when applied to different photos). There's a nice tritone that uses black and two grays, named "Bl WmGray 7 WmGray 2." We'll wrap things up with another nice duotone—this one's named "Warm Gray 11 bl 2," and gives you the duotone effect shown here. Well, there you have it—four of my favorites (and don't forget, when you're done, convert back to RGB mode for color inkjet printing).

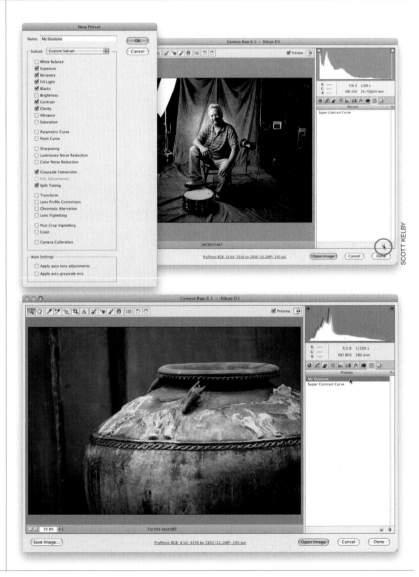

Creating Your Own One-Click Presets

Now that we created split tones and duotones, this is the perfect time to start making your own one-click presets. That way, the next time you open a photo that you want to have that same effect, you don't have to go through all those steps (converting it to black and white, tweaking it, then applying the Split Toning settings), you can just click one button and all those settings are applied at once, giving you an instant one-click effect anytime. Of course, these presets aren't just for split tones and duotones—make one anytime you want to reuse any settings.

Step One:

Since we just created that duotone effect, we'll go ahead and use that to create a one-click preset. Just remember—anytime you come up with a look you like, you can save it as a preset. To create a preset, you click on the Presets icon (it's the second icon from the right at the top of the Panel area), and then click on the New Preset icon (shown circled here in red) to bring up the New Preset dialog (seen here). Now, just turn on the checkboxes for the adjustments you want copied to your preset (as shown here), give your preset a name, and then click the OK button.

Step Two:

Once you've saved the preset, it appears in the Presets list (since there's only two presets here, I'm not sure it qualifies as a list at this point, but you get the idea, right?). To apply it is really a one-click process—just open a different photo, go to the Presets panel, and click on the preset (as shown here), and all those settings are applied. Keep in mind, though, because the exposure is different for every photo, if you save a preset where you had to tweak the exposure a lot, that same exposure will be applied anytime you apply this preset. That's why you might want to save just the split-tone/duotone settings and not all the exposure stuff, too.

I saved this for the last page, because I wanted to share all my favorite techniques for doing B&W using just Photoshop's tools, and although I still use those techniques from time to time, it would be pretty disingenuous of me if I didn't tell you what I do most of the time, which is: I use Nik Software's Silver Efex Pro black-and-white plug-in. Almost all the pros I know use it as well, and it's absolutely brilliant (and super-easy to use). You can download the free 15-day trial copy from www.niksoftware.com and see for yourself. Here's how I use it:

If You're Really, Really Serious About B&W, Then Consider This Instead

Step One:
Once you install Silver Efex Pro, open the image you want to convert from color to B&W, then go under Photoshop's Filter menu, under Nik Software, and choose **Silver Efex Pro**. When the window opens, it gives you the default conversion (which isn't bad all by itself), and a host of controls on the right side (but honestly, I literally never touch those controls).

Step Two:
The magic of this plug-in is its B&W (and duotone) presets. They're listed along the left side of the window, complete with a small preview of how the effect will look, but here's where I always start: on their High Structure preset. Eight times out of 10, that's the one I choose, because it has it's own high-contrast, sharpened look that is wonderful for so many images. However, if I'm converting a portrait, I'll often wind up using a different preset, because High Structure can be too intense when your subject is a person. So, I click on the top preset in the list, and then click on each preset below it until I find one that looks good to me, then I click OK in the bottom-right corner and I'm done. That's all I do. It's fast, easy, and it looks fantastic. That's just what I want.

Photoshop Killer Tips

Why the Fill Dialog Shows Up Sometimes, but Not Others

If you have a flattened image (so, it's just a Background layer), and you make a selection and press the **Delete (PC: Backspace) key**, the Fill dialog appears, (Content-Aware is selected in the Use pop-up menu, by default). But there are times when hitting Delete won't bring up the Fill dialog. Instead, if you have a multi-layered document, it will delete whatever is inside the selection on your current layer, making it transparent. (That's either, "Yikes!" or "Great!" depending on how you look at it.) Also, if you have only one single layer (that is not a Background layer), you'll again delete anything inside your selection and make it transparent. So, to bring up the Fill dialog in those instances, just use **Shift-Delete (PC: Shift-Backspace)** instead.

Move an Object Between Documents and Have It Appear in the Exact Same Place

If you have something on a layer in one document, and you want the object to appear in the exact same place in an-

other open document, here's what you do: First, press-and-hold the Command (PC: Ctrl) key, go to the Layers panel and click on the layer's thumbnail to put a selection around your object. Then, press **Command-C (PC: Ctrl-C)** to Copy that object into memory. Switch to the other document, then go under the Edit menu, under Paste Special, and choose **Paste in Place**. Now it will appear in the exact same position in the other document (provided, of course, the other document is the same size and resolution). This also works with selected areas—not just layers.

Removing Red Eye

If you have a photo that has someone with the dreaded red-eye problem, it's a 15-second fix. Use the Zoom tool **(Z)** to zoom in tight on the eye, then get the Red Eye tool from the Toolbox (it's under the Spot Healing Brush, or press **Shift-J** until you have it). Click it once on the red area of the eye, and in just a second or two, the red is gone. If your first try doesn't select all the red, increase the

Pupil Size up in the Options Bar. If the retouch doesn't look dark enough (the pupil looks gray, rather than black), just increase the Darken Amount up in the Options Bar.

Dragged-and-Dropped Images Don't Have to Appear as Smart Objects

You learned earlier that you can drag-and-drop images from Mini Bridge right into open documents (and if there isn't a document open, it'll open as a new document), but by default it always drags in as a Smart Object. If you'd rather it didn't, press **Command-K (PC: Ctrl-K)** to bring up Photoshop's Preferences, click on General on the left, then turn off the checkbox for Place or Drag Raster Images as Smart Objects.

Photoshop Killer Tips

Getting Sharp Edges on Your Stroke Layer Effect

If you've applied a large stroke using the Stroke layer effect (under the Layer menu) or Stroke layer style (by clicking on the Add Layer Style icon at the bottom of the Layers panel and choosing **Stroke** from the pop-up menu), you've probably already noticed that the edges start to get rounded, and the bigger you make the stroke, the rounder they get. So, what's the trick to nice, sharp straight edges? Switch the Stroke position or location to Inside. That's it!

White Balance Quick Fix

If you have an image whose white balance is way off, and you didn't shoot it in RAW, try this: go under the Image menu, under Adjustments, and choose **Match Color**. When the Match Color dialog appears, just turn on the Neutralize checkbox in the Image Options section. It works better than you'd think for most white balance

problems (plus, you can write an action to do all that for you).

Change Ruler Increments

If you want to quickly change the unit of measure in your ruler (say, from pixels to inches or from centimeters to millimeters), just Right-click anywhere inside the Rulers and choose your new unit of measurement from the pop-up menu that appears.

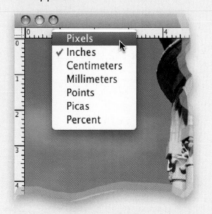

Using "Scrubby Sliders"

Anytime you see a numerical field in Photoshop (like the Opacity field in the Layers panel, for example), you

can change the setting without typing in a number, or dragging the tiny slider. Instead. click directly on the word "Opacity" and drag left (to lower the opacity) or right (to increase it). This is very fast, and totally addictive, and if you're not using it yet, you've got to try it. There's no faster way to made quick changes (also, press-and-hold the Shift key while using it, and it goes even faster).

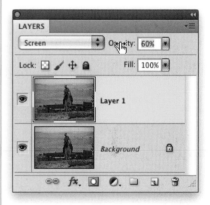

Doing a Smooth Zoom In

Another way to zoom in on your image is to click-and-hold the Zoom tool (the magnifying glass icon) on the spot where you want to zoom, and it smoothly zooms in right on that spot. The only downside is that it does it so smoothly, it's actually slow. It does look cool, but again, it's slow. That's why the new CS5 zoom (click with the tool and drag to the right) works so much better (though it's not nearly as cool to show to your friends as the "slow zoom").

Photo by Scott Kelby Multiple Exposures: 1/400 sec, 1/1600 sec, 1/800 sec, 1/125 sec, 1/80 sec | Aperture Value: ƒ/3.5

We Are HDR
creating HDR images

Tell me this isn't the perfect name for a chapter on HDR. The band is named hdr, their album is called We Are Hdr, and there's a song on the album called, "We Are HDR." This was destiny, my friends. Now, I have to admit, I have no idea if the HDR they are referring to actually stands for the type of HDR (High Dynamic Range) imaging we're talking about in this chapter, but on some level, I like to think it does (although it probably stands for something more like "Heavy Donut Raid" or "Her Darn Rottweiler" or maybe "Hi, Don Rickles"). Anyway, if there's a topic that gets photographers really riled up, it's HDR (Highly Decaffeinated Roast), so I don't really want to take us down that rabbit hole. Now, as you'll learn, there are two types of HDR (Hardee's Delicious Ribs): The good one, where you expand the dynamic range of the photo, getting a greater range of tone and light than today's digital cameras can create, which gives you an image that's closer to what the human eye captures. And the evil HDR (House Developers' Revolt), which makes your images look like a movie still from a Harry Potter movie. Now, I know as you read this, you're thinking, "Oh, I would want that first thing" and at this point, I totally believe that's what you think you want. But here's the thing: there's one slider in Photoshop CS5's new Merge to HDR Pro feature that lets you go from real to surreal pretty much by just sliding it one way or the other. And I know that, at some point, when nobody's looking, you're going to drag toward the fantasy side, and then—bam!—you're hooked, and before long, you're tone mapping everything from your wedding photos to baby photos, and you're friends and family will sit you down and try to help wean you off the "hard stuff," but the lure of surreal HDR (Hallucinogenic Deli Relish) is just too strong. Don't say I didn't warn you.

Setting Up Your Camera to Shoot HDR

For the HDR (High Dynamic Range) technique to work, you have to "shoot for HDR" (in other words, you have to set up your camera to shoot exposure-bracketed shots that can be used by Photoshop to create an HDR image). Here, I'm going to show you how to set up both Nikon and Canon cameras (the two most popular DSLR brands) to shoot three- and five-stop brackets, so all you have to do is hold the shutter button and your camera will do the rest.

Step One:
When you're shooting for HDR, you're going to be shooting multiple shots of the exact same scene (at different exposures), and since these images need to be perfectly aligned with one another, you really need to be shooting on a tripod. Now, that being said, Photoshop does have an Auto-Align feature that does an amazingly good job, so if you don't have a tripod, or you're in a situation where you can't use one, you can try hand-holding—just make sure you're shooting in a well-lit area, so your shutter speed will be fast enough that your images won't be blurry.

SCOTT KELBY AND BRAD MOORE

Step Two:
We'll need to vary our exposure as we take each HDR shot, but we can't vary the f-stop or our depth of field will change from shot to shot, so instead we vary our shutter speed (actually, the camera will do this for us). So, switch your camera to Aperture Priority mode (the A mode on Nikon cameras, like a D300S, D700, D3S, and D3X, and the Av mode on Canon cameras like the 50D, 7D, 5D Mark II, 1D Mark IV, etc.). In Aperture Priority mode, we choose an aperture (like f/8 or f/11 for outdoor shots), and then the camera will vary the shutter speed for us.

BRAD MOORE

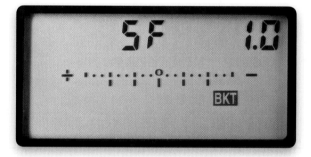

Step Three:
Go ahead and compose your shot, and focus on the scene you want to shoot. Once it's in focus, go ahead and switch your lens to Manual focus. That way, while your camera is taking multiple shots, it doesn't accidentally change focus. Now, just so we're clear, you're not going to manually focus—you're going to go ahead and use Auto focus just like always, but once it's focused on your scene, just switch off Auto focus, and then don't touch the lens.

Step Four:
Now we set up the camera to shoot brack-eted, which tells the camera to shoot the regular exposure, and then extra photos that are exposed both brighter and darker. The minimum number of exposures you can use for HDR is three, but I generally take five bracketed photos for my HDR images (although some folks take as many as nine). So, with five, I wind up with one shot with my normal exposure, then two darker shots (one 1 stop underexposed and one 2 stops underexposed), followed by two brighter ones (one 1 stop over-exposed and one 2 stops overexposed). Here's how to set up your camera to shoot bracketed (we'll start with a Nikon D300S, for example): To turn on bracketing on a Nikon D300S, press the Fn (function) button on the front of the camera, below the lens. Then use the main command dial to choose how many exposures to bracket (the control panel on the top of the camera shows the bracketing settings; choose 5F, so you get five bracketed shots). Use the sub-command dial (in front of the shutter button) to set the bracketing amount to 1 stop (as seen here).

Continued

Step Five:
Now, switch your Nikon camera to Continuous High shooting mode, and just press-and-hold the shutter button until it takes all five bracketed shots for you. That's it. Okay, on to the setup for Canon cameras.

TIP: Use a Low ISO
Because HDR shots are likely to increase any noise in your image, try to shoot your HDR shots using the lowest ISO you can get away with (100 ISO on most Canon cameras, or 200 ISO on Nikon DSLRs).

Step Six:
To turn on bracketing for a Canon camera (like the Canon 50D), start by going to the Camera Tab menu in the LCD on the back of the camera, then scroll down to Expo Comp/AEB (Auto Exposure Bracketing), and press the Set button. Now, use the Main Dial to choose 2 stops brighter, then press the Set button again (this automatically sets the bracketing to also shoot 2 stops darker). Now set your camera to High-Speed Continuous Shooting mode, and then press-and-hold the shutter button and your camera will automatically shoot all five bracketed photos (once all five are taken, you can release the shutter button). That's all there is to it.

Note: Because I shoot with a Nikon camera, which only brackets in 1-stop increments, I have to shoot five bracketed images to have one that's 2 stops underexposed and one that's 2 stops overexposed. However, Canon DSLRs bracket in 2-stop increments, so you'll only need to shoot three bracketed images. They contain enough depth to make the HDR (actually, the darker image is more important than the lighter one), and by only using three photos, the processing is much faster.

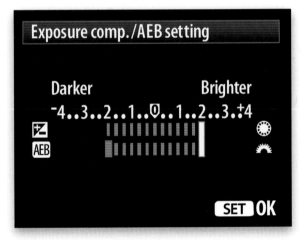

Creating HDR Images in Photoshop CS5

Photoshop CS5's HDR Pro is one of the biggest stars of the entire CS5 upgrade, and gets my award for Most Improved Feature in CS5 (because the HDR feature in CS4 and earlier versions was just...well...I'm not sure it was HDR). HDR Pro lets us do the entire HDR processing and tone mapping all within Photoshop itself, without having to buy third-party plug-ins, and its low-noise and built-in ghosting controls are the best available out there, which makes this a really usable and powerful tool, whether you want photorealistic or hyperreal, surrealistic HDR images.

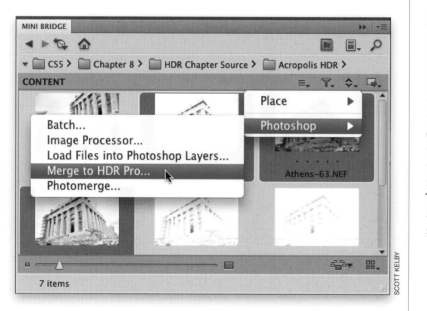

Step One:
If you shot for HDR (like I talked about in the previous tutorial), you can take those images straight from Mini Bridge to Photoshop's Merge to HDR Pro feature. In the example here, I've selected three shots I bracketed with my camera (one with the normal exposure, one that's 2 stops underexposed, and one that's 2 stops overexposed). Once you've selected them, go under Mini Bridge's Tools icon's menu, under Photoshop, and choose **Merge to HDR Pro** (as shown here).

Continued

Step Two:

After a few moments, you'll see the Merge to HDR Pro dialog appear (seen here) with the default settings applied, but they are so subtle you may not notice that anything's been done to your images at all. It displays the images it combined to create the single HDR exposure below the main preview (I always give these a quick glance to see that I did in fact use the correct three shots—here you can see the shot on the bottom left has an Exposure Value [EV] of +2.00 [2 stops brighter]; the center image is the normal exposure; and the one on the right has an EV of –2.00 [2 stops darker]). At the top right of the dialog, you'll see a pop-up menu that says **Local Adaptation.** That Local Adaptation option is the only one you want to use (the others are holdovers from the "bad HDR" of CS4 and earlier).

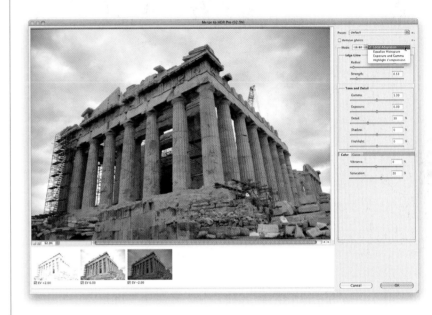

Step Three:

You might be tempted to choose one of the built-in presets from the Preset pop-up menu at the top right—but don't do it. The presets are...well...I don't know a nice way to say how bad they are, so go ahead, take 30 seconds, try a few out, and then you'll know for yourself. Anyway, ignore those and just know that, instead, a lot of your editing work will be spent finding a good balance between the two Edge Glow sliders. The Radius slider controls the size of the edge glow, and the Strength slider controls the contrast of that glow. Move these two sliders in small increments and you'll stay out of trouble. I'm going to give you some of my favorite settings shortly, but for now, we'll use the settings I use the most—we call them "Scott 5." So, set the Radius at 176 and the Strength at 0.47 (as shown here).

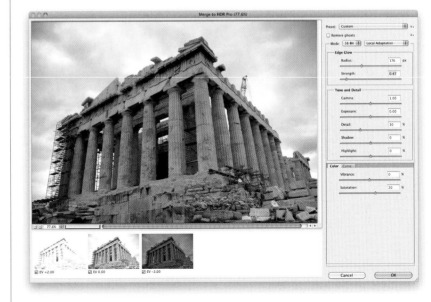

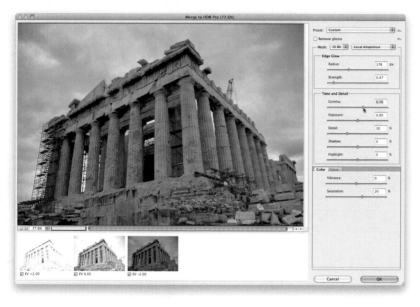

Step Four:

The next section down is Tone and Detail, and we'll start with the Gamma slider. If your overall exposure looks pretty decent, you probably won't have to mess with the Gamma slider much (especially if you're trying to create a photorealistic HDR image, rather than the hyper-contrast fantasy look). The Gamma slider controls the midtones, and if you drag the slider in either direction, you'll see how it affects the image. For this image, which is going more in the hyperreal direction, set the Gamma to the right at 0.76 (as shown here).

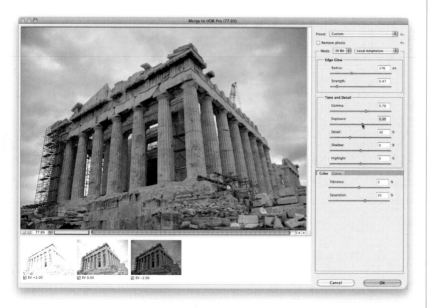

Step Five:

The Exposure slider controls the overall exposure, much in the same way the Exposure slider does in Camera Raw (dragging to the left darkens the overall image; dragging to the right brightens it). In this case, go ahead and drag the Exposure to 0.30 to lighten things just a little bit.

Continued

Step Six:

The next slider down is the Detail slider, which kind of acts like the Clarity slider in Camera Raw (it adds something similar to midtone contrast), and cranking this one way up helps to create the hyperreal-fantasy look. In this case, set the Detail amount at 300% (as shown here). It's starting to now get that "HDR look" (though it's not very photorealistic, but we'll be tackling that in a moment).

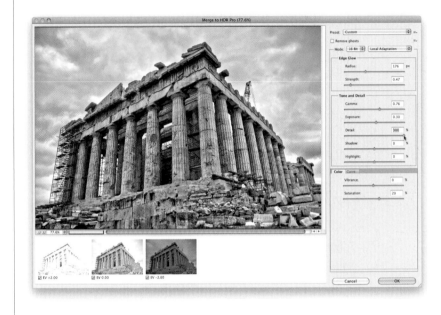

Step Seven:

The next two sliders—Shadow and High-light—don't usually have a dramatic effect, but they're handy when you need them. Dragging the Shadow slider to the right makes the shadow detail lighter—kind of like Camera Raw's Fill Light (but with-out as much power). The Highlight slider acts like Camera Raw's Recovery slider and dragging it to the left pulls back the very brightest highlight areas, but again, it doesn't have nearly as much effect as really cranking up Camera Raw's Recovery slider. Here, go ahead and set the Shadow amount at 100 and the Highlight amount at −100.

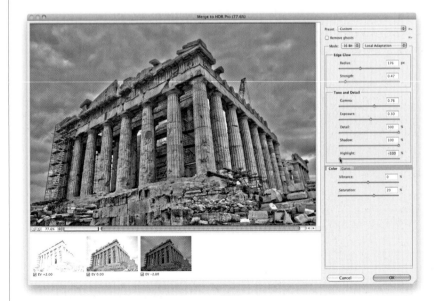

Step Eight:

The section at the bottom has two tabs: Color and Curve. The Color tab has Vibrance and Saturation controls (like Camera Raw's), so if you need to make the colors more vibrant, try dragging the Vibrance slider to the right. If you want to take your image to "Harry Potter world," then add in the Saturation slider, as well. Here, we'll set the Vibrance at 22 and the Saturation at 26 (the only reason we're doing something this extreme is because the image doesn't have much color to begin with). If you need to add more contrast, click on the Curve tab and create an S-curve. Add points to the curve by clicking along the diagonal line, then move them by dragging them up/down. We'll add the S-curve you see here at the bottom. Also, I turned on the Remove Ghosts checkbox (at the top right) in case the clouds moved a bit between shots (more on this later in the chapter).

TIP: Get That "Old-Timey" Look

If you increase the Vibrance and then decrease the Saturation, it gives your image that "old-timey look" (there's probably a better description, but you know what I mean). Give it a try, and I'll bet you'll say, "Hey, that's the old-timey look."

Step Nine:

Now, click the OK button at the bottom right to have Photoshop process the image. When it's done, you'll see the HDR image appear in Photoshop (as seen here). Now, there's something many people don't realize about the post-production process of HDR images: there's always a second round of processing in Camera Raw (this isn't new—we did this back in CS4 with third-party plug-ins, too!).

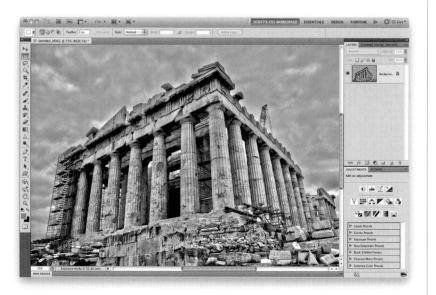

Continued

Step 10:

Before we start the post-production process, you have to save the file as a TIFF or JPEG (if you want to keep it in 16-bit mode, save it as a TIFF, otherwise, JPEG is fine) and then close it. Then go under Photoshop's File menu and choose **Open (PC: Open As)**. When the Open dialog appears, click on the JPEG or TIFF image you just saved, and from the Format (PC: Open As) pop-up menu at the bottom of the dialog, choose **Camera Raw** (as shown here) to have the image open in Camera Raw for processing, and then click Open.

Step 11:

When the image opens in Camera Raw, I usually crank up the Clarity amount (which brings out lots of little details), and in this case, we'll crank it up to +42 (as shown here). I also increased the Exposure to +0.35, the Recovery to 89, the Fill Light to 23, and the Blacks to 34.

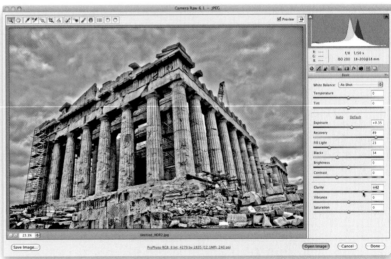

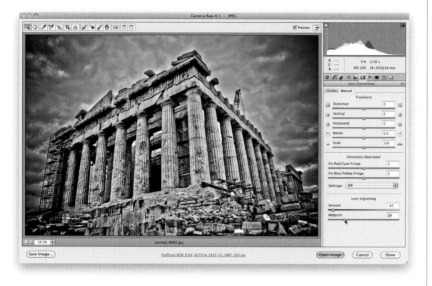

Step 12:

Next, we'll add a dark edge vignette (this is a very popular look in hyperreal HDR images), so click on the Lens Corrections icon (the fifth icon from the right) at the top of the Panel area, then at the top of the panel, click on the Manual tab. At the bottom of the panel, in the Lens Vignetting section, drag the Amount slider all the way to the left to darken the edges, and then drag the Midpoint slider to the left to extend the darkening inward from just the corners, so it's more even and larger all the way around.

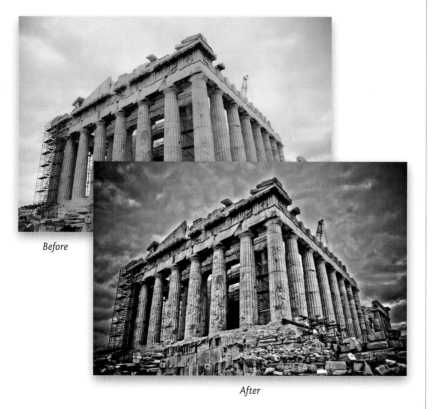

Before

After

Step 13:

That's it (well, that's it if you were going for the hyperreal look). Now, these settings worked for this particular image, but you could open a different image, and these settings might not work at all, which is why on the next two pages, I'm going to give you a few settings that I use myself for different HDR images when I want them to have the hyperreal look. What I recommend is trying them out, saving them as presets (see the next step), and then when you open an HDR image, at least you'll have a couple of starting points that are better than the presets that come with Merge to HDR Pro.

Continued

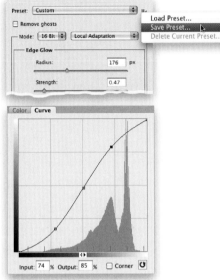

Step 14:

The settings we've used so far are the settings I use most of the time with Merge to HDR Pro, because they seem to work on almost any image. Around the office, we just call them "Scott 5" (because that's the name I gave the preset I saved with those settings). Here, I put them together in one place, so you can find them easily (don't forget to add the S-curve, though). Also, once you enter these, I would save them as a preset (but of course, you don't have to call them Scott 5). I always try these first: Under Edge Glow, set the Radius at 176 and set the Strength down to 0.47. Under Tone and Detail, set the Gamma at 0.76 and the Exposure at 0.30. Push the Detail all the way to 300%. Now, for the next two sliders, I pretty much use the same settings for every hyper-real look: I open the shadows fully up (setting the Shadow slider at 100%) and clamp the highlights fully down (setting the Highlight slider at –100%). In the last section, increase the Vibrance to 22% and the Saturation to 26%, then click on the Curve tab and make an S-curve (see Step Eight) to add contrast. Once you've put these settings in, if you like the look (of course, it depends on the image), go to the flyout menu to the right of the Preset pop-up menu, and choose **Save Preset** (as shown here). Give this new preset a name and it will be added to the bottom of the Preset pop-up menu.

Step 15:

This one doesn't look a whole lot different than the previous one, except I've learned that subtle differences between the Radius and Strength amounts can make a big difference. Set the Radius at 166, and the Strength at 0.39. Leave all the Tone and Detail settings like they were in Step 14, but then at the bottom, crank the Vibrance up to 80%, and set the Saturation down to 0%. Go ahead and save that one as a preset, too!

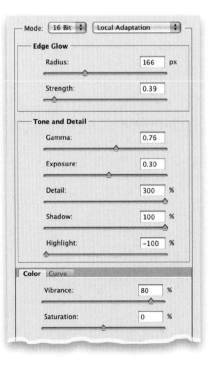

Step 16:

This particular one is a bit punchier, a bit more over the top, but it's worth trying because, on some images, it's just the ticket. Set the Radius at 370 and the Strength at 1.84. Set the Gamma at 0.23, the Exposure at –0.35, and the Detail down to just 156%. Set the Shadow and Highlight amounts the same as always (Shadow at 100%, Highlight at –100%). Down in the bottom section, set the Vibrance to 82% and the Saturation to just 10%. Of course, I always have the curve set to an S-curve to add more contrast. Now save this one as a preset, too, then I have one more for ya.

Step 17:

Our last hyperreal preset just tweaks things a little bit, but fairly often, that's all you need (and don't forget, you're going to do some post-processing after the fact, and with this one, you'll probably be adding lots of contrast and clarity in Camera Raw after the HDR processing). Set the Radius at 83 and the Strength at 0.43. Set the Tone and Detail settings like this: Gamma at 0.23, Exposure at 0.80, Detail at 270%, and Shadow and Highlight both at 100% (yup, I'm throwin' ya a curve ball). This one really pumps up the color, so set the Vibrance at 76% and the Saturation at 52%. Just remember: you may apply this preset and it might look terrible, depending on the image you try it on (this is why you need all five of these presets. At least one will get you in the ballpark).

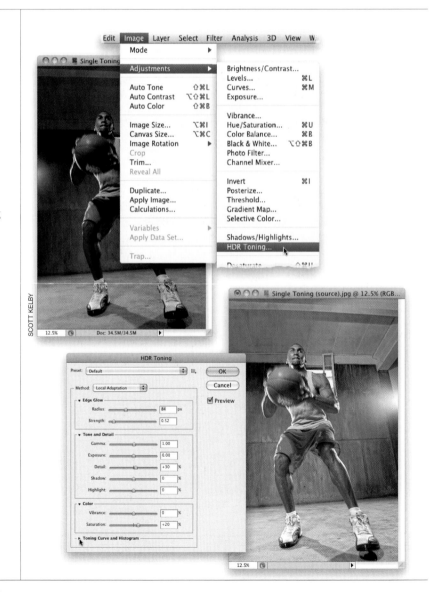

Single-Image HDR Toning Effect

If you didn't shoot for HDR (meaning you don't have at least three bracketed images of the same scene), you can still do single-image toning. While it doesn't create the exact same result, it does create a pretty cool effect, and best of all, it uses the same controls as the regular Merge to HDR Pro dialog does for multi-image HDR processing. So, you already pretty much know what to do (except I've found the controls are much more sensitive with just one image than they are when applying them to a multi-image, real HDR).

Step One:
Open the image you want to add a "faux-HDR" look to, then go under the Image menu, under Adjustments, and choose **HDR Toning** (as shown here). Before we go on, I just want to reiterate what I said in the intro above: while the controls in the HDR Toning dialog look the same as the Merge to HDR Pro controls, they seem to be much more sensitive, so you can't use the same settings and get the same effect—you have to back everything off a bit.

Step Two:
When the HDR Toning dialog appears, the default settings give your image somewhat of a tone-mapped effect (as seen here, where the image is more con-trasty, brighter in the shadow areas, appears to have some clarity applied, and the colors are more vivid). This is what I mean by being more sensitive, because when you open a bracketed multi-image HDR photo, with the default settings, you hardly notice a difference in tone at all. Now, let's crank things up and get the faux-HDR look from this one image. *Note:* If the Toning Curve and Histogram section at the bottom of the dialog is collapsed, just click on the right-facing arrow to the left of the section header to expand it.

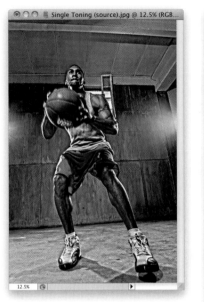

Step Three:

We're going to take what we learned when using Merge to HDR Pro and apply it here, but again, without moving our sliders nearly as much in either direction. Start by setting your Edge Glow Radius to 60 and the Strength to 0.87. In the Tone and Detail section, set your Gamma to 1.00 and your Exposure to +0.57 to brighten the image a bit. Set your Detail to +185% to add that clarity-like crispness (take a look at the wall behind him), then set your Shadow slider to +41% and your Highlight to −36% (here the Shadow and Highlight sliders really make a big difference). In the Color section, leave the Vibrance set to 0%, but lower the Saturation to −10% to get that desaturated portrait look that's so popular right now. The image looks a little too light in the shadow areas, so go down to the Toning Curve and Histogram section, click once on the lower third of the diagonal line, and drag downward (as seen here) to darken up the shadow areas a bit.

Step Four:

Click OK to apply your settings (again, these settings work for this particular image—you'll have to play around with the sliders, depending on the image). I'm showing you a before/after here (with an edge vignette added as a finishing touch—see page 237), but we're not done yet, because on the next page, I'm going to show you another way to apply this effect that you actually might find more useful in day-to-day photo editing. For now, here's what the before and after look like using the settings you applied in Step Three. By the way, now would be a good time to save those settings as a preset, don'tchathink (just click on the flyout menu to the right of the Preset pop-up menu)?

Before

After

Continued

Step Five:

In the last project, we applied the HDR Toning look to the entire image, but most of the time I use this, I just want to apply it to part of the image. For example, here, I just want to apply it to the foreground of the image, so we'll need more than one layer to do this. Unfortunately, you can't apply HDR Toning on an image with multiple layers. In fact, if you have a multi-layered image, and you open HDR Toning, it tells you it's going to flatten the image first. Of course, you can click No in the dialog, and just cancel the HDR Toning, keeping your layers intact. But, for this technique we need multiple layers, so start by going under the Image menu and choosing **Duplicate** (as shown here). When the Duplicate Image dialog appears, just click OK (no need to rename it anything special).

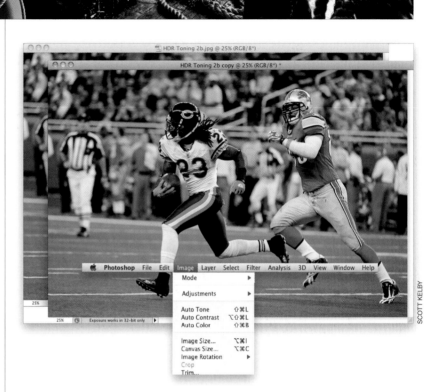

Step Six:

Now go under the Image menu, under Adjustments, and choose **HDR Toning** for this duplicate of your main image. We're going to apply a setting that'll enhance the contrast and detail in the players' uniforms, helmets, and the ball (all the stuff in the foreground). So, set your Edge Glow Radius to 118 and the Strength to 0.80. In the Tone and Detail section, set your Gamma to 0.82 and your Exposure to −0.57 to darken the image a bit. Set your Detail to 112% to add crispness, then set your Shadow slider to −22% and your Highlight to +36%. In the Color section, leave the Vibrance set to 23%, but lower the Saturation to 20%. So, how did I come up with these settings? Knowing that the Detail slider is the "main" slider for all this, get it where you want it and then try the other ones to tweak it.

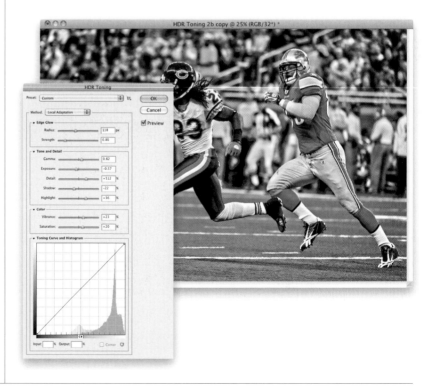

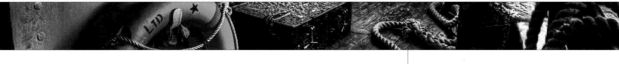

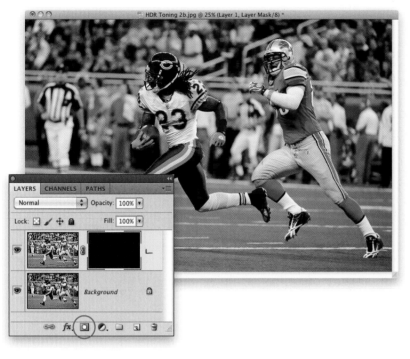

Step Seven:

Click OK to apply your HDR Toning. Then, get the Move tool **(V)**, press-and-hold the Shift key, and drag-and-drop this duplicate image on top of the original. (*Note:* If you're using the Application Frame, go under the Window menu and turn it off, if you're not used to dragging-and-dropping layers with it on.) Holding the Shift key down as you drag perfectly aligns the HDR Toning image with the original and, if you look in the Layers panel, you'll see that they are now both in the same document on separate layers. So, press-and-hold the Option (PC: Alt) key and click on the Add Layer Mask icon at the bottom of the panel (shown circled here). This puts a black mask over your HDR Toning layer, hiding it from view, and allowing us to just reveal part of this layer where we want it.

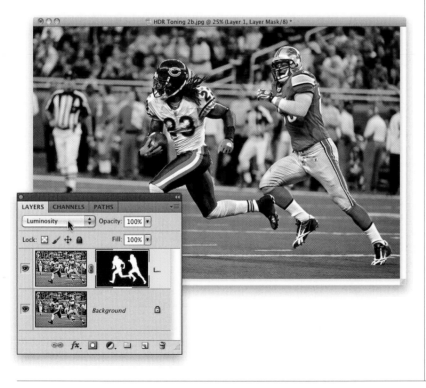

Step Eight:

Next, get the Brush tool **(B)**, and with your Foreground color set to white, choose a medium-sized, soft-edged brush from the Brush Picker in the Options Bar, and paint over just the areas you want to have this HDR Toning look. I've found that this look doesn't look very good on areas with a shallow depth of field, so I avoid those areas altogether. In this case, I painted over the two players in front, their jerseys, helmets, and pants, and the ball. By applying the HDR Toning this way, the background still looks realistic, but the players in the foreground get that added detail. Lastly, you'll probably notice the colors look more saturated, but if you want to maintain more of the original color, at the top of the Layers panel, switch the layer blend mode to Luminosity (as shown here), which completes the effect.

Dealing with Ghosting in Merge to HDR Pro

If anything was moving slightly in the scene you were photographing (like water in a lake, or tree branches in the wind, or people walking by, etc.), you'll have a ghosting problem, where that object is either blurry (at best), or you'll actually see a transparent ghost of that part of the image (henceforth the name). In this photo of New York's Times Square, although I was on a tripod, it was shot at night, requiring longer exposures, and both people and cars were moving in the scene, and that created ghosting problems galore!

Step One:
Go ahead and select your HDR bracketed images in Mini Bridge, then choose **Merge to HDR Pro** from Mini Bridge's Tools icon's pop-up menu. When the images open in the Merge to HDR Pro dialog, use the Scott 5 settings I gave you in Step 14 in the "Creating HDR Images in Photoshop CS5" project (near the beginning of this chapter), but since this image was shot at night, increase the Exposure amount to 0.80 to brighten it up, and also set the Shadow slider to –100. Now, zoom in to at least a 100% view, and you'll see that there's a lot of ghosting in the image (the car on the left is totally blurry, and parts of the heads of the two guys on the right are see-through).

Step Two:
Turn on the Remove Ghosts checkbox at the top right of the dialog (it's shown circled here in red). Merge to HDR Pro tries to deal with the ghosting by looking for things that are in common in all your exposures to lock onto and it does a pretty amazing job of it. Of course, sometimes it makes the wrong guess (more likely, if you're creating HDR from JPEG images rather than from RAW images), and if this happens, you can choose which of your bracketed photos you think it should lock onto, by clicking on its thumbnail in the filmstrip at the bottom of the dialog.

SCOTT KELBY

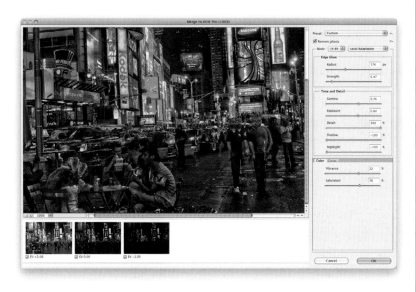

Step Three:

The thumbnail with the green highlight around it is the one it chose to lock onto for de-ghosting purposes (you'll only see this green highlight when the Remove Ghosts checkbox is on), and if you look back in Step Two, you'll see that it originally chose the thumbnail on the left. If you want to try one of the other images, and see if using it does a better job than the one Photoshop chose, just click on it down in the filmstrip. Here, I clicked on the third image, and it actually looks worse. (*Note:* If you shot a multi-photo exposure of something, like waves rushing to the shore, you can actually choose which individual wave you want visible using this same technique, so it's not just for ghosting.) So, at this point, I'd click back on the first thumbnail, which did a pretty amazing job.

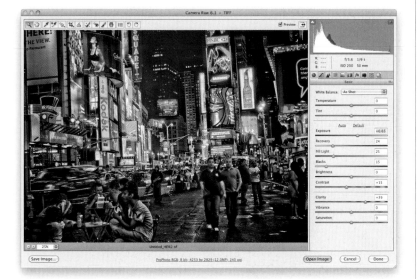

Step Four:

You finish this surreal style HDR image off just like you learned in "Creating HDR Images in Photoshop CS5"—by saving it as a TIFF or JPEG, then reopening it in Camera Raw for the finishing moves. In this case, I added a standard edge vignette in the Lens Corrections panel (what's an HDR without a huge vignette, eh?), and then I used the settings you see here in the Basic Panel: set the Exposure at +0.65, Recovery at 24, Fill Light at 25, Blacks at 15, and increase the Contrast to +15. Lastly, as always, I pumped up the Clarity (in this case, to +39, as shown here). Now, in this image, there's a lot of ghosting throughout (not just the people and cars, but the moving signs, as well), but more than likely, your ghosting will be caused by a swaying tree branch, or ripples in a pond, or one of a million things that move for the sole purpose of messing up HDR images (kidding).

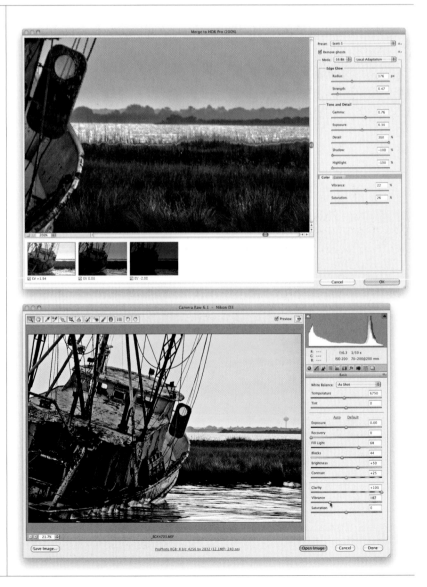

Fixing Edge Problems in Your HDR Shots

If you like to apply heavy HDR effects to your HDR images (not that there's anything wrong with that), depending on the image, you're likely to have at least one or more areas where the edge of something in your photo looks "funky" (like someone traced along the edge with a magic marker). It's one of those "you'll definitely know it when you see it" things. It happened in the HDR photo we used earlier in the High Pass sharpening project, so I pulled a trick I use to hide that ugly edge problem. Here's what to do when it happens to you:

Step One:
Go ahead and process your bracketed multi-photo HDR image as normal, using Merge to HDR Pro (here, I used my Scott 5 settings [see page 204], and turned on the Remove Ghosts checkbox at the top right, because of the moving water in the background). I zoomed in on the shoreline to the right of the rusty old fishing boat, where you can see a great example of the edge problem I'm talking about. It looks like someone went along that shoreline with a marker, doesn't it? To me, that totally tanks the shot, but we can't fix this within Merge to HDR Pro itself, so go ahead and process the shot, and click OK.

Step Two:
Now, go to Mini Bridge and find the first photo of your three (or five, seven, etc.) images you used to make your HDR image (this should be the one with the normal exposure, before the bracketing in your camera kicked it). Right-click on it, and choose **Open in Camera Raw** to open this image in Camera Raw (or just double-click on it, if it's a RAW image). Now, you're going to give it a "fake HDR" look (not a lot, but enough to give it a high-contrast look). This usually entails four things: (1) increasing the Fill Light, (2) increasing the Blacks, (3) increasing the Clarity a lot, and (4) lowering the amount of Vibrance to get a bit of a desaturated look. Here are the settings I used on this image: Fill Light at 68; Blacks at 44; Clarity at +100; Vibrance at −47.

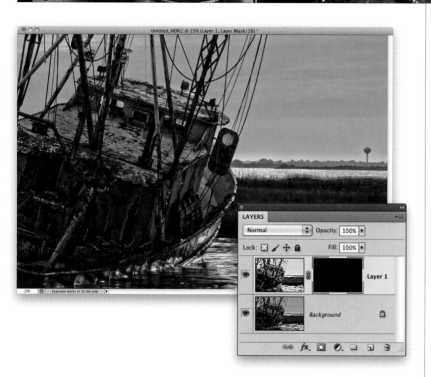

Step Three:

Go ahead and click OK to open that single image in Photoshop. Now, get the Move tool **(V),** press-and-hold the Shift key, and drag-and-drop this fake HDR image on top of your real HDR image (holding the Shift key makes sure the two line right up). (*Note:* If you handheld your original HDR image, and Photoshop had to do some layer alignment before it applied the HDR effect, holding the Shift key may not be enough to line these two perfectly up. If that's the case, then in the Layers panel, select both layers, go under the Edit menu, choose **Auto-Align Layers**, and click OK to have Photoshop align them.) Next, press-and-hold the Option (PC: Alt) key and click on the Add Layer Mask icon at the bottom of the Layers panel, to hide this fake HDR layer behind a black mask.

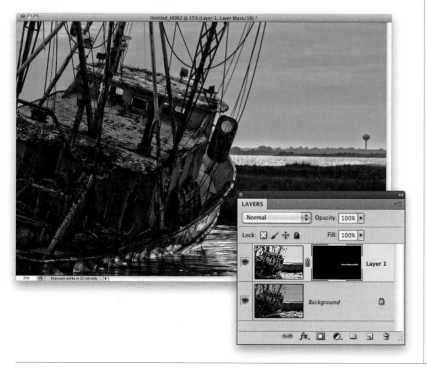

Step Four:

Set your Foreground color to white, get the Brush tool **(B)**, choose a small, soft-edged brush from the Brush Picker in the Options Bar (size it so it's just slightly larger than the magic marker-like edge area), then just paint right along that messed-up edge. As you do, it reveals the edge from the fake HDR image, which doesn't have the edge problem at all. Because you added all that Clarity and Fill light (among other things) to the fake HDR image, the two blend together perfectly, and your edge problem is gone (as seen here).

HDR Finishing Technique for That "Photomatix" Glow Look

Before Photoshop CS5 introduced Merge to HDR Pro, we all used a really good third-party plug-in called Photomatix Pro, and I could always tell when an image had been processed in Photomatix Pro, because it had this trademark "sharp, but with a blurry glow" kind of look to it. I know a lot of folks have been accustomed to that look, so I've been kind of recreating something like it in Photoshop for my own HDR photos, and I'm including it here for those of you moving from Photomatix Pro to Merge to HDR Pro who might miss that trademark look.

Step One:
Go ahead and select the three bracketed images in Mini Bridge (of course, you can download these same images from the book's download page, mentioned in the introduction), and then choose **Merge to HDR Pro** from Mini Bridge's Tools icon's pop-up menu, and when it opens in Merge to HDR Pro, it'll look like what you see here, by default. It looks extremely "blah," but I knew that would be the case—I took the shot knowing I'd be throwing lots of HDR processing on it (I thought the grungy alleyway, with old bikes, textured walls, and hanging clothes, might make a fun HDR Pro project).

Step Two:
Now, let's get crazy. For this surreal look, I used the following settings: Set the Radius at 118 and the Strength down to 0.47. Set the Gamma at 0.39, the Exposure to 0.30, push the Detail all the way to 300%, and set the Shadow and Highlight amounts at 0%. Then, at the bottom, increase the Vibrance to 100% and the Saturation to 53%. You can also add an S-Curve to add contrast by clicking on the Curve tab (see page 201 on creating an S-curve). Now, turn on the Remove Ghosts checkbox at the top right and click OK. (By the way, if you've been wondering what really over-the-top HDR tone mapping looks like, I'd say this qualifies.)

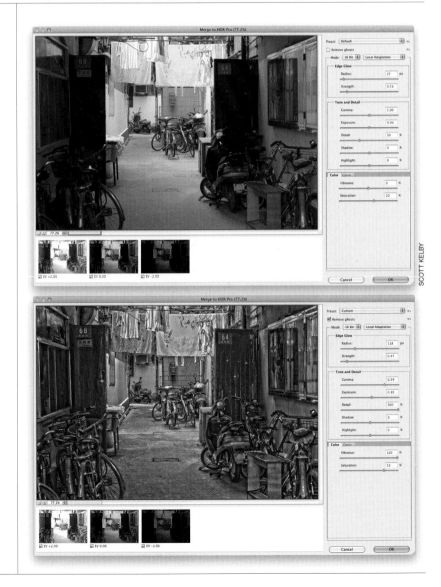

SCOTT KELBY

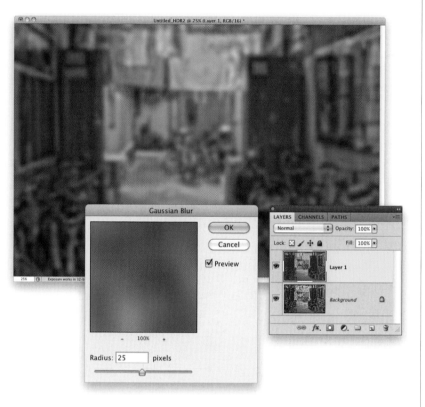

Step Three:

When the image opens in Photoshop, press **Command-J (PC: Ctrl-J)** to duplicate the Background layer. Then go under the Filter menu, under Blur, and choose **Gaussian Blur**. When the dialog appears, enter 25 pixels as your Radius (as shown here), and click OK. This blurs the living daylights out of your image, but that's okay—it's the first step in getting our "sharp, but with a blurry glow" look.

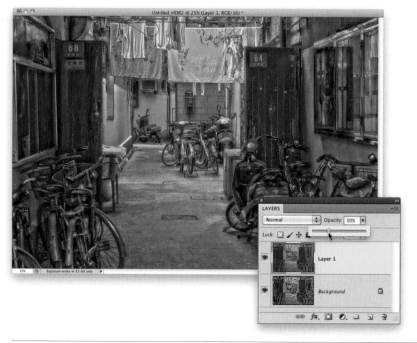

Step Four:

Go to the Layers panel, and lower the Opacity of this layer to around 30% (this varies from image to image, but generally I use between 20% and 30%). This is what gives it that sharp-yet-blurry look. You start with a really crisp HDR image, but then you add a low-opacity blur to it, and everything kind of gets this hazy glow to it, but because the opacity is so low, it still looks sharp. At this point, I would go to the Layers panel's flyout menu and choose **Flatten Image** to flatten your layers, save the image as a TIFF or JPEG, then reopen it in Camera Raw for your final finishing touches (like I did earlier at the end of the Ghosting project, and just like I did there, I'd add a dark edge vignette, as well).

Photoshop Killer Tips

Zooming In Really Tight? There's a Pixel Grid to Help You Out

You won't see this neat little feature unless you zoom in to 600% magnification or more—it's a little pixel grid that appears that makes it visually easier to tell pixels apart when you're zoomed in crazy tight. It's on by default (give it a try—zoom in crazy tight and see), but if you want to turn it off, just go under the View menu, under Show, and choose **Pixel Grid**.

Create a New Document Just Like the Last One

There's a super-handy, yet little known shortcut, that lets you create a brand new document using the exact same specs (size, resolution, color mode, etc.) as the last one you made. Instead of choosing **Command-N (PC: Ctrl-N)** to bring up the New dialog, just press

Command-Option-N (PC: Ctrl-Alt-N), and when the New dialog appears, all the specs for your last document will be entered for you.

Hide All Your Panels Fast

If you want to focus on your photo, and temporarily hide your Toolbox, Options Bar, Application Bar, and all your panels, just press the **Tab key.** Press it again to bring it all back.

Saving Time in HDR Pro

The more images you use to create your HDR images, the longer it takes HDR Pro to compile your final image, so this is a case where less is more. I usually use three images (one normal exposure, one that's 2 stops darker, and one 2 stops brighter), but an interesting tidbit I learned from one of the Photoshop product managers is that, for the best results, you need more darker photos than lighter ones. So, if you don't mind the extra wait, you're better off having just one image with a really bright exposure and four darker ones, than you are with an equal balance.

Editing the Lens Correction Grid

When you use the Lens Correction filter in CS5, the first thing you'll notice is that "annoying grid" isn't turned on by default (by the way, the only reason it was annoying was because it was

turned on by default). Now, not only is it off by default, but you can edit the size and color of the grid itself. When you turn on the Show Grid checkbox at the bottom of the dialog, a Size

field and a color swatch become available to the right of the checkbox. Also, although there is a grid in the Lens Corrections panel of Camera Raw (press **V** to toggle it on/off), you can't change the size or color of that grid.

Need Help Finding the Right Colors?

Back in CS4, Adobe introduced this very cool little utility called "Kuler" which was designed to help you find, mix, match, and try out different color schemes, and it was so popular that it spawned its own online community, with users sharing and rating different sets of colors based on themes. Now in CS5, Kuler is built right into Photoshop in its own panel. Just go under the Window menu, under Extensions, and choose **Kuler**, and browse some of the most popular color combos right within Photoshop. If you see a set of colors you like, double-click on it to see them as larger swatches in a panel.

Photoshop Killer Tips

To make any of those color swatches your Foreground color, just double-click on it.

Getting Rid of Your Empty Layers Fast

In CS5, Adobe included a built-in script that will go through your Layers panel and remove any empty layers (layers with nothing on them) automatically (once you get a large multi-layered project going, you wind up with more of these than you'd think). To have Photoshop tidy things up for you, go under the File menu, under Scripts, and choose **Delete All Empty Layers.**

Removing Noise from Cell Phone Photos

Since Photoshop is a pro tool, most of us probably wouldn't even think of using Camera Raw's built-in Noise Reduction feature to remove the noise from our cell phone camera's photos, but…why not? Cell phone photos are notorious for color noise, which Camera Raw cleans up really well. Try it one time, and I'll bet you'll use it more than you ever dreamed (to open a cell phone photo in Camera Raw, just find it on your computer in Mini Bridge, then Right-click on it and choose **Open in Camera Raw**).

Using the HUD Pop-Up Color Picker

If you've ever thought, "There's got to be an easier way to pick colors than clicking on the Foreground color swatch every time," you're gonna love this: It's a pop-up Color picker (Adobe calls it the HUD [Heads-Up Display], because you keep your eyes on the image, instead of looking over and down at the Foreground/Background color swatches). First, choose a Brush tool, then just press **Command-Option-Ctrl (PC: Alt-Shift)** and **click (PC: Right-click)** on your image. It brings up a simplified color picker where you can quickly choose your color (I find it easier if you choose the hue first, from the bar on the right, then choose the tint and saturation of the color from the box on the left).

Three Ways to Fix the Color in Indoor Shots

You can shoot outside all day and be getting shots that look just great, but step indoors and everything changes. The culprit is Auto white balance (the default setting on digital cameras, and most people never change from this default). With Auto white balance, shooting indoors (like the interior shot shown below) you get what you see here—a photo that looks way too yellow (or if I had shot in an office, where the standard is fluorescent lighting, it would be too blue). Here are three different ways to deal with the problem:.

Step One:

Here's a photo taken in the lobby of a hotel and, of course, it has the type of lighting you're likely to find in a lobby (or a home), called "tungsten lighting" (by photographers and people who sell lighting for a living), which is why the color in the photo looks so yellow (pretty typical for shots taken indoors when your white balance set to Auto). The first method is to add a blue Photo Filter adjustment to offset the yellow and make the color look more natural, so click on the Photo Filter icon in the Adjustments panel (it's shown circled here).

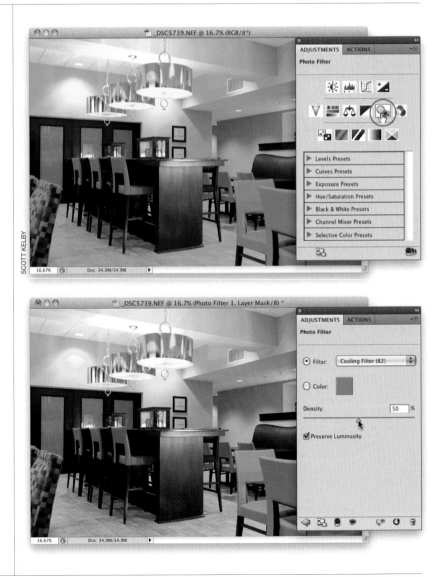

Step Two:

Just a heads up: when you choose Photo Filter, the default filter is yellow, so your photo looks even worse at first, but that's easy to fix. From the Filter pop-up menu, choose **Cooling Filter (82)**, as seen here, and then drag the Density (amount) slider to the right until the image looks more natural. Here, I dragged it over to 50% (the amount will be different depending on the photo, so this is a judgment call you'll have to make). This correction looks okay, but if you have the original RAW image, you can get a much better correction than this using Camera Raw.

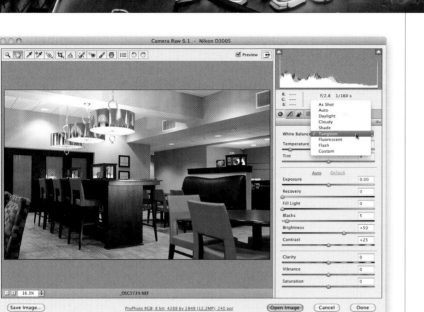

Step Three:

If you took the original shot in RAW, this is the best case scenario, because you'll usually get much better results by opening the image in Camera Raw and choosing one of the built-in presets in the White Balance pop-up menu, like Tungsten (shown here), which pretty much fixes the problem, and does it without washing out the red color in the chairs (if you look back at the image in Step Two, the chairs lost some of the saturation in the reds. It was a fair trade—to lose some of the red to get the rest of the color fixed—but this method, with a RAW photo, is much better all around). In short: you'll get better results fixing the white balance of RAW images in Camera Raw than you will for JPEG or TIFF images.

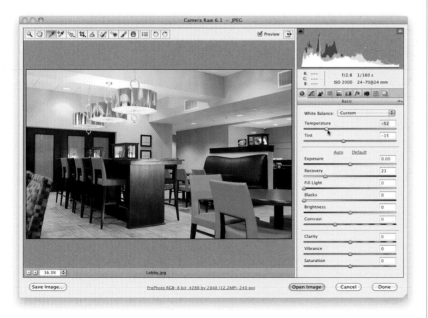

Step Four:

If your original shot was taken as a JPEG or TIFF, you can still use Camera Raw to adjust your white balance, but the results won't be as good as if it had been shot in RAW. Click on the photo in Mini Bridge, then Right-click on it and choose **Open in Camera Raw.** When it opens, you'll see that something's missing—there is no Tungsten preset for JPEGs or TIFFs, only As Shot and Auto (Auto seems to look okay as a starting place for this photo, but I had to drag the Temperature slider to the left a bit to remove more of the yellow, and it still doesn't look as good as the simple Tungsten preset used on the RAW image in Step Three). Your other choice is to get the White Balance tool and click on a light gray area in the photo (I tried this, as well, and in this case, it looked worse than the Auto preset).

Continued

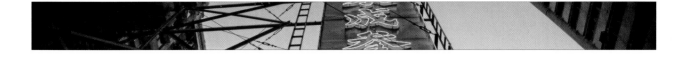

When Your Subject Is in the Shadows

We all wind up shooting subjects that are backlit (where the light is behind your subject). That's because our eyes automatically adjust to the situation and we see the subject just fine in our viewfinder. The problem is our cameras aren't nearly as sophisticated as our eyes are, so you're almost guaranteed to get some shots where the subject is way too dark. Although I feel you get better results using Camera Raw's Fill Light and Recovery sliders, Shadows/Highlights does a fairly decent job, and there's a trick you can use to make the adjustment re-editable.

Step One:

Open a photo where your subject is in the shadows (it can be a person, or a building, or anything backlit). In this example, the light is coming from the windows behind our subject, so he appears almost like a silhouette. Ideally, we'd like to brighten him up, and darken the light from the windows and the wall to the right by pulling back the highlights. To do this, first go under Filter menu and choose **Convert for Smart Filters**. This lets you apply the adjustment as if it was an adjustment layer (meaning you can re-edit it later if you need to, or even delete the adjustment altogether). Even though the adjustment we're going to apply isn't found under the Filter menu, for some reason Adobe lets it act like it is a regular filter, so why not take advantage of it, eh? Now go under the Image menu, under Adjustments, and choose **Shadows/Highlights**.

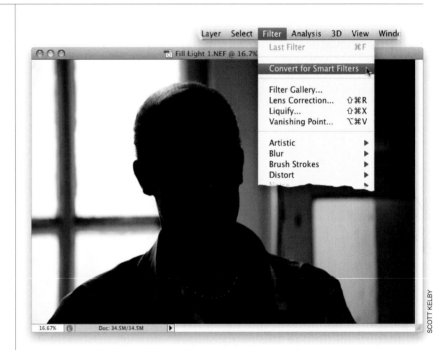

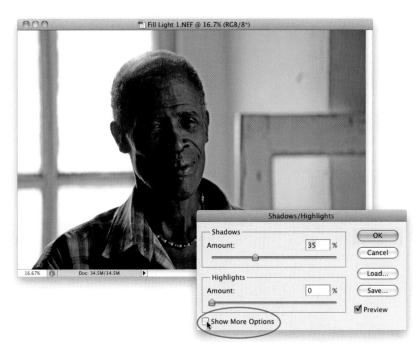

Step Two:

If you're choosing Shadows/Highlights, you probably have a problem in the shadow areas, which is why, by default, it's set to open up (lighten) the shadow areas in your photo by 35% (as seen here). In previous versions of Photoshop, the default setting was 50%, but most users felt it was too high a setting, so in CS5, Adobe set it down to something more reasonable. However, in this case, our subject is so buried in the shadows that we'll have to open the shadows quite a bit, but the problem with opening the shadows 50% or more is your photos tend to look "milky." To get around that, turn on the Show More Options checkbox, as shown here.

Step Three:

This brings up an expanded version of the dialog (as shown here). I have a little formula that I use that usually gives me the opened up shadow areas I need, without looking totally fake. First, I usually leave the Amount somewhere around 35% (the final amount depends on the individual photo, and here I had to increase it to 75). Then, I drag the Shadows Radius slider to the right to between 65 and 80 (as shown here), which smoothes out the effect even more. (The Radius amount determines how many pixels each adjustment affects, so to affect a wider range of pixels, increase the amount.)

TIP: Save a New Default

If you come up with some settings you like, click the Save As Defaults button in the bottom-left corner of the dialog, and now it will open with your settings.

Continued

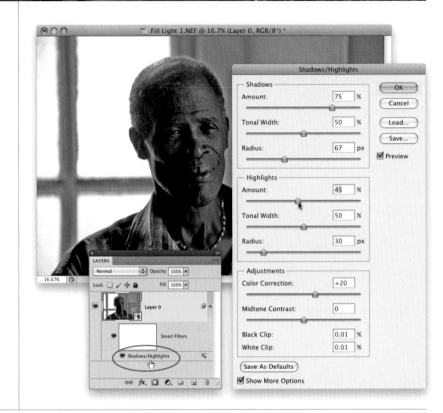

Step Four:

Now that the shadows are opened up (and look reasonably realistic), you can work on the highlights. In most cases, you'll only have to fix one or the other—the shadows or the highlights, but not both. It takes someone special to actually take a photo that is so wrong on every level that it needs both areas adjusted (like I did here). So, to pull back (darken) the highlights in the window and on the wall on the right, go to the Highlights section and drag the Amount slider to the right (as shown here). Now, if later you need to tweak these changes, because in Step One you applied this as a Smart Filter, you can go to the Layers panel, double-click directly on the words "Shadows/Highlights" (as shown here), and the Shadows/Highlights dialog will appear again, with the settings you used previously. Just make any changes you want, then click OK.

Before

After (opening up the shadows and pulling back the highlights)

Nothing ruins an outdoor shot like a dull gray sky (well, except for one other thing—later in this chapter, you'll learn how to remove tourists), but luckily, in many cases, you can save the shot by darkening the midtones a bit, and adding a blue tint or gradient to the sky. Here's how to do both:

Fixing Shots with a Dull Gray Sky

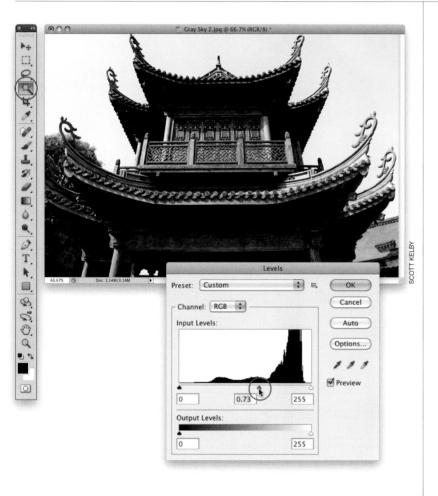

Step One:
Here's a shot taken in Beijing's Tiananmen Square, and the sky is that flat gray that we all hate for travel and outdoor shots. Before we go any farther, the first thing I usually try is to press **Command-L (PC: Ctrl-L)** to open the Levels dialog, and darken the midtones by dragging the center Input Levels slider (circled here in red) to the right. If there is any detail in the sky we can't see, this will usually do the trick, but unfortunately for this image, it just made the gray, grayer, so once I tried it, I hit Cancel instead of OK. Of course, to adjust the sky, you'll have to select it first. You can use any selection tool you're comfortable with, but for something simple like this, I usually just use the Magic Wand tool (press **Shift-W** until you have it; it's nested with the Quick Selection tool).

Continued

Step Two:

Click the Magic Wand tool on the gray sky to select it. I set my Tolerance (up in the Options Bar) to 10, so it doesn't accidentally select the buildings at the bottom of the image, as well (when I tried my usual Tolerance setting of 20, it selected too much). At 10, one click won't select the entire sky, so press-and-hold the Shift key and click in any areas it didn't select (it may take you a few Shift-clicks to get the whole sky selected). Now, although this isn't exactly what this project is about, you could paste a totally different image of clouds into this selected area. You'd do that by opening a photo of clouds, pressing **Command-A (PC: Ctrl-A)** to Select All, then pressing **Command-C (PC: Ctrl-C)** to Copy that image into memory. Then, you'd switch back to the first image, go under the Edit menu, under Paste Special, and choose **Paste Into** to paste the clouds into your selected area.

Step Three:

Instead, we're going to open a photo that has a sky color we like (you can download this same photo, and most of the key photos used in this book, at the Web address listed in the introduction at the front of the book). Once you open the image, switch to the Eyedropper tool **(I)**, and click once on the darkest blue area in the image (as shown here) to make that your Foreground color. Now, press the letter **X** to swap your Foreground and Background colors, then click the Eyedropper on the brightest blue in the photo (lower in the sky), so that now your Foreground is a lighter blue, and your Background is a darker blue.

Step Four:

If you've never used the Magic Wand tool before, you've already learned that sometimes it leaves little white gaps where it didn't quite select every little pixel. That's why, when I use the Magic Wand tool to select something like a sky, I usually expand the selection outward by 1 pixel to pick up that little edge pixel it sometimes misses. To do that, go under the Select menu, under Modify, and choose **Expand**. When the Expand Selection dialog appears (shown here), enter 1, and click OK to grow your selection by 1 pixel.

TIP: The Color Selector Ring

That ring that appears when you use the Eyedropper tool is new in CS5, and it's there to help you see which color you're selecting. The outside ring is a neutral gray, which just helps to make sure you're seeing the right color without being influenced by other colors around it. The bottom half of the inside ring shows the old color, and the top half shows what your Foreground color would change to if you clicked right now.

Step Five:

Go to the Layers panel and add a new, blank layer by clicking on the Create a New Layer icon at the bottom of the panel, then switch to the Gradient tool **(G)**, and click-and-drag your gradient from about the bottom 1/3 of the photo upward to about the top 1/3 (the light blue color should be at the bottom of the gradient). This fills the photo with a gradient made up of your Foreground and Background colors (as seen here). For some images, you can leave this gradient as is, but I think it usually looks a little too fakey, which is why there's a Step Six.

Continued

Step Six:

First, press **Command-D (PC: Ctrl-D)** to Deselect, then go to the Layers panel and lower the Opacity for this gradient layer until the sky looks more realistic and blends in better with the rest of the image (in the image shown here, I thought that was around 78%, but you'll have to make the call on an image by image basis).

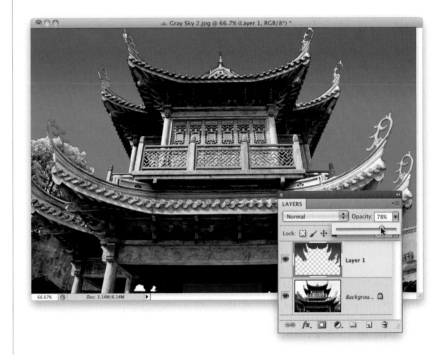

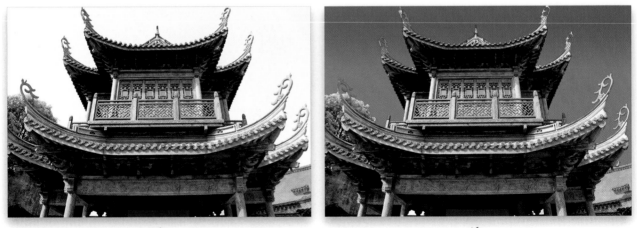

Before *After*

Using the Dodge and Burn Tools

In previous versions of Photoshop, when we wanted to dodge and burn, we had to jump through a bunch of hoops (creating special layers, and using blend modes and such), because the Dodge and Burn tools were…well…let's just say they weren't the best. Luckily, Adobe greatly updated these tools, which totally fixed the problem, and now it's safe to use the Dodge and Burn tools for lightening and darkening different parts of your image.

Step One:
In the photo shown here, we want to highlight the store at the top of the staircase (and the staircase itself), but the light simply didn't fall where we wish it had, so first we're going to dodge (lighten) the staircase and the store (so they're the brightest things in the photo, and draw the eye). Then, we're going to burn (darken) the areas that we wish were darker (like the walls on either side, and the area above the store at the top of the stairs). Basically, we're just going to rearrange how the light is falling on our photo. Now, I don't dodge and burn directly on the photo. Instead, press **Command-J (PC: Ctrl-J)** to duplicate the layer. That way, if we don't like what we've done, we can lessen the effect (by lowering the layer's opacity) or undo it altogether by throwing the layer away.

Continued

Step Two:

Get the Dodge tool **(O)** from the Toolbox (as shown here), and begin painting over the area you want to lighten (in our case, we'll start by painting over the center of the staircase—you can see the brush cursor near the bottom of the stairs in the example shown here). Keep holding the mouse button down as you paint, because the Dodge and Burn tools have a build-up effect—each time you release the mouse button and start painting again, the amount of Dodge (or Burn) builds up.

TIP: Your Brush Cursor Works Better

Back in CS4, Adobe tweaked how the brush tip cursor works, so that if you move it over something darker than it is (which happens very often), it actually has a very tiny glow around it, so now you can see the size and location of your brush dramatically easier when you're over dark areas.

Step Three:

Release the mouse button, and paint over that same area again, and you'll see how it gets another level brighter. Remember—while the mouse button is held down, you're painting one level of brightness. Release the mouse button, then click-and-paint over that area, and you're painting over the original brightness with more brightness, and so on (it's kind of like polishing a silver platter—the more times you polish it, the brighter it gets). Now look at how much brighter the staircase is here, compared with the original image in Step One.

Step Four:

Now, let's work on the store's front at the top of the stairs. Start painting over it to dodge (brighten), release the mouse button, paint it again, and repeat, until it really stands out (like you see here) Now, before we switch to burning in the background, take a look up in the Options Bar for this tool, and you can see that we've been dodging just the Midtones (and that's generally where I do my dodging and burning), but if you wanted the tool to just affect the Highlight or Shadow areas, you can choose that from that Range pop-up menu. Also, the 50% Exposure amount is fine for something like this, but if I were doing this on a portrait, I'd usually want something much more subtle, and I'd lower the amount to around 10%–15%.

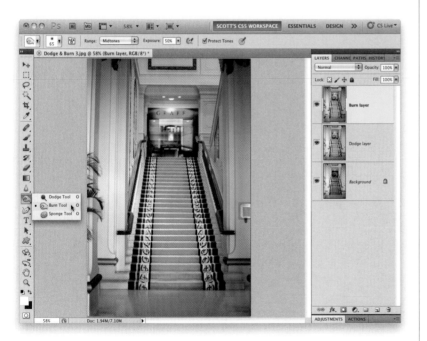

Step Five:

Now let's switch to burning: first start by pressing **Command-J (PC: Ctrl-J)** to duplicate your top layer (so, at this point, you've got the original untouched image as your Background layer, the brightened Dodge layer in the middle (I renamed it "Dodge layer" just to make it easier to see), and a copy of the brightened layer on top, which is the one we're going to burn on (I named it "Burn layer"). By keeping everything on separate layers, if you don't like the burning effect, you can reduce it by lowering the opacity, or delete it altogether and you won't lose the dodging you did on the layer below it. Now get the Burn tool (as shown here), and paint over the walls on either side of the staircase. By darkening those areas, it puts the focus on the staircase even more, which leads the eye. (Whether you realize it or not, you're painting with light. Cool!)

Continued

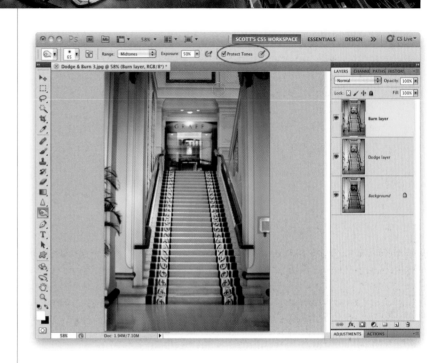

Step Six:

Now, paint over the wall area above the store, and then I'd go over the walls on the side of the staircase one more time, because they're still pretty bright, and still drawing the eye a bit too much. One more thing: up in the Options Bar you'll see a checkbox for Protect Tones. That's the checkbox that helps to keep the color of what you're dodging and burning intact, so things just get brighter or darker, and not sunburned and color saturated. I leave this on all the time, even when I'm not dodging and burning portraits (which is when it's most useful). Below is a before/after, and while I'm usually fairly subtle with my dodging and burning, here I took things a little farther than I normally would, just to show a clear example of the power of dodging and burning.

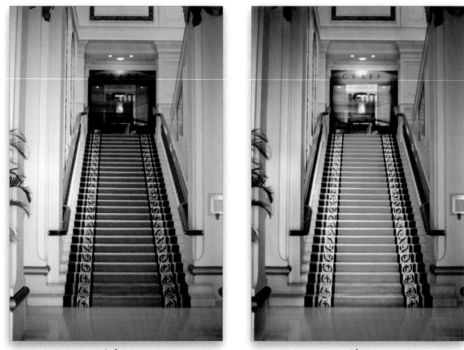

Before *After*

Shooting at a wide-open aperture (like f/4, f/2.8, or f/2, etc.) is very popular with outdoor portraits, because it creates a very shallow depth of field, putting the background out of focus, which adds separation and helps your subject stand out from a busy background. The problem is that you can't always shoot at wide-open apertures—especially in bright sunlight—but luckily for us, there's a fix we can apply in Photoshop to create that "shot wide open" look.

Fixing Depth-of-Field Problems

SCOTT KELBY

Step One:
Here's a photo I shot in the middle of the day, using an off-camera flash with a shoot-through umbrella (up high, aiming down toward my subject, and placed to the left of my camera position) to add some dimension and depth to the light. The problem is that the scene was too bright to shoot it at f/2.8 without stacking a bunch of neutral density filters on my lens (which I didn't have with me at the time), so my f-stop wound up being f/13, which means everything is in sharp focus (great for landscape shots, or in-studio portraits, but not so great here on location with a busy, and fairly unattractive, background).

Continued

Step Two:

Start by getting the Quick Selection tool (shown circled here), and paint over the bride. As you do, it does all the hard work for you, and selects the bride (there's a lot more of the Quick Selection tool later in this chapter). The one problem area is the gap beside her arm on the right—it selects that area, too (which shouldn't be selected), so press-and-hold the Option (PC: Alt) key, then use the **Left Bracket key** to shrink your brush size way down, and paint over that area (as seen here) and it gets deselected.

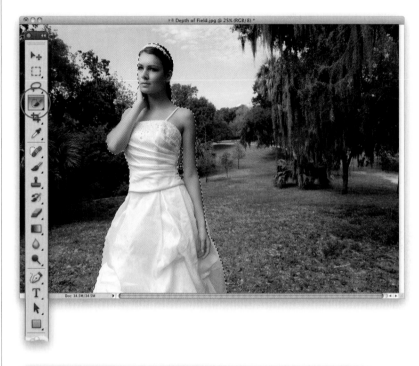

Step Three:

By itself, the Quick Selection tool doesn't always make nice, smooth selections, so once your selection is in place, click the Refine Edge button up in the Options Bar. In the View pop-up menu, choose **Black & White** (so you see a white/black mask view, as seen here), then turn on the Smart Radius checkbox (make sure you read "Making Really Tricky Selections" later in this chapter for why we're doing this). Now, since this is a fairly simple selection (no fine hair blowing in the wind, etc.), you'll just drag the Radius slider a little bit to the right (as shown here, where I dragged it to 3.6 pixels) to smooth out the selection and make it less jaggy. Down in the Output section, make sure Output To is set to **Selection**, then click OK.

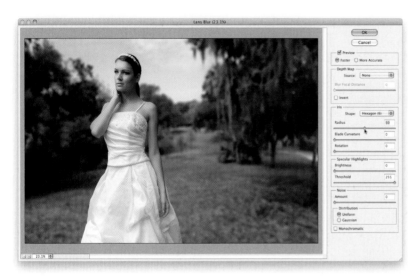

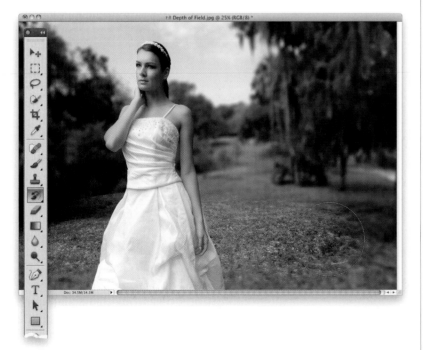

Step Four:

This returns you to your image with your smoother, more refined selection in place. Press **Command-Shift-I (PC: Ctrl-Shift-I)** to Inverse your selection, so the background is selected. Now it's time to add the blurring. The Gaussian Blur filter looks too fake and tends to smear things a bit, so go under the Filter menu, under Blur, and choose **Lens Blur**, which gives a more lens-like blur. When the Lens Blur dialog appears, drag the Radius slider to around 50, then click OK (this isn't the fastest filter, so it'll take a minute or so), and press **Command-D (PC: Ctrl-D)** to Deselect. *Note:* We're not putting her up on her own separate layer, then blurring the Background layer, because the original image of her would still be on the Background layer. She would blur back there, then you'd have to clone away her smeared edges.

Step Five:

If this was a close-up head-and-shoulders type shot, you could get away with leaving the entire background behind her really blurry, but because this shot is a ¾-length, it looks kind of weird seeing the ground a foot behind her totally out of focus, so we're going to tweak this just a bit to get a more realistic effect for this particular image. Get the History Brush tool **(Y)**, which I think of as "undo on a brush," and choose a really huge, soft-edged brush tip size from the Brush Picker up in the Options Bar (like the one you see here—I used the **Right Bracket key** on my keyboard to jump up to a 900-pixel brush), then paint a single stroke from the far left, straight across to the far right. This removes the blurring from this area right behind the bride, and because you used such a huge brush, it fades off behind her into the blurriness.

Continued

Step Six:

When you're painting with that brush, don't paint all the way to the bottom of the photo—leave a little bit blurry at the bottom to mimic what real shallow depth of field would create, which is a little bit of shallow focus right at the front of the image. Lastly, I would finish this photo off by adding a dark edge vignette. Go under the Filter menu and choose **Lens Correction**. When the dialog appears, click on the Custom tab, then in the Vignette section (shown at the bottom here), drag the Amount to –88 to darken the edges, and the Midpoint to +29 to extend that darkening farther in toward the center, then click OK. If your bride looks a bit dark, press **Command-L (PC: Ctrl-L)** to bring up Levels and click the Auto button. That should do the trick.

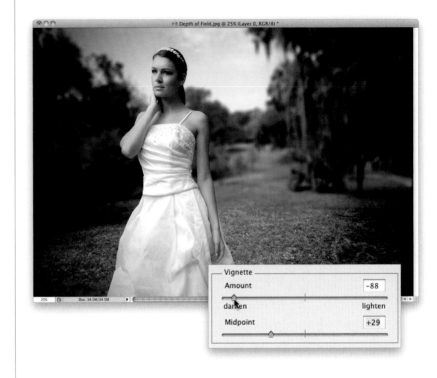

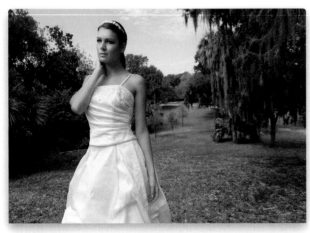

Before

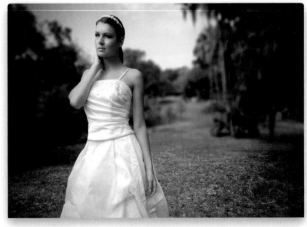

After

I get more requests for how to fix this problem than probably all the rest combined. The reason is it's so darn hard to fix. If you're lucky, you get to spend an hour or more desperately cloning. In many cases, you're just stuck with it. However, if you're smart, you'll invest an extra 30 seconds while shooting to take one shot with the glasses off (or ideally, one "glasses off" shot for each new pose). Do that, and Photoshop will make this fix absolutely simple. If this sounds like a pain, then you've never spent an hour desperately cloning away a reflection.

Fixing Reflections in Glasses

Step One:
Before we get into this, make sure you read the short intro up top here first, or you're going to wonder what's going on in Step Two. Okay, here's a photo of a co-worker with his glasses on.

Step Two:
I could see right away that we were going to have a reflection in his glasses, so I told him after the shot not to move his head, but just to reach up and remove his glasses, and then we took another shot. Now, with both images open, get the Move tool (V), press-and-hold the Shift key, and click-and-drag the "no glasses" shot on top of the "glasses" photo.

Continued

Step Three:

Holding the Shift key will help get the alignment of the two layers somewhat close, but in this case, it's still off by a bit because the shot was hand-held. Anyway, for this to work, the two photos have to be lined up with each other right on the money, and in CS5, Photoshop will do it for you. You start by going to the Layers panel, clicking on the Background layer, then pressing-and-holding the Command (PC: Ctrl) key and clicking on Layer 1 to select them both (you can see they're both highlighted here). Then go under the Edit menu and choose **Auto-Align Layers** (if that function is grayed out, it's because you don't have both layers selected). When the dialog appears, leave it set to Auto and just click OK.

Step Four:

A little progress bar will appear telling you that it's aligning the selected layers based on their content, and within a few seconds the two layers will be precisely lined up (as shown here. Of course, it's hard for you to tell they're precisely lined up unless you've downloaded these two photos and checked it yourself. What? You didn't know you could download these same photos and follow along? That's only because you skipped the introduction at the front of the book). Once your images are aligned, use the Crop tool **(C)** to crop away any transparent areas. Okay, now you'll need to hide the top layer by clicking on the little Eye icon to the left of the layer, then click once on the Background layer (as shown here). Now you're seeing the original shot, with the reflection in the glasses.

Step Five:

You're going to need to select the inside area of both lenses, and you can use whichever selection tool you're most comfortable with (like the Magnetic Lasso tool perhaps), but for a job like this, I think the Pen tool is perfect. If you choose to go the Pen tool route, get the Pen tool **(P)**, then go up to the Options Bar and click on the second icon from the left (so it just draws a path). Then click the Pen tool once on a lower part of one of the glass lenses, move your cursor over to the left, and click, hold, and drag slightly to the left (as shown here). This draws a slightly curved path between the two points (the farther you drag after clicking, the more the curve bends).

Step Six:

So basically, that's how it works—you move a little further along the lens, click, hold, and drag. Move again—click, hold, and drag, and continue this as you're basically going to trace around the lens with a path. When you get back to the point where you started, a little circle appears in the bottom-right corner of your Pen tool's icon letting you know you've come "full circle." Click on that point to close your path. Now do the same thing to the other lens. Once you've gotten paths drawn around both lenses, press **Command-Return (PC: Ctrl-Enter)** to turn your paths into a selection (as shown here). Remember, you don't have to do this using the Pen tool—use any selection tool(s) you're comfortable with.

Continued

Step Seven:

After your selection is in place, make the top layer visible again (seen here) by clicking in the first column on the Layers panel where the Eye icon used to be. Then, click on the top layer to select it.

Step Eight:

To complete the effect, just click the Add Layer Mask icon at the bottom of the Layers panel (as shown here) and the eyes from the top layer replace the eyes from the original glasses layer, and your reflection problems are gone.

Before (notice the reflection—most visible in the right eye) *After (the reflection is gone)*

Fixing Group Shots the Easy Way

Group shots are always a challenge because, without a doubt, somebody in the group will be totally hammered (at least, that's been the experience with my family. You know I'm kidding, right?). Okay, the real problem is that in group photos there's always one or more people who blinked at just the wrong time, or forgot to smile, or weren't looking at the camera, etc. Of course, you could just take their expression from another frame and combine it with this one, but that takes a lot of work. Well, at least it did before the Auto Blend feature. This thing rocks!

Step One:
Here's a photo of a cute family. The problem here is the dad isn't looking very happy and the baby has her head turned.

Step Two:
Of course, with group shots you take as many shots as the group will endure, and luckily in the very next frame there was a great shot of the dad smiling, and the baby looking at the camera, but now the mom has her eyes closed. So, the idea is to take the dad and baby from this shot, and combine them with the previous photo, where the mom has her eyes open.

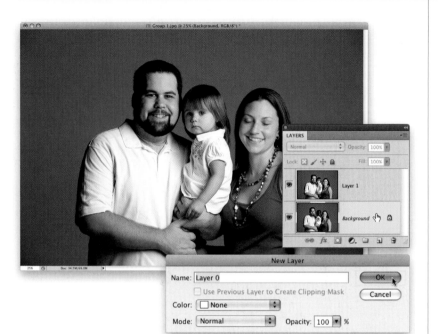

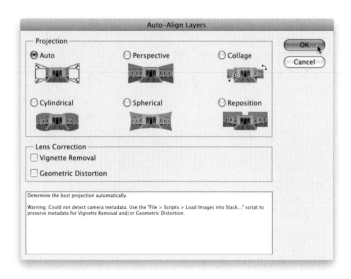

Step Three:
Start by dragging the two photos into the same document: get the Move tool **(V)**, press-and-hold the Shift key, and click-and-drag one photo over onto the other (it will appear as its own layer in the other document, as you can see in the Layers panel shown here). Now, you'll need to convert the Background layer into a regular layer, so go to the Layers panel and double-click directly on the Background layer. This brings up the New Layer dialog (shown here), which by default renames your Background layer as Layer 0. Just click OK and it's now a regular ol' Photoshop layer.

Step Four:
Usually, the photos line up pretty well if the shots were taken on a tripod, but if you handheld them, or your subjects move a bit, you'll want to select both layers and choose **Auto-Align Layers** from the Edit menu first to have Photoshop align the two layers for you. In this case, Auto-Align Layers seemed to squash the top photo a little, so I pressed **Command-T (PC: Ctrl-T)** to bring up Free Transform and just dragged the bottom-center point down to match the bottom layer.

Continued

Step Five:

The next two steps couldn't be easier: First, in the Layers panel, hide Layer 0 from view by clicking on the little Eye icon to the left of the layer. Then click on Layer 1. Now, get the Rectangular Marquee tool **(M)** and draw a rectangular selection over the parts of this layer that don't look good (in other words, you're going to delete everything you don't want to keep—so put a selection around the mom on the right) and hit the Delete (PC: Backspace) key. This leaves you with just the part of this layer you want to keep. Now, Deselect by pressing **Command-D (PC: Ctrl-D)**.

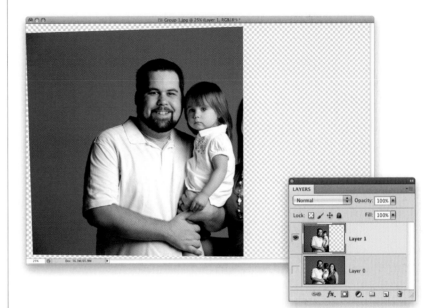

Step Six:

Hide that top layer from view, and make Layer 0 visible again by clicking once in the first column where the little Eye icon used to be. Click on Layer 0, then do the same thing—erase what you don't want (in this case, you're putting a Rectangular Marquee selection around the dad and baby), then press the Delete (PC: Backspace) key, so you have the image you see here. Now you can Deselect. The key thing to remember here is this: make sure these two layers overlap, because Photoshop needs some overlapping area to do its blending (in other words, don't erase so much that there's any gap between the two layers—it's got to overlap. I'd shoot for a 20% overlap if you can, although I didn't have that much here, because the baby shifted position, moving her head closer to the dad).

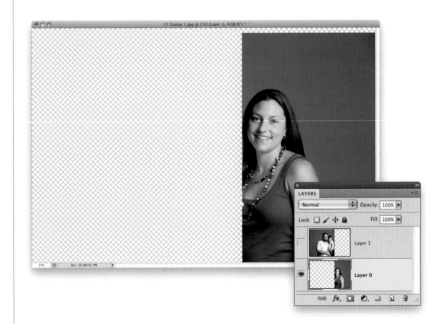

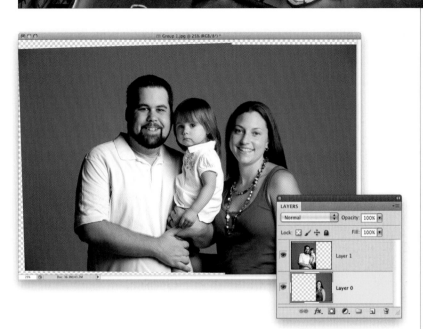

Step Seven:
Go to the Layers panel and make both layers visible (as seen here). Now, you have the right poses together, but you also have a very harsh seam moving right through the mom's face and shirt. It looks "pieced together" big time. Of course, you could add layer masks and try blending the edges yourself with the Brush tool, but that's what makes this technique so sweet: CS5 will do a brilliant job of all that for you—in just seconds.

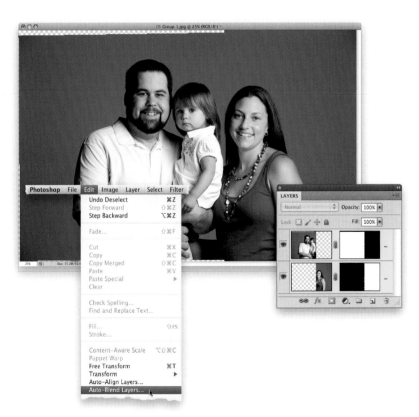

Step Eight:
Here's the last step: select both layers in the Layers panel (click on one layer, press-and-hold the Command [PC: Ctrl] key, then click on the other layer to select it as well), then once both layers are selected, go under the Edit menu, choose Auto-Blend Layers, and click OK in the resulting dialog. That's it—in just seconds you have a perfectly smooth, seamless blend of the two photos, and Photoshop did all the hard work. Now, you can just grab the Crop tool **(C)** and crop away any transparent areas left by the alignment. You can see the before/after on the next page. It does leave the layer masks that Auto-Blend Layers creates in place, just in case you want to tweak them, but I haven't come up with an instance where I needed to yet. Just choose Flatten Image from the Layers panel's flyout menu, and you're done.

Continued

Before (the dad and baby on the left are in bad poses—
one has her head turned, one's not smiling)

After (the first photo is seamlessly blended with the
second photo, replacing the dad and baby on the left
with their better poses from a different frame)

This is a very common problem, and photographers use everything from reflectors to strobes placed down low in front of the subject to open up dark, deep-set eye sockets. Luckily, there's a pretty quick and easy way to fix this problem in Photoshop. Here's how:

Fixing Dark Eye Sockets

SCOTT KELBY

Step One:
Here's the image we're going to work on, and if you look at her eyes, and the eye socket area surrounding them, you can see that they're a bit dark. Brightening the whites of the eyes would help, but the area around them will still be kind of shadowy, so we may as well kill two birds with one stone, and fix both at the same time.

Step Two:
Go to the Layers panel and duplicate the Background layer (the quickest way is just to press **Command-J [PC: Ctrl-J]**). Now, change the blend mode of this duplicate layer from Normal to **Screen** (as seen here). This makes the entire image much brighter.

Continued

Step Three:

We need to hide the brighter layer from view, so press-and-hold the Option (PC: Alt) key and click on the Add Layer Mask icon at the bottom of the Layers panel (it's shown circled here in red). This hides your brighter Screen layer behind a black layer mask (as seen here). Now, switch to the Brush tool **(B)**, choose a smallish, soft-edged brush, and paint a few strokes over the dark eye sockets and eyes (as shown here). Now, I know at this point, it looks like she was out in the sun too long with a large pair of sunglasses on, but we're going to fix that in the next step.

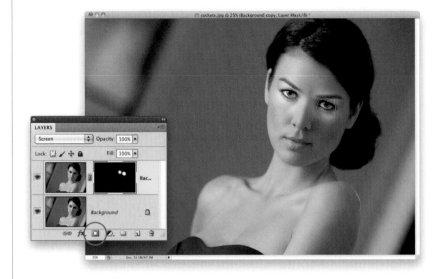

Step Four:

What brings this all together is lowering the Opacity of this layer, until the parts that you painted over and brightened in the previous step blend in with the rest of her face. This takes just a few seconds to match the two up, and it does an incredibly effective job. See how, when you lower the Opacity to around 35% (which works for this particular photo—each photo and skin tone will be different, so your opacity amount will be, too), it blends right in? Compare this image in Step Four with the one in Step One and you'll see what I mean. If you're doing a lot of photos, like high school senior portraits, or bridesmaids at a wedding, this method is much, much faster than fixing everyone's eyes individually.

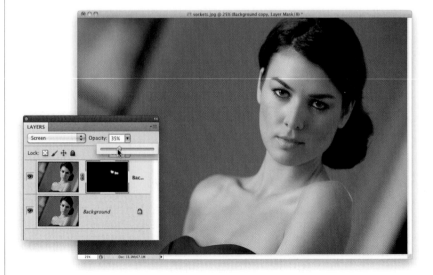

In CS4, Adobe added one of those seemingly little things that is actually a really big thing—the ability to resize your brush visually onscreen. I've been using the Left and Right Bracket keys to change brush sizes for years, and that works pretty well, but you never get exactly the size you want (because they jump between preset increments), and you never get there fast enough. But now, not only do you finally get the exact size you want really fast—the first time—you can use a slight variation of the technique to change the hardness of your brush, as well. Ahhh, it's always the little things, isn't it?

The Fastest Way to Resize Brushes Ever (Plus, You Can Change Their Hardness, Too)

Step One:
When you have a Brush tool selected, just press-and-hold **Option-Control (PC: Ctrl-Alt)** and then **click-and-drag (PC: Right-click-and-drag)** to the right or left onscreen. A red brush preview will appear inside your cursor (as seen here)—drag right to increase the brush size preview or left to shrink the size. When you're done, just release those keys and you're set. Not only is this the fastest way to resize, it shows you more than just the round brush-size cursor—it includes the feathered edges of the brush, so you see the real size of what you'll be painting with (see how the feathered edge extends beyond the usual round brush size cursor)?

TIP: Change Your Preview Color
If you want to change the color of your brush preview, go to Photoshop's Preferences **(Command-K [PC: Ctrl-K])**, click on Cursors on the left, and in the Brush Preview section, click on the red Color swatch, which brings up a Color Picker where you can choose a new color.

Continued

Step Two:
To change the Hardness setting, you do almost the same thing—press-and-hold **Option-Control (PC: Ctrl-Alt)**, but this time, **click-and-drag (PC: Right-click-and-drag)** down to harden the edges, and up to make them softer (here I dragged down so far that it's perfectly hard-edged now).

TIP: Turn on Open GL Drawing
If you don't see the red brush preview, you'll need check your preferences first. So, go to Photoshop's preferences **(Command-K [PC: Ctrl-K])**, and click on Performance on the left side. In the GPU Settings section near the bottom right, turn on the Enable OpenGL Drawing checkbox, then restart Photoshop.

Most of the selecting jobs you'll ever have to do in Photoshop are pretty easy, and you can usually get away with using the Magic Wand, Lasso, or Pen tools for most jobs, but the one that has always kicked our butts is when we have to select hair. Over the years we've come up with all sorts of tricks, including the intricate Channels techniques I covered in my Photoshop Channels Book, but all these techniques kind of went right out the window when Adobe supercharged the Quick Selection tool in Photoshop CS5 with the new Refine Edge feature. This is, hands down, one of the most useful, and most powerful, tools in all of CS5.

Making Really Tricky Selections, Like Hair

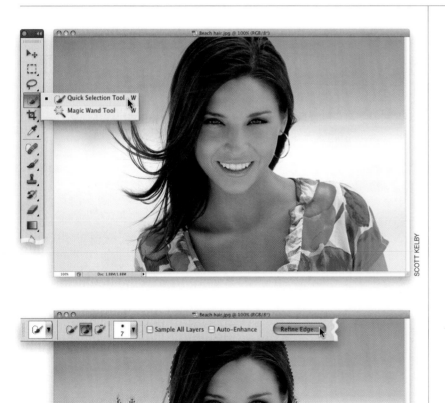

Step One:
Start by opening the image you want to make a selection in, and getting the Quick Selection tool from the Toolbox (as shown here). If you're thinking this is the same tool from Photoshop CS4…well, you're right. But, it's the new features in Refine Edge that make it really powerful. If you never used the Quick Selection tool back in CS4, here's how it works: you just take it and paint loosely over the areas you want to select, and it kind of expands to select the area (kind of like a much smarter version of the Magic Wand tool, but using different technology).

Step Two:
Take the tool and paint over your subject. Don't forget the flyaway hair on the left side. If it selects too much, press-and-hold the Option key and paint over that accidentally selected area to remove it from your selection. Remember, it's not going to look perfect at this point, but that's what the Refine Edge control is for, so go ahead and click the Refine Edge button up in the Options Bar (as shown here).

Continued

Step Three:

When the Refine Edge dialog appears, you have a lot of choices for your View Mode (including just the standard old Marching Ants), but to really see how your selection looks, I think the best View is **Black & White**, which shows your selection as a standard layer mask. As you can see, the Quick Selection tool, by itself, isn't gettin' the job done (the edges are jaggy and harsh, and there's no wispy hair selected at all), which is why we need Refine Edge to help us out. However, the trick to working effectively in this dialog is to use just the Edge Detection section and, honestly, I would avoid the Adjust Edge section in the center altogether, because you'll spend too much time fussing with sliders, trying to make it work. I figure you guys want me to tell you when to avoid stuff, too, and this is one of those cases.

Step Four:

Next, turn on the Smart Radius checkbox, which is the edge technology that knows the difference between a soft edge and a hard edge, so it can make a mask that includes both. This checkbox is so important that I leave it on all the time (if you want it always on, as well, just turn it on and then turn on the Remember Settings checkbox at the bottom of the dialog). Now, drag the Radius slider to the right, and as you do, watch the hair on the left side. It doesn't take a big move with this slider before you start seeing hair detail magically appear (as seen here). For simple selections, leave the Radius amount down low. When you have a tricky selection, like fine hair blowing in the wind, you'll have to increase it higher, so remember: trickier selections mean higher Radius amounts.

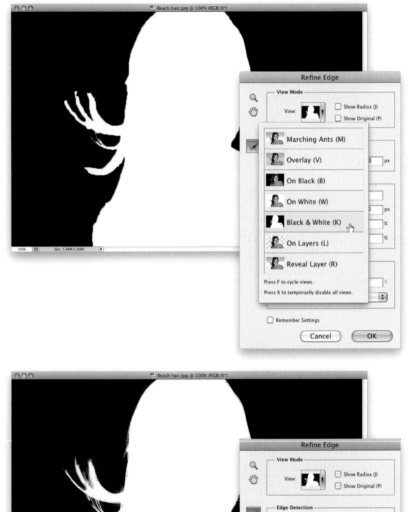

Step Five:

Now let's change our view to see if there are any areas we missed. For this part of the process, I use the Overlay view (seen here), because the parts that didn't get selected show up in white. So, choose **Overlay** from the View pop-up menu (as shown here).

TIP: Which View Is Which

Although I generally only use the Black & White mask view and the Overlay view, here's what the rest do: Marching Ants gives you just what you'd expect—a standard marching ants selection, just like always. On Black puts your selected area on a solid black background, while On White is on a solid white background (helpful if you're doing selections of product photography, because you can see what the final image will look like). On Layers shows your selection on a transparent layer, and Reveal Layer just shows the original image without any selection in place (so it's the before view). Like it says right there on the View menu, you can press **F** to toggle through the views.

Step Six:

What you need to do next is tell Photoshop exactly where the problem areas are, so it can better define those areas. You do that with the Redefine Radius tool **(E)**, shown circled here in red. Get the brush and simply paint over the areas where you see white peeking through, and it redefines those areas. This is what gives you that fine hair detail.

Continued

Step Seven:

If you look closely, you'll see that her hoop earring on the right side didn't get selected at all, so use the **Left Bracket key** to shrink the size of the brush down to where it's just slightly larger than the hoop, then paint over it. It'll look like it's painting in white, but when you're done, it just redefines the area and tells Photoshop that this area needs some work, and it "redoes" its thing.

Step Eight:

Now skip down to the Output section, where you'll find a checkbox to Decontaminate Colors. What this does is remove the color spillover on your subject from the old original background. It basically desaturates the edge pixels a bit so when you place this image on a different background, the edge color doesn't give you away. Also, just below that, you get to choose what the result of all this will be: Will your selected subject be sent over to a new blank document, or just a new layer in this document, or a new layer with a layer mask already attached? I always choose to make a new layer (with a layer mask) in the same document. That way, if I really mess up, I can just grab the Brush tool and paint over those areas on the layer mask to bring them back to how they looked when I first opened the image.

Step Nine:

Now, open the new background image you want to use in your composite. (You knew we were going to put her on a different background, right? I mean, why else would we be worrying about selecting her hair?) Get the Move tool **(V)**, press-and-hold the Shift key to keep the background photo centered, then click-and-drag this background image into your working document. (*Note:* This is easier if you have the Application Frame turned off and can see at least part of both images on your screen.)

Step 10:

In the Layers panel, click on the background image's layer (Layer 1 here), and drag it beneath the layer with your subject on it, so it appears behind her (as seen here). Chances are that the colors from the two images aren't going to be right on the money, because they came from two different lighting scenarios. Her overall color looks much warmer than the background setting we've put her into, but I've got a trick you can use that will help make the colors work between the two.

Continued

Step 11:
First, we need to load the layer mask on the top layer as a selection, so press-and-hold the Command (PC: Ctrl) key and click directly on the layer mask thumbnail (as shown here), and it loads the layer mask as a selection.

Step 12:
Make sure Layer 1 (the background image you dragged in earlier) is still the active layer, then press **Command-J (PC: Ctrl-J)** to put this selected area up on its own separate layer. Now, drag this layer to the top of the layer stack (as shown here). Since this is a selection of the background, in the exact shape of your subject, you get what you see here—it looks like the background image, but with a thin outline around your subject. Well, that's about to change.

Step 13:

We need a selection around this layer again, so press-and-hold the Command (PC: Ctrl) key and click on the top layer's thumbnail to load it as a selection. Once the selection is in place, we're going to need to get a blend of all the background colors, so go under the Filter menu, under Blur, and choose **Average**.

Step 14:

It doesn't bring up a dialog or anything, it just does its thing, and creates a blur that averages all the colors in the selected area together (as shown here). Press **Command-D (PC: Ctrl-D)** to Deselect. It doesn't look right yet, but it will in just a moment.

Continued

Removing Distracting Stuff Using Content-Aware Fill

This is probably one of the main reasons you bought the CS5 upgrade—to get Content-Aware Fill, because it's just incredibly amazing. That being said, as amazing as it is, it's incredibly simple to use, so don't let the fact that it only took four pages in the book to cover perhaps the most famous feature in all of CS5 throw you off. What makes the feature even more amazing is that you have to do so little—Photoshop does all the heavy lifting. Here are a couple of examples of ways to use it to remove distracting things you wish weren't in the photo:

Step One:

In this case, we have someone sneaking into the scene from the far left side of the image, and it takes away from what's happening in the rest of the image. To have Content-Aware Fill remove that one-third of a person, just get the Lasso tool **(L)** and draw a very loose selection around them. Don't get too close—a loose selection, like the one you see here, is fine.

Step Two:

Now press the Delete (PC: Backspace) key on your keyboard, and the Fill dialog will appear, with **Content-Aware** selected in the Use pop-up menu (as shown here). Just click OK, sit back, and prepare to be amazed. (I know—it's freaky). Go ahead and Deselect by pressing **Command-D (PC: Ctrl-D)**. Look at how it replaced the missing grass in the proper perspective. This is the essence of being "content aware" and being totally aware of what's around it. The more I use it, the more it amazes me, but part of using this effectively is learning it's weaknesses, and how to get around them when possible.

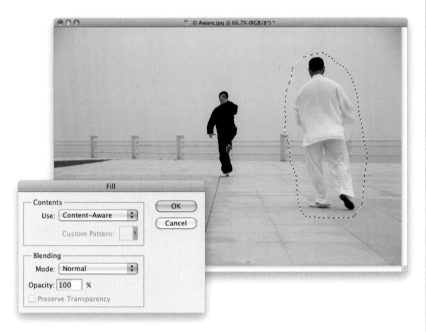

Step Three:
As well as it did removing that one-third of a person on the far left, it's not going to do a good job if you want to remove the guy on the right. It seems like it should work just fine, but it doesn't. Well, at least not at first, but we're going to kind of make it work. Start by putting a loose selection around him, then hit the Delete (PC: Backspace) key, and when the Fill dialog appears, don't touch anything, just click OK.

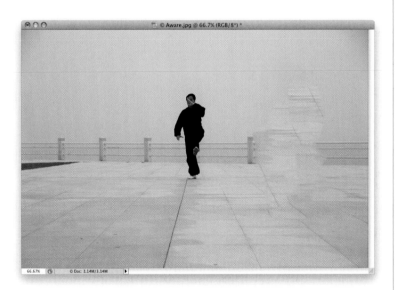

Step Four:
In this case, it didn't really work as well as we had hoped. Now, your first inclination is to undo, and then switch to the Clone Stamp tool, but don't quite yet. One thing I've learned about Content-Aware Fill is that it is sometimes chooses different places to sample content from, so instead of switching to the Clone Stamp tool, try this first: press **Command-Z (PC: Ctrl-Z)** to Undo the Content-Aware Fill, and then just try it again. You might be surprised that it samples from a different area, and it might work this time. However, it didn't for me, but don't worry—I've got a back-up plan. Go ahead and deselect.

Continued

Step Five:

Now, let's think of things differently at this point. Let's not think, "Content-Aware Fill didn't work." Let's think, "Hey, I can use Content-Aware Fill to fill that concrete-looking shape on the right side of the photo." So, make a loose Lasso selection around the concrete-looking blob, then bring up Content-Aware Fill again, and give it a shot.

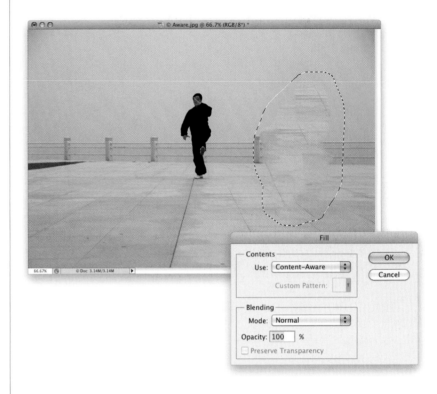

Step Six:

Wow—this is a lot better. It's not fully there, but a lot, lot better (more on taking it up a notch in a moment). Now, you will fall deeply in love with Content-Aware Fill if you can come to peace with the fact that it won't work perfectly every time, but if it does 70% or 80% of the work for me (in removing something I don't want), that means I only have to do the other 20%, and that makes it worth its weight in gold. If it does the entire job for me, and sometimes it surely does, then it's even better, right? Right. Also, it helps to know that the more random the background is behind the object you want to remove, the better job Content-Aware Fill generally does for you. (By the way, do you think we could pull that same scam again? The one we did in Step Five?)

Step Seven:

Put a Lasso selection around the area that's still messed up (where the guy on the right used to be), and try the Content-Aware Fill thing on that area, and see what happens. Well, you don't really have to, because I'm showing you here. It's pretty darn close now, and just needs a little touch-up (notice how the railings don't quite match up?). Well, let's see what happens if you tried to move the guy in the black outfit—you know what to do: Lasso, then hit Delete.

Step Eight:

For some reason, it worked much better on him, first time out, than it did on the guy on the right. If you look at the fence behind where he was, you do have a tiny bit of touch-up with the Clone Stamp tool to make his removal really seamless (that fence needs a tiny bit of fixing, right?), but when you think of how much Content-Aware Fill did for you, it makes you start to wonder how you lived without it.

TIP: Painting Using Content-Aware Fill

The method you just learned has you making a selection, and then filling it using Content-Aware Fill. If you'd rather paint than select, you can use the Spot Healing Brush—just make sure the Content-Aware radio button is on up in the Options Bar, then paint right over what you want gone.

Photoshop Killer Tips

How to Make Shadows/Highlights an Adjustment Layer

Well, it won't technically be an adjustment layer, but it will act and perform exactly like one. Here's what you do: First, go under the Filter menu and choose **Convert for Smart Filters** (which converts the layer into a Smart Object). Then go under the Image menu, under Adjustments, and choose **Shadows/Highlights**. Now, choose any settings you like, then click OK. If you look in the Layers panel, you'll see that attached below your layer is a layer mask (just like an adjustment layer), and if you double-click on the words "Shadows/Highlights" below the mask, it brings up the dialog again, with the last settings you applied (just like an adjustment layer), and if you click on the little adjustment sliders icon to the right of the name, it brings up a dialog where you can change the blend mode and opacity (just like an adjustment layer), and you can click the Eye icon to turn the adjustment on/off (just like an adjustment layer), and finally, you can delete it anytime during your project (just like an adjustment layer).

Not Sure Which Blend Mode Is the Right One?

Then just press **Shift-+** to toggle through all the layer blend modes one-by-one, so you can quickly find out which one looks best to you.

Changing the Position of Your Lens Flare

When you use the Lens Flare filter (found under the Filter menu, under Render) it puts the flare in the center of your image, but you can actually choose the position for your flare center (which changes the look of your flare quite a bit) by just clicking-and-dragging the flare center within the filter's Preview window. By the way, a great way to apply this filter is add a new layer, fill it with black, then run the filter, change its layer blend mode

to **Screen**, and it will blend in with your image, so you can drag it wherever you'd like (if an edge shows, add a layer mask and paint over the edges in black with a huge, soft-edged brush).

How to Change the Order of the Brushes in the Brush Picker

Go under the Edit menu and choose **Preset Manager**. When the dialog opens, by default it's set to display all your brushes, so now all you have to do is click-and-drag them into the order you want them. When you've got everything in the order you want, click the Done button.

Changing the Color of Your Guides

Want to change the color of those guides you drag out from the rulers? Just pull out a guide, then double-click directly on it, and it brings up the Preferences dialog for Guides, Grid & Slices, where you can choose

Photoshop Killer Tips

any color you'd like. You can also press **Command-K (PC: Ctrl-K)** and click on Guides, Grid & Slices on the left.

What That Fill Field Does

In the Layers panel, right below the Opacity field is a Fill field, which has had Photoshop users scratching their head since it debuted several versions ago. It only kicks in when you have a layer style applied to a layer, like a drop shadow or bevel. If you have something on a layer and you apply a drop shadow to it, then lower the Opacity amount, the object and its shadow both fade away, right? But if you lower the Fill amount only, the object starts to fade away, but the drop shadow stays at 100% opacity.

The Hidden Shortcut for Flattening Your Layers

There technically isn't a keyboard shortcut for the Flatten command, but I use a standard shortcut for flattening my image all the time. It's **Command-Shift-E (PC: Ctrl-Shift-E)**. That's actually the

shortcut for Merge Visible, so it only works if you don't have any hidden layers, but I usually don't, so it usually works.

Customizing the HUD Pop-Up Color Picker

In CS5, you can have a heads-up display color picker appear onscreen when you're using the Brush tool by pressing **Command-Option-Ctrl (PC: Alt-Shift) and clicking (PC: Right-clicking)**. And, did you know you also get to choose which type and size of HUD you want? Press **Command-K (PC: Ctrl-K)** to bring up Photoshop's preferences, click on General on the left, then up near the top of the General preferences is a HUD Color Picker pop-up menu for choosing your style and size.

Changing Brush Blend Modes on the Fly

If you want to change the blend mode for your current brush without traveling up to the Options Bar, just press **Shift-Ctrl (PC: Shift)** and **click (PC: Right-click)** anywhere in your image, and a pop-up menu of Brush tool blend modes appears.

Creating Cast Shadows

To create a cast shadow (rather than a drop shadow), first apply a Drop

Shadow layer style to your object (choose Drop Shadow from the Add Layer Style pop-up menu at the bottom of the Layers panel, change your settings, and click OK), then go under the Layer menu, under Layer Styles, and choose **Create Layer**. This puts the drop shadow on its own separate layer. Click on that new drop shadow layer, then press **Command-T (PC: Ctrl-T)** to bring up Free Transform. Now, press-and-hold the Command (PC: Ctrl) key, grab the top center point, and drag down at a 45° angle to create a cast shadow (like your shadow is casting onto the floor).

Copying Layer Masks from One Layer to Another

If you've created a layer mask, and you want that same mask to appear on a different layer, press-and-hold the Option (PC: Alt) key and just drag-and-drop that mask on the layer where you want it. It makes a copy leaving the original intact. If you want to remove the mask from one layer and apply it to another, then don't hold the Option key and, instead, just click-and-drag the mask to the layer where you want it.

Step Five:

To knock the exact same hole out of the B&W layer (which means there will be "eye holes" knocked out of the top two layers, so you'll see the original eyes from the Background layer), just press-and-hold the **Option (PC: Alt) key**, click directly on the layer mask thumbnail itself on the top layer, and drag it to the middle layer. This puts an exact copy of the top layer's layer mask on your middle layer (as shown here). Now you're seeing the original full-color unretouched eyes from the Background layer. Pretty neat little trick, eh?

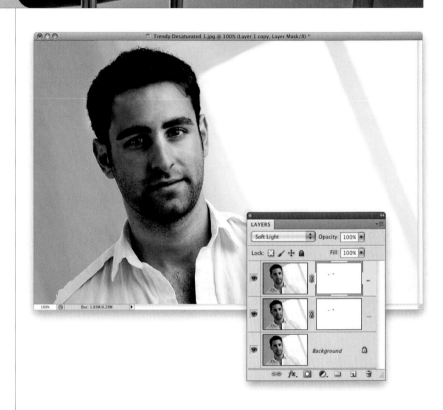

Step Six:

Now flatten the image by choosing **Flatten Image** from the Layers panel's flyout menu. The final step is to add some noise, so go under the Filter menu, under Noise, and choose **Add Noise**. When the Add Noise filter dialog appears (seen here), set the Distribution to Gaussian, and turn on the Monochromatic checkbox (otherwise, your noise will appear as little red, green, and blue specks, which looks really lame). Lastly, dial in an amount of noise that while visible, isn't overly noisy. I'm working on a very low-resolution version, so I only used 4%, but on a high-res digital camera photo, you'll probably have to use between 10% and 12% to see much of anything. You can see the before/after at the top of the next page. Beyond that, I gave you some other examples of how this effect looks on other portraits.

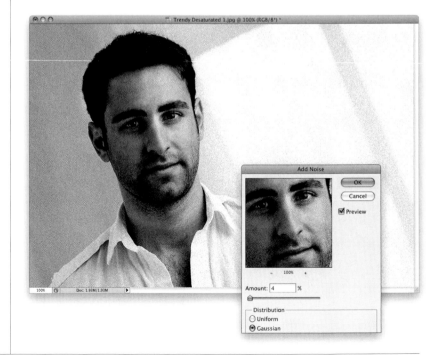

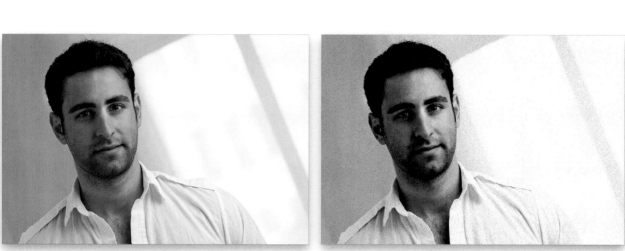

Before *After*

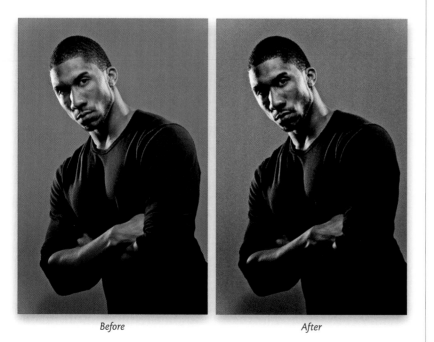

Before *After*

Step Seven:
Here's another example using the exact same technique, and you can see how different the effect looks on a completely different image. I particularly love the almost bronze skin tone it creates in this image. Very cool stuff. Turn the page for more examples.

TIP: Don't Add Too Much Noise
Be careful not to add too much noise, because when you add an Unsharp Mask to the image (which you would do at the very end, right before you save the file), it enhances and brings out any noise (intentional or otherwise) in the photo.

ANOTHER TIP: Background Only
I once saw this effect used in a motorcycle print ad. They applied the effect to the background, and then masked (knocked out) the bike so it was in full color. It really looked very slick (almost eerie in a cool eerie way).

Continued

Step Eight:

Here's the same technique applied to a photo of a woman, however I didn't knock out the eyes because her eye color was pretty subtle. Instead I lowered the Brush tool's opacity to 50% and painted over her lips on the top layer, then copied that layer mask down to the B&W layer (just like before with the eyes—same technique with the mask). Without doing that, her lips looked pretty cold, and this way the subtle 50% pink looks right with the rest of the photo.

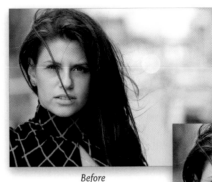

Before

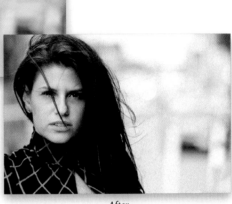

After

TIP: Vary the Opacity

Here are a couple of variations you can try with this effect: If the effect seems too subtle when you first apply it, of course you could try Overlay mode as I mentioned earlier, but before you try that, try duplicating the Soft Light layer once and watch how that pumps up the effect. Of course, you can lower the opacity of that layer if it's too much. Another trick to try is to lower the opacity of the original Soft Light layer to 70%, which brings back some color with almost a tinting effect. Give it a shot and see what you think. One last thing: wouldn't this be a great effect to apply as an action? Oh yeah—that's what I'm talkin' 'bout!

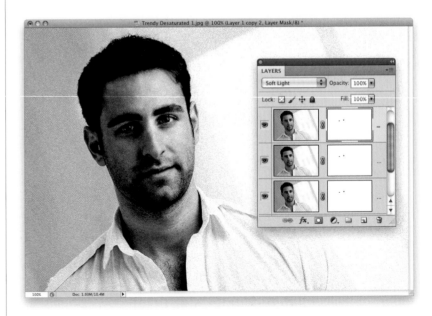

High-Contrast Look

The super-high-contrast, desaturated look is incredibly popular right now, and while there are a number of plug-ins that can give you this look, along with a Camera Raw technique I'll show you next, I also wanted to include this version, which I learned from German retoucher Calvin Hollywood, who shared this technique during a stint as my special guest blogger at my daily blog (www.scottkelby .com). The great thing about his version is: (1) you can write an action for it and apply it with one click, and (2) you don't need to buy a third-party plug-in to get this look. My thanks to Calvin for sharing this technique with me, and now you.

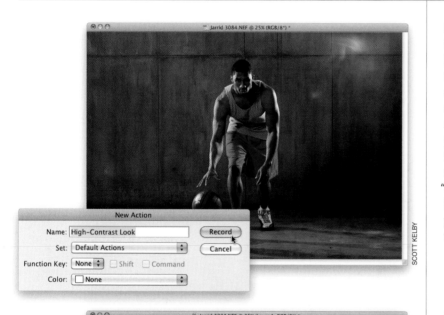

Step One:
Open the image you want to apply a high-contrast look to. Let's start, right off the bat, by creating an action to record our steps, so when you're done, you can reapply this same look to other photos with just one click. Go to the Actions panel, and click on the Create New Action icon at the bottom of the panel. When the New Action dialog appears, name this "High-Contrast Look" and click the Record button. Now it's recording every move you make…every step you take, it'll be watching you (sorry, I just couldn't resist).

Step Two:
Make a copy of your Background layer by pressing **Command-J (PC: Ctrl-J)**. Now, change the blend mode of this duplicate layer to **Vivid Light** (I know it doesn't look pretty now, but it'll get better in a few more moves).

Continued

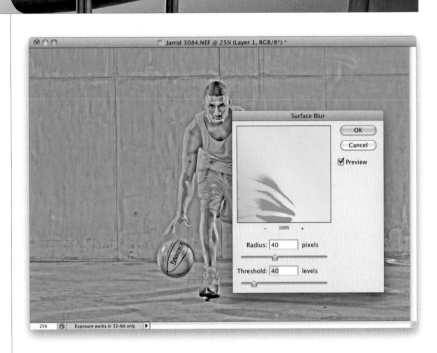

Step Three:

Now press **Command-I (PC: Ctrl-I)** to Invert the layer (it should look pretty gray at this point). Next, go under the Filter menu, under Blur, and choose **Surface Blur**. When the dialog appears, enter 40 for the Radius and 40 for the Threshold, and click OK (it takes a while for this particular filter to do its thing, so be patient. If you're running this on a 16-bit version of your photo, this wouldn't be a bad time to grab a cup of coffee. Maybe a sandwich, too).

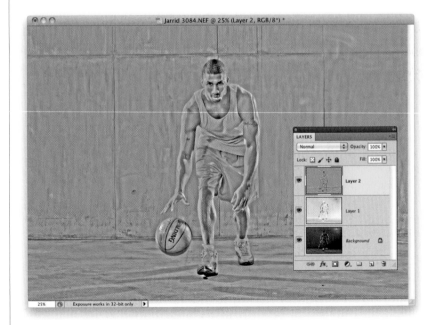

Step Four:

We need to change the layer's blend mode again, but we can't change this one from Vivid Light or it will mess up the effect, so instead we're going to create a new layer, on top of the stack, that looks like a flattened version of the image. That way, we can change its blend mode to get a different look. This is called "creating a merged layer," and you get this layer by pressing **Command-Option-Shift-E (PC: Ctrl-Alt-Shift-E)**.

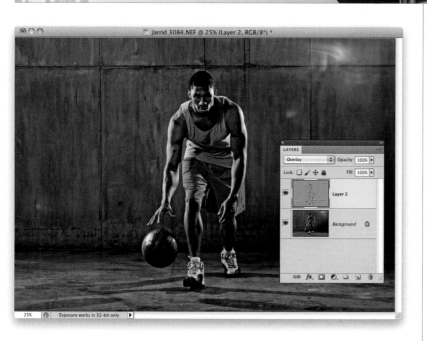

Step Five:
Now that you have this new merged layer, you need to delete the middle layer (the one you ran the Surface Blur upon), so drag it onto the Trash icon at the bottom of the Layers panel. Next, change the blend mode of your merged layer (Layer 2) to **Overlay**, and now you can start to see the effect taking shape (although we still have a little to do to bring it home).

Step Six:
Go under the Image menu, under Adjustments, and choose **Shadows/ Highlights**. When the dialog appears, drag the Shadows Amount down to 0. Then, you're going to add what amounts to Camera Raw's Clarity by increasing the amount of Midtone Contrast on this Overlay layer. (If you don't see the Adjustments section, turn on the Show More Options checkbox at the bottom left.) Go down near the bottom of the dialog and drag the Midtone Contrast slider to the right, and watch how your image starts to get that crispy look (crispy, in a good way). Of course, the farther to the right you drag, the crispier it gets, so don't go too far, because you're still going to sharpen this image. Now click OK, then go to the Layers panel's flyout menu and choose **Flatten Image**. Next, you're going to add a popular finishing touch to this type of look—an edge vignette.

Continued

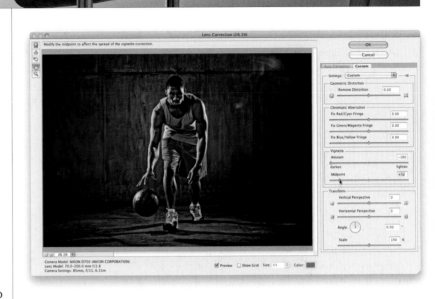

Step Seven:

Go under the Filter menu and choose **Lens Correction**. When the dialog opens, click on the Custom tab, and then in the Vignette section, drag the Amount slider to the left to –100 (this slider determines how dark the edges will be), then drag the Midpoint slider to around 12 (this determines how far in toward the center of the image the edge darkening extends, and we want it pretty large in this case), and click OK. The final step, which is optional, is to add mega-sharpening using the High Pass sharpening technique found in Chapter 11, then flatten the image again, and you're done. Go to the Actions panel and click the square Stop button at the bottom of the panel to stop recording. Open a different image and test your action on it by clicking on the action, then clicking the Play button at the bottom of the panel. A before/after is shown below.

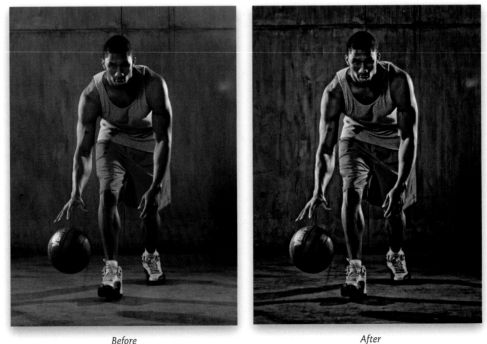

Before *After*

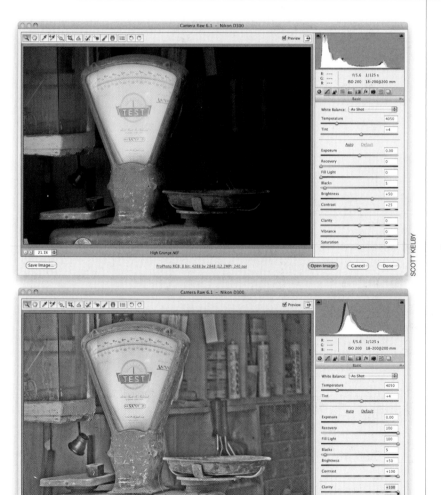

Getting the Grungy, High-Contrast Look Right Within Camera Raw

If you want that extreme contrast, grungy look, you can create it right within Camera Raw itself by just dragging a few sliders in the Basic panel and then adding a vignette. If you're going to leave Camera Raw and go to Photoshop at some point anyway, you should try poppin' some High Pass sharpening on this puppy. Shots like this, with lots of texture and metal, just love a little High Pass tossed on them, so give it a try. But let's not get ahead of ourselves—here's the grungy look made easy:

Step One:
Open a photo in Camera Raw. This is one of those effects that needs the right kind of image for it to look right. Photos with lots of detail, texture, along with anything metallic, and lots of contrast seem to work best (it also works great for sports portraits, cars, even some landscapes. In other words: I wouldn't apply this effect to a shot of a cute little fuzzy bunny). Here's the original RAW image open in Camera Raw. (*Note*: This effect actually seems to come out better when you run it on RAW images, rather than JPEG or TIFF, but it does work on all three.)

Step Two:
Set these four sliders all at 100: Recovery, Fill Light, Contrast, and Clarity (as shown here). This is going to make your image look kind of washed out (like you see here). The brightness for this photo looks okay, because it was kind of dark when we started, but if your image was already kind of bright in the first place, it's going to look really bright now. If that's the case, you can go ahead and lower the Exposure amount (just drag the Exposure slider to the left until the brightness looks normal. The image will still look washed out, but it shouldn't be crazy bright).

Continued

Step Three:

Now, you're going to bring back all the saturation and warmth to the color in the image by dragging the Blacks slider way up to the right. Keep dragging until the photo looks balanced (like it does here, where I dragged it over to +51). If the colors look too colorful and vibrant (and they probably will), just lower the Vibrance amount until it looks just a little desaturated (that's part of "the look"). Here, I lowered the Vibrance to −30. It did seem just a little dark at this point, so I also dragged the Exposure slider to +0.35.

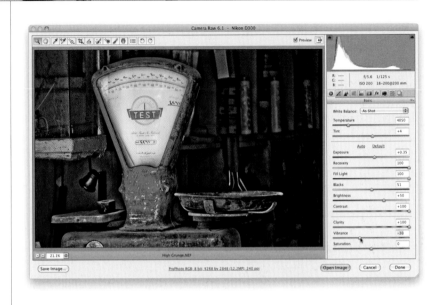

Step Four:

The finishing move for this effect is to add a dark edge vignette. So, click on the Lens Corrections icon (sixth from the left at the top of the Panel area), then click on the Manual tab, and in the Lens Vignetting section, drag the Amount slider to the left to darken the edges a bit (here, I dragged over to −48), and the Midpoint slider to the left to move the darkening farther into the center (I dragged it to around 43) to finish off the image (as seen here). Compare this to the original, and you can see the appeal of this effect, which almost looks a little like an HDR photo. Well, that's it—the whole grungy enchilada right within Camera Raw. (But, I gotta ask ya—is this baby screamin' for some High Pass sharpening, or what? See the next chapter for more on that.)

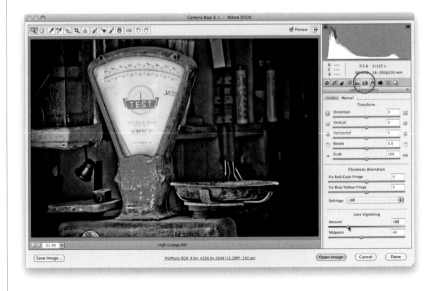

Traditional skylight filters have been popular with photographers for years, because they help cut haze, and cut down on the blue color casts you sometimes get when part of your image is in the distance (like a mountain range in a landscape shot). The overall effect is a warming effect, and even though traditional screw-on filters actually have a magenta color cast to them, here in Photoshop we use a warming filter to get a similar effect and warm up an otherwise cold image.

Skylight Filter Effect

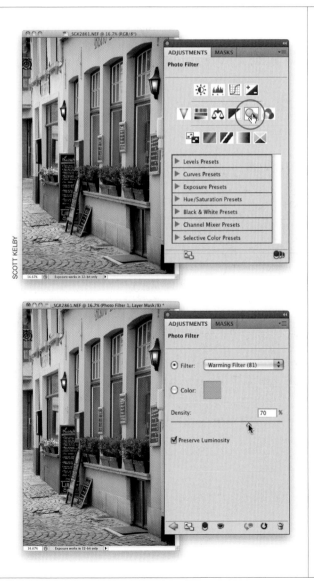

Step One:
Open the color photo you want to apply a Skylight Filter effect to in Photoshop CS5. Go to the Adjustments panel and click on the Photo Filter icon (it's the icon with a camera and a circle to the left of it—it's second from the right in the middle row).

Step Two:
Choose **Warming Filter** (81) from the pop-up menu, then increase the Density amount to 70% (as shown here).

Continued

Step Three:

Now go to the Layers panel and change the blend mode of this layer to **Soft Light** at the top left of the panel to complete the effect. *Note:* Changing the blend mode to Soft Light adds a bit of contrast, as well, so if it looks too contrasty after making this change, just lower the Opacity setting for this layer (at the top right of the Layers panel) until it looks about right (start at 50% and see what that looks like. In the photo shown here, the added contrast looks good, so I left it at 100%, but depending on the photo, you might have to tweak that Opacity setting a little bit). Below is a side-by-side before/after.

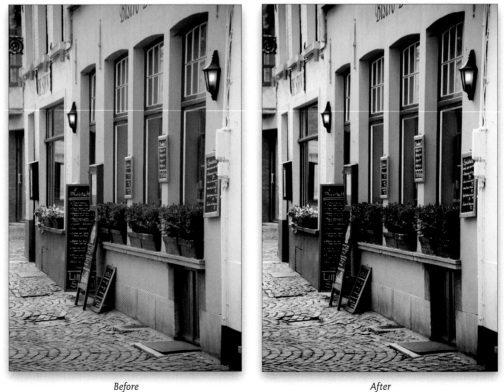

Before *After*

This is another one of those effects that has grown in popularity over the past year or so, and it takes just a few steps to totally nail the look. By the way, you could add an optional Polaroid-look border when you're done. First, select the entire photo, and cut it onto its own layer. Then, add two inches of white canvas area around the photo. Add a Drop Shadow layer style, then add a Stroke layer style. Set your stroke color to white, the location to Inside, set the Size to 120, and click OK—you're done.

The Faded Antique Look

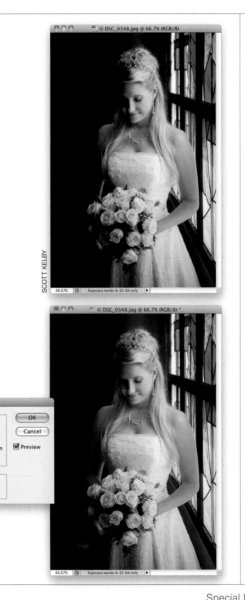

Step One:
Start with the photo you want to apply the technique to (we're going to use a bridal photo here. You can download the same photo from the book's companion website. In fact, you can download most of the key images used in the book, so you can follow right along. The Web address is in that introduction in the front of the book that you skipped).

Step Two:
First, you're going to add a very warm, yellowish tint to the image (while still leaving it in color) by going under the Image menu, under Adjustments, and choosing **Color Balance**. When the dialog appears, drag the top slider over toward Red, until it reads +26. Drag the center slider toward Magenta to –9, and drag the bottom slider over toward Yellow, to –59 (as shown here). Make sure the Preserve Luminosity checkbox is turned on, and that Midtones are selected for your Tone Balance (it's the center radio button). Now click OK.

Continued

Step Three:

Now, you'll need to desaturate the colors a bit (remember, those old, faded photos didn't have the bright, punchy colors we have today), so go under the Image menu, under Adjustments, and choose **Hue/Saturation**. When the dialog appears, drag the Saturation slider to −70 (as shown here) to remove some, but not all, of the color from the image. Now click OK.

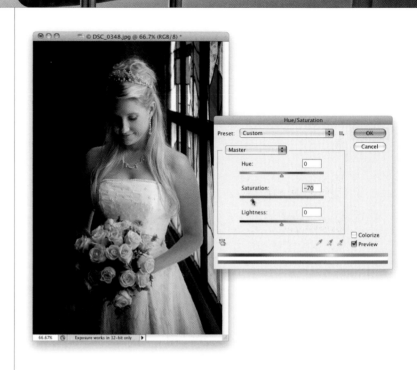

Step Four:

Press **Command-J (PC: Ctrl-J)** to duplicate the Background layer, then change the blend mode of this duplicate layer to **Screen** (as shown here), which makes the whole photo very bright and a little blown out (it's all part of the effect). Now press **Command-E (PC: Ctrl-E)** to flatten the two layers into one.

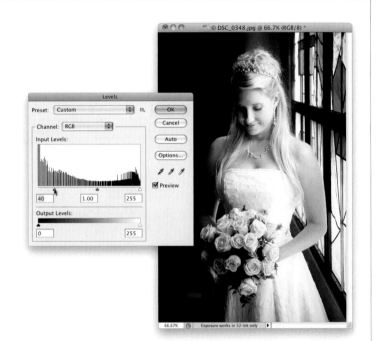

Step Five:
Press **Command-L (PC: Ctrl-L)** to bring up the Levels dialog, and drag the shadows Input Levels slider (the triangle under the far-left side of the histogram graph) to the right a bit (as shown here) to darken in the shadow areas, so there's a big difference between the bright areas and the dark areas.

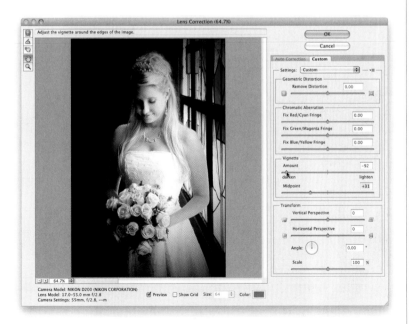

Step Six:
Now you're going to darken the edges of the photo on all sides, to give it that burned-in edge look. Go under the Filter menu and choose **Lens Correction**. When the dialog comes up, click on the Custom tab in the top right, then go down to the Vignette section, and drag the Amount slider almost all the way over to the left to darken the edges quite a bit (as I did here, where I dragged it over to −92). Now drag the Midpoint slider (which determines how far in toward the center of your image the darkening extends) to the left to +31 (as seen here), so it almost looks like there's a soft spotlight right on the bride. Click OK when you're done.

Continued

TIP: Why Make Panos with Photo-merge Instead of Auto-Align Layers?

If you use Auto-Align Layers, you'll notice that many of the layout features seem the same as in Photomerge. So, why use Photomerge for stitching? It's because Photomerge does more than just align layers—it stacks all your images into one document, then it aligns them (like Auto-Align Layers), but then it blends them together into one seamless pano. It does all three things at once. So don't let the Photomerge dialog fool you—it's doing more than it seems.

Step Six:

Press **Return (PC: Enter)**, and your pano is cropped down to size (as shown below) and you can make any other adjustments you want. Now, for Photoshop to pull this mini-miracle off, there's just one rule to remember when you're shooting: over-lap each photo segment by around 20%. That's the one rule I still teach. Do that, and the rest will take care of itself.

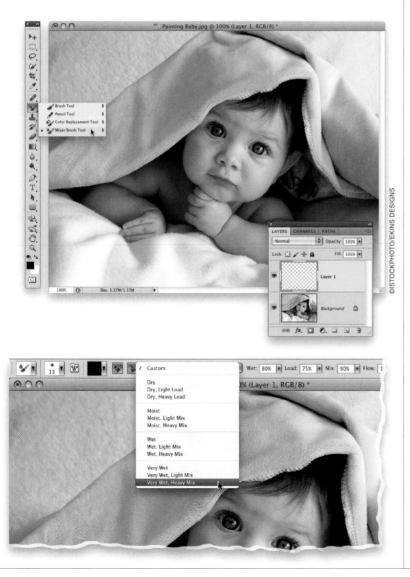

Turn a Photo into a Painting

Being able to easily turn a photo into a realistic-looking painting has been on the photographer's wish list for quite some time (this look is very popular with wedding and portrait photographers), and in Photoshop CS5, Adobe majorly updated the painting tools and painting engine, allowing the most realistic photo-paintings yet. The idea is not to paint the subject from scratch, but to use the colors and tones from the original image, and mix them using brushes that make the photo look like a painting (luckily, it's easier than it sounds).

Step One:
Open an image you want to turn into a painting. Now, you're going to want to paint on a separate layer above your Background layer, so start by creating a blank layer (click on the Create a New Layer icon at the bottom of the Layers panel). Next, get the new Mixer Brush tool from the toolbox (click-and-hold on the Brush tool, and the other tools appear in a flyout menu [as shown here], or press **Shift-B** until you have it).

Step Two:
When you choose the Mixer Brush tool, all sorts of new Brush options appear up in the Options Bar, along with a number of Blending Brush Combination presets for how the brush applies your "paint." For this particular project, we're going to go with an oil painting look, so from the presets pop-up menu, choose **Very Wet, Heavy Mix** (as shown here).

Continued

Step Three:

There are a couple of other little tweaks we need to make up in the Options Bar to set up our brush the way we'll need it for this look. Starting at the left, there's a button for loading the brush after each stroke, and it's on by default. Go ahead and turn this off by clicking on it (it's circled here in red). Now, come all the way over to the right side of the Options Bar and turn on the Sample All Layers checkbox. This is really important, because turning this on lets us automatically use the colors from the original photo on the Background layer, which is pretty much the key to making this all work.

Step Four:

One last thing before we begin painting: we have to choose our brush tip. Click on the Brush icon on the far-left side of the Options Bar (it's the second icon from the left), and the Brush Picker appears. You're going to start by painting over the background areas first, so let's choose a good brush for that—the Flat Fan High Bristle Count brush (as shown here).

Step Five:

Now you're going to start painting over the image, but the idea is to paint in the direction of the shape (for example, later, when you paint over the baby's hair, you'd paint in the direction the hair is going). You're going to need to vary the size of your brush using the **Left** and **Right Bracket keys** on your keyboard (the Left Bracket key makes your brush smaller; the right, larger. They're located to the right of the letter "P" on your keyboard). Start painting over the blanket on the baby's head, and just try to stay pretty much inside the lines, which I know these days is supposed to be a mentally limiting exercise, because in kindergarten we're told to always stay inside the lines, and now everybody wants to paint outside the lines so they experience personal growth, but these people aren't painting with the Mixer Brush tool in CS5, so just paint inside the lines for now, and let your therapist deal with the aftermath at your next visit (kidding).

Step Six:

Go ahead and paint the blanket the baby's lying on, as well, then you're going to switch brushes to something smaller for the detail areas (like the baby's face). So, go up to the Brush Picker and choose the Round Curve Low Bristle Percent brush (as shown here), lower the size of your brush, and begin painting over the contours of the baby's face (it won't look good quite yet, but the next steps are what bring this baby home. Well, at least figuratively). Also, if it seems "too wet," lower the Wet amount (up in the Options Bar) to around 15%, then lower the Mix amount to around 52%, and the Flow amount to 60%, so the intensity of the effect is much lower.

Continued

Photo by Scott Kelby Exposure: 1/1250 sec | Focal Length: 18mm | Aperture Value: f/7

Sharpen Your Teeth
sharpening techniques

I had two really good song titles to choose from for this chapter: "Sharpen Your Teeth" by Ugly Casanova or "Sharpen Your Sticks" by The Bags. Is it just me, or at this point in time, have they totally run out of cool band names? Back when I was a kid (just a few years ago, mind you), band names made sense. There were The Beatles, and The Turtles, and The Animals, and The Monkees, and The Flesh Eating Mutant Zombies, and The Carnivorous Flesh Eating Vege-tarians, and The Bulimic Fresh Salad Bar Restockers, and names that really made sense. But, "The Bags?" Unless this is a group whose members are made up of elderly women from Yonkers, I think it's totally misnamed. You see, when I was a kid, when a band was named The Turtles, its mem-bers looked and acted like turtles. That's what made it great (remember their hit single "Peeking Out of My Shell," or who could forget "Slowly Crossing a Busy Highway" or my favorite "I Got Hit Crossing a Busy Highway"?). But

today, you don't have to look ugly to be in a band named Ugly Casanova, and I think that's just wrong. It's a classic bait-and-switch. If I were in a band (and I am), I would name it something that reflects the real makeup of the group, and how we act. An ideal name for our band would be The Devastatingly Handsome Super Hunky Guys With Six-Pack Abs (though our fans would probably just call us TDHSHGWSPA for short). I could picture us playing at large 24-hour health clubs and Gold's Gyms, and other places where beautiful people (like ourselves) gather to high-five one another on being beautiful. Then, as we grew in popularity, we'd have to hire a manager. Before long he would sit us down and tell us that we're living a lie, and that TDHSHGWSPA is not really the right name for our band, and he'd propose something along the lines of Muscle Bound Studs Who Are Loose With Money or more likely, The Bags.

Sharpening Essentials

After you've color corrected your photo and right before you save your file, you'll definitely want to sharpen it. I sharpen every digital camera photo, either to help bring back some of the original crispness that gets lost during the correction process, or to help fix a photo that's slightly out of focus. Either way, I haven't met a digital camera (or scanned) photo that I didn't think needed a little sharpening. Here's a basic technique for sharpening the entire photo:

Step One:

Open the photo you want to sharpen. Because Photoshop displays your photo differently at different magnifications, choosing the right magnification (also called the zoom amount) for sharpening is critical. Because today's digital cameras produce such large-sized files, it's now pretty much generally accepted that the proper magnification to view your photos during sharpening is 50%. If you look up in your image window's title bar, it displays the current percentage of zoom (shown circled here in red). The quickest way to get to a 50% magnification is to press **Command-+ (plus sign; PC: Ctrl-+)** or **Command-– (minus sign; PC: Ctrl-–)** to zoom the magnification in or out.

Step Two:

Once you're viewing your photo at 50% size, go under the Filter menu, under Sharpen, and choose **Unsharp Mask**. (If you're familiar with traditional darkroom techniques, you probably recognize the term "unsharp mask" from when you would make a blurred copy of the original photo and an "unsharp" version to use as a mask to create a new photo whose edges appeared sharper.)

Step Three:

When the Unsharp Mask dialog appears, you'll see three sliders. The Amount slider determines the amount of sharpening applied to the photo; the Radius slider determines how many pixels out from the edge the sharpening will affect; and Threshold determines how different a pixel must be from the surrounding area before it's considered an edge pixel and sharpened by the filter (by the way, the Threshold slider works the opposite of what you might think—the lower the number, the more intense the sharpening effect). So what numbers do you enter? I'll give you some great starting points on the following pages, but for now, we'll just use these settings—Amount: 120%, Radius: 1, and Threshold: 3. Click OK and the sharpening is applied to the entire photo (see the After photo below).

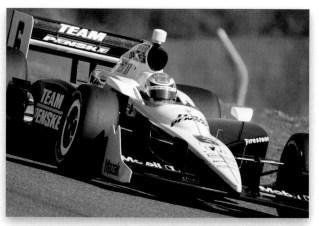

Before

After

Continued

Soft subject sharpening:

Here are Unsharp Mask settings—
Amount: 150%, Radius: 1, Threshold: 10—
that work well for images where the
subject is of a softer nature (e.g., flowers,
puppies, people, rainbows, etc.). It's a
subtle application of sharpening that is
very well suited to these types of subjects.

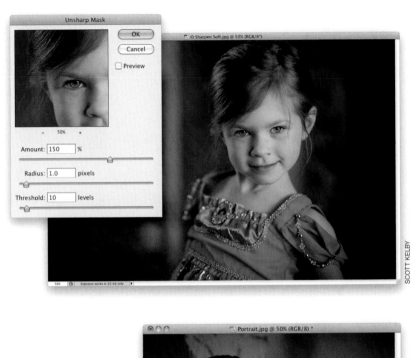

Portrait sharpening:

If you're sharpening close-up portraits, try
these settings—Amount: 75%, Radius: 2,
Threshold: 3—which apply another form
of subtle sharpening, but with enough
punch to make eyes sparkle a little
bit, and bring out highlights in your
subject's hair.

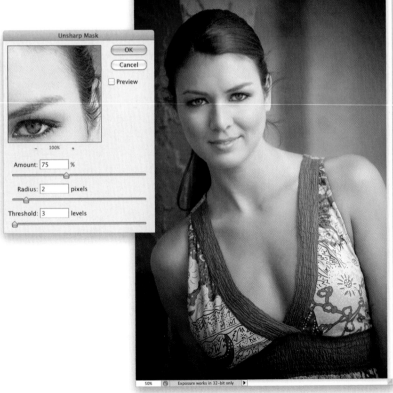

SCOTT KELBY

Moderate sharpening:

This is a moderate amount of sharpening that works nicely on everything from product shots, to photos of home interiors and exteriors, to landscapes (and in this case, a pay phone). These are my favorite settings when you need some nice snappy sharpening. Try applying these settings—Amount: 120%, Radius: 1, Threshold: 3—and see how you like it (my guess is you will). Take a look at how it added snap and detail to the buttons.

SCOTT KELBY

Maximum sharpening:

I use these settings—Amount: 65%, Radius: 4, Threshold: 3—in only two situations: (1) The photo is visibly out of focus and it needs a heavy application of sharpening to try to bring it back into focus. (2) The photo contains lots of well-defined edges (e.g., rocks, buildings, coins, cars, machinery, etc.). In this photo, the heavy amount of sharpening really brings out the detail along the roof line and in the shutters and bricks.

Continued

All-purpose sharpening:

These are probably my all-around favorite sharpening settings—Amount: 85%, Radius: 1, Threshold: 4—and I use these most of the time. It's not a "knock-you-over-the-head" type of sharpening—maybe that's why I like it. It's subtle enough that you can apply it twice if your photo doesn't seem sharp enough the first time you run it, but once will usually do the trick.

Web sharpening:

I use these settings—Amount: 200%, Radius: 0.3, Threshold: 0—for Web graphics that look blurry. (When you drop the resolution from a high-res, 300-ppi photo down to 72 ppi for the Web, the photo often gets a bit blurry and soft.) If the sharpening doesn't seem sharp enough, try increasing the Amount to 400%. I also use this same setting (Amount: 400%) on out-of-focus photos. It adds some noise, but I've seen it rescue photos that I would otherwise have thrown away.

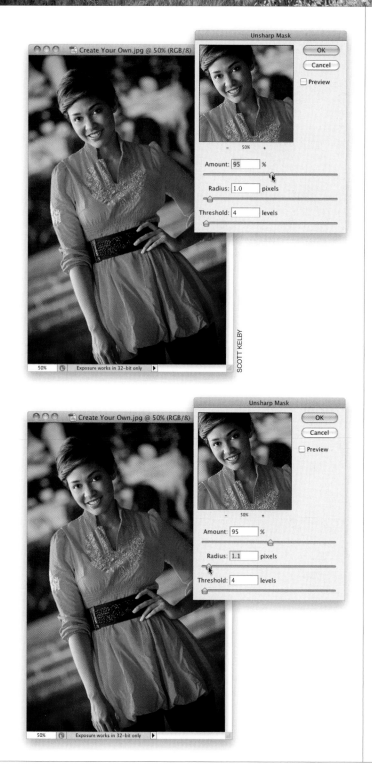

SCOTT KELBY

Coming up with your own settings:
If you want to experiment and come up with your own custom blend of sharpening, I'll give you some typical ranges for each adjustment so you can find your own sharpening "sweet spot."

Amount
Typical ranges run anywhere from 50% to 150%. This isn't a hard-and-fast rule—just a typical range for adjusting the Amount, where going below 50% won't have enough effect, and going above 150% might get you into sharpening trouble (depending on how you set the Radius and Threshold). You're fairly safe staying under 150%. (In the example here, I reset my Radius and Threshold to 1 and 4, respectively.)

Radius
Most of the time, you'll use just 1 pixel, but you can go as high as (get ready) 2 pixels. You saw one setting I gave you earlier for extreme situations, where you can take the Radius as high as 4 pixels. I once heard a tale of a man in Cincinnati who used 5, but I'm not sure I believe it. (Incidentally, Adobe allows you to raise the Radius amount to [get this] 250! If you ask me, anyone caught using 250 as their Radius setting should be incarcerated for a period not to exceed one year and a penalty not to exceed $2,500.)

Continued

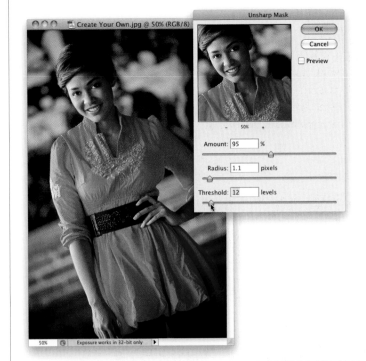

Threshold

A pretty safe range for the Threshold setting is anywhere from 3 to around 20 (3 being the most intense, 20 being much more subtle. I know, shouldn't 3 be more subtle and 20 be more intense? Don't get me started). If you really need to increase the intensity of your sharpening, you can lower the Threshold to 0, but keep a good eye on what you're doing (watch for noise appearing in your photo).

The Final Image

For the final sharpened image you see here, I used the Portrait sharpening settings I gave earlier, and then I just dragged the Amount slider to the right (increasing the amount of sharpening), until it looked right to me (I wound up at around 85%, so I didn't have to drag too far). If you're uncomfortable with creating your own custom Unsharp Mask settings, then start with this: pick a starting point (one of the set of settings I gave on the previous pages), and then just move the Amount slider and nothing else (so, don't touch the Radius and Threshold sliders). Try that for a while, and it won't be long before you'll find a situation where you ask yourself, "I wonder if lowering the Threshold would help?" and by then, you'll be perfectly comfortable with it.

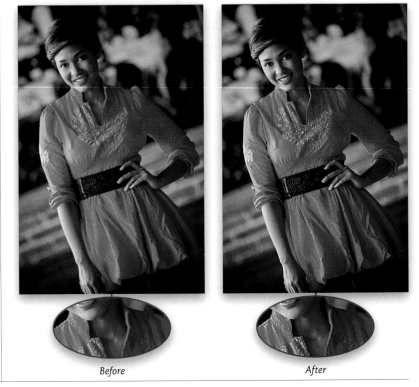

Before *After*

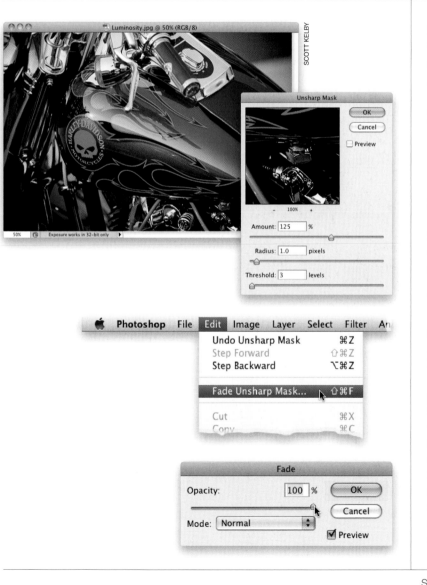

This sharpening technique is my most-often-used technique, and it has replaced the Lab Sharpening technique I've used in the past, because it's quicker and easier, and pretty much accomplishes the same thing, which is helping to avoid the color halos and color artifacts (spots and noise) that appear when you add a lot of sharpening to a photo. Because it helps avoid those halos and other color problems, it allows you to apply more sharpening than you normally could get away with.

Luminosity Sharpening

Step One:
Open the RGB photo you want to sharpen, and apply an Unsharp Mask just like you normally would (for this particular photo, let's apply these settings—Amount: 125, Radius: 1, Threshold: 3, which is my recipe for nice, punchy sharpening).

Step Two:
Immediately after you've applied the sharpening, go under the Edit menu and choose **Fade Unsharp Mask** (as shown below).

TIP: Undo on a Slider
I think of Fade's Opacity slider (seen here) as "Undo on a slider," because if you drag it down to 0, it undoes your sharpening. If you leave it at 100%, it's the full sharpening. If you lower the Opacity to 50%, you get half the sharpening applied, and so on. So, if I apply sharpening and I think it's too much, rather than changing all the settings and trying again, I'll just use the Fade Opacity slider to lower the amount a bit. I'll also use Fade when I've applied some sharpening and it's not enough. I just apply the Unsharp Mask filter again, then lower the Opacity to 50%. That way, I get 1½ sharpenings.

Continued

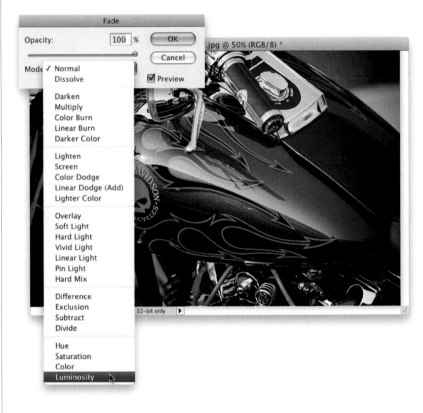

Step Three:

So, at this point, you can ignore the Opacity slider altogether, because the only thing you're going to do here is change the Fade dialog's Mode pop-up menu from Normal to **Luminosity** (as shown here). Now your sharpening is applied to just the luminosity (detail) areas of your photo, and not the color areas, and by doing this it helps avoid color halos and other pitfalls of sharpening a color image.

Step Four:

Click the OK button, and now your sharpening is applied to just the luminosity of the image (which is very much like the old Lab mode sharpening we used to do, where you convert your image to Lab color mode, then just sharpen the Lightness channel, and then convert back to RGB color). So, should you apply this brand of sharpening to every digital camera photo you take? I would. In fact, I do, and since I perform this function quite often, I automated the process (as you'll see in the next step).

SCOTT KELBY

Step Five:
Open a different RGB photo, and let's do the whole Luminosity sharpening thing again, but this time, before you start the process, go under the Window menu and choose **Actions** to bring up the Actions panel (seen here). The Actions panel is a "steps recorder" that records any set of repetitive steps and lets you instantly play them back (apply them to another photo) by simply pressing one button (you'll totally dig this). In the Actions panel, click on the Create New Action icon at the bottom of the panel (it looks just like the Create a New Layer icon from the Layers panel, and it's shown circled in red here).

Step Six:
Clicking that icon brings up the New Action dialog (shown here). The Name field is automatically highlighted, so go ahead and give this new action a name. (I named mine "Luminosity Sharpen." I know—how original!) Then, from the Function Key pop-up menu, choose the number of the Function key (F-key) on your keyboard that you want to assign to the action (this is the key you'll hit to make the action do its thing). I've assigned mine F11, but you can choose any open F-key that suits you (but everybody knows F11 is, in fact, the coolest of all F-keys—just ask anyone. On a Mac, you may need to turn off the OS keyboard shortcut for F11 first). You'll notice that the New Actions dialog has no OK button. Instead, there's a Record button, because once you exit this dialog, Photoshop starts recording your steps. So go ahead and click Record.

Continued

Step Seven:

With Photoshop recording every move you make, do the Luminosity sharpening technique you learned on the previous pages (apply your favorite Unsharp Mask setting, then go under the Edit menu, choose Fade Unsharp Mask, and when the dialog appears, change the blend mode to Luminosity and click OK. Also, if you generally like a second helping of sharpening, you can run the filter again, but don't forget to Fade to Luminosity right after you're done). Now, in the Actions panel, click on the Stop icon at the bottom of the panel (it's the square icon, first from the left, shown circled here in red).

Step Eight:

This stops the recording process. If you look in the Actions panel, you'll see all your steps recorded in the order you did them. Also, if you expand the right-facing triangle beside each step (as shown here), you'll see more detail, including individual settings, for the steps it recorded. You can see here that I used the Amount: 120%, Radius: 1, and Threshold: 3 Unsharp Mask settings.

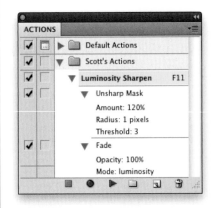

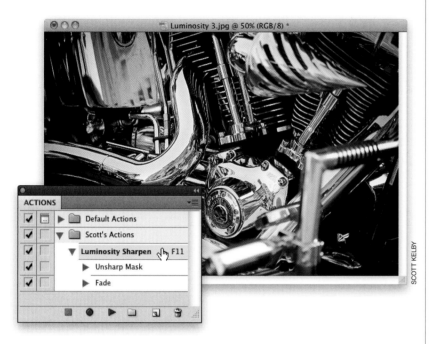

SCOTT KELBY

Step Nine:

Now, open a different RGB photo and let's test your action to see that it works (it's important to test it now before moving on to the next step). Press the F-key you assigned to your action (you chose F11, right? I knew it!). Photoshop immediately applies the sharpening to the Luminosity for you, and does it all faster than you could ever do it manually, because it takes place behind the scenes with no dialogs popping up.

Step 10:

Now that you've tested your action, we're going to put that baby to work. Of course, you could open more photos and then press F11 to have your action Luminosity sharpen them one at a time, but there's a better way. Once you've written an action, you can apply that action to an entire folder full of photos—and Photoshop will totally automate the whole process for you (it will literally open every photo in the folder and apply your Luminosity sharpening, and then save and close every photo—all automatically. How cool is that?). This is called batch processing, and here's how it works: Go under the File menu, under Automate, and choose **Batch** to bring up the Batch dialog (or you can choose Batch from the Tools icon menu's Photoshop submenu within Mini Bridge—you have to select the photos you want to batch sharpen first). At the top of the dialog, within the Play section, choose your Luminosity Sharpen action from the Action pop-up menu (if it's not already selected, as shown here).

Continued

Step 11:
In the Source section of the Batch dialog, you tell Photoshop which folder of photos you want to Luminosity sharpen. So, choose **Folder** from the Source pop-up menu (you can also choose Bridge to run this batch action on selected photos from Mini Bridge or Big Bridge, or you can import photos from another source, or choose to run it on images that are already open in Photoshop). Then, click on the Choose button. A standard Open dialog will appear (shown here) so you can navigate to your folder of photos you want to sharpen. Once you find that folder, click on it (as shown), then click the Choose (PC: OK) button.

Step 12:
In the Destination section of the Batch dialog, you tell Photoshop where you want to put these photos once the action has done its thing. If you choose Save and Close from the Destination pop-up menu (as shown here), Photoshop will save the images in the same folder they're in. If you select Folder from the Destination pop-up menu, Photoshop will place your Luminosity-sharpened photos into a totally different folder. To do this, click on the Choose button in the Destination section, navigate to your target folder (or create a new one), and click Choose (PC: OK).

Destination: Folder

Choose... Macintosh HD:Users:scottkelby:Desktop:Client Work:Travel:Sharpened Photos:

☐ Override Action "Save As" Commands

File Naming

Example: Tuscany01.gif

Tuscany	+	2 Digit Serial Number	+
extension	+		+
	+		

Starting serial#: 1

Compatibility: ☑ Windows ☑ Mac OS ☑ Unix

Step 13:

If you do choose to move them to a new folder, you can automatically rename your photos in the process. In short, here's how the file naming works: In the first field within the File Naming section, you type the basic name you want all the files to have. In the other fields, you can choose (from a pop-up menu) the automatic numbering scheme to use (adding a 1-digit number, 2-digit number, etc., and if you choose this, there's a field near the bottom where you can choose which number to start with). You can also choose to add the appropriate file extension (JPG, TIFF, etc.) in upper- or lowercase to the end of the new name. At the bottom of the dialog, there's a row of checkboxes for choosing compatibility with other operating systems. I generally turn all of these on, because ya never know. When you're finally done in the Batch dialog, click OK and Photoshop will automatically Luminosity sharpen, rename, and save all your photos in a new folder for you. Nice!

Using CS5's Updated Sharpen Tool

Back in Photoshop CS4, Adobe updated a few tools that really needed some serious updating (like the Dodge and Burn tools) by rewriting the underlying logic of each, and now not only are they usable (for perhaps the first time ever), but they're actually great. In CS5, Adobe went back and fixed another tool—the Sharpen tool—taking it from its previous role as a "noise generator/pixel destroyer" to what Adobe Product Manager Bryan Hughes has called "... the most advanced sharpening in any of our products." Here's how it works:

Step One:
Start by choosing the Sharpen tool from the Toolbox (it's found nested beneath the Blur tool, as seen here). Once you've got the tool, go up to the Options Bar and make sure the Protect Detail checkbox (shown circled here in red) is turned on (this is the checkbox that makes all the difference, as it turns on the new CS5 advanced sharpening algorithm for this tool).

Step Two:
I usually duplicate the Background layer at this point (by pressing **Command-J [PC: Ctrl-J]**) and apply the sharpening to this duplicate layer. That way, if I think the sharpening looks too intense, I can just lower the amount of it by lowering the opacity of this layer. I also usually zoom in (by pressing **Command-+ [plus sign; PC: Ctrl-+]** on a detail area (like her belt), so I can really see the effects of the sharpening clearly (another benefit of applying the sharpening to a duplicate layer is that you can quickly see a before/after of all the sharpening by showing/hiding the layer).

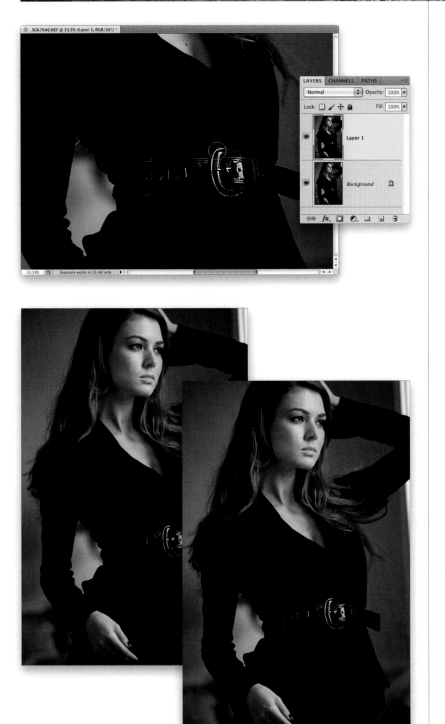

Step Three:

Now, choose a medium-sized, soft-edged brush from the Brush Picker in the Options Bar, and then simply take the Sharpen tool and paint over just the areas you want to appear sharp (this is really handy for portraits like this, because you can avoid areas you want to remain soft, like skin, but then super-sharpen areas you want to be really nice and crisp, like her belt). Since this tool is doing a lot of math behind the scenes, depending on how much you paint, you might have to wait a moment or two before the final sharpening is revealed. Back in the CS4 version of this book, I used to teach a more complex version of this idea of "painting with sharpness," because we couldn't use the Sharpen tool back then—it would just ruin your image. Instead, we had to super-sharpen a duplicate layer, hide it behind a black layer mask, and paint the sharpening back in where we wanted it.

Step Four:

Here's a before/after of the image after painting over areas that you'd normally sharpen, like her clothes, hair, and belt, while avoiding all areas of flesh tone. *Note:* One of the tricks the pros use to get incredibly sharp-looking photos is to apply their sharpening once, and then go back and spot sharpen only those areas in the photo that can hold a lot of sharpening (for example, areas that contain chrome, metal, steel, buttons on clothing, jewelry, or even your subject's eyes in some cases). So, first apply the regular Unsharp Mask filter to the entire image, then go back with the Sharpen tool and paint over just those areas that can really take a lot of sharpening. It makes the whole photo look that much sharper, even though you just super-sharpened a few key areas.

When to Use the Smart Sharpen Filter Instead

Although it hasn't caught on like many of us hoped, the Smart Sharpen filter offers some of the most advanced sharpening available in Photoshop CS5 (along with the newly updated Sharpen tool), because within it is a special sharpening algorithm that's better than the one found in the ever popular Unsharp Mask filter—you just have to know where to turn it on. Because Unsharp Mask is still so popular (old habits are hard to break), I find that I generally switch to Smart Sharpen when I run into a photo that's visibly out of focus.

Step One:
Go under the Filter menu, under Sharpen, and choose **Smart Sharpen**. This filter is in Basic mode by default, so there are only two sliders: Amount controls the amount of sharpening (I know, "duh!") and Radius determines how many pixels the sharpening will affect. The default Amount setting of 100% seems too high to me for everyday use, so I usually find myself lowering it to between 60% and 70%. The Radius is set at 1 by default, and I rarely change that, but for this image, I raised it to 2.

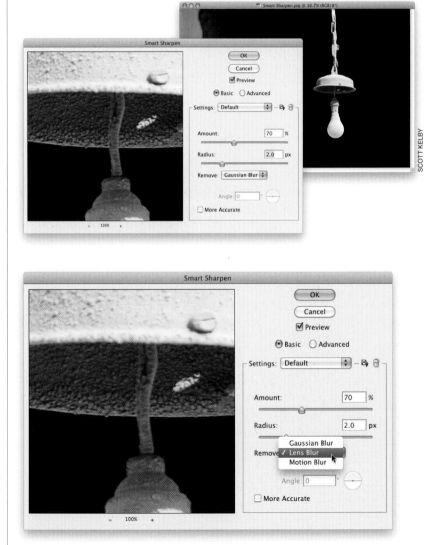

SCOTT KELBY

Step Two:
Below the Radius slider is the Remove pop-up menu (shown here), which lists the three types of blurs you can reduce. Gaussian Blur (the default) applies the same sharpening you get using the regular Unsharp Mask filter. Motion Blur is useless, unless you can accurately determine the angle of blur in your image (which I've yet to be able to do even once). The third one is the one I recommend: Lens Blur. This uses a sharpening algorithm created by Adobe's engineers that's better at detecting edges, so it creates fewer color halos than you'd get with the other choices, and overall I think it gives you better sharpening for most images.

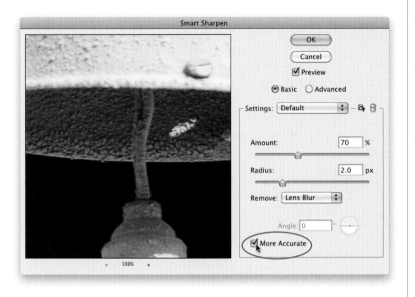

Step Three:

The only downside to choosing Lens Blur is that it makes the filter take a little longer to "do its thing." (That's why it's not the default choice, even though it provides better-quality sharpening.) After you choose Lens Blur, go to the bottom of the dialog and you'll see a checkbox for More Accurate. It gives you (according to Adobe) more accurate sharpening by applying multiple iterations of the sharpening. I leave More Accurate turned on nearly all the time. (After all, who wants "less accurate" sharpening?) *Note:* If you're working on a large file, the More Accurate option can cause the filter to process slower, so it's up to you if it's worth the wait (I think it is). By the way, the use of the More Accurate checkbox is one of those topics that Photoshop users debate back and forth in online forums. For regular everyday sharpening it might be overkill, but again, the reason I use Smart Sharpen is because the photo is visibly blurry, slightly out of focus, or needs major sharpening to save. So I leave this on all the time.

Step Four:

If you find yourself applying a setting such as this over and over again, you can save these settings and add them to the Settings pop-up menu at the top of the dialog by clicking on the floppy disk icon to the right of the pop-up menu. (Why a floppy disk icon? I have no idea.) This brings up a dialog for you to name your saved settings, and then click OK. Now, the next time you're in the Smart Sharpen filter dialog and you want to instantly call up your saved settings, just choose it from the Settings pop-up menu (as shown here).

Continued

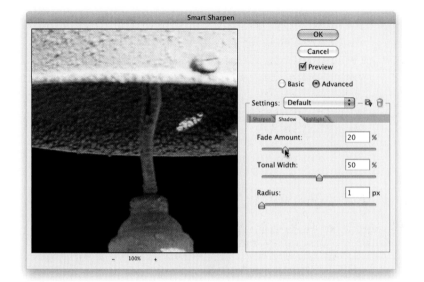

Step Five:

If you click the Advanced radio button, it reveals two additional tabs with controls for reducing the sharpening in just the shadow or just the highlight areas that are applied to the settings you chose back in the Basic section. That's why in the Shadow and Highlight tabs, the top slider says "Fade Amount" rather than just "Amount." As you drag the Fade Amount slider to the right, you're reducing the amount of sharpening already applied, which can help reduce any halos in the highlights. (*Note:* Without increasing the amount of fade, you can't tweak the Tonal Width and Radius amounts. They only kick in when you increase the Fade Amount.) Thankfully, I rarely have had to use these Advanced controls, so 99% of my work in Smart Sharpen is done using the Basic controls.

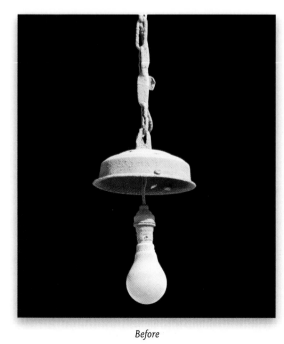

Before

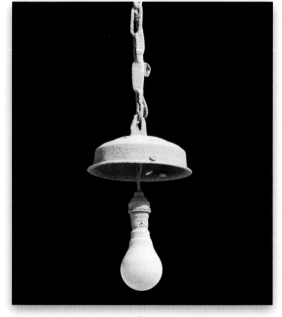

After

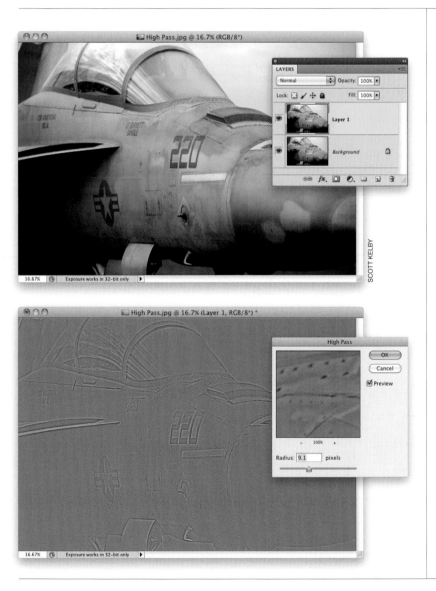

I don't normally include the same technique twice in the same book, but if you read the HDR chapter, I included High Pass sharpening there too, because it's become kind of synonymous with HDR processing. Of course, what I'm concerned about is that you skipped over the HDR chapter altogether, and came here to the sharpening chapter, and you'd be wondering why the very popular High Pass sharpening technique (which creates extreme sharpening) wasn't included in the book. Well, it's so good, it is covered twice. :)

High Pass Sharpening

Step One:
Open a photo that needs some extreme sharpening, like this photo taken at an airshow. Duplicate the Background layer by pressing **Command-J (PC: Ctrl-J)**, as shown here.

Step Two:
Go under the Filter menu, under Other, and choose **High Pass**. You use this filter to accentuate the edges in the photo, and making those edges stand out can really give the impression of mega-sharpening. I start by dragging the Radius slider all the way to the left (everything turns gray onscreen), then I start dragging it over to the right. For non-HDR images, I don't drag it all that far—I just drag until I see the edges of objects in the photos appear clearly, and then I stop. The farther you drag, the more intense the sharpening will be, but if you drag too far, you start to get these huge glows and the effect starts to fall apart, so don't get carried away. Now, click OK to apply the sharpening.

Continued

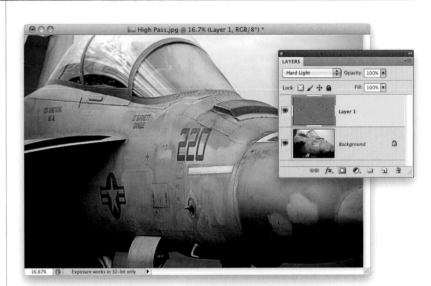

Step Three:

In the Layers panel, change the layer blend mode of this layer from Normal to **Hard Light**. This removes the gray color from the layer, but leaves the edges accentuated, making the entire photo appear much sharper (as seen here). If the sharpening seems too intense, you can control the amount of the effect by lowering the layer's Opacity in the Layers panel.

Step Four:

If you want even more sharpening, duplicate the High Pass layer to double-up the sharpening. If that's too much, lower the Opacity of the top layer. One problem with High Pass sharpening is that you might get a glow along some edges (like the one along the bottom of the plane in Step Three). The trick to getting rid of that is to: (1) press **Command-E (PC: Ctrl-E)** to merge the two High Pass layers, (2) click the Add Layer Mask button at the bottom of the panel, (3) get the Brush tool **(B)**, and with a small soft-edged brush and your Foreground color set to black, (4) paint right along the edge, revealing the original, unsharpened edge with no glow. A before/after is below.

For more sharpening, duplicate the layer

Merge the two layers and add a layer mask

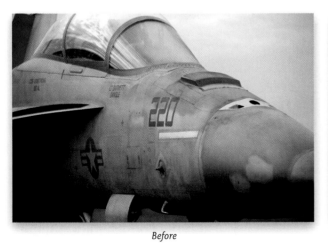

Before

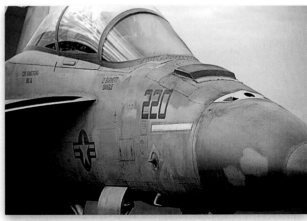

After

If you wind up doing all your edits from right within Camera Raw, and then you save straight to a JPEG or TIFF right from Camera Raw, as well (skipping the jump to Photoshop altogether), you'll still want to sharpen your image for how the image will be viewed (onscreen, in print, etc.). This is called "output sharpening" (the sharpening you do in Camera Raw's Detail panel is called "input sharpening," because it's designed to replace the sharpening that would have been done in your camera if you had shot in JPEG or TIFF mode).

Output Sharpening in Camera Raw

SCOTT KELBY

Step One:
Before we do this output sharpening, it's important to note that this sharpening only kicks in if you're going to save your image from right here within Camera Raw by clicking the Save Image button in the bottom-left corner of the Camera Raw window. If you click the Open Image or Done button, the output sharpening is not applied. Okay, now that you know, you find output sharpening by clicking on the line of text (which looks like a Web link) below the Preview area (it's circled here in red).

Step Two:
First, choose how you want this image sharpened from the Sharpen For pop-up menu near the bottom: For Screen is for images you're going to post on the Web, email to a client, or present in a slide show. If the image is going to be printed, choose whether you'll be printing to Glossy Paper or Matte Paper. Lastly, choose the amount of sharpening you want from the Amount pop-up menu. Camera Raw will do the math based on the image's resolution, your paper choice, and amount choice (I never choose Low, by the way) to calculate the exact right amount of output sharpening. *Note:* When you click OK, sharpening stays on from now on. To turn it off, choose **None** from the Sharpen For pop-up menu.

Setting Up Your Camera's Color Space

Although there are entire books written on the subject of color management, in this chapter we're going to focus on just one thing—getting what comes out of your color inkjet printer to match what you see onscreen. That's what it's all about, and if you follow the steps in this chapter, you'll get prints that match your screen. We're going to start by setting up your camera's color space, so you'll get the best results from screen to print. *Note:* You can skip this if you only shoot in RAW.

Step One:
If you shoot in JPEG or TIFF mode (or JPEG + Raw), you'll want to set your camera's color space to match what you're going to use in Photoshop for your color space (to get consistent color from your camera to Photoshop to your printer, you'll want everybody speaking the same language, right?). I recommend you change your camera's color space from its default sRGB to Adobe RGB (1998), which is a better color space for photographers whose final image will come from a color inkjet printer.

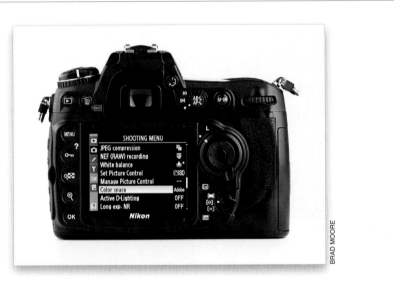

Step Two:
On a Nikon DSLR, you'll usually find the Color Space control under the Shooting Menu (as shown here at left). On most Canon DSLRs, you'll find the Color Space control under the Shooting menu, as well (as shown here on the right). Change the space to Adobe RGB. If you're not shooting Nikon or Canon, it's time to dig up your owner's manual (or, ideally, download it in PDF format from the manufacturer's website) to find out how to make the switch to Adobe RGB (1998). Again, if you're shooting in RAW, you can skip this altogether.

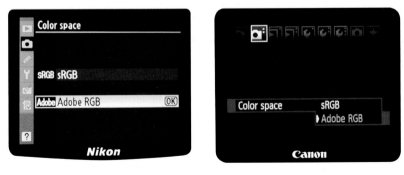

This is one of those topics that tend to make people crazy, and since there is no Official Board of Resolution Standards, this is the type of thing that gets argued endlessly in online discussion forums. That being said, I take the word of my friend and fellow photographer Dan Steinhardt from Epson (the man behind the popular Epson Print Academy), who lives this stuff day in and day out (Dan and I did an online training class on printing and this was just about the first topic we covered, because for so many, this is a real stumbling block). Here's what we do:

Resolution for Printing

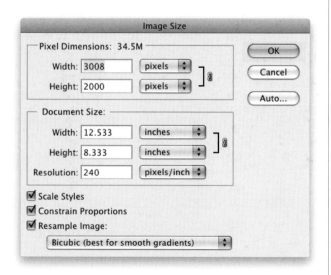

Step One:
To see what your current photo's resolution is, go under the Image menu and choose **Image Size** (or press **Command-Option-I [PC: Ctrl-Alt-I]**). Ideally, for printing to a color inkjet printer, I like to be at 240 ppi (pixels per inch), but I often print at 200 ppi, and will go as low as 180 ppi (but 180 ppi is absolutely the lowest I'll go. Anything below that and, depending on the image, you'll start to visibly lose print quality). So, I guess the good news here is: you don't need as much resolution as you might think (even for a printing press). Here's an image taken with a 12-megapixel camera and you can see that at 240 ppi, I can print an image that is nearly 12x18".

Step Two:
Here's the resolution from a 6-megapixel camera. At 240 ppi I can only print an 8x12.5" image. So, to make it larger, I turn off the Resample Image checkbox, type in 200 as my new resolution, and then I'd have an image size of 10x15" (with no loss of quality). If I lower it to 180 ppi (as low as I would ever go), then I get the print up to a finished size of 11x16.75" (nearly that of a 12-megapixel camera), and I did it all without losing quality (because I turned off the Resample Image checkbox, but before you do this, you need to read about resizing in Chapter 5).

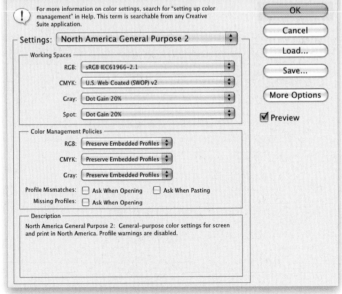

Setting Up Photoshop's Color Space

Photoshop's default color space is sRGB (some pros refer to it as "stupid RGB"), which is fine for photos going on the Web, but your printer can print a wider range of colors than sRGB (particularly in the blues and greens). So, if you work in sRGB, you're essentially leaving out those rich, vivid colors you could be seeing. That's why we either change our color space to Adobe RGB (1998) if you're shooting in JPEG or TIFF, which is better for printing those images, or ProPhoto RGB if you shoot in RAW or work with Photoshop Lightroom. Here's how to set up both:

Step One:
Before we do this, I just want to reiterate that you only want to make this change if your final print will be output to your own color inkjet. If you're sending your images out to an outside lab for prints, you should probably stay in sRGB—both in the camera and in Photoshop—as most labs are set up to handle sRGB files. Your best bet: ask your lab which color space they prefer. Okay, now on to Photoshop: go under the Edit menu and choose **Color Settings** (as shown here).

Step Two:
This brings up the Color Settings dialog. By default, it uses a group of settings called "North America General Purpose 2." Now, does anything about the phrase "General Purpose" sound like it would be a good space for pro photographers? Didn't think so. The tip-off is that under Working Spaces, the RGB space is set to sRGB IEC61966–2.1 (which is the longhand technical name for what we simply call sRGB). In short, you don't want to use this group of settings. They're for goobers— not for you (unless of course, you are a goober, which I doubt because you bought this book, and they don't sell this book to goobers. It's in each bookstore's contract).

Step Three:

To get a preset group of settings that's better for photographers, from the Settings pop-up menu, choose **North America Prepress 2**. Don't let it throw you that we're using prepress settings here—they work great for color inkjet printing because it uses the Adobe RGB (1998) color space. It also sets up the appropriate warning dialogs to help you keep your color management plan in action when opening photos from outside sources or other cameras (more on this on the next page).

Step Four:

If you're shooting in RAW exclusively, or using Lightroom (Adobe's awesome application for photographers), then you'll want to change your color space in Photoshop to **ProPhoto RGB** to get the best prints from your RAW images (plus, if you use Lightroom, you'll wind up moving images back and forth between Lightroom and Photoshop from time to time, and since Lightroom's native color space is ProPhoto RGB, you'll want to keep everything consistent. While you might use Lightroom for your JPEG or TIFF images, there's really no advantage to choosing ProPhoto RGB for them). You change Photoshop's Color Space to PhotoPro RGB in the Color Settings dialog (just choose it from the RGB menu, as shown here). That way, when you open a RAW photo in Photoshop (or import a file from Lightroom), everything stays in the same consistent color space and if you wind up bringing an image from Lightroom over to Photoshop, and end up printing it in Photoshop (instead of jumping back to Lightroom for printing), you'll get better results.

Continued

Step Five:

About those warnings that help you keep your color management on track: Let's say you open a JPEG photo, and your camera was set to shoot in Adobe RGB (1998), and your Photoshop is set the same way. The two color spaces match, so no warnings appear. But, if you open a JPEG photo you took six months ago, it will probably still be in sRGB, which doesn't match your Photoshop working space. That's a mismatch, so you'd get the warning dialog shown here, telling you this. Luckily it gives you the choice of how to handle it. I recommend converting that document's colors to your current working space (as shown here).

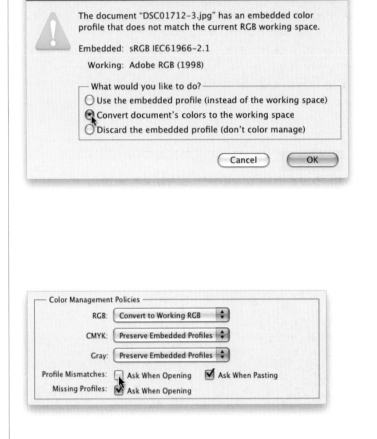

Step Six:

You can have Photoshop do this conversion automatically anytime it finds a mismatch. Just reopen the Color Settings dialog, and under Color Management Policies, in the RGB pop-up menu, change your default setting to **Convert to Working RGB** (as shown here). For Profile Mismatches, turn off the Ask When Opening checkbox. Now when you open sRGB photos, they will automatically update to match your current working space. Nice!

Step Seven:

Okay, so what if a friend emails you a photo, you open it in Photoshop, and the photo doesn't have any color profile at all? Well, once that photo is open in Photoshop, you can convert that "untagged" image to Adobe RGB (1998) by going under the Edit menu and choosing **Assign Profile**. When the Assign Profile dialog appears, click on the Profile radio button, ensure Adobe RGB (1998) is selected in the pop-up menu, then click OK.

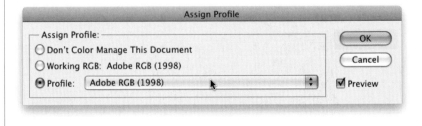

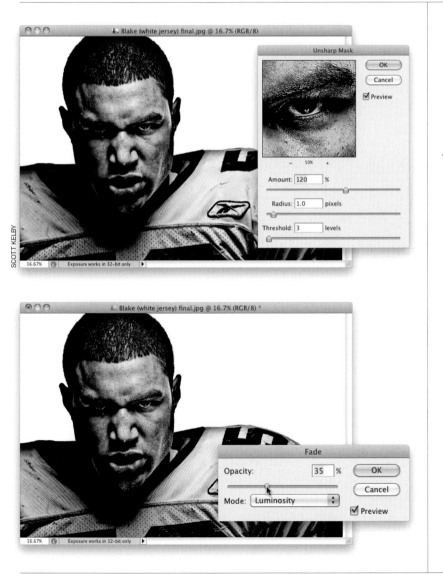

When we apply sharpening, we apply it so it looks good on our computer screen, right? But when you actually make a print, a lot of that sharpening that looks fine on a 72- or 96- dpi computer screen, gets lost on a high-resolution print at 240 ppi. Because the sharpening gets reduced when we make a print, we have to sharpen so our photo looks a bit too sharp onscreen, but then looks perfect when it prints. Here's how I apply sharpening for images I'm going to print:

Sharpening for Printing

Step One:
Start by doing a trick my buddy Shelly Katz shared with me: duplicate the Background layer (by pressing **Command-J [PC: Ctrl-J]**) and do your print sharpening on this duplicate layer (that way, you don't mess with the already sharpened original image on the Background layer). Name this new layer "Sharpened for Print," then go under the Filter menu, under Sharpen, and choose **Unsharp Mask**. For most 240 ppi images, I apply these settings: Amount 120; Radius 1; Threshold 3.

Step Two:
Next, reapply the Unsharp Mask filter with the same settings by pressing **Command-F (PC: Ctrl-F)**. Then, at the top of the Layers panel, change the layer blend mode to **Luminosity** (so the sharpening is only applied to the detail of the photo, and not the color), then use the Opacity slider to control how much sharpening is applied. Start at 50% and see if it looks a little bit oversharpened. If it looks like a little bit too much, stop—you want it to look a little oversharpened. If you think it's way too much, lower the opacity to around 35% and re-evaluate. When it looks right (a little too sharp), make a test print. My guess is that you'll want to raise the opacity up a little higher, because it won't be as sharp as you thought.

Sending Your Images to Be Printed at a Photo Lab

Besides printing images on my own color inkjet printer, I also send a decent amount of my print work out to a photo lab (I use Mpix.com as my lab) for a number of reasons—like if I want metallic prints, or I want the image mounted, matted and/or framed with glass, or I want a print that's larger than I can print in-house. Here's how to prep your images for uploading to be printed at a photo lab:

Step One:
First, contact the photo lab where you're sending your image, and ask what color profile they want you to use. Chances are they are going to want you to convert your image to sRGB color mode. I know this flies in the face of what we do when we print our own images, but I know a number of big, high-quality photo labs (Mpix.com included) that all request that you convert your images to sRGB first, and for their workflow, it works. If they don't request you convert to sRGB, they may have you download a color profile they've created for you, and you'll use it the same way as you'll assign sRGB in the next step.

Step Two:
With your image open in Photoshop, go under the Edit menu, choose **Convert to Profile**, and you'll see the image's current color profile at the top of the dialog (here, my image is a RAW image, and so it's set to ProPhoto RGB). Under Destination Space, from the Profile pop-up menu, choose **Working RGB – sRGB IEC61966-2.1.** If you downloaded a profile from your lab, you'll choose that instead (more on where to save downloads on page 355). Click OK, and don't be surprised if the image looks pretty much the same. In fact, be happy if it does, but at least now it's set up to get the best results from your photo lab.

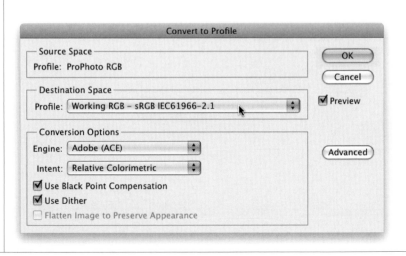

You Have to Calibrate Your Monitor Before You Go Any Further

If you really want what comes out of your printer to match what you see onscreen, then I don't want to have to be the one to tell you this, but…you absolutely, positively have to calibrate your monitor using a hardware calibrator. The good news is that today it's an absolutely simple, totally automated process. The bad news is that you have to buy a hardware calibrator. With hardware calibration, it's measuring your actual monitor and building an accurate profile for the exact monitor you're using, and yes—it makes that big a difference.

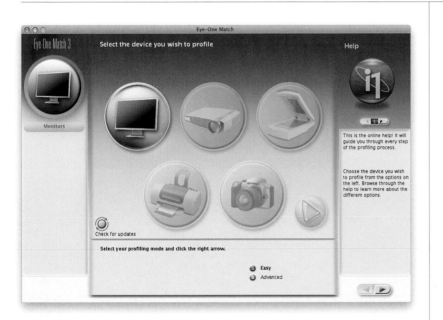

Step One:
I use X-Rite's i1 Display 2 hardware calibrator (around $200 street price), because it's simple, affordable, and most of the pros I know rely on it, as well. So, I'm going to use it as an example here, but it's not necessary to get this same one (Datacolor makes the Spider3 Elite, which is another popular choice in this price range). You start by installing the Eye-One Match 3 software that comes with the i1 Display 2. Now, plug the i1 Display 2 into your computer's USB port, then launch the software to bring up the main window (seen here). You do two things here: (1) you choose which device to profile (in this case, a monitor), and (2) you choose your profiling mode (you choose between Easy or Advanced. Honestly, I just use the Easy mode most of the time—it works great and does all the work for you).

Continued

Step Two:

After choosing Easy, press the Right Arrow button in the bottom right, and the window you see here will appear. Here you just tell the software which type of monitor you have: an LCD (a flat-panel monitor), a CRT (a glass monitor with a tube), or a laptop (which is what I'm using, so I clicked on Laptop, as shown here), then press the Right Arrow button again.

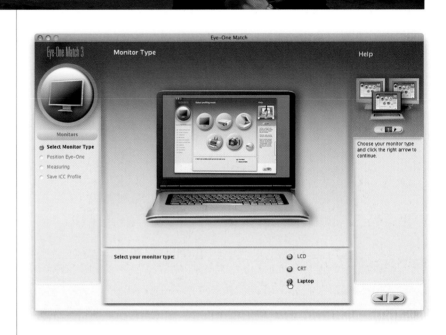

Step Three:

The next screen asks you to Place Your Eye-One Display on the Monitor, which means you drape the sensor over your monitor so it sits flat against your monitor and the cord hangs over the back. The sensor comes with a counterweight you can attach to the cord, so you can position the sensor approximately in the center of your screen without it slipping down. There are built-in suction cups for use on CRT monitors.

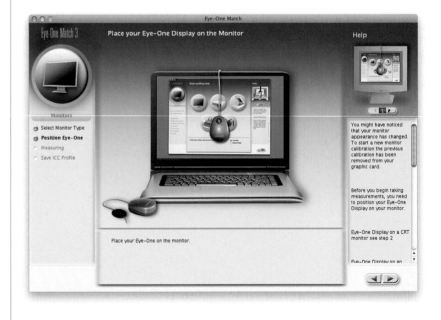

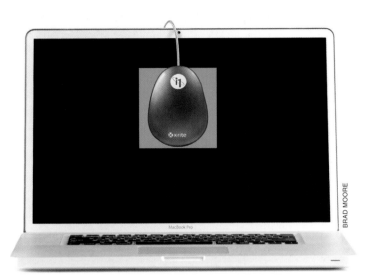

BRAD MOORE

Step Four:
Once the sensor is in position (this takes all of about 20 seconds) click the Right Arrow button, sit back, and relax. You'll see the software conduct a series of onscreen tests, using gray and white rectangles and various color swatches, as shown here. (*Note:* Be careful not to watch these onscreen tests while listening to Jimi Hendrix's "Are You Experienced," because before you know it, you'll be on your way to Canada in a psychedelic VW Microbus with only an acoustic guitar and a hand-drawn map to a campus protest. Hey, I've seen it happen.)

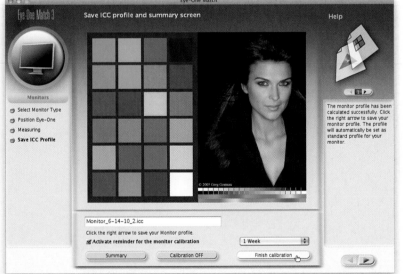

Step Five:
This testing only goes on for around six or seven minutes (at least, that's all it took for my laptop), then it's done. It does let you see a before and after (using the buttons on the bottom), and you'll probably be shocked when you see the before/after results (most people are amazed at how blue or red their screen was every day, yet they never noticed). Once you've compared your before and after, click the Finish Calibration button and that's it—your monitor is accurately profiled, and it even installs the profile for you and then quits. It should be called "Too Easy" mode.

The Other Secret to Getting Pro-Quality Prints That Match Your Screen

When you buy a color inkjet printer and install the printer driver that comes with it, it basically lets Photoshop know what kind of printer is being used, and that's about it. But to get pro-quality results, you need a color profile for your printer based on the exact type of paper you'll be printing on. Most inkjet paper manufacturers now create custom profiles for their papers, and you can usually download them free from their websites. Does this really make that big a difference? Ask any pro. Here's how to find and install these profiles:

Step One:
Your first step is to go to the website of the company that makes the paper you're going to be printing on and search for their downloadable color profiles for your printer. I use the term "search" because they're usually not in a really obvious place. I use two Epson printers—a Stylus Photo R2880 and a Stylus Pro 3880—and I generally print on Epson paper. When I installed the 3880's printer driver, I was tickled to find that it also installed custom color profiles for all Epson papers (this is rare), but my R2880 (like most printers) doesn't. So, the first stop would be Epson's website, where you'd click on Printers & All-in-Ones under Get Drivers & Support link (as shown here). *Note:* Even if you're not an Epson user, still follow along (you'll see why).

Step Two:
Once you get to Drivers & Support, find your particular printer in the list. Click on that link, and on the next page, click on Drivers & Downloads (choose Windows or Macintosh). On that page is a link to the printer's Premium ICC Profiles page.

Step Three:
When you click that link, a page appears with a list of Mac and Windows ICC profiles for Epson's papers and printers. I primarily print on two papers: (1) Epson's Ultra Premium Photo Paper Luster, and (2) Epson's Velvet Fine Art paper. So, I'd download the ICC profiles for them under Glossy Papers (as shown here) and the Fine Art Papers (at the bottom of the window). They download onto your computer, and you just double-click the installer for each one, and they're added to your list of profiles in Photoshop (I'll show how to choose them in the Print dialog a little later). That's it—you download them, double-click to install, and they'll be waiting for you in Photoshop's print dialog. Easy enough. But what if you're not using Epson paper? Or if you have a different printer, like a Canon or an HP?

Continued

Step Four:

We'll tackle the different paper issue first (because they're tied together). I mentioned earlier that I usually print on Epson papers. I say usually because sometimes I want a final print that fits in a 16x20" standard pre-made frame, without having to cut or trim the photo. In those cases, I use Red River Paper's 16x20" Ultra Satin Pro instead (which is very much like Epson's Ultra Premium Luster, but it's already pre-cut to 16x20"). So, even though you're printing on an Epson printer, now you'd go to Red River Paper's site (www.redriverpaper.com) to find their color profiles for my other printer—the Epson 3880. (Remember, profiles come from the company that makes the paper.) On the Red River Paper home-page is a link for Premium Photographic Inkjet Papers, so click on that.

Step Five:

Once you click that link, things get easier, because on the left side of the next page (under Helpful Info) is a clear, direct link right to their free downloadable color profiles (as seen here). Making profiles easy to find like this is extremely rare (it's almost too easy—it must be a trap, right?). So, click on that Color Profiles link and it takes you right to the profiles for Epson printers, as seen in Step Six (how sweet is that?).

Step Six:

Under the section named Epson Wide Format, there's a direct link to the Epson Pro 3880 (as shown here), but did you also notice that there are ICC Color profiles for the Canon printers, as well? See, the process is the same for other printers, but be aware: although HP and Canon both make pro-quality photo printers, Epson had the pro market to itself for quite a while, so while Epson profiles are created by most major paper manufacturers, you may not always find paper profiles for HP and Canon printers. As you can see at Red River, they widely support Epson, and some Canon profiles are there, too—but there's only one for HP. That doesn't mean this won't change, but as of the writing of this book, that's the reality. Speaking of change—the look and navigation of websites change pretty regularly, so if these sites look different when you visit them, don't freak out. Okay, you can freak out, but just a little.

Step Seven:

Although profiles from Epson's website come with an installer, in Red River's case (and in the case of many other paper manufacturers), you just get the profile (shown here) and instructions, so you install it yourself (don't worry—it's easy). On a PC, just Right-click on the profile and choose Install Profile. Easy enough. On a Mac, go to your hard disk, open your Library folder, and open your Color-Sync folder, where you'll see a Profiles folder. Just drag the file in there and you're set (in Photoshop CS5 you don't even have to restart Photoshop—it automatically updates).

Continued

Step Eight:

Now, you'll access your profile by choosing **Print** from Photoshop's File menu. In the Print dialog, change the Color Handling pop-up menu to **Photoshop Manages Color**. Then, click on the Printer Profile pop-up menu, and your new color profile(s) will appear (as shown here). In our example, I'm printing to an Epson 3880 using Red River's Ultra Pro Satin paper, so that's what I'm choosing here as my printer profile (it's named RR UPSat Ep3880.icc). More on using these color profiles later in this chapter.

TIP: Creating Your Own Profiles

You can also pay an outside service to create a custom profile for your printer. You print a test sheet (which they provide), overnight it to them, and they'll use an expensive colorimeter to measure your test print and create a custom profile. The catch: it's only good for that printer, on that paper, with that ink. If anything changes, your custom profile is just about worthless. Of course, you could do your own personal printer profiling (using something like one of X-Rite's i1 Solutions), so you can re-profile each time you change paper or inks. It's really determined by your fussiness/time/money factor (if you know what I mean).

Okay, so at this point, you've set Photoshop to the proper color space for the type of photo you're going to be printing (RAW, JPEG, TIFF, etc., see page 344), you've hardware calibrated your monitor (see page 349), and you've even downloaded a printer profile for the exact printer model and style of paper you're printing on. In short—you're there. Luckily, you only have to do all that stuff once—now we can just sit back and print. Well, pretty much.

Making the Print (Finally, It All Comes Together)

Step One:
Go under Photoshop's File menu and choose **Print** (as shown here) or just press **Command-P (PC: Ctrl-P)**.

Step Two:
When the Print dialog appears, let's choose your printer first. At the top of the center column, choose the printer you want to print to from the Printer pop-up menu. You can choose your page orientation by clicking on the Portrait and Landscape Orientation icons to the right of the Print Settings button (as shown here).

SCOTT KELBY

Continued

Step Three:
In the Print dialog, at the top of the far-right column, make sure **Color Management** is selected from the pop-up menu (as shown here).

TIP: 16-Bit Printing on a Mac
If you're working on a Mac, with 16-bit images, and have a 16-bit compatible printer, you can take advantage of CS5's support for 16-bit printing by turning on the Send 16-bit Data checkbox (right below the Print Settings button). Sixteen-bit printing gives you an expanded dynamic range on printers that support it, but at this time, this feature is only available for Mac OS X Leopard or higher users (this is a limitation of the Windows operating system, not Photoshop).

Step Four:
From the Color Handling pop-up menu, choose **Photoshop Manages Colors** (as shown here) so we can use the color pro-file we downloaded for our printer and paper combination, which will give us the best possible match. Here's the thing: by default, the Color Handling is set up to have your printer manage colors. You really only want to choose this if you weren't able to download the printer/paper profile for your printer. So, basically having your printer manage colors is your backup plan. It's not your first choice, but today's printers have gotten to the point that if you have to go with this, it still does a decent job (that wasn't the case just a few years ago—if you didn't have a color profile, you didn't have a chance at getting a pro-quality print).

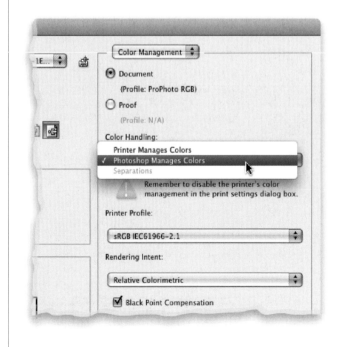

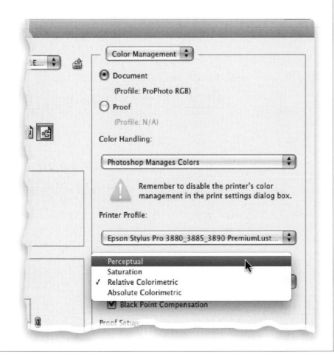

Step Five:

After you've selected Photoshop Manages Colors, you'll need to choose your profile from the Printer Profile pop-up menu. I'm going to be printing to an Epson Stylus Pro 3880 printer using Epson's Ultra Premium Photo Paper Luster, so I'll choose the printer/paper profile that matches my printer and my paper (as I mentioned in the previous technique, the Epson 3880 came with color profiles for Epson papers already installed). Doing this optimizes the color to give the best possible color print on that printer using that paper.

Step Six:

Now, you'll need to choose the Rendering Intent. There are four choices here, but only two I recommend: either Relative Colorimetric (which is the default setting) or Perceptual. Here's the thing: I've had printers where I got the best looking prints with my Rendering Intent set to Perceptual, but currently, on my Epson Stylus Pro 3880, I get better results when it's set to Relative Colorimetric. So, which one gives the best results for your printer? I recommend printing a photo once using Perceptual, then print the same print using Relative Colorimetric, and when you compare the two, you'll know.

TIP: The Gamut Warning Isn't for Us

The Gamut Warning checkbox (beneath the preview area) is not designed for use when printing to a color inkjet (like we are here) or any other RGB printer. It warns you if colors are outside the printable range for a CMYK printing press, so unless you are outputting to a printing press, you can turn this off.

Continued

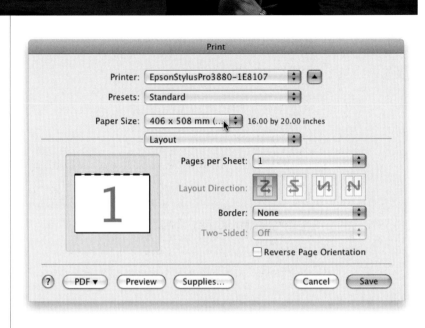

Step Seven:

Lastly, just make sure the Black Point Compensation checkbox is turned on (it should be by default) to help maintain more detail and color in the shadow areas. Now, go back to the center column and click the Print Settings button, and when you do, Photoshop opens your print driver's OS Print (PC: Printer Properties) dialog (I use Epson printers, so the Print dialog you see here is from an Epson on a Mac, but if you have a Canon or HP, the print driver dialog will have the same basic functions, just in a different layout). Your printer will already be chosen in the Printer pop-up menu. On a Windows PC, you'll skip the Print dialog and just see your printer's options. From the Paper Size pop-up menu (found in the Paper Settings on a PC) choose your paper size (in this case, a 16x20" sheet). You can also choose whether you want it to be borderless.

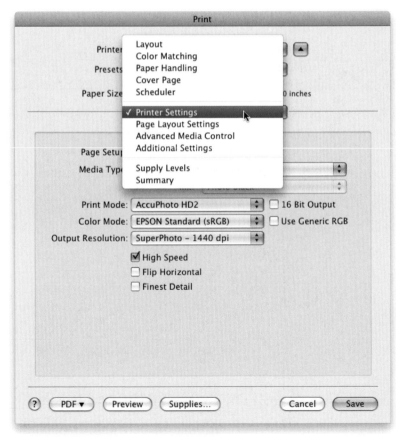

Step Eight:

Click on the Layout pop-up menu to reveal a list of printer options. There are two critical changes we need to make here. First, choose Printer Settings (as shown here), so we can configure the printer to give us the best-quality prints.

WARNING: From this point on, what appears in the Layout pop-up menu is contingent on your particular printer's options. You may or may not be able to access these same settings, so you may need to view each option to find the settings you need to adjust. If you're using a Windows PC, you may have to click on the Advanced tab or an Advanced button to be able to choose from similar settings.

Step Nine:
Once you choose Printer Settings, and those options appear, make sure the type of paper you'll be printing on is chosen in the Media Type pop-up menu (as shown here). This is very important, because this sends a whole series of instructions to the printer, including everything from the amount of ink it should lay down, to the drying time of the paper, to the proper platen gap for the printer, and so on. In our example, I'm printing on Ultra Premium Photo Paper Luster—one of my favorite Epson papers for color and black-and-white prints. (My very favorite is their Exhibition Fiber Paper. It's a little pricey, so I save this for important prints, but man is it sweet! My other favorite is their Velvet Fine Art Paper, which I use when I want more of a painterly watercolor look and feel. It works really nicely for the right kind of photos because the paper has a lot of texture, so your photos look softer. Try it for shots of flowers, nature, soft landscapes, and any shot where tack-sharp focus is not the goal. Velvet Fine Art Paper is also a very forgiving paper when your photo is slightly out of focus).

Step 10:
Choose your Output Resolution from the pop-up menu (on a PC, choose Quality Options from the Print Quality pop-up menu, then use the slider to set the quality level). I use SuperPhoto - 2880 dpi because I want to get the highest possible quality (little known fact: at 2880 dpi, it doesn't use more ink—it just takes longer. Now ya know).

Continued

Step 11:

This next change, turning off the printer's color management, is critical. You do this by choosing **Off (No Color Management)** in the Color Mode pop-up menu (on a PC, click on the Custom radio button and you'll be able to choose Off [No Color Adjustment] from the Mode pop-up menu). You want no color adjustment from your printer—you're letting Photoshop manage your color instead.

Step 12:

Now you're ready to print, so press the Save (PC: OK) button to get back to Photoshop's Print dialog, and hit the Print button to get prints that match your screen, as you've color managed your photo from beginning to end.

WARNING: If you're printing to a color inkjet printer, don't ever convert your photo to CMYK format (even though you may be tempted to because your printer uses cyan, magenta, yellow, and black inks). The conversion from RGB to CMYK inks happens within the printer itself, and if you do it first in Photoshop, your printer will attempt to convert it again in the printer, and your printed colors will be way off.

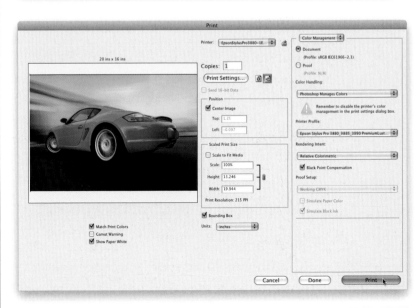

This is the first edition of this book to include how to do soft proofing, because I don't use—or recommend—soft proofing myself, and I don't want to include techniques I don't really use. But, I have had so many people ask me about it recently, I felt I had to include it. Just know that my advice about this is simple: nothing beats a real proof. If you're serious about making great prints, make a test print—soft proofing just gives you a hint of what it might look like. A test print is what it actually looks like. Okay, I'm off my soap box. Here's how it's done:

Soft Proofing in Photoshop

Step One:
Start by downloading the free color profile from the company that makes the paper you're going to be printing on (see page 352 for where to get these and how to install them). Open the image you want to soft proof, then under the View menu, under Proof Setup, choose **Custom** (as shown here).

Step Two:
When the Customize Proof Condition dialog appears, from the Device to Simulate pop-up menu, choose the color profile for the printer/paper combo you'll be using (here, I've chosen an Epson Stylus Pro 3880 printing to Velvet Fine Art Paper). Next, choose the Rendering Intent (see page 359 for more on this), and make sure you leave Black Point Compensation turned on. Down in the Display Options (On-Screen) section, leave Simulate Paper Color and Simulate Black Ink both turned off. You can toggle the Preview checkbox on/off to see a before/after of the simulation of what your print might look like with that profile on that paper (though, of course, it can't simulate how your sharpening might look on different papers, just the color. Kinda). Give it a try and then compare it with a real test print, and you'll be able to determine if soft proofing is for you.

What to Do If the Print Still Doesn't Match Your Screen

Okay, what do you do if you followed all these steps—you've hardware calibrated your monitor, you've got the right paper profiles, and color profiles, and profiles of profiles, and so on, and you've carefully turned on every checkbox, chosen all the right color profiles, and you've done everything right—but the print still doesn't match what you see onscreen? You know what we do? We fix it in Photoshop. That's right—we make some simple tweaks that get the image looking right fast.

Your Print Is Too Dark

This is one of the most common problems, and it's mostly because today's monitors are so much more incredibly brighter (either that, or you're literally viewing your images in a room that's too dark). Luckily, this is an easy fix and here's what I do: Press **Command-J (PC: Ctrl-J)** to duplicate the Background layer, then at the top of the Layers panel, change the layer blend mode to **Screen** to make everything much brighter. Now, lower the Opacity of this layer to 25% and (this is key here) make a test print. Next, look at the print, and see if it's a perfect match, or if it's still too dark. If it's still too dark, set the Opacity to 35% and make another test print. It'll probably take a few test prints to nail it, but once you do, your problem is solved (by the way, this is a great thing to make into an action).

Your Print Is Too Light

This is less likely, but just as easy to fix. Duplicate the Background layer, then change the layer blend mode to **Multiply** to make everything darker. Now, lower the Opacity of this layer to 20% and make a test print. Again, you may have to make a few test prints to get the right amount, but once you've got it, you've got it. Now, make that into an action (name it something like "Prep for Print") and any time you print, just run that action first.

Hue/Saturation

Preset: Custom

Reds

Hue: 0

Saturation: -20

Lightness: 0

315°/345° 15°\45°

☐ Colorize
☑ Preview

Workflow Options

Space: ProPhoto RGB

Depth: 8 Bits/Channel ✓ 16 Bits/Channel

Size: 4256 by 2832 (12.1 MP)

Resolution: 240 pixels/inch

Sharpen For: None Amount: Standard

☐ Open in Photoshop as Smart Objects

Add Noise

OK
Cancel
☑ Preview

100%

Amount: 4.00 %

Distribution
○ Uniform
◉ Gaussian

☑ Monochromatic

Your Print Is Too Red (Blue, etc.)

This is one you might run into if your print has some sort of color cast. First, before you mess with the image, press the letter **F** on your keyboard to put a solid gray background behind your photo, and then just look to see if the image onscreen actually has too much red. If it does, then press **Command-U (PC: Ctrl-U)** to bring up Hue/Saturation. From the second pop-up menu, choose **Reds**, then lower the Saturation amount to –20%, and then (you knew this was coming, right?) make a test print. You'll then know if 20% was too much, too little, or just right. Once you make a few test prints and nail it, save those steps as an action and run it before you print each time.

Your Print Has Visible Banding

The more you've tweaked an image, the more likely you'll run into this (where the colors have visible bands, rather than just smoothly graduating from color to color. It's most often seen in blue skies). There are two ways to deal with this: If you shot in RAW, make sure you keep the image in 16-bit mode (don't have it down sample to 8-bit when it leaves Camera Raw). Click the Workflow Options link beneath the Preview area in Camera Raw, and choose **16 Bits/Channel** from the Depth pop-up menu. Stay in 16-bit through the entire printing process. If your original was a JPEG, then there's no going back to a 16-bit original (and just converting to 16-bit mode does nothing), so instead try this: Go under the Filter menu, under Noise, and choose **Add Noise**. In the dialog, set the Amount to 4%, click on the Gaussian radio button, and turn on the Monochromatic checkbox. You'll see the noise onscreen, but it disappears when you print the image (and usually, the banding disappears right along with it).

Photoshop Killer Tips

Using CS5 on a MacBook Pro?

Then you've probably experienced a weird thing where all of a sudden your screen rotates, or your image suddenly zooms in (or out). It's because the track pad on a MacBook Pro supports Gestures, which are great for most things, but tend to drive you insane when using Photoshop. You can turn off Gestures by pressing **Command-K (PC: Ctrl-K)** to bring up Photoshop's Preferences, then click on Interface (in the list on the left), and at the bottom of the General section, turn off the Enable Gestures checkbox.

Canceling an Adjustment Layer Edit

If you're working with an adjustment layer, and you want to cancel your edit, click the circular arrow at the bottom left of the Adjustments panel. If you don't want the adjustment layer at all, you can quickly delete it by clicking on the Trash icon to the right of the circular arrow.

What's That * Up in Your Document's Title Bar Mean?

That's just letting you know that the image you're working on has an embedded color profile that's different from the one you chose in Photoshop (for example, you'd see this if you brought an image over from Lightroom, whose default color space is ProPhoto RGB, but Photoshop's default color space is sRGB, so since the two don't match, it just puts that asterisk up top in case you care.

Change Your Background Canvas Color

By default, the area around your document is a medium gray color, but you can choose any color you'd like by just Right-clicking anywhere on that gray canvas area and choosing **Select Custom Color** from the pop-up menu.

Tip for Finding Out Which Fonts Look Best with Your Layout

This is an incredibly handy tip, especially if you're doing poster layouts, and you want to find just the right font to com-

plement your photo. Go ahead and create some type, then double-click on the Type layer's thumbnail in the Layers panel to select all your type. Now, click your cursor once in the Font field up in the Options Bar, and you can use the **Up/Down Arrow key**s on your keyboard to scroll through all the installed fonts on your system, and your highlighted type changes live onscreen as you do.

Refining Your Masks Using Color Range

If you've created a layer mask, and want to tweak it a bit, you can add the Color Range feature as part of your tweaking arsenal. I use this to quickly select images that are on a white background. Try this: Click on the Add Layer Mask icon at the bottom of the Layers panel (you'll have to be on a duplicate or unlocked layer), then go under the Select menu, and choose **Color Range**. With the first Eyedropper tool on the left (below the Save button), click on the background once (not in the image itself, in the mask preview right there in the Color Range

Photoshop Killer Tips

dialog), and then raise the Fuzziness amount until it selects the background. That usually does most of the masking for me. Click OK, and now you can quickly paint in any missing parts using the Brush tool set to paint in black. This gives you a mask of the background selection. To make your mask a selection of your subject, make sure the mask is selected, and press Command-I to Invert it.

Tip for When You're Zoomed In Tight

If you're zoomed in tight on a photo, there is nothing more frustrating than trying to move to a different part of the image using the scroll bars (they always seem to move you way too far, and then eventually you just have to zoom back out and then zoom back in again). Instead, just press-and-hold the **Spacebar**, and it temporarily switches you to the Hand tool, so you can click-and-drag the image right where you want it. When you release the Spacebar, it returns you to the tool you were using.

How to See Just One of Your Layers

Just **Option-Click (PC: Alt-click)** on the Eye icon beside the layer you want to see, and all the others are hidden from view. Even though all the other layers are hidden, you can scroll through them by pressing-and-holding the **Option (PC: Alt)** key, and then using the **Left** and **Right Bracket keys** to move up/down the stack of layers. Want to bring them all back? Just Option-click on that Eye icon again.

Handy Shortcuts for Blend Modes

Most people wind up using the same handful of layer blend modes—Multiply, Screen, Overlay, Hard Light, and Soft Light. If those sound like your favorites, you can save yourself some time by jumping directly to the one you want using a simple keyboard shortcut. For example, to jump directly to Screen mode, you'd press **Option-Shift-S (PC: Alt-Shift-S)**, for Multiply mode, you'd press **Option-Shift-M (PC: Alt-Shift-M)**, and so on. To run through the different shortcuts, just try different letters on your keyboard.

Toggling Through Your Open Documents

To jump from open document to open document, just press **Ctrl-Tab** to cycle through them one by one.

This is particularly handy if you're using tabbed windows.

Putting Your Drop Shadow Right Where You Want It

If you're adding a drop shadow behind your photo using a **Drop Shadow** layer style (choose Drop Shadow from the Add a Layer Style icon's pop-up menu), you don't have to mess with the Angle or Distance fields whatsoever. Instead, move your cursor outside the Layer Style

dialog—over into your image area—and just click-and-drag the shadow itself right where you want it.

CS5 Tip for Wacom Tablet Users Who Use Their Tablet in Their Lap

Back in CS4, Adobe introduced Fluid Canvas Rotation, which lets tablet users who work with their tablet in their lap rotate the screen to match the current angle of their tablet (you turn this on by clicking on the Hand tool, choosing the Rotate View tool, and then clicking-and-dragging that within your image to rotate the canvas). There was only one problem, though: when you rotated the canvas, it rotated your brushes, too (which really wouldn't happen in real life). Luckily, in CS5, your canvas rotates, but now your brushes stay intact.

My Photoshop CS5 Digital Photography Workflow

I've been asked many times, "What is your Photoshop digital photography workflow?" (What should I do first? What comes next? Etc.) So, I thought I would add this chapter here in the back of the book to bring it all together. This chapter isn't about learning new techniques (you've already learned all the things you'll need for your workflow); it's about seeing the whole process, from start to finish, in order. Every photographer has a different workflow that works for them, and I hope that sharing mine helps you build a workflow that works for you and your style of work.

Step One:

Today, most of my workflow takes place in Camera Raw, because no matter whether you're using JPEG, TIFF, or RAW images, I honestly believe it is the fastest and easiest way to get your images looking the way you want them. So, I start by opening the folder of images I imported from my camera's memory card in Mini Bridge. I'm going to edit one of the photos that I took while on vacation, shot from the open upper deck of a double-decker bus in downtown Hong Kong (of course, you can download this same image and follow right along with me—the Web address is in the book's introduction up front). Right-click on the image in Mini Bridge and choose Open in Camera Raw (as shown here).

Step Two:

Here's the original RAW image open in Camera Raw. The first thing I do at this point is figure out what's wrong with the photo, and the question I ask myself is simple: "What do I wish were different?" Here, I wish the sky was darker and there was more definition in the clouds. I wish the buildings were less shadowed, and had more detail, contrast, and color. Of course, I wish everything was sharper, but since I always sharpen every photo, that's a given.

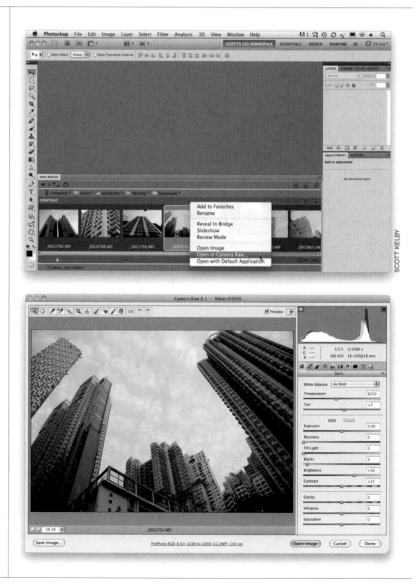

Step Three:

Normally I start by adjusting the white balance (see page 28), but in this case, I'm okay with the overall color temperature (don't get me wrong, I'm going to pump up the color in just a moment, but as far as it being too warm or too cool, or just totally wrong, I'm okay with that part for this particular photo. That's pretty common for shots taken outdoors where white balance usually isn't a big issue). To get more contrast, and punchier color, go to the Camera Calibration panel, and try out the different presets in the Camera Profile Name pop-up menu. The one that looked best to me was Camera Vivid, but of course, that's because my goal here was to really punch up the color. The added contrast it brings doesn't hurt in this case either.

Step Four:

Now, we're going to focus on the overall exposure problem, which is "sky too bright and buildings too dark." We'll start by lowering the midtones, which will darken the sky for us, so go back to the Basic panel, grab the Brightness slider, and drag it to the left until it reads –5. (By the way, I got to that number by dragging to the left until it looked good to me. Very scientific, I know.)

Continued

Step Five:

To get those buildings out of the shadows, we're going to have to increase the Fill Light quite a bit, so drag that slider over to around 70 (as shown here), which opens up the shadow areas quite a bit. (*Note:* When you really bump up the Fill Light like this, you can start to get a bit of an HDR-look to your image, which I kinda like, but depending on how you feel about that look, you may not want to push it that far. And, if you add lots of Clarity, which I will shortly, then it really gets that "look.") For now, let's just add the Fill light and move on. (Back in Chapter 2, I mentioned that if you push the Fill Light slider this far, you might have to increase the Blacks amount, so the image doesn't look washed out. In this case, we're okay without it, but keep that in mind any time you use lots of Fill Light.)

Step Six:

Now that you've darkened the midtones and adjusted the Fill Light, take a look at the histogram up in the top-right corner, and you'll see that there aren't a lot of highlights in this photo (the right side of the graph is flat. Well, you can't see it here, but look at the image in Step Five, or just look on your own screen, eh?), so drag the Exposure slider to the right to brighten the overall image and expand the tonal range, so there are some highlight areas in it (I dragged it to +0.85). Of course, everything is brighter now, so you might have to bring up the Blacks (I dragged mine all the way up to 25), and lower the Brightness a bit more (that sky's a little too light again) to around –24. This actually helped the colors get more punchy (thanks to the increase in the Blacks, which increases the color saturation in the shadow areas at the same time).

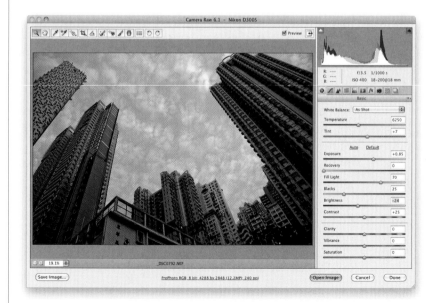

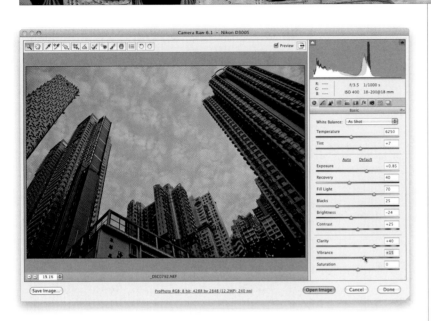

Step Seven:

Now to make the image "pop" a little more, let's boost the Clarity (midtone contrast), and the Vibrance. Increase the Clarity amount to +40 (if you want more of an HDR look, increase it to +70), and increase the Vibrance a bit to +15 (as shown here). Take a look at the image here, and you'll notice that the edges are darker. It's suffering from some edge vignetting, and also a bit of geometric distortion, as well, so we'll head over to the Lens Corrections panel (it's the fifth icon from the right) to have Camera Raw automatically fix both.

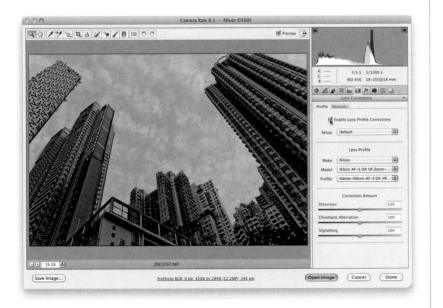

Step Eight:

When you get there, click on the Profile tab, then turn on the checkbox for Enable Lens Profile Corrections, and it reads the embedded EXIF data that was added to the image at the moment it was taken, then it applies a correction based on the make and model of the lens you used (more on this, back on page 66). Not only is the edge vignetting problem gone, but the distortion of the buildings on the sides of the image has been fixed, too! Now, thankfully, not every image I take has a lens distortion or vignetting problem, so I don't always have to do this step, but when you need to (like I did here), it's nice to know it's automated. By the way, if it didn't find a profile to fix your lens problem, then click on the Manual tab and adjust it yourself (see page 67 for more on manual adjustment).

Continued

Step Nine:

At this point, I'm going to give you an optional step, and the reason I'm doing this is that I'm just not happy with the sky. It's darker, but because there were so many other exposure problems, it's still not where I want it (although I'm happy with the buildings, color, and contrast for everything else). So, what I would do is use the Adjustment Brush here to darken the midtones and add a lot of contrast to the sky. The advantage of doing it here in Camera Raw is that you get to use the Auto Mask feature (more on that back on page 99), which makes painting the sky in darker, while avoiding the buildings, a breeze. Click on the Adjustment Brush up in the toolbar, then in the Adjustment Brush panel, click the – (minus sign) button to the left of Brightness and lower that amount to –50, then increase the Contrast to +90, and start painting over the sky (as shown here). Yeah baby—that's what I'm talkin' 'bout!

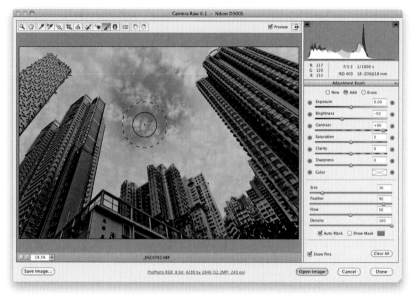

Step 10:

Keep painting in the sky until you've painted entirely over it. Just be sure not to let that little crosshair in the center of your brush stray over onto the edge of a building, or it will start darkening that, as well (though you will probably have to let it stray over the railing a bit when you do the building in front). After you've painted it all in (with Auto Mask turned on), you might even want to increase the Saturation a little (here, I bumped it up to +12) just to make the sky a little bluer. I think that's about all we need to do in Camera Raw, so let's open this baby up in Photoshop and finish 'er off. Click the Open Image button to open your image in Photoshop.

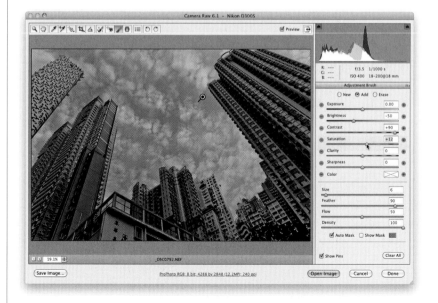

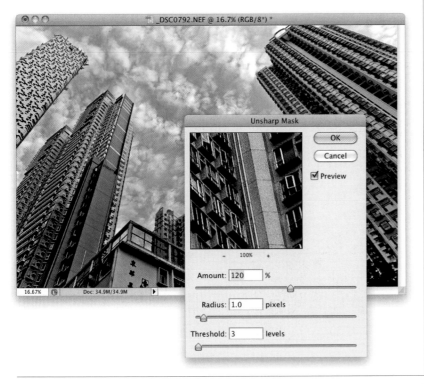

Step 11:

When the image opens, take another look at it and see how it looks to you. To me, the sky and buildings now look balanced (as they do in Step 10), but the whole image looks a little flat (like it needs a Levels adjustment). This is simple: just go under the Image menu, under Adjustments, and choose Levels. Now click the Auto button, and—bam—it's punchy again (though it might be a little too colorful at this point, so you'll have to make the call if your next step shouldn't be to go to Hue/Saturation [also under Adjustments] and lower the Saturation amount to around –20. I wouldn't argue with you if you did, as it looks a little overly colorful, but it's your call).

Step 12:

So, you might be wondering why I left in the book the two or three instances where I had to go back and retweak a change I just made? I left those in because that's how it really happens fairly often, in my own real workflow—you make one change that fixes one part of your image, but then that creates, or undoes, an earlier fix, so it's kind of a balancing act where you make an edit, sit back, look at the image, see what it looks like now, and change it accordingly. It doesn't always just come together the first time out, so I wanted you to really see that it's a process that evolves while you go. At this point, it's time to sharpen (I usually save this until last), so go under the Filter menu, under Sharpen, and choose Unsharp Mask. Enter 120% for Amount, leave the Radius at 1, and set the Threshold to 3 (more on sharpening, starting back on page 316).

Continued

Step 13:
After I run the Unsharp Mask filter, I try to limit any halos or other color nasties that might appear by immediately going under the Edit menu and choosing Fade. Then, I change the Blend mode to Luminosity (as seen here), which applies my sharpening to just the detail areas of the image, and not the color areas, which helps me avoid lots of sharpening hazards. A before/after is shown below (I didn't back off the Hue/Saturation amount, since that step is optional and up to you). Since we did wind up using a lot of Fill Light and Clarity, it has a little bit of the HDR look to it, but if you want even more, go under the Image menu, under Adjustments, and choose Shadows/Highlights. Lower the Shadow Amount to 0, but increase the Midtone Contrast slider (if you don't see it, turn on the Show More Options check-box) to around +25. Want an even more HDR look? Add some High Pass sharpening (see page 208).

Before

After

Index